# 100 Years of Cruelty

2009

# 100 Years of Cruelty

# Essays on Artaud

edited by
**Edward Scheer**

POWER PUBLICATIONS and **ARTSPACE**
Sydney

The chapter by Alan Cholodenko was written in the author's capacity
as staff member of the Department of Art History and Theory, The
University of Sydney.

*Published by*
Power Publications
Power Institute
University of Sydney
NSW 2006
Australia

Artspace Visual Arts Centre Ltd
43–51 Cowper Wharf Road
Woolloomooloo
NSW 2011
Australia

*General Editor*
Julian Pefanis

*Managing Editor*
Greg Shapley

*Cover Design*
Carmen Zurl
Cover image © Bibliothèque nationale de Paris.

*Printed by*
Southwood Press, Marrickville

*National Library of Australia Cataloguing-in-publication data:*

100 years of cruelty : essays on Artaud.

ISBN 1 86487 291 8

1. Artaud, Antonin, 1896–1948 – Criticism and interpretation. 2. Cruelty in
literature. I. Scheer, Edward. II. Title : One hundred years of cruelty.

848.91209

# Contents

# Preface and acknowledgments

*100 Years Of Cruelty* was first of all an event which celebrated the centenary of the birth of Antonin Artaud and examined some of the traces of his endless provocations. This collection of essays, which had their origin in the conference of 1996, explores the remnants of that event and completes the project of which it was the first manifestation. At the turning of the millennium, these essays amplify Artaud's irrecuperable twentieth-century voice.

As Jane Goodall wrote at the time of the conference: "When 'fair, reasonable and responsible' are the keywords whose banalising hold hardens every day, we need the voice of one who knows *un bougre d'ignoble saligaud* (a filthy rotten bastard) when he sees one. ... Artaud never belonged to his own time."[1] This collection of essays takes this untimeliness of Artaud's as a means of opening a space in which to interrogate current cultural values through the optic of his "vast, strange, promiscuous oeuvre."[2] This is not a book of cultural studies but a book about how to rethink from the roots the very concepts of culture which such studies repeatedly deploy. As Sylvère Lotringer noted in an early version of his essay, Artaud was someone who experienced "the culture's dissonance on the most cellular level." He was the outsider of his time and in this time his is still a voice which both resonates with the energy and exhaustion we are living through and prefigures the crises and openings to come.

> "It's my work that's made me electric," I said to God.
> "I know you've always thought you were a battery,
> but you're nothing to the battery I'm going to use to make you glitter,
> to make you glitter,
> you old antero-colitic bugger." (Artaud XX, 170)

Edward Scheer says that Artaud wrote about inspiration, about the catalytic power of an experience to change you, to force you to think other than the way you

I

think, to shift course mid-stream. But what is the value of all this if not to increase your passion for living? Perhaps it is just this that his work still offers to people who risk an encounter with it. For it will take a certain persistence, even a degree of perversity, to maintain a relation to this work. The purpose of an event like *100 Years Of Cruelty*, and the book which gathers some of its essential insights, is only to open a window onto such an encounter. I hope it is an inspiration and that it might work to encourage the kinds of innovation in art and in intellectual life that Artaud called for and for which he will be remembered.

As director of Artspace, the institution through which this event was conceived, organised and staged, I would like to extend my gratitude to the advisory committee: Dr. Edward Scheer, Dr. Alan Cholodenko and Associate Professor Jane Goodall, in particular to Dr. Scheer for the sustained initiative that generated both the conference and this publication. His enthusiasm and commitment was essential to the realisation of this response to Artaud. He has overseen the completion of an enormous interdisciplinary and multi-institutional project which registers some of the immensity of the impact of Artaud's ideas on contemporary thought and visual culture.

Acknowledgement should also be made of the major contributions of the following: the French Embassy; the University of Western Sydney Nepean; the University of Sydney through the Power Institute: Centre for Art and Visual Culture and the Department of Art History and Theory, and the College of the Arts; the University of Newcastle Central Coast; Macquarie University; the Powerhouse Museum; New South Wales Film and Television Office; ABC's Radio National and Classic FM. Thanks also to Liz Schwaiger for her smooth management of the publication, Nicholas Strobbe for proofreading, Carmen Zurl for her cover design and Julian Pefanis at Power for facilitating this institutional collaboration.

—Nicholas Tsoutas, August 1999

**NOTES**
1    Jane Goodall, Conference handbook.
2    ibid.

# An Introduction to Cruelty

*Edward Scheer*

'Cruelty is the consciousness that misses nothing'
—Jane Goodall on *Meridian*, ABC Radio 6/9/96

"One Hundred Years of Cruelty" began with a reading by Jacques Derrida live via satellite from Paris at the Clancy auditorium at the University of New South Wales. His two texts were from *Forcener le subjectile* (To frenzy the subjectile), a piece about Artaud's drawings which has only appeared in full translation since the event,[1] and a text-in-progress on the meaning of one of Artaud's pseudonyms 'le Mômo' (idiot, nut etc.), a piece which was destined for presentation at MOMA in New York later that same year. We could not include these texts in this collection but there are two fragments, two images of Derrida on that opening evening which I retain. The first was when he recited some of Artaud's glossolalia in a loud declamatory voice, the philosopher become actor, reversing Artaud's own trajectory. It was the clearest his voice sounded all evening and it occurred at the exact moment in which his reading manoeuvred to amplify Artaud's alternative plans for language; the physicality of the utterance overwhelming the sense, in Derrida's performance, disrupting the flow of scarcely audible explication, and presenting the audience with a perverse flash of presence (via satellite). The second was the response he made to a question that he found particularly irksome. He simply lowered his head so that all the audience could see was a circular shock of white hair. The

1

physical move made any spoken text seem superfluous. Wasn't this precisely Artaud's argument in the theatre texts...?[2]

Samuel Weber's text, appropriately, on an evening he shared with a satellite image, interrogated the virtuality of Artaud's theatre, arguing that the question of the virtual is essential to an understanding Artaud's theatre writings which insist on the potential of an action and on maintaining that potential and not exhausting it. Weber's essay also situates Artaud in a historical continuum beginning with Plato and Aristotle. This unlikely sequence produces some remarkable insights into Artaud's rejection of naturalistic theatre. It is based, as Weber sees it, on a rejection of humanism as the principal mode of understanding the functions of theatre and of thought, a rejection which occurred well before the post-structuralist critique of humanism and which still, as Weber says, has implications for our 'capacity to know, to learn and to teach.'

Sylvère Lotringer would be known to many readers as the man who brought much contemporary French critical writing to the anglophone world through the publishing house Semiotext(e) which grew from his office at Columbia University in New York, but he has also met and interviewed just about anyone who ever knew Artaud. His text is primarily biographical but without the sensationalism so frequently encountered in Artaud biographies. In a discussion with Jane Goodall and myself in the final section of the book, he talks about the time Marthe Robert was walking with Artaud when he was complaining about the pains in his hands and feet from being nailed up on the cross all those years ago in Palestine, and when she challenged him he just shrugged and changed the subject. This type of observation suggests an Artaud whom we otherwise would not know through the decades of obfuscation provided by the systematic romanticisation of the madman and guru. This one is the man who, as Lotringer argues, never stopped

throwing the dice with his own subjectivity. Every extant thing was, for him, up for grabs and could be re-invented with a little madness, yes, but also a little anger, a little energy, and a bit of intellectual brio.

This is the one we are introduced to not only in Sylvère's paper but in the performances that accompanied the event: UK artist Crow's performance in the basement at Sydney's Performance Space imagining the sound of Artaud's voice after death, Mike Parr's 72 hour durational event at the Finger Wharf in Woolloomooloo Bay, alternately walking a long corridor under spotlights and collapsing from exhaustion while his image was projected onto a wall in a gallery in Artspace opposite ... and Nick Tsoutas' frenzied action in the forecourt of Artspace drawing hundreds of red circles on white paper, a performance which came to an early conclusion when bystanders began burning the paper and throwing it into the performance area starting spot fires and risking injury to both the performer himself and the assembled pieces of audio and video equipment with which Tsoutas was interacting. All of these pieces, despite their diversity, recall an extreme figure whose voice still raises itself beyond the placid academic legato of conferenceville. They recall the noisy, difficult, inspirational Artaud, the one who makes you want to take more risks in your life, to accept less protocol and more inventiveness, but also less peace and more fury. Not raving loony, just ecstatically, performatively miffed.

As Jane Goodall notes: 'Artaud, virtuoso of the insult as well as the scream, may be one of the voices we need most right now, to remind us what moral fury sounds like'. Goodall, as the premier Australian scholar on Artaud, was naturally the source for much of the inspiration behind the event and the contributions of its participants, in particular her book *Artaud and the Gnostic Drama* (Oxford: Clarendon 1994) which, apart from Artaud's own works, is by far the most frequently cited text in this collection. Her thoughts on the broader

cultural significance of Artaud's writings construct them as a kind of necessary virus attacking the host organism which is, as Artaud knew, desperately and unknowingly sick:

> Artaud wrote for a culture in crisis. The latest surge of economic rationalism that hit during the time we were planning the conference was for me thrown into sharp relief as I started to re-read the work. Artaud is, amongst other things, a bizarre logician, whose thought is so fertile and diverse it challenges most of the ground rules of meaning making but in doing so opens up other ways of seeing ... Set against the kinds of fertile logical manoeuvres found in Artaud, and the impassioned provocation they offer, economic logics seem to demonstrate some kind of intellectual collapse — a collapse of dimensionality. The effect is to bring out a corresponding collapse in cultural life. The monetarist rationale discovers dependencies everywhere and starts acting like some kind of rampant immune system, determined to reject them from the body politic.[3]

Jane Goodall's other contribution to the event was a radio piece on Artaud's narrative strategies appropriately using the motif of the ear. In this piece, as she does in her book Goodall sees Artaud's 'genius for interpretation' writing a dimension of playfulness to the ... on which has often been hidden ... insistence on Artaud's madness as a ... orce which silences the will of the ...

Another major figure in the collection is Allen S. Weiss who writes about the poetics of the *ictus* — a term which identifies a uniquely Artaudian strategy regarding language. Weiss notes that the *ictus* gathers the meanings of beat, stress, seizure and stroke combining the strict organisation of Artaud's style and imagery with its physicality and immediacy and also its violence. In this sense Weiss's writing constitutes itself as a kind of polygraph, recording the electrical impulses of a

multiplicity of bodies, detecting here and there the trace of a displaced intention, a failed sublimation, a reversal or an introversion of the semiotic drives. But it is a polygraph also in the sense that it produces a copy of those traces in lyrical éclats and theoretical polyphonies bursting through the lines on the page. Weiss has written extensively on Artaud's radiophonic experiments in a way which similarly reflects Artaud's practice of digging out concepts by the roots ... never content to simply record a reading, his radiophonic experiments explore the thresholds of sense and obscenity, the thresholds of the intelligible and the listenable.

In fact, Artaud's theatre writings form a comparatively minor part of his oeuvre which treats cinema, fine arts, literature and other media with equal doses of contempt and crusading intensity. The idea behind this collection in "100 Years of Cruelty" was to reflect the diversity of his interests and effects and the contributors have, appropriately, explored wildly divergent topics. Patrick Fuery offers a meditation on postmodern love. Lesley Stern analyses the poetics of abuse in Artaud in her *mise-en-scène* of the obscene. Rex Butler opens the space of the Artaud institution to find a permanent incompleteness there which works at arresting our words and intentions and demands our response. Alan Cholodenko reads Artaud and Baudrillard together and comprehensively links their two projects as manifestations of the same strategic cultural terror. Bill Schaffer reproduces the form versus formlessness dichotomy in a highly original way, folding it into a logical S-bend, while Frances Dyson examines Artaud's encounter with musical composition in a way which again does not fail to respond to Artaud's demand for stylistic risk and conceptual density. Douglas Kahn's linking of Artaud and the American avant-garde is especially important as it establishes the origins of this well known but not often understood relation with a flair for the key historical moment, while Lisabeth During reveals the anguish of Artaud not in the way we know so

well, of the pathological poet maudit, but of one who, like the metaphysical philosophers, was unable to resist the 'ontological contagion' in which inauthentic selves abjectly examine the open wounds left on the world after the departure of Being. She places him in conversation with philosophers and, accordingly, we close the book with three philosophical conversations on Artaud.

All these texts are cruel, that's to say necessary and vital signs of Artaud's ongoing significance to our thought and culture. Yet this exploration of cruelty is not an obsessive thanatographic survey of the writer's corpse or corpus so much as an attempt to follow the traces left in our culture by his thought, his work, and even his life, for it was a life: shambolic, diseased and extreme beyond any recuperation, which attracted us to him in the beginning, but only in order to leave him and so to amplify what he was saying to us.

## NOTES

1   Jacques Derrida, "To Unsense the subjectile," in Jacques Derrida and Paule Thévenin, *The Secret Art of Antonin Artaud*, transl. Mary Ann Caws (Cambridge Mass. and London: MIT Press, 1998) 59–157.

2   At this point I should say to the anarchists who were protesting outside the venue and who thought "One Hundred Years of Cruelty" was celebrating political torture and institutional evil, that it was really the impossibility of presence, of authenticity, which was the nub of cruelty for Artaud, as these were and are questions to which we must ineluctably return. In this case the question of Derrida's impossible presence, as he had said that he couldn't even imagine '*un tel voyage*' to Australia at that time, but agreed to participate in '*cette folie technologique*' (letter to the organisers, 3 March 1996).

3   Jane Goodall, 'Not done with the judgement of Artaud' *Real Time* 16 (Dec 1996–Jan 1997) 5. This same issue includes some of the comments I make in this introduction.

# The Greatest Thing of All

## The Virtual Reality of Theatre

*Samuel Weber*

"One Hundred Years of Cruelty" — Only one hundred? Did cruelty begin in 1896? Certainly the past century has been particularly distinguished in this respect, and if we can judge from the events of recent years, the century to come will hardly be any better. So much has changed in these years, and yet, in respect to cruelty, so much has remained the same; for instance, since the year 1933, when Antonin Artaud wrote the following words:

> The question is to know what we want. If we are prepared for war, plagues, famine and massacres we don't even need to say so, all we have to do is carry on. Carry on behaving like snobs, rushing en masse to hear this or that singer, to see this or that admirable show, this or that exhibition in which impressive forms burst forth here and there, but at random and without any true conscience of the forces they could stir up.
> I am not one of those who believe that civilisation has to change in order for theatre to change; but I do believe that theatre, utilised in the highest and most difficult sense possible, has the power to influence the aspect and formation of things.
> That is why I am proposing a theatre of cruelty. Not the cruelty we can exercise upon each other by hacking at each other's bodies, carving up our personal anatomies, or, like Assyrian emperors, sending parcels of human ears, noses, or neatly severed nostrils through the mail; but the much more terrible and necessary cruelty which things can exercise against us. We are not free. And the sky can still fall on our heads. And theatre has been created to teach us that first of all.[1]

7

"One Hundred Years of Cruelty": Artaud saw them coming, found himself in their midst, suffered their terrible impact more than most. But why then should he have proposed, if only for a time, to bring cruelty to the theatre? Why bother to theatricalise cruelty rather than just letting it take its course, as indeed it does every day, without requiring any help from Antonin Artaud? What claim can this bizarre project of Artaud still make on the attention of those for whom cruelty has become as ordinary, as self-evident, as banal as the evening news? Why bother, then, with a '*theatre* of cruelty,' when cruelty *itself* abounds?

> And it will be said that the example calls for the example, that the attitude of healing invites healing and that of murder calls for murder. Everything depends on the way and the purity with which things are done. There is a risk. But it should not be forgotten that if a theatrical gesture is violent, it is also disinterested; and that theatre teaches precisely the uselessness of the action which, once accomplished, is never to be done again. (82/99)

Artaud's defence of a 'theatre of cruelty' is not to deny that it *could* incite one to commit the acts it performs. "There is a risk involved, but in the present circumstances I believe it is a risk worth taking" (83/99). For, properly performed, namely *theatrically*, the violent gesture remains *singular*. "Once accomplished," Artaud insists, "it can never be identically repeated," above all, not in the world "outside":

> Whatever the conflicts that haunt the heads of an epoch, I defy a spectator whose blood will have been traversed by violent scenes, who will have felt in himself the passage of a superior action, who will have seen in extraordinary exploits the extraordinary and essential movements of his thought illuminated as in a flash ...
> I defy him to abandon himself on the outside to ideas of war, of revolt and of dangerous murders. (82/98–99)

And yet, is the fact that the theatrical gesture, even violent, remains singular and disinterested, enough to justify bringing it on the stage, and indeed, making it into a determining factor of theatre itself? A further justification is required. And it is curious, symptomatic and revealing to see how Artaud, in order to legitimate his notion of cruelty, is led, here and elsewhere, to appeal to precisely the tradition he so often attacks. In this case: that of an Aristotelian conception of theatre. For does not Artaud's defence of the 'theatre of cruelty' here recall Aristotle's defence of tragedy in terms of *catharsis*, as a kind of purgation? Is there not throughout Artaud's writings on theatre an appeal to "action" that "doubles," as it were, Aristotle's emphasis on tragic mimesis as the imitation of an *action*, a *praxeos*? And does not his emphasis, in the passages quoted, on a certain pedagogical or didactic function of theatre also echo the *Poetics*, where Aristotle seeks to justify mimesis against its Platonic condemnation by stressing its didactic virtues? Artaud wants his listeners, and readers, not to forget what theatre above all teaches: that we are not free, that the sky can still fall upon our heads, and above all, that an action performed on the stage can never be simply repeated elsewhere.

If Theatre for Artaud — and not just for him — is always a question of "doubles" and of "ghosts," could it be that the 'theatre of cruelty' is in some sense haunted by Aristotle? By the very tradition against which Artaud also rebels? And, if this were so, what would it tell us of the relation of "doubles" and "ghosts" to their "originals"? And hence, of the nature of theatre as the medium of such *duplicity*?

It may be useful, therefore, in attempting to discover just what is distinctive and lasting about Artaud's conception of theatre, and in particular in the cruelty it entails, to begin with a brief discussion of the ways in which his conception of theatre both *derives* and *diverges* from the tradition first powerfully articulated in the *Poetics* of Aristotle. It should be remembered, of course, that

Artaud himself, unlike Brecht for instance, never considered himself primarily "anti-Aristotelian." Rather, the tradition from which he sought to distance himself, above all, was the more recent and modern tradition of theatre that had developed in the West since the Renaissance, a theatre which he designated and condemned above all for being "psychological." Such a position, however, is by no means simply anti-Aristotelian. In his *Poetics*, Aristotle leaves no question about the fact that it is not "character" (*ethos*) that is the most decisive element in tragedy, but rather first of all *action* and, secondly, its narrative articulation as *mythos*, or *plot*. It might seem, especially to a contemporary perspective, that it is difficult to speak of *action* without speaking of *actors*. But Aristotle insists that the two must be separated:

> The greatest of these elements is the structuring of the incidents. For tragedy is an imitation not of men but of a life (*bios*), of an action (*praxeos*) and they include the characters along with the actions for the sake of the latter. Thus the structure of events, the plot (*mythos*) is the goal (*telos*) of tragedy and *the goal is the greatest thing of all*.
> Again: a tragedy cannot exist without a plot, but it can without characters: thus the tragedies of most of our modern poets are devoid of character and in general many poets are like that[2]

Action can thus do without character (*ethos*) but never without *plot* (*mythos*). And it is here, with respect to this "mythological" dimension of Aristotle's conception of plot, that the difference to Artaud begins to emerge. What is at stake is not *simply* a question of *representation*, for Artaud never envisaged simply eliminating or abandoning representation entirely in favour of pure performance (as is evident from his own stagings and proposals for the *Théâtre Alfred Jarry*). What he did insist on, however, is that the dimension of the "represented" no longer entirely dominate the practice of theatre. This domination, whose

theoretical justification does indeed go back to Aristotle, entails two distinct if often interrelated aspects. The first consists in the elevation of "character" and its representation to the predominant theatrical function. The rejection of this predominance, however, is, as we have just seen, a position that Aristotle had elaborated long before Artaud. It is only on the second point that the divergence between the two emerges with clarity. It is no accident that Aristotle does not treat of theatre as such in his *Poetics*, but rather only of those *forms* of it that he considers most worthy of discussion: tragedy and, secondarily, comedy. From this choice everything else follows more or less necessarily. Above all, the subordination of everything peculiar to the *medium* of theatre to its thematic *content*, which Aristotle identifies, first with the action, and then with its structured representation as *plot, mythos*. Much of Aristotle's discussion of tragedy, therefore, focuses on the question of how effective tragic plots are constructed. Underlying Aristotle's approach to this question is his conception of theatrical mimesis as above all a *learning experience*, albeit one that proceeds more through feeling, *pathos*, than through conceptual understanding.

We should keep in mind, of course, that Aristotle's discussion of theatre in the *Poetics* did not take place in a vacuum, but like much of his thinking was intended as a response to Plato, and in this particular case, to the latter's categorical condemnation of theatre and mimesis in the *Republic* and elsewhere. Plato considered mimesis in general to be a dangerous process since it involved a distancing from the nature of things which at the same time could be seductively pleasurable. In this respect, Plato held theatre to be a particularly dangerous form of mimetic activity, since the pleasure it produced could easily encourage people to forget *where* they came from, *who* they were, and *where* they belonged. Against this notion, Aristotle in the *Poetics* seeks to defend mimesis by stressing its role in the process of learning: mimesis, for

Aristotle, is an indispensable learning experience and must be cultivated as such. For Aristotle, then, it is essential to approach theatre as an important pedagogical tool, which is why tragedy is singled out as its exemplary and most worthwhile form.

Aristotle's discussion of the structure of plot, then, proceeds from his general defence of mimesis against the Platonic condemnation:

> The habit of imitating is congenital to human beings from childhood [actually man differs from the other animals in that he is the most imitative, and learns his first lessons through imitation]. A proof of this is what happens in our experience. There are things which we see with pain so far as they themselves are concerned but whose images, even when executed in very great detail, we view with pleasure. The cause of this is that learning is eminently pleasurable ...
>
> The reason [we] take pleasure in seeing the images is that in the process of viewing [we] find [ourselves] learning, that is, reckoning what kind a given thing belongs to: "This individual is a So-and-so." Because if the viewer happens not to have seen such a thing before, the reproduction will not produce the pleasure *qua* reproduction but through its workmanship or color or something of that sort. (20–21, 48b)

According to Aristotle, then, we learn through mimetic behaviour and actions. One of these involves the viewing of images. We find it pleasurable to view images that we recognise, he argues. But to recognise an image, we must already know what it represents. Learning through seeing is an actualisation of a knowledge that we already have, but only virtually. Learning as actualisation consists in an act of judgement and of predication: "This one here is a so-and-so." In this act the encounter with a perceived object becomes pleasurable by permitting the viewer to find the predicates required to identify the object and put it in its place.

The construction of plot, therefore, has to serve this purpose: it must represent the action as a unified and comprehensible whole, with beginning, middle and end. More specifically, "it must be possible for the beginning and the end to be seen together in one view" (63, 59b). Such unification requires, however, a certain type of narrative. It is precisely this narrative that Artaud singles out for criticism:

> If people have lost the habit of going to the theater, if we have all finally come to think of theatre as an inferior art, as a means of popular distraction and to use it as an outlet for our worst instincts, it is because we have been accustomed for four hundred years, that is since the Renaissance, to a theatre that is purely descriptive and which recounts psychology. (92/52)

The juxtaposition of Artaud and Aristotle allows us to see what is distinctive in the 'theatre of cruelty.' What Artaud condemns is not simply narrative as such, but the kind of narrative that Aristotle himself would have condemned: that which sacrifices *action* to *character*. What Artaud condemns is a theatre that "recounts psychology," i.e., that tells stories whose unity derives from the structure of character, of the individual figures involved. But Artaud does not stop there. For "psychology," as he uses the term, does not just designate the state of mind or soul of *individual* human beings or subjects: it goes further, although I hasten to add that those of you who must rely on the English translation of *The Theatre and Its Double* might easily mistake the direction in which Artaud is moving. For there is an error in translating one of Artaud's most powerful formulations. A few lines after the passages just cited, Artaud writes the following:

> If, in Shakespeare, man is sometimes preoccupied with what goes beyond him, *it is always ultimately a question of the consequences of this preoccupation in man, which is to say, a question of psychology*. (77/92; my italics SW)

For Artaud, as this more literal translation makes clear, the issue is not simply that of the representation of "character" in the sense of the portrayal of individual human beings on the stage. Rather, what is at the heart of "psychology," as Artaud here uses the term, is the underlying *humanism* it conceals, an anthropomorphism that places not just individuals, but through them the very idea of "Man" himself at the centre of all things and of theatre as well. The English translation, unfortunately, makes a slight but symptomatic error: instead of translating *l'homme* as "man" it renders it as "*a man*," and then proceeds consistently to translate the concluding part of the sentence as though it were referring to an individual person or character rather than to "man" as such. What emerges in the English translation, therefore, is a critique of psychology as *individualistic*, perhaps, but not as *anthropocentric*, which is ultimately Artaud's point. Here is the published English translation:

> If, in Shakespeare, a man is sometimes preoccupied with what transcends him, it is always in order to determine the ultimate consequences of this preoccupation *within him*, i.e. psychology. (TD: 77)

I call your attention to this problem of translation for two reasons. First, to alert you to a general problem with translations (and those of Artaud are certainly no worse than many others, and probably better than most): since translators are generally concerned with rendering the text being translated into idiomatic language, and thereby making it familiar and plausible, such "idiomatisation" can easily efface precisely what in the original *resists* established conventions of decorum and meaning. Second, the kinds of errors or distortions that occur almost always reveal a more general state of affairs, and rarely ever are merely idiosyncratic. Here, what is being resisted in the translation is precisely a condemnation of psychology directed not just against a form of individualism but against humanism itself. "Theatre" and

"cruelty" for Artaud are both inseparably linked with what he at various times refers to as the "inhuman": the "rigor" and "necessity" which he constantly associated with "cruelty" suggests that the forces at work in it cannot be measured in terms of the distinctive traits of modern man: above all, those of self-consciousness, freedom and autonomy.

What Artaud is therefore criticising in the passage just cited is that all theatrical movements which carry the human subject beyond itself, even in Shakespeare, are ultimately recuperated and resituated once their effects are measured in terms of human beings. That is what "psychology" is all about: it is concerned not ultimately with individuals, but with making "man" the measure of all things and, in particular, the measure of all theatre.

It is not, therefore, the theatrical use of narrative elements as such that concerns Artaud, but the dominance of an anthropologically anchored and teleologically oriented type of storytelling. Why? As long as the privilege of "man" is taken for granted, the cosmos in which he dwells can be assumed to have a certain stability. With man at the centre of the universe, the sky's the limit. But if man can no longer be assumed to provide the governing principle of life and of death, of being and of nonbeing, then there is no assurance that the *sky* will stay put. It "can *still* fall on our heads." On that part of our bodies commonly identified with the seat of the distinctive faculty of man: the capacity for reason and self-consciousness. The capacity to know, to learn and to teach.

"The sky can still fall on our heads" — why should Artaud resort to just this formulation to describe what he is after with the notion of 'theatre of cruelty'? It may help if we recall once again Aristotle's insistence that a tragic plot should be capable of being "taken in at a single view" (30, 51a).[3] The unity of such a "view" in turn presupposes a stable and detached *point* of view, a position from which the plot can be taken in as a unified whole. This in turn presupposes a certain arrangement of space: a clear-

cut separation, for instance, between stage and audience, actors and spectators. It is precisely this stable partitioning of space and the kind of localisation that it permits which Artaud challenges, continuing a tradition that goes back at least to Nietzsche's *Birth of Tragedy* and Kierkegaard's *Repetition*. What this emerging thought of a space that would be irreducibly theatrical does is to break with a tradition that is not merely as old as the Renaissance, but which once again takes us back to Aristotle's discussions in the *Poetics*. In his approach to theatre, through a perspective that focuses upon tragedy and comedy, Aristotle relegates everything having to do with the specific medium of theatre to the margins: above all, what he calls *opsis*, everything properly "optical" and "theatrical." But perhaps even more, he marginalises everything having to do with the *condition* of *opsis*, which is to say, everything having to do with space and place, with localisation and lighting, and finally everything connected with *bodies*, masks and, in general, the stage. All of this is subordinated in Aristotle's discussion to the thematic elements of theatre: which is to say, to plot, action and character. And the form in which Aristotle accomplishes this marginalisation is, curiously and significantly, to privilege *mythos* over all other aspects of theatre. What determines the quality of tragedy, then, is, first and foremost, *plot* understood as the temporal arrangement of events so as to form a meaningful and comprehensible whole.

However, as usual, the story is not quite so simple. In order for plots to be effective theatrically, Aristotle stresses, it is not enough for them to be unified. They must also be *dramatic*. Which is to say, in order for a *learning* experience to take place it must include a passage through non-knowledge. That passage then becomes the obligatory structural factor in constituting a narrative unity that would be properly *dramatic*. The term Aristotle uses to designate this trait is, in Greek, *peripeteia*, "peripety" in English, which is to say, a sudden and unexpected turn of

events. The French have a better term for it, which goes back at least to Diderot's *Paradoxe sur le comédien*: it is, *coup de théâtre*. Literally, a stroke or blow, something that more or less violently *interrupts* an expectation or a conscious plan. This is precisely how Aristotle defines *peripeteia*: as "a shift of what is being undertaken to the opposite" (35, 52a) producing an "outcome very different from what one intended" (51, 56a). It is this emphasis on the theatrical importance of an abrupt and violent turn of events, one that is both unexpected and yet also in some sense *necessary*, that most closely links Aristotle's notion of *peripeteia* to Artaud's conception of cruelty. Both insist on the implacable rigour and violence of a turn of events that escapes conscious control and that, as such, constitutes an essential moment of theatre. The difference, however, is that Aristotle insists that the most effective *peripeteia* are those that are accompanied by an almost instantaneous *anagnoresis*, "recognition." *Anagnoresis*, like *peripeteia*, involves a sudden turn or shift, but this time in the other direction as it were, "a shift from ignorance to awareness" (36, 52a). Although Aristotle stresses that "it is possible for" such a shift "to take place in relation to inanimate objects and chance occurrences" (52b), the examples he gives, from *Oedipus Rex* and *Iphigenia*, indicate that "the recognition" involved entails primarily "a recognition of persons" (37, 52b). Here then, finally, a decisive distinction between Aristotle's notion of *peripeteia* and Artaud's of cruelty begins to emerge. For Aristotle the sudden surprise is merely a means for the acquisition or confirmation of knowledge, albeit a knowledge that passes by the emotions of "pity and fear" rather than by way of conceptual understanding. But the condition of such feelings appears for Aristotle to reside in the recognition of similitude between spectator and hero, no matter how great the distance between them. If the noble hero is overwhelmed by the import of an "action" that gets out of hand, a similar fate could in principle await the spectator, whose condition vis-à-vis such forces is one

of even greater dependency. The placing of human figures, otherwise known as "heroes," at the centre of the tragic "action," even if the significance of this action does not derive from them as individuals, gives to the action the requisite unity, coherence and wholeness required by theatre if it is to exercise its pedagogic function as Aristotle conceives it. For however one chooses to read the Aristotelian notion of "purification," *catharsis*, the result of such "expulsion" is a more unified conception of human beings and their relation to the world than that which was manifested by the tragic conflict. It is the confirmation of such unity through conflict that is the ultimate "goal" of theatre qua tragedy—and for Aristotle, we recall, the "goal is the greatest thing of all" (27, 50a).

Precisely such unity, however, is what Artaud's 'theatre of cruelty' calls into question: unity of meaning, of action, of the subject, and above all, of time, space and *place*. It is this last point that is perhaps decisive. What is both explicit and massive in Aristotle's *Poetics*, as well as the theatrical tradition informed by it, is that everything having to do with the specificity of the theatrical medium, with that *opsis* that Aristotle sought to treat as a mere technical and material accessory, is relegated to the margins. Plot, character, ideas — their hierarchical sequence may be shuffled around, but these three factors continue to dictate the conception and performance of theatre even (and especially) today. Artaud was not the first to protest against this tradition, nor to note how effectively it has diminished and delegitimised the distinctive resources of theatre. But the manner in which he interpreted those resources remains not just unique, but in certain aspects prophetic.

It is here, I believe, and not so much in the possibility of *actually realising* a 'theatre of cruelty,' that the relevance of Artaud's theatrical writings is to be sought. In other words, the *actuality* of the 'theatre of cruelty' lies not in its practical feasibility but in its relation to the *future*. It is a future, however, that excludes neither the

"present" nor the "past." That the 'theatre of cruelty' is a theatre of the future can be seen in the way in which it anticipates, but also alters, many of the effects that today are designated by the term "virtuality," effects associated primarily with the spread and mounting influence of the electronic media over all walks of life.

What is "virtualisation"? Obviously, the term is elusive and there are many ways of defining it. I will take one that strikes me as particularly suggestive, if by no means exhaustive. It is to be found in a recent book by Pierre Lévy, entitled *Qu'est-ce que le virtuel?* In this book Lévy offers the following approach to the question of virtualisation:

> What is virtualisation? Not the virtual as a manner of being, but virtualisation as a dynamic. Virtualisation can be defined as the inverse movement of actualisation. It consists in a passage from the actual to the virtual, in an "elevation to potentiality" of the entity under consideration. Virtualisation is not derealisation (the transformation of a reality into a complex of possibilities), but rather a change of identity, a displacement of the centre of ontological gravity of the object being considered: instead of being defined principally by its actuality (as a "solution"), the entity henceforth finds its essential consistency in a problematic field. To virtualise an entity is to discover a general question to which it refers, to transform the entity in the direction of this interrogation and to redefine the initial actuality as the response to a particular question.[4]

It should be noted that "detachment from the here and now" (Lévy: 17), which is yet another way Lévy characterises virtualisation, is of course in itself nothing new. Indeed, it continues what could be called the "metaphysical" tendency that has been one of the mainstreams of Western thought ever since Plato. And the "dialogical" model of "question" and "answer" invoked by Lévy in defining the notion of virtualisation also has its origins in the Socratic dialectic, which could be described as an effort to "virtualise" the certitudes that are "actually" taken

for granted and thus to reveal problems where before there seemed only self-evident solutions. I emphasise this continuity between the Socratic dialectic and Lévy's definition of virtualisation as problematisation in order to suggest that Artaud's rejection of the notion of dialogue as essential to theatre distances him from that tradition. As is well known, the interpretation of theatre as essentially *dialogical* was *one* of the mechanisms by which Artaud considered Western theatre to have been deprived of its specific resources:

> How does it happen that in the theatre, at least in the theatre as we know it in Europe, or better in the West, everything specifically theatrical, i.e. everything that cannot be expressed in speech, in words, or, if you prefer, everything that is not contained in the dialogue is left in the background? How does it happen that the Occidental theatre does not see theatre under any other aspect than as a theatre of dialogue?
> Dialogue — a thing written and spoken — does not belong specifically to the stage, it belongs to books. (37/45)

Dialogue, as an exchange of questions and answers, is anchored in *meaning*. Meaning, however, at least as traditionally conceived, is considered to transcend factors of space and of place. Meaning is assumed to *stay the same* no matter *where and when* it occurs. It thereby denies the relevance of precisely those factors that Artaud considered specific to theatre:

> I say that the stage is a concrete physical place which asks to be filled, and to be given its own concrete language to speak. (37)

Despite his attack on verbal discourse, Artaud never dreamed of simply abolishing language but rather of restoring its capacity to signify, in short: its virtuality. To do this, the tyranny of meaning had to be supplanted by a language of signification: a language above all, of gesture,

intonation, attitude and movement, but without a recognisable or identifiable "goal." The absence of such a goal would allow the movement of language, its signifying force, to come into its own without being subordinated to a purpose. The incidence of such a language of signification would have to be inseparable from its location in time and space. But that location can never be stabilised once and for all. The performance of a gesture on the stage remains tied to a singular situation. This is why the most concrete manifestation of such a language would be not expression but rather *interruption*. To remain singular, gestures, sounds, or movements must interrupt themselves on the way to fruition. It is as if Artaud sought to sever what for Aristotle had to stay together: as though he sought to detach *peripeteia* from *anagnoresis*, fear from pity, emotion from feeling, discharge from purgation, theatre from drama, tragedy and the totalising idea of the hero. For the hero stands for the human, and the "human" imposes meaning on all things. If the "goal," as Aristotle states, is "the greatest thing of all," then "man" names the actualisation of that greatness, of that "all." For man names the being that claims the right to set its own goals, and hence also to set goals for all other beings and for being as a whole. Artaud's innovative turn is to dehumanise the notion of *peripeteia* and thereby to turn it against its *mythological* origins. If the greatest of myths, in this sense, is that which goes under the name of "man," it is this myth that Artaud singles out as the greatest obstacle to theatre. Against it he seeks to mobilise a certain notion of "things":

> A moment ago I mentioned danger. The best way, it seems to me, to realize this idea of danger on the stage is through the *objective* unforeseen, the unforeseen not in situations but in things, the abrupt, untimely transition from a thought image to a true image. An example would be the appearance of an invented Being, made of wood and cloth, entirely pieced together (*crée de toutes pièces*), corresponding to nothing (literally: answering to

nothing, *ne répondant à rien*), and yet disquieting by
nature, capable of reintroducing on the stage a whiff of
that great metaphysical fear that is at the root of all
ancient theatre. (44/53)

This "invented Being," of which Kafka's *Odradek*[5]
could be an avatar, is theatrical in precisely the same
uncanny way. In Kafka's short text we find the narrator
(the Housefather) unable to discern in *Odradek* any sign
either of a goal, a purpose, *or* of its absence: "The whole
appears senseless, it is true, but in its way complete." One
never knows where and when one is going to stumble
upon Odradek, who has "no fixed residence" and hangs
out on the periphery of domestic living space: stairways,
halls, attic, cellar. But what really worries the Housefather
is that this strange thing may well turn out to outlive him,
his children and even theirs. Things can survive where
humans can't. But are they still alive? Were they ever?
Where "things" are concerned, life and death are not easy
to distinguish. "He doesn't seem to harm anyone,"
concludes the Housefather, "but the idea that he might
actually outlive me is almost painful."

Would the determination of the "goal" as "the greatest
*thing* of all" be an effort to avoid such pain? Would what we
call *meaning* name yet another such effort? And would the
idea of a transparent, cohesive and coherent narrative mark
an attempt to avoid "that great metaphysical fear" in which
Artaud saw the primary resource of his 'theatre of cruelty,'
which was also a theatre of Doubles and of Ghosts? For the
'theatre of cruelty,' then, it was not the "goal" of "meaning"
or the mythic plot that was "the greatest thing of all" but
rather the "great metaphysical fear" itself. And yet, how
could such a fear avoid in turn turning into a goal? The goal
of the 'theatre of cruelty,' for instance. Only, perhaps, by
being mindful of the singular virtuality of theatre, which
prevents it from being identically repeatable, generalisable,
theorisable, and perhaps even realisable.

This is perhaps why such issues cannot simply, for
Artaud, ever be discussed in pure abstraction from their

scenic singularity. It could also explain why some of the most powerfully theatrical articulations in his writing were not written "for" theatre, not at least in the dramatic sense of the term. One such instance is his celebrated essay on "The Theatre and the Plague." Neither purely theoretical nor purely theatrical, this text demonstrates most forcefully what Artaud elsewhere, in "The Alchemical Theatre," calls "the virtual reality of theatre" (49/60).

In "The Theatre and the Plague," which he first delivered in April of 1933 at the Sorbonne, Artaud recounts the spread of the plague in Marseille in 1720. After a brief discussion of plagues and their possible etiologies, Artaud describes the *stages* through which the plague passes as it spreads throughout the city. It is here that we encounter an allegory of the origin of theatre. This consists of four *stages* which, at the same time, and perhaps above all, mark what can be called the *theatricalisation* of the *stage* (temporal as well as spatial). As we shall see, this *theatricalisation* also involves a kind of *virtualisation*, although it is one that contrasts in certain decisive aspects with virtualisation as it is generally understood and practised today. Let us begin, however, by retracing Artaud's account of the four stages of the plague.

First, as the plague takes hold in the city, there is a progressive collapse of all normal institutions and services, the dissolution of what Artaud in French designates as *"les cadres réguliers"* the "regular framework" that defines and maintains social space and time in periods of normalcy:

> Once the plague is established in a city, the regular frameworks collapse; maintenance of roads and sewers ceases; army, police, municipality disappear; pyres are lit with whatever arms are available in order to burn the dead. Each family wants to have its own. (23/29)

Note here how the institution of the family emerges and attempts, as it were, to take up the slack as the social polity begins to collapse. But what form does this take? Artaud tells us quite precisely: "each family wants to have its own"

— its own pyre, in this case. Which is to say, its own *property rights* in the face of death. The scourge afflicts everyone collectively, but "each family wants to have its own." This type of response is not entirely unfamiliar to us today. But the resurgence of "family values" is soon caught up in the very crisis that brought it forth:

> (Each family wants to have its own.) Then, with wood, places and even flames growing rare, family feuds break out around the pyres, soon followed by a general flight, for the corpses have grown too numerous. Already the dead clog the streets, forming crumbling pyramids whose fringes are gnawed at by animals. The stench rises into the air like a flame. Whole streets are blocked by heaps of the dead. (ibid.)

The orderly, organised space of the city disintegrates, and families contribute to the chaos in their struggle to preserve a minimum of property and propriety — "Each family wants its own" — and each succeeds, but not as planned. Each family gets its "own," but what it gets is death and disintegration that rapidly sweep away all possibility of ownership. The first and most significant sign of this disassociation is the blockage of the avenues of communication. As a result, habitual movements no longer are possible. In their stead, however, a new kind of movement and communication *burst out*, and, with them, a new arrangement of space and time. This new arrangement ushers in the *second stage* of the plague:

> (Entire streets are blocked by the piles of the dead.) It is at that very moment (*c'est alors que*) that the houses open up and delirious plague-ridden victims, their minds overwhelmed with hideous visions, stream forth screaming into the streets. The disease [but note that Artaud uses a French word here which means not just "disease" but also "evil" as well as "pain": *le mal*] at work in their guts, pervading their entire organism, breaks free in mental explosions (*se libère en fusées par l'esprit*). Other plague victims, lacking all bubos, delirium, pain

and rash, proudly observe themselves in the mirror, bursting with health, before falling dead [on the spot], their shaving mugs *still* in their hands, [*still*] full of scorn for the other victims. (my italics SW)

This second *stage* is thus marked by the implosion of the closed space of domesticity, with houses and homes breaking down and forcing their inhabitants to flee into a space that is no longer either public or private. The orderly, goal-directed movements of organised social life are progressively supplanted by the pointless gestures and explosive spasms, both physical and mental, of those whose bodies and being have become the staging ground of the plague. What is in the process of breaking down here is the last vestige of self-control, the faculty of self-consciousness itself. Those who have no visible, outward signs of the plague, and "who feel themselves bursting with health" (*se sentant crever de santé*), "burst" indeed, but not with health. Here, the *peripeteia* does not interrupt an action or an intention, in the sense envisaged by Aristotle, but rather self-consciousness itself. It imposes a different temporality: that of the belated reaction. Consciousness cannot catch up with the plague and its effects. People congratulate themselves on having escaped, and drop dead *still* "full of scorn for the victims." This belated temporality drives a wedge into the visible. The scene, for all of its horror, moves away from drama and from tragedy, towards comedy, and perhaps even more, towards *farce*. For not only is the consciousness of the characters increasingly inadequate to the situation, but the very idea of action itself, of a plot, increasingly disappears. The lack of visible signs of the plague becomes itself an invisible sign of its power. Visibility loses all transparency and reflexivity all reliability. The stage is set for what will be the final *coup de théâtre*. But, before it can strike, a final effort is undertaken to ward it off. This effort, which brings us to the *third* stage of the plague, only confirms the domination of *farce*, although one that is *still* not quite ready to assume its theatricality:

Over the poisonous, thick, bloody streams, coloured by
anxiety and opium, which gush from the corpses, strange
figures dressed in wax, with noses long as rods, eyes of
glass, mounted on a kind of Japanese sandal composed of
double wooden tablets, the one horizontal in the form of
a sole, the other vertical, isolating them from infected
fluids, pass by chanting absurd litanies whose virtues do
not prevent them from sinking into the flames in turn.
Such ignorant doctors display only their fear and their
puerility. (23–24/29)

Such carnivalesque figures — which, once again, should be
quite familiar to many of us — appear, in this third stage, as
a parody of the order they seek to maintain. With their
disappearance, however, the last vestiges of propriety, and
of property, are condemned. And it is at this point that we
arrive at the fourth and final "stage" of the plague, that in
and on which theatre finally takes (its) place:

Into the opened houses enter the dregs of the
population, immunised, it seems, by their frenzied greed,
laying hands on riches from which they sense it will be
useless to profit. It is at that very moment (*Et c'est alors*)
that theatre takes (its) place (*que le théâtre s'installe*).
Theatre, which is to say, that immediate gratuitousness
which imposes acts that are useless and without profit for
actuality (*qui pousse à des actes inutiles et sans profit
pour l'actualité*). (24/29–30)

*Acting without actualising itself*, it is here that the
'theatre of cruelty' "installs itself," takes its place, as a
reality that is irreducibly *virtual*, but in a way that is quite
different from the virtualisation with which we today are
increasingly familiar. For however widespread and
ubiquitous its effects, virtualisation today is almost always
and everywhere construed and undertaken from the
perspective of *actuality*. Even Pierre Lévy, who, as we
have seen, draws much of his inspiration from Deleuze's
seminal discussion of virtuality in *Difference and*

*Repetition*, links *virtuality* inescapably, if negatively, to *actuality*. As we have seen, he defines *virtualisation* as a process of *de-actualisation*, which is to say, as an inverted mode of making actual, transforming into acts. Action, by contrast, in the 'theatre of cruelty,' can not be measured, either positively or negatively, in terms of actuality. For virtualisation, as Artaud describes the plague, no longer has any *goal* whatsoever. Not the greatest and not the smallest. For what it attacks is not *actualisation* as such, but rather its specifically modern condition of possibility, which can be designated as *appropriability*. The virtualisation that takes place today, in the media and elsewhere, cannot be separated from the economic dictates of what is called *globalisation*, which in turn does have a very definite, if problematic, *goal*: that of the *maximisation of profit*. Profit, however, entails however not just the production of "value," but of value that is *appropriable*. Capital therefore continues to impose its goal upon virtualisation, which by and large is permitted to develop only insofar as it serves this particular end.

It is this goal or *telos* — that of profit and appropriation, in all senses — that is explicitly challenged by Artaud's virtual 'theatre of cruelty.' This is why it is a serious mistake to render, as the published English translation does, the key phrase in this fourth and final stage of the plague, which describes the emergence of theatre, as its "birth": "And at that moment the theatre is born" (24). Although here, as elsewhere, Artaud is enormously indebted to the author of *The Birth of Tragedy*, the 'theatre of cruelty' is still not *born*, not even *stillborn*, if by "birth" we mean its coming into a world from which it was previously absent. Theatre, like the plague, does not have to *come* into the world: it is already *there*, albeit dormant. Its time is not the linear time of narrative, of plot, of beginning, middle and end, of before and after. Nor is the time of theatre that of production. Theatre is not made, if by "making" is meant a process of conscious and deliberate construction governed by a design, a plan, an idea or a goal. Least of all, however, is theatre

*created*, if by creation is meant *creatio ex nihilo*. Artaud, as always in decisive moments such as these, is extremely precise in his choice of words, of those words whose power over the theatre he knew could be dislodged only through a *precision* that *cut* into the specious self-evidence of self-contained meaning. What Artaud writes in French, to describe the emergence of theatre, is that "*c'est alors que le théâtre s'installe*": it is then, at that moment, "that theatre *installs* itself," *takes* its place. To "install oneself," however, is to *take* a place that is *already there*, to occupy it, indeed, to *expropriate* it and, in the process, to *transform* it. That is precisely what theatre does when it makes the site into a scene, the place into a stage, and it is this alteration and expropriation that makes it *cruel*. It involves, above all, a movement of dispossession, but not for profit. A place is robbed of its apparent unity, meaning, propriety. Houses are demolished, the barrier between inside and outside, domesticity and politics, private and public breaks down, just as Artaud envisaged eliminating the partition in theatres between the stage and the audience, or, more generally, between theatre and its other. The 'theatre of cruelty' was to take place in barns and hangars, rather than in established "theatres." The audience was to be placed at the centre of the theatrical space, but on movable seats, so as to be able to follow a spectacle that was to exploit *all* the dimensions of space, not just that which was positioned "in front" of the public. The *Vor-stellung*, the German word that signifies both theatrical performance and mental representation, (the Vor-stellung) would no longer serve as an *alibi* by which *subjects* could hope to *exonerate* themselves and escape from their involvement in what was necessarily a violation of all constituted legality. The space of the theatre would not just be "outside" or "inside" — it would take hold of the body itself, that of humans as of things, turning them into stages for unheard of peripeteias where sound becomes silence, fluids freeze, and matter becomes hollow.

The "gratuitousness" of the theatrical act, then, is inseparable from the rule of law, which it must presuppose

in order to violate, although Artaud always understood the violation to be, paradoxically, prior to any inviolate identity. It must presuppose therefore organised, delimited spaces: those of domesticity, of propriety, but also of the *polis* — the city, the state, the nation and indeed, the cosmos. At the same time, however, the expropriating effects of theatre are and must remain *virtual*. Of this Artaud never left any doubt. Theatre is inseparable from a virtuality that is irreducible not just to actuality but also to *any other form* of *appropriability*, including, first and foremost, *Man*. Not just the idea of man but "his" appearance has long served to justify the possibility of and right to such appropriation. It is the dismantling, therefore, of this image of self-containment and of self-contentment that forms that primary action of the plague and makes it a powerful analogy and allegory of theatre. Once again, however, it must not be forgotten that the plague, and theatre, can only trigger forces that are *already there*, ready and waiting, temporarily immobilised:

> The plague takes images that are dormant, a latent disorder, and suddenly pushes them to become the most extreme gestures; and theatre also takes gestures and pushes them to the limit: like the plague it reforges the chain between what is and what is not, between the virtuality of the possible and what exists materialised in nature. It recovers all the conflicts that sleep in us, restoring them to us with their forces and giving these forces names that we salute as symbols: and behold, before our eyes a battle of symbols takes place. (37/34)

The self-containment of the "image" is thus literally pushed to the *extreme*, where it suddenly reveals itself to be in touch with the other, with what it is not, with the outside. In place of the self-contained image, representing its "content," there is revealed the process by which that content was contained: through the arresting of signification, of a process that always involves a pointing *elsewhere*. This is why the image driven to the "extreme"

becomes *gesture*: the gesture points *away*. But not
towards a goal, towards that goal which, for Aristotle, was
"the greatest thing of all." The goal as end and purpose
has been supplanted by the extreme as enabling limit, but
as a limit that also disables. It is at this limit, the limit of
gesture and *gesticulation*, where gesture shades into
spasm, stutter and tic, that the 'theatre of cruelty' *takes
place*. But the place it *takes* can never be its own. It must
always belong to another. And this is why its taking place
must be conflictual and why a certain violence and
violation must mark the 'theatre of cruelty.' It is peripeteia
without end or goal, and, therefore, a peripeteia that
remains virtual.

This is why the "place" or "stage" of the 'theatre of
cruelty' can never be simple or straightforward. It must
always be a place of a *singular duplicity*. Like Nietzsche,
who begins *The Birth of Tragedy* by explicitly asserting the
"duplicity" (*Duplizität*) of the great antagonistic forces he
is about to describe: the Dionysian and the Apollonian.
This Nietzschean duplicity foreshadows the "doubles" and
"ghosts" that haunt the 'theatre of cruelty.' The double
and its shadows are what replace and supplant the
"heroes" of dramatic theatre. They are virtual heroes of a
stage that is itself split and doubled, the space of what
Artaud, near the end of his lecture, describes as an
"essential separation":

> The theatre, like the plague, is in the image of this
> carnage and this essential separation. It releases conflicts,
> disengages powers, unleashes possibilities, and if these
> possibilities and these forces are black, it is the fault not
> of the plague or of the theatre but of life. (31/38)

Virtualisation, then, is not simply de-actualisation but
"separation." If the theatre, like the plague, plays on
forces that are already "there," it is because of this
"essential separation" or *separability* of place "itself." To
close its borders it must *still* remain in contact with what
it excludes. Such contact may be temporarily forgotten,

excluded from consciousness, but its effects do not go away. Separation, in short, does not *dissolve* the relation to the other or to the outside, nor does it reduce that other to a goal or purpose that would complete a story and make it intelligible. Rather, separation *communicates* with that from which it distances itself, even if that communication has to be "delirious," Artaud's word for describing the spread of the plague (25/33).

We can try to ignore such delirium, confine it, shore up the borders that seem to separate us from it, try to purify our cities and our states from everything alien. We can try to forget Artaud and his wild ravings. We can organise our lives and our worlds to best meet our goals. We can, in short, carry on as we have been doing — and cruelty will continue to take care of itself. Or we can try to remember that cruelty did not begin nor end with Antonin Artaud, who, in placing this word at the centre of his theatre, took a risk for which he paid dearly, but one which he esteemed had to be taken "in the actual circumstances" (83/99).

Are our "actual circumstances" today so very different? Do we come together tonight to reassure ourselves that One Hundred Years of Cruelty are finally over? Or to celebrate that they have only just begun? One Hundred, Two Hundred, Two Thousand: The sky's the limit. But this is a sky that can *still* fall on our heads. Still? Why *still*? Has it *already* fallen? Virtually? There is a risk, of course. But is it one we can afford *not* to take?

## NOTES

1    Antonin Artaud, "No More Masterpieces" *The Theater and its Double* transl. Mary Caroline Richards (New York: Grove Weidenfeld, 1958) 78–79. *Oeuvres complètes*, IV: 94–95. English translation modified where necessary. Future references to these editions will be given in the body of the text, with the English page numbers first, followed by those of the French edition.

2  Aristotle, *Poetics*, transl. and introd. Gerald F. Else (Ann Arbor: The University of Michigan Press, 1970) 27, 50a. Further references in the text are to page and section numbers of this edition respectively.

3  See also *Poetics*, 19–21, 59b: "It must be possible for the beginning and the end to be seen together in one view."

4  Pierre Lévy, *Qu'est-ce que le virtuel?* (Paris: Editions de la Découverte, 1995) 15–16.

5  Franz Kafka, "Die Sorge eines Hausvaters" (The Cares of a Family man) in *The Metamorphosis, The Penal Colony and other Stories* transl. Edwin Muir (New York: Schocken, 1988) 160. I use a more literal translation of 'Housefather'.

# Non-Genital Thought

*Rex Butler*

The crucial thing
is that we know
that behind the order
of this world
there is another
— Artaud, 'The Question Arises Of...'[1]

When the blood dries and the screams fade away, what is
left of Artaud, as this volume so compellingly
demonstrates, is the institution, the institution that is
Artaud. Now, as Jacques Derrida remarks in his essay 'La
parole soufflée,' there is nothing accidental about Artaud
becoming an institution: if Artaud becomes an institution,
it is because of something in his work — as in all work
upon which an institution is founded — that allows or
requires this. But what could this be? Derrida provides us
with a paradoxical answer: he says it is not a certain
*something* there — a particular theme or form — but a
certain *nothing*. It is the very absence of something to say
that produces both Artaud and the possibility of speaking
about him. Derrida writes:

> Unpower [*impouvoir*], which appears thematically in the
> letters to Rivière, is not, as is known, simple impotence,
> the sterility of 'having nothing to say' or the lack of
> inspiration. On the contrary, it is inspiration itself: the
> force of a void, the cyclonic breath [*souffle*] of a
> prompter [*souffleur*] who draws his breath in and
> thereby robs me of that which he first allowed to
> approach me and which I believed I could say *in my own
> name*.[2]

And further:

> My meaning-to-say [*vouloir-dire*] finds itself lacking
> something in relation to the signifier and is inscribed
> passively, we might say, even if the reflection of this lack
> determines the urgency of experience as excess: the
> autonomy of the signifier as the stratification and
> historical potentialisation of meaning as a historical
> system, that is, a system that is open at some point.[3]

We would want to ask two questions here, which will
direct the rest of our paper. First of all, what does Artaud
mean by speaking of inspiration as that prompter who
draws in his breath to create a void, which allows him to
speak, though not perhaps in his own name? What of
Artaud himself as *our* inspiration, that prompter who
draws in his breath to allow us to speak, though again
perhaps not in our own name? Secondly, what of this void
which brings about a certain lack in both Artaud and
ourselves as opening up the possibility of the institution
Artaud as a historical system, that is, a system that is open
at some point? Is there a connection to be made between
this lack, this nothing to say, and this openness, the fact
that he must always wait until the future for his meaning
to be given, that makes Artaud possible as an institution
and allows him to live on as one of the names for the very
impossibility of speaking in one's name? And do his own
texts understand this about themselves, not only
*exemplifying* but *commenting upon* it — and is this not
finally what also helps create their institutionality?

We are, of course, proposing a very different Artaud
here from the usual one. But, insofar as we consider his
work as a simple transgression, unequivocally opposed to
its literary commemoration, we would have to regard a
collection like this, or speaking of Artaud at all, as
testifying only to the failure of his work, or at least to a self-
contradiction on the part of its interpreter. Hence the
nostalgia and pathos of so much writing about Artaud. As
against this, we want to see his work as somehow *about* its

institutional future, as what resists its institutionalisation not in being opposed to it but in ceaselessly leading it on; or its opposition to its institutionalisation as just what makes it possible, forever drawing it on or advancing it. If there is a "cruelty" implicit in Artaud's work, it lies not in its transgression or resistance, but in what allows a thought to be transmitted and, furthermore, in what *ensures* that it will be transmitted. It is the cruelty implicit in adding a thought to the world, in determining that it will not be forgotten or overlooked; it is the cruelty involved in a thought that necessarily makes itself true, that cannot be denied. It is the cruelty, in other words, the difficulty, of a thought that wills itself to be canonical; the *singularity* of a thought that is able to find the one line of argument that creates a "void" within its object, shows that there is something missing from it that it is able to fill; that is able to *double* this other, at once to follow it completely and entirely to reverse its meaning. That is, that can be its prompter, its inspiration.

We see all of this, for example, in Artaud's correspondence with Jacques Rivière, then editor of the prestigious journal *La Nouvelle Revue Française*. What is not often recognised there — despite the innumerable studies made of them — is that these letters are not merely an attempt to destroy the academy, to tear down the built-up tradition of French literature, but also the record of an ambitious young poet's efforts to be published, to enter this history (the two alternatives do not at all preclude one another). It is precisely in this context that we must understand Artaud's remarks on inspiration in them, from which Derrida draws. Inspiration for Artaud is not brought about by the feeling that something is present, but by the feeling that something is missing or absent. More specifically, it is inspiration itself which produces the very lack it arrives to fill and which was not noticed before, but whose replacement now makes it seem arbitrary, as though it could be otherwise. Inspiration, as it were, is the finding

of that master-signifier which "requilts" reality as it stands. It is a kind of nothing, the thinking or introduction of a certain nothing: "Inspiration is nothing but a foetus and the word is nothing but a foetus. I only know that when I wanted to write, words failed me, that's all."[4] (And we could go here into the whole question of inspiration or breathing in, which he tropes as feminine, as the opening up of a certain void in Artaud's texts, from 'An Affective Athleticism' in *The Theatre and Its Double* to his privileging of "sound, noises. and cries" for their "vibratory" qualities, from the whole thematics of dissonance and echo in *Héliogobale* to his ambivalence towards bodily orifices and particularly towards what he calls the "cunt" as that void out of which he comes and which he could never cease to repay in the later poetry.)[5]

However, if inspiration is a kind of nothing, the feeling or pressure of nothing-to-say, it is this nothing that will henceforth be known by the name Artaud or that will become Artaud's proper subject. If there is a kind of loss or absence involved in thinking, it is just this loss or absence that Artaud will try to recoup as his. Artaud, we might already begin to say, is the very name for his own dissemination. And we see this in the well-known passage from the letters where Artaud speaks of this nothing-to-say only to turn it into a having-said-something, thus claiming this void, this void that precedes his speech, and not just his, as his alone, as brought about and only possible because of him. (Here we would want to compare Artaud and Beckett as the two major exponents of this impossibility of speech, the "I can't go on, I have just gone on.") Artaud writes to Rivière:

> I would like you to understand clearly it is not a matter of the sort of partial-existence which comes from what is commonly called inspiration, but from total abstraction, from total wastage. This is why I also told you I had nothing further, no work in the offing, the few things I submitted to you being the vestiges of what I was able to salvage from the utter void.[6]

An admission which is not without a certain cunning, a certain calculation, for when Rivière eventually offers to publish their correspondence, Artaud is able to reply:

> Should [a man] be condemned to oblivion on the pretext that he can only give fragments of himself? You yourself do not think so, and the proof is the importance you attach to these fragments. I had long since thought of suggesting we collect them together. I had not dared to do it up to now and your letter responds to my wishes.[7]

This, indeed, is Artaud's entire strategy with Rivière and with that literary tradition he represents. It is never a matter of simple opposition — for, again, Artaud wants to belong to that tradition; his works are written with a careful eye to the future — but rather of a kind of *doubling* or requilting of what is, in which everything the other says is true, but only for a reason they cannot see. Thus, Artaud does not disagree with Rivière in his assessment that his poems are a failure, that judged by conventional standards they do not succeed; but this, he argues, *is* just their point, and, beyond this, what they show is that henceforth all poetry can only be understood within the terms they set, as an attempt either to cover over or hide from that essential void or failure — the "abandonment of thought" in its "materialisation in words"[8] — they reveal. Now, of course, Rivière, as a right-thinking man of letters, has no response to this, and their dialogue ends in an impasse; but this kind of doubling is to be Artaud's "method" throughout his work: the introduction of a certain nothing to explain why things are exactly as they are, but only for a completely other reason. We might just give two examples of this here. The first is from the 1925 prose fragment "Nerve Scales": "INSPIRATION CERTAINLY EXISTS. And there is a luminous point where all reality is rediscovered, only changed, transformed, by — what? — a nucleus of the magic use of things."[9] The second is a footnote from the 1929 pamphlet *Art and Death*:

> Everything in the order of the written word which
> abandons the field of clear, orderly perception,
> everything which aims at reversing appearances and
> introduces doubt about the position of mental images
> and their relationship to one another, everything which
> provokes confusion without destroying the strength of an
> emergent thought, everything which disrupts the
> relationship between things by giving this agitated
> thought an even greater aspect of truth and violence —
> all these offer death a loophole and put us in touch with
> certain more acute states of mind in the throes of which
> death [we might say nothingness] expresses itself.[10]

This is why, undoubtedly, Artaud is so hard to
assimilate to a conventional politics of liberation, why
throughout his life he rejected the economic explanation
of Marxism, the unconscious explanation of Surrealism
and even the theological explanation of religion. For
Artaud himself does not stand for anything, does not
oppose anything to the world as it is (and thus the various
manifestos he wrote throughout his life are not
manifestos in the usual sense). Rather, he accepts the
"implacable necessity"[11] of the world, wants to drive its
cruelty and madness to the limit only to show that, at this
limit, its fundamental order begins to turn upon itself,
reveals itself as standing in for an underlying absence
which opens it up and makes it possible. From his essay
'Theatre and the Plague': "Theatre takes gestures and
develops them to the limit. Just like the plague, it
refigures the links between what does and does not exist,
between the virtual order of the possible and the material
nature of experience."[12] (And here we have the whole
question of the "fatalism" of Artaud's approach, the way
that cruelty is not to be confused with pain and suffering
but is a form of "strictness, diligence, unrelenting
decisiveness, irreversible and absolute determination"[13] —
and the compatibility of this fatalism with a kind of
"will,"[14] the fact that, as with Nietzsche, this fatalism must
also be striven for.)

This notion of a doubling of the world, of a statement that at once completely accepts the way things are and reverses them entirely, takes us to another of the great themes of Artaud's work, one that has often been commented on but that can perhaps be seen here in a new light: the power of words themselves to make their own reality; the importance, as Artaud gets Rivière to admit in the correspondence, of language breaking with the task of "reproduction."[15] For, of course, this nothing Artaud speaks of is non-empirical, unable actually to be presented; but after it has been put forward, reality can only be seen in its terms; there is no way of refuting or going beyond it (or this is the hope of such an inspiration — at least, the question of whether such a judgement "takes" or not is not to be determined factually). In a sense, that is, the very saying of these words makes them true; they do not represent a prior state of being, but are or constitute this very state of being. Words become flesh, are incarnated, or to use Artaud's beautiful pun from the letters, which speaks of the cruelty and forcing implicit in this idea of language, are simply "carnate": "As far as I was concerned, the problem was not to find out what might manage to worm its way into the structure of written language, but into the web of my living soul, by which words entered like knives in lasting carnation."[16] It is this power of language to make and not merely to reflect reality that is the second great theme of the letters (and this idea of words being their own reality, referring only to themselves, gets us towards the asignifying rhythmic chants and glossolalia of the later poetry, that signifier without signified that would be the master-signifier or "witness word"[17] which reshapes or requilts reality). It is for this reason that Artaud can criticise the notion of "innateness" in the letters, both the idea that there is anything innate or pre-existent in him to express (for language takes him beyond or outside of himself from the very beginning) and that there is anything innate or subsistent in reality to which he must be faithful. He writes:

> I am innately genital, and if we examine what that means
> closely it means that I have never made the most of myself.
> There are some fools who think of themselves as beings, as
> innately beings. I am he who, in order to be, must whip his
> innateness. One must be a being innately, that is, always
> whipping this sort of non-existent kennel [*chenil* — also
> hole or hovel], O bitches of impossibility![18]

Gilles Deleuze has analysed this passage in the chapter
'The Image of Thought' in his *Difference and Repetition*,
correctly pointing out that in it Artaud opposes any notion
of a natural disposition or inclination towards thought, or
thought as a form of reminiscence, in favour of a thought
which attempts to "bring into being that which does not
yet exist,"[19] that is, which is inspired in our sense of the
term; but he perhaps errs in the end by calling this a
genital thought or a "genitality"[20] in thought. For, as we
have already remarked and as Deleuze himself notes,
Artaud in this conception of thought is wanting to see it as
having nothing to do with re-production or re-
presentation, but instead as a process whose origins and
transmission are more difficult to trace than that,
something that as it were creates itself, brings itself about,
owes nothing to anybody or anything.[21] (Hence Artaud's
paranoia that his thought owes something to somebody,
for example, God or his parents; his fury at a
psychoanalysis that would try to explain it, root it down to
a material state of affairs.) It is a thought that would be a
kind of virgin birth, an annunciation not an enunciation,
the word becoming flesh but resolutely non-genital. As
Artaud says in the 'Preface' to the published letters: "For
the things which go ploc-ploc in my genitals [and here
again the idea of hollowness, a certain void or inspiration
leading to thought] are not ideas but beings, and I will
not stand universal sexuality that endlessly saps and
sheaths me from head to toe."[22] And this rethinking of
Deleuze allows us to ask very carefully what he means by
"immanence" both here and in his other discussions of
Artaud in *Anti-Oedipus* and *A Thousand Plateaus*, how it

might be misunderstood by his commentators and perhaps even by himself as a simple levelling of the distinction between Ideas and their realisation, Being and beings. For if there is an immanence in Artaud, an immanence as opposed to innateness, it is to be seen not as a levelling but precisely in terms of that *doubling* we spoke of before: innateness must always be "whipped" and Artaud must always remain an "innate" man because immanence is not a state that can ever be attained but a kind of limit, a limit that both enables and cuts against this innateness. Something always actually takes the place of this void or nothingness, and it is thus always a matter of doubling it, showing that it only stands in for something else, that it could be otherwise. (And here perhaps the outlines of a solution to the long-running dispute as to whether Artaud is a monist or a dualist; and a way of understanding Derrida's argument, in 'La parole soufflée' and elsewhere, that there is a double use of signs in Artaud, at once a desire for presence and an exposure of its impossibility. We might say that Artaud wants to show the "void" at the heart of the world, but could do so only by taking its place; he wants to fill in this "void" at the origin of his thought, to owe nothing to anybody, but he could do this only thanks to the inspiration of another or only to open up another void that would again need filling — and here we move towards that question we began with, of Artaud as our "void" or inspiration today, he who allows us to speak endlessly of him in saying nothing, to which we shall return.)

    In order to show all this in a little more detail, however — and to tie together the three themes we have taken up so far: the void as inspiration, words as their own reality and criticism as a doubling of the world — we might turn for a moment to Artaud's *The Theatre and Its Double*. Of course, this is a text that has been taken up many times before, but it might once again reveal something when looked at with these issues in mind. First of all, what does Artaud mean by "theatre" there? As is well known, theatre

is not defined by any formal properties for him: no script, no role, not even a formal stage. Nothing is repeated or predicted in this theatre; nothing is produced or determined by it. Rather, the 'theatre of cruelty' comes about as a result of Artaud's statement that things just as they are can be theatre: "Everything that acts is cruelty."[23] Or perhaps, following Artaud, who immediately adds that "theatre must rebuild itself on a concept of this drastic action pushed to the limit,"[24] we might say that theatre is a kind of *limit*. But it is a limit that, if it has not yet been attained, nevertheless already implicitly exists — and our very attempt to bring it about, to accomplish it, is already an effect of it, already in a way to bring it about. The 'theatre of cruelty' at once already exists and never will. It both "rediscovers the idea of figures and archetypal symbols which act like sudden silences, fermata, adrenalin calls, incendiary images surging into our abruptly woken minds,"[25] and "only really happens the moment the inconceivable begins."[26] And this is to say that, if theatre is a limit, it is not a limit on a horizon that either can or cannot be crossed, but a limit *within* things that is traversed all the time only for it to be reconstituted elsewhere.

What, then, would be the relation of this 'theatre of cruelty' to that reality which it wants to capture or express? In a sense, we would say that it only subtracts a certain nothing from it, replaces what is with the sign. (This is the complexity of Artaud's attitude towards the stage, at once wanting to get rid of the theatrical stage as conventionally conceived, breaking down the distinction between actors and spectators, and insisting on a kind of metaphysical stage or division between theatre and life. Of the Balinese theatre he says, for example: "Theatre only exists through the degree of its objectification on stage.")[27] It is the paradox of saying, as we suggested above, that theatre is only reality as it is, that reality completely fills it up, that there is "no gap between theatre and life,"[28] and that theatre is always something

else beyond this, virtual, that limit which both makes the real real and ensures it is never entirely so. The 'theatre of cruelty,' that is, is only an effect of reality and allows this very reality. It introduces a kind of void or absence into reality and thus brings it about. Reality henceforth is only conceivable in the form of theatre, in other words, on the basis of the sign. After the hypothesis of the 'theatre of cruelty,' appearance, the identity of the world to itself, is not simply what it is, but is only conceivable on the basis of, can only be explained by, the distance, the void — to use Artaud's word, the "space"[29] — of the sign (that is, only insofar as it has been inspired or willed by another). Theatre doubles reality, or reality becomes the double of theatre. From the 'First Manifesto of the Theatre of Cruelty':

> There is no question of putting metaphysical ideas directly on stage but of creating kinds of temptations, vacuums, around these ideas. Theatre breaks away from language's intellectual subjugation by conveying the sense of a new, deeper intellectualism hidden under these gestures and signs and raised to the dignity of special exorcisms.[30]

But to slow this down and to say it more carefully, Artaud does not simply understand himself as "making up" reality in *The Theatre and Its Double*, introducing a void that does not exist before him. Rather, he also understands himself to be imitating reality or giving expression to a void which already exists.[31] But the enigma is that in this very repetition — rehearsal — of the world a certain void or gap is opened up; the world now lacks something, which is this very copy. In a sense, the world cannot be understood without this copy which doubles it. It is only in the very relationship between — the umbilical limbo linking — the world and its copy that the truth of the world is to be found. (It is this that explains the confusion which runs throughout all of Artaud's thought, and which he cannot be said ever to

have finally resolved, between theatre as the *imitation* of the world — "like the plague, it is a revelation urging forward the exteriorisation of a latent undercurrent of cruelty"[32] — and theatre as the *creation* of the world — "like alchemy, it is a virtual art, so to speak, and does not contain its object within it any more than it contains reality."[33] In truth, impossibly, it is both.)

We return to the theme of Artaud's work bringing itself about, its words becoming flesh, but perhaps in a slightly more complicated way than before (it is not simply self-referential; it can only make itself via a pre-existing void). Artaud speaks of a kind of absence in the world, something missing from it, but it is only after he says this that it is true. There is here a complex question of self-knowledge that would need one day to be unravelled in more detail. Artaud's text attempts to fill in a void, attain self-presence, but precisely the effect of this is to bring this void about, to double what is, render it incomplete, explicable only for another reason. Artaud's text, then, is intriguingly self-contradictory, does not do what it says. But ultimately we cannot decide whether this is deliberate: whether he thinks this void exists before him or not; whether his text tries to speak (impossibly) of that difference which allows the resemblance of the world to itself or whether this difference is revealed — against his intentions — in its very attempt to bring about this self-presence. This is undoubtedly what Derrida is getting at in his 'La parole soufflée', where he at first comments on the problem of Artaud wanting to speak of a sign without difference within a language that can only ceaselessly draw attention to this difference and then suggests that it might be this very difference itself that is thematised (again impossibly) by Artaud, that his work is already deconstructive, as it were. It is this undecidability itself that is the real subject of Derrida's essay, and what he ultimately means by the "madness" implicit in Artaud's text:

> Artaud's 'metaphysics', at its most critical moments, fulfils

the most profound and permanent ambition of Western metaphysics. But through another twist of the text, the most difficult one, Artaud affirms the cruel (that is to say, in the sense in which he takes this word, necessary) law of difference: a law that is raised to the level of consciousness and is no longer experienced within metaphysical naïveté. [Though we might ask at this point how this could ever entirely become conscious.] This duplicity of Artaud's text, simultaneously more and less than a stratagem, has unceasingly obliged us to pass over to the other side of the limit, and thereby to demonstrate the closure of the presence in which he had to enclose himself in order to denounce the naïve implications within difference. At this point, things ceaselessly and rapidly pass into each other, and the critical experience of difference resembles the naïve and metaphysical implications within difference, such that to an inexpert scrutiny we could appear to be scrutinising Artaud's metaphysics from the standpoint of metaphysics itself when we are actually delimiting a fatal complicity.[34]

It is also in this context that we would want to take up Deleuze and Guattari's adoption of Artaud, and more particularly his notion of the 'body without organs,' in their texts *Anti-Oedipus* and *A Thousand Plateaus*, and to turn it either against them or against certain interpretations of their work. For, again, the 'body without organs' is not a simple immanence or something that can be definitively attained. Rather, it is an *internal* limit to things, that which ensures there can be no total principle to the world but that for every attempt to territorialise or master it there is an equal or opposite deterritorialisation. For Deleuze and Guattari, that is, the 'body without organs' is indeed a kind of lack or absence, but it is not a lack that exists before the processes of production or desire, which these would attempt to fill, but a lack that comes about *at the same time as* them, which they both attempt to fill and bring about: "Production is never organised on the basis of a pre-existing need or lack. It is lack which infiltrates, creates empty spaces or vacuoles, and propagates itself in accordance with the

organisation of an already existing organisation of production."[35] If the 'body without organs' is always missing from reality, therefore, it is not that we can never say what it is. As Deleuze and Guattari make clear, nothing is missing from reality; reality is always complete. It is just that henceforth this reality or realisation must be understood for a different reason. It necessarily arises as the attempt to fill in the void of a "prior" 'body without organs,' a void which it in turn brings about as Deleuze and Guattari say of capitalism, which is precisely the most profound attempt to circumscribe and induce reality:

> For capitalism constantly counteracts, inhibits this inherent tendency [to schizophrenia, to deterritorialisation] while at the same time allowing it full reign; it continually seeks to avoid reaching its limit while simultaneously moving towards that limit ... This is the twofold movement of decoding or deterritorialisation flows on the one hand and their violent and artificial reterritorialisation on the other.[36]

And here, too, in all of this, Deleuze and Guattari's writing — as with Artaud's and Derrida's — maintains a very special relationship with what it speaks of. For in a world — this is the explicit problem *Anti-Oedipus* and *A Thousand Plateaus* set for themselves in trying to formulate an alternative politics after the "failure" of May 1968 — where there are no longer any exterior standards of Judgement, Progress, Truth, to speak for, it would be in the very ability to describe and account for the real as it is that a different explanation of things is opened up, that there is proof of another world behind this one. To paraphrase the Spinozist insight, it would be our very capacity to describe our own lack of freedom that would be our only freedom — and this is what is meant also by Nietzschean perspectivism (not that there are alternate viewpoints onto the world, but that any particular viewpoint is always able to be doubled). All this would be to return once more to the inseparability in Artaud of submission to an "implacable necessity" and spontaneous

and unmotivated revolt. And certainly here we would want to think through the connection between the Artaudian conception of theatre, Deleuze and Guattari's 'body without organs,' and Derrida's *subjectile* as that medium, support or void upon which all else is inscribed, but which, although being nothing else but this surface of inscription, also ensures that no representation is total, that it is always projected towards or subject to a certain outside or other.[37]

To conclude here, what is all this finally to say about Artaud's influence upon the twentieth century? What would it mean to think his legacy as 100 years of cruelty? What is it that Artaud has left us? What is it of him that remains behind? To go back to those remarks of Derrida's we began by quoting, we would say that it is just this notion of thought and critique as a kind of *doubling*. If we say that thought after Artaud has been influenced by him, it is not in terms of any doctrine or aesthetic form (for, as we have seen, it is just these that he fought against). Rather, as Derrida implies, it is that all thought must henceforth understand itself as a kind of "inspiration" (and "inspired" perhaps first of all by him): the creation of a void in what is, through "the cyclonic breath of a prompter who draws his breath in." In other words, modern thought must understand itself as a nothing to say, an inability to go outside or beyond the system it addresses, always having to follow a prompter "who robs me of that which he first allowed to approach me and which I believed I could say in my own name," but through the expression of this nothing to say, the repetition of this prompter, a void is opened up in the preceding system (whether or not it was there before this second is impossible to say). We realise in retrospect that this prompter was none other than us, that the very impossibility of speaking in our own name is the name we shall be. And this is the paradoxical status of those great literary and philosophical institutions of the late nineteenth and twentieth centuries that are founded on proper names — Marx, Nietzsche, Artaud, Bataille, Joyce, Lacan, Derrida, Deleuze, and so on: they at once seem to go against

everything these names stand for, the singularity and untranslatability of their thought, and precisely need to be instituted because this thought only exists as the effect of a certain repetition. The meaning of the thought on which they are based is not lost as a result of its institutionalisation because its meaning is this loss: the message it has to tell is that it only exists as that void which opens up to allow the other to speak, to speak in their name. This is why we can never exactly say what these founders' work means, why it is always different from itself, and yet why it is unable definitively to be lost or distorted, is always the same; why their letter (like Artaud's letters to Rivière) always and never arrives. And these texts themselves — again perhaps only in retrospect — seem to reflect upon this. Finally, then, to come back to that second passage of Derrida's we quoted, it would be just this incompletability, this perpetual openness to re-reading, to doubling, to the contingency of history (and their understanding of this), that makes these texts institutions. (Another great institution like this, which in 1996 is beginning its second 100 years of cruelty, and which is both a product of and a reflection upon this kind of doubling: psychoanalysis, which was born in 1895 with the publication of Freud and Breuer's *Studies in Hysteria* and Freud's writing of *Project for a Scientific Psychology*. And this doubling, this conception of the institution as both opposed to and an effect of doubling, is the only real connection between the two, despite all attempts to psychoanalyse Artaud or to subject psychoanalysis to a certain delirium or "madness.")

And the question here for us — asked with all the hubris of the young Artaud writing to Rivière — is how can we ourselves belong to this tradition, how can we not merely *represent* or *imitate* Artaud, which would always fail, but *present* or *be* him? It is a matter perhaps of doubling Artaud ourselves, which is at once to see him as that prompter who comes before us and who would "rob us of that which we believed we could say in our name" and as only an effect of us, of actually having nothing to say. This, however, is not

simply a matter of doing away with the necessity of judgement or academic competence, of saying that "anything goes" in our interpretation: the cruelty, the implacability, the necessity, of any truly new thought — which, again, Artaud reflected upon — is how difficult it is to find that single thread which at once completely accounts for the other and explains him in absolutely different terms. For if thought is not a matter of re-presentation, then we precisely cannot know what this thread is in advance but can realise it only in retrospect (we can only understand our work when another takes it up). We must at once be faithful and unfaithful, chaste and "penetrated and raped by collective consciousness,"[38] in relation to the work of the other. (And this would be what Deleuze means by speaking of Artaud in terms of a "transcendental empiricism" in *Difference and Repetition*[39] and of interpretation in terms of a simultaneous "love and hate" in the chapter 'To Have Done with Judgment' in *Critique et clinique*.)[40]

Certainly, the intriguing thing about Artaud's writing, to conclude here — and this perhaps to open up a whole new way of understanding him — is not that he wanted to destroy the possibility of reading him in the future, but that he at once did everything possible to ensure this, that he would belong to literary history, and knew in the end that this could not be guaranteed; that he both made it very difficult to go beyond him, to refute or surpass him, and yet understood that unless someone was able to do so, to double him, find another unexpected meaning in his text, he would die, be forgotten (an artist, that is — and here we would have to refer to the essays on Van Gogh and Lautréamont — in a way "suicides himself," lives on only in submitting to an essential and inevitable killing).[41] This is the contradiction that drives all thought: the fact that it is at once autogenerative, attempts to account for itself entirely, and is only possible insofar as it takes the place of another, lives on only to the extent that another sees something missing in it. This is beautifully put by Deleuze in his 'I Have Nothing to Admit', where he speaks of his relationship to

previous philosophy, an account that at the same time evokes a virginal birth and a certain inspiration brought about by a hole or void: "But what really helped me come off at the time was, I believe, to view the history of philosophy as a buggering process or, what amounts to the same thing, an immaculate conception."[42] Artaud too has much the same intuition in his poem 'Here Lies,' where he speaks both of the endless attempt to destroy or surpass one's "pappamummy" and of the endless void his passing will leave:

> As for me, uncomplicated
> Antonin Artaud,
> no one can touch me
> when one is only a man
> or
> god.
> I don't believe in father,
> in mother,
> got no pappamummy,
> nature,
> mind or god, devil,
> body
> or being, life
> or nothingness,
> nothing inside or out,
> and above all no mouth to mouth Being,
> that sewer drilled with teeth
> where man, who sucked his substance
> from me, looked at me at the time
> waiting to get hold of a pappamummy
> and remake an existence
> free of me,
> over and above my corpse,
> taken
> from the void
> itself.[43]

## NOTES

1   Antonin Artaud, "The Question Arises Of..." *Artaud on Theatre*, ed. Claude Schumacher, (London: Methuen, 1989) 189.

2   Jacques Derrida, "La parole soufflée" *Writing and Difference* (Chicago: University of Chicago Press, 1978) 176.

3   ibid., 178–9.

4   "Correspondence with Jacques Rivière" *Collected Works*, vol. 1 (London: John Calder, 1968) 19.

5   On inspiration or breathing in as the opening up of a certain void, see "An Affective Athleticism" *Collected Works*, vol. 4 (London: John Calder, 1974), and for remarks on this void as feminine, see 102–3. On "sound, noise and cries" and their "vibratory" qualities, see "No More Masterpieces" ibid., 62. On the themes of echo and dissonance, see *Héliogobale*, in *Oeuvres complètes*, tome 7, (Paris: Gallimard, 1976–) 62. Carol Jacobs comments very well on these in her The Dissimulating Harmony: *The Image of Interpretation in Nietzsche, Rilke, Artaud and Benjamin* (Baltimore: Johns Hopkins University Press, 1978) esp. 77–81. For Artaud's ambivalence towards bodily orifices as at once that void out of which he comes (as female genitalia) and that void which would allow him to speak of this (as the mouth), see "Fragmentations" ("out of the motherless cunt I shall make an obscure, total, obtuse and absolute soul") *Artaud Anthology*, ed. Jack Hirschman, (San Francisco: City Lights Books, 1965) 174; "Here Where I Stand" ("It isn't worthy of God/to be a body/to have a body./Who is it who is worthy of being/SLASHED?"), ibid., 203; and "I Hate and Renounce as a Coward" ("I hate and renounce as a coward every being who consents to live without giving himself over to the control and the exclusive search for the validity of the created breath"), ibid., 224. We might also think here of Artaud's remarks that "ideas are only the voids of the body," "Shit to the Spirit," ibid., 111, and "I noticed that opium lifted me towards something, against something I was not ready to be against: the idea of stopping up a dreadful void. In order to stop it up, it would be necessary to *work*, to work in a special way", "Dear Doctor and Friend," ibid., 200. Finally, in his "Letter on Lautréamont," Artaud writes of Lautréamont (though it would also apply to him):

"Incapable of a simple everyday letter, he always gives the sense of a certain elliptoid tremor of the Word, which, for whatever object, does not lend itself to be being utilised without a shudder," ibid., 123.

6   "Correspondence with Jacques Rivière," vol. 1, 28.

7   ibid., 27.

8   ibid., 40.

9   Artaud, *Nerve Scales*, ibid., 72.

10  Artaud, *Art and Death*, ibid., 92. See also *Héliogobale*: "In every poetry there is an essential contradiction. Poetry is the pulverised multiplicity that produces flames. And the poetry that brings back order first resuscitates disorder, a disorder with flaming facets; it makes these facets clash with one another which it then brings back to a single point — fire, gesture, blood, cries," tome 7, 106.

11  Artaud, "Letters on Cruelty" *Collected Works*, vol. 4, 78.

12  Artaud, "Theatre and the Plague," ibid., 17.

13  Artaud, "Letters on Cruelty" ibid., 77. On the opposition of the 'theatre of cruelty' to chance and improvisation, see also p. 84. This also explains Artaud's interest in ritual, predestination and forms of prophecy (tarot cards, horoscopes and numerology). See on this, for example, his writings on New Mexico, *Oeuvres complètes*, tome 8, and the Tarahumaras, *Oeuvres complètes*, tome 9, and *The New Revelations of Being, Oeuvres complètes*, tome 7.

14  Artaud, "Alchemist Theatre" *Collected Works*, vol. 4, 36. See also "Dear Doctor and Friend" *Artaud Anthology* 199.

15  Artaud, "Correspondence with Rivière," vol. 1, 37.

16  ibid., 18.

17  Artaud, *Nerve Scales*, ibid., 71 (although the translation there uses the expression "corroborating word" for the French "*mot-témoin*": "At times I am only at a loss for one word, a simple unimportant little word, to be great, to speak in the tone of the prophets. A corroborating word, an exact word, a subtle word, a word thoroughly steeped in my bones, comes out of me to stand at the furthest limits of my being, and which would mean nothing to most men"). See also on this "witness word," Jane Goodall, *Artaud and the Gnostic Drama* (Oxford: Oxford University Press, 1994) 61.

18  Artaud, "Correspondence with Jacques Rivière," vol. 1, 19.

19  Gilles Deleuze, *Difference and Repetition* transl. Paul Patton (New York: Colombia University Press, 1994) 147.

20  ibid., 147.

21  On the mysterious transmission of thought, not to be confused with anything simply material, see "Theatre and the Plague," vol. 4, esp. 12.

22  Artaud, "Correspondence with Jacques Rivière," vol. 1, 21.

23  Artaud, "Theatre and Cruelty," vol. 4, 64.

24  ibid., 64.

25  Artaud, "Theatre and the Plague," ibid., 17. See also on this aspect of the 'theatre of cruelty' Artaud's comparison of it to alchemy in the chapter "Alchemist Theatre": "Where alchemy, through its signs, is like the mental Double of an act effective on the level of real matter alone, theatre ought to be considered the Double not of this immediate, everyday reality, which has been slowly truncated to a mere lifeless copy, as empty as it is saccharined, but another, deadlier archetypal reality in which Origins, like dolphins, quickly dive back into the gloom of the deep once they have shown their heads," ibid., 34.

26  ibid., 17.

27  Artaud, "On the Balinese Theatre," ibid., 38. On this doing away with the stage, see the "First Manifesto" of the 'theatre of cruelty,' ibid., 73. On the necessity of retaining a certain stage, see "Oriental and Western Theatre": "Drama is encompassed within the limits of everything that can happen on stage," ibid., 51. We come back here to the "abstraction" or doubling required for cruelty in Artaud's sense of the word and for inspiration in general ("I would like you to understand clearly it is not a matter of the sort of partial-existence which comes from what is commonly called inspiration, but from total abstraction, from true wastage").

28  Artaud, "Second Manifesto," ibid., 97.

29  See on this space, "Letters on Language", ibid., 87; on the sign, "On the Balinese Theatre," ibid., 39; on the hieroglyph, "Production and Metaphysics," ibid., 27.

30  Artaud, "First Manifesto," ibid., 69. See also on this vacuum, and the way that it both allows and comes from imitation (inspiration): "'Any true feeling cannot in reality be expressed. To do so is to betray it. To express it, however, is to *conceal* it. True expression conceals what it exhibits. It pits the mind against nature's real vacuum, by creating in reaction a kind of fullness of thought. Or rather, it creates a vacuum in thought, in relation to the manifest illusion of

nature. Any strong feeling produces an idea of emptiness
within us, and lucid language which prevents this emptiness
also prevents poetry appearing in thought. For this reason
an image, an allegory, a form disguising what it means to
reveal, has more meaning to the mind than the
enlightenment brought about by words or their analysis,'"
"Oriental and Western Theatre," ibid., 53.

31   Hence the ambiguity of Derrida's phrase "meaning-to-say" or
"*vouloir-dire*" with regard to Artaud, which both hints at
something yet to be said and would only exist in retrospect,
after it has been said.

32   Artaud, "Theatre and the Plague," vol. 4, 19.

33   Artaud, "Alchemist Theatre," ibid., 34.

34   Derrida, "La parole soufflée," 194. On the question of this
"madness," see 193. On the possibility of thematising this
difference that allows resemblance, see, for example,
Derrida's use of the word "furtiveness" throughout his text,
which at once speaks of this difference and could only be an
effect of it: "Insinuating itself into the name of the person
who speaks, this difference is nothing, is furtiveness itself: it is
the instantaneous and original elusion without which no
speech could catch its breath," 178. There is an interesting
discussion of this "thievery" in *Artaud and the Gnostic
Drama* where Goodall points out the necessary limitation it
imposes upon Derrida's analysis, in which he must "steal"
from Artaud his very discourse about theft: "As Derrida's own
approach gets under way, he enters this space [of
interpretation] by adopting the 'I' of Artaud as the 'I' of his
own text. Curiously, the appropriation of the 'I' of Artaud
serves in the production of a discourse about theft," 213. It is
this very phenomenon, we argue, that Artaud's oeuvre —
impossibly — is about, and that allows Artaud to live on as an
institution. It is what allows Goodall's own discourse, for
instance, which must similarly "thieve" and "misappropriate"
from Artaud. And we would say the same about Goodall's —
and our — relationship to Derrida. In Derrida, too, the "I"
produces a kind of void that lives on precisely in being stolen
or spirited away. We might argue against Derrida, as Goodall
does there, get him wrong or right, or find perhaps
unintended meanings in his work; but his work is already
*about* this, lives on in saying "nothing." This is not to say that
Derrida simply masters his dissemination, that his letter

always returns to him intact, as someone like Slavoj Zizek would argue. Rather, we would say that the name Derrida — like Artaud's — is co-determinous with its own dissemination, stands in for or reveals its own absence, perhaps a little like that king Zizek speaks of who is the "place-holder of the void" (see Slavoj Zizek, *For They Know Not What They Do: Enjoyment as a Political Factor* (London: London, 1991) esp. 267 et seq.). And we would like to re-read here Artaud's *Héliogobale or the Anarchist Crowned*, whose hero is similarly only the name for his own dissemination, is made up of all the names and texts in history. Carol Jacobs speaks very well of this notion of doubling at stake in *Héliogobale*, which she calls "*démarquage*" (see *The Dissimulating Harmony*, 75–7).

35  Gilles Deleuze and Félix Guattari, *Anti-Oedipus; Capitalism and Schizophrenia* (New York: Viking Press, 1977) 28.

36  ibid., 34. See also the passage later where they cite Jean-Joseph Goux, p. 230–1. See also *A Thousand Plateaus*, where they speak of the 'body without organs' as an impossible limit ("You never reach the Body without Organs, you can't reach it, you are forever attaining it, it is a limit") that is always being crossed ("The Body without Organs: it is already under way the moment the body has had enough of organs and wants to slough them off, or loses them"), Gilles Deleuze and Félix Guattari, *A Thousand Plateaus: Capitalism and Schizophrenia* transl. Brian Massumi (Minneapolis: University of Minnesota Press, 1987) 150.

37  See Jacques Derrida: "The subjectile is itself between two places. It has two situations. As the support of a representation, it is the subject which has become a *gisant*, spread out, stretched out, inert, neutral. But if it does not fall out like this, if it is not abandoned to this downfall or dejection, it can still be of interest for itself and not for its representation, for *what* it represents or for the representation it bears. It is then treated otherwise: as that which participates in the forceful throwing or casting, but also, and for just that, as what has to be traversed, pierced, penetrated, in order to have done with the screen, that is, the inert support of representation. The subjectile, for example, the paper or the canvas, then becomes a membrane; and the trajectory of what is thrown upon it

should dynamise this skin in perforating it, traversing it, passing through to the other side," "Maddening the Subjectile" *Yale French Studies* 84 (1994) 168.

38   Artaud, "Letter on Lautréamont," *Artaud Anthology*, 128.

39   Deleuze, *Difference and Repetition* 147. The "transcendental" would speak of the way this doubling has nothing to do with what is doubled; "empiricism" of the way this doubling is only the pure repetition of what comes before.

40   Gilles Deleuze, "Pour en finir avec le jugement" *Critique et clinique* (Paris: Minuit, 1993) 169.

41   See "Van Gogh: The Man Suicided by Society" and "Letter on Lautréamont," *Artaud Anthology*.

42   Gilles Deleuze, "I Have Nothing to Admit," Special Issue on *Anti-Oedipus*, Semiotext(e), vol. 2, no. 3 (1977) 112.

43   "Here Lies" *Artaud Anthology* 247. On the anus or void as the origin of the world, see "Letter Against the Kabbala" ("for the asshole not the countenance is the cavity out of which all the things of this world below have issued"), ibid., 114.

# Sketches of the *jet*

## Artaud's Abreaction of the System of Fine Arts[1]

*Edward Scheer*

My drawings are not drawings but documents and one must look at and understand what is deep inside them. It is wrong to only judge them from an artistic or truthful point of view, as vivid and successful object, as one hears all the time: "that's all very fine but it lacks textbook formation and technique and Mr. Artaud is really only a beginner at drawing, he needs ten years apprenticeship, either personal or at the school of fine arts." This is rubbish, because I worked for ten years on the drawing in the course of my whole existence. (XXI: 266)

## The social body and the stolen body: a problem of representation

For Artaud, bodily fluids such as blood, sperm, saliva, even the humours of the eyes are profoundly socialised fluids. They are the lubricants of the judgement of God because they facilitate the reproduction and representation of inauthentic life, just as the synovial fluids in the joints facilitate the articulation of the body which thereby expresses its subservience to the creator. To be articulated is *to be spoken for* instead of *speaking for oneself, of* oneself, in one's own true language. It is to be mediated, separated from oneself. So the first act of defiance will be to disarticulate the body and redistribute its energies, its fluids, its bones and musculature. To

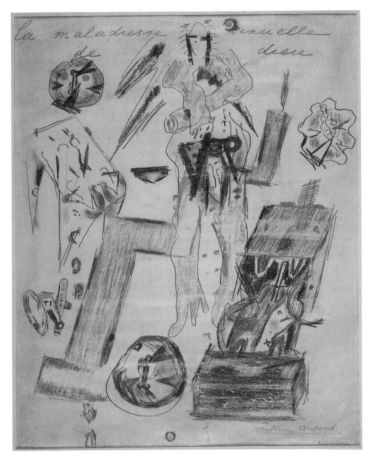

Antonin Artaud, *La maladresse sexuelle de dieu* (1946), graphite and wax crayon, 63 x 49 cm.
Musée National d'Art Moderne, Centre National d'Art et de Culture Georges Pompidou.
Photo Adam Rzepka © Centre Georges Pompidou.

release the synovia from the joints of God (institutions) and sperm, saliva and the humours from their pre-ordained tasks (to further the work of the spirit of God). But the problem of the representation of this new, other body remains. How does one impersonate the non-human man? This is why Artaud needs existing representations for his abreactive work of defiant counter-creation, to feed this task and this body. In short, he will need to eat his words, which, as Artaud knows well, will make him very sick.

## La maladresse sexuelle de dieu

For it isn't normal to spiritually slobber over people in order to impose the ten commandments on them. And this is how all initiates have proceeded from Plato to Empedocles, even the Buddha and Cakya-Mouni. They churned up their sperm of the spirit over the entire extension of consciousness in order to impose their Institutions there. (XIII: 125)

For Artaud, God is a perverted sex maniac as well as a logomaniac, sowing his seed so indiscriminately that every being is affected/infected by it. In a late drawing he describes all of this succinctly as "La maladresse sexuelle de dieu" (The sexual maladdress/ inappropriateness of God). This phrase is inscribed at the top of the page and is also the title given to the sketch.

The drawing, in pencil and chalk, consists of a spectral central figure whose hands have been chopped off surrounded by fragments of images of pierced bones, predatory teeth, images of castration, detached penises, boxes (model coffins), circumscribed splashes of blue, green and pink pencil and two small intensely black marks which could be cigarette burns. Everything on the page suggests sudden frenzied movement, the aftermath of an explosion whose detonation was utterly elsewhere, beyond the frame, prior to the birth of the work. The content,

including the title (Artaud insists that his hand-written texts: signatures, titles and commentaries are a part of the drawings and not to be considered separately), seems to represent an attack on the constituted body, the image of God. God's skill as a draughtsman is also called into question, his design for the body is repudiated in Artaud's drawing, in the disarticulation of the body, its de-composition. The images of castration in the drawing indicate Artaud's desire that this bad design be discontinued and that no further sexual maladdress should be tolerated. Artaud described the drawing as "voluntarily botched, thrown onto the page as if contemptuous of forms and traits, in order to spurn the captured idea and to successfully make it fail. The maladroit idea of god voluntarily badly drawn up on the page...."(ibid.)

It is not the execution of a maladdress which we encounter in Artaud's drawings but an abreaction of it by which Artaud remembers the maladdress which gave rise to the problem of representation as misappropriation and precipitates it on the page in order to denounce it:

> This drawing like all my others is not the drawing of a man who doesn't know how to draw, but the drawing of a man who has abandonned the principle of drawing/design and who wants to draw according to his age, mine, since he has never learned anything through principle, law or art, but solely through experience of labour, and I should say not instantaneous but instant, I mean immediately worthy. Worthy in relation to all the forces which in time and space are opposed to the manual labour, and not only the manual but the nervous and physical labour of creation. That's to say against the soul's captivity in the spirit, and its presentation in place in the being of reality.[2]

Artaud wants to wrest drawing away from its domicile in the image from where it can be tyrannised by the *principe du dessin* and return it to the "nervous and physical" moments of its "creation."

## Abortions and Abreactions

But creation must be abreacted in the *contre-maladresse* of the drawing in such a way as to give birth to the image as a kind of abortion. The artist must go through all the labour of creation but, in order to avoid being stolen at birth, the progeny, the work, must be jettisoned, precipitated, aborted. Accordingly, no "pure drawing" will henceforth be possible after God's obstetric malversation:

> I despaired of pure drawing ... I mean that we have an opaque spot on the eye from the fact that our present ocular vision is *deformed*, suppressed, oppressed, reverted and suffocated by certain malversations on the principle of our cranial structure, as on the dental architecture of our being, from the coccyx at the bottom of the vertebrae, up to the assizes of the forceps of the sustaining jaws of the brain. (XXI: 266)

In the process of being born, ie., masticated and spat out by God, *being* sustains a kind of congenital eye damage which subsequently distorts all observations, perceptions and optic judgements. This is God's principal maladdress, his blundering creation has left us with an ocular deformation which makes aesthetic judgements highly unreliable since they can never be authentic and unmediated. How can the determination and judgement of technique be effected under these circumstances? Our pure vision has been conjured away. We have been swindled of our sight, mis-sighted (mis-cited/maladdressed). One might accuse Artaud of a certain optic over-sensitivity here, an aversion to seeing what is before his eyes bordering on an allergic response. But this is precisely the point: the effect of good technique, of the *principle of drawing/design* is the production of this distorted vision to the point of a physical distortion or inflammation accompanied by a discharge of mucus, the over-activation of the in-between surface or membrane (subjectile). Artaud's conjunctivitis (inflammation of the

mucus membrane of the eyelids) constitutes another problem of articulation, of the *conjunctive*, of clarity and distinctness, of being envisioned/spoken for in advance, of being always already represented. This conjunctivitis is endemic to being, so for the work to be seen clearly it must be aborted. Similarly, for the general restoration of vision, it is not a kind of renaissance that will be necessary, but a precipitated re-routing of the process of birth, a kind of re-abortion.

To avoid just simply playing into the hands of the swindler, in order to be one step ahead of him, the work must be brought on ahead of its 'natural' term, in advance of its vague deadline: "*l'échéance précaire de l'oeuvre*" (the precarious settlement date of the oeuvre)(*FS*: 59). Derrida accounts for this experience in reference to the infidelities of the subjectile: "The subjectile, place of betrayal, always resembles an apparatus of abortion"(*FS*: 80).

That which drives the representation: life force, creative impulse, *ananké* (necessity), *cruelty* in Artaud's terms, is always betrayed as soon as it takes form. Any expression is therefore excremental, the new-born is always substituted at birth and in seeking out its authenticity it can only be frustrated, maddened, frenzied since it is always already modified by/in/on/through a subjectile (as that which receives the impulse to form, the place in representation where the stroke occurs). Artaud will seek to make these modifications visible in his drawings, forcing the subjectile to reveal what it only pretends not to know about the birth of the drawing. For Artaud it's function under the aegis of the system of fine arts was to be the cradle of aborted works; in other words, the tomb of authentic creation.

So Artaud harasses and harangues it, draws attention to its blind spot, its own opaque blotch, spoiling the surface of its transparency. Timidly it must come out of hiding, the abject midwife of the oeuvre, the conniving henchman of God. For the subjectile is that place where things take form. It is always constructed as somehow

appurtenant, secondary, inert; cradle/tomb. To reactivate it, to frenzy it, is to challenge not only the *principle of drawing/design*, but the infamous history of creation itself, by which the passivity of the subjectile was prescribed. Artaud's *modus operandi* will be to make visible how the subjectile has been made to act falsely or not at all, under the *system of fine arts*, and then restore it to its impossible truth.

## Subjectile as chora

A month prior to the execution of the drawing *La maladresse sexuelle de dieu* Artaud composed a sketch which he called *La machine de l'être* (The machine of being), also known as *dessin à regarder de traviole* (drawing to be looked at askew). This piece, drawn in pencil and coloured chalk, consists of pictographic assemblages of organs and body contours juxtaposed with machinic images, with bubbles of text drawn to resemble breasts. The page is stained and crumpled with deep creases which are visible even in a reproduction of it. Artaud describes this piece as follows:

> This drawing is a serious attempt to give life and existence to that which, up to today, has never been received in art, the spoiling of the subjectile, the pitiful maladdress of forms which collapse around an idea after having toiled for how many eternities to rejoin it. The page is dirty and faulty, the paper crumpled, the characters drawn by the consciousness of a child. I wanted all that torment and that winding of the consciousness of the searcher in the middle of and around their idea to make sense for once, that they should be received and become part of the achieved work, for in that work there is an idea. (XIX: 259)

But the naïveté of this sketch is only a ruse for forcing art to accept what it has never hitherto accepted, namely the

activation of the subjectile. The notorious history of the
treacherous subjectile has never been told in art. Artaud,
in telling this story, betrays this treachery by exposing it,
by dramatising what it does, or rather what it has always
refrained from doing, since, as the passive receiver of
forms, it has played a disingenuous role in the history of
history. It is both an accomplice of the spirit of God and
the scene where his crimes are carried out:
representation, language etc., but where they are never
recognised as such. This is why the drawing is a *"dessin à
regarder de traviole"* (to be looked at askew). It must be
received obliquely. The viewer is encouraged to put an
incorrect construction on the drawing *qua* drawing. One
is not meant to accept it as an art object but as a
document of the failed forms which it represents and
which collapsed around the idea which they could only
betray as they entered the atmosphere of the subjectile.

## Treatments #1: the *jet*[3]

The primacy of the *jet* is an essential point in Artaud's
thought and in all his performative work of writing and
drawing. The idea that the fundamental import of a work
consists in its working, in the energetic act of creation
which can only be an abreaction since the logic of
creation is itself bastardised. It is a concept that Artaud
worked and re-worked from his earliest writings and one
that would subsequently bleed into countless experiments
in the post-war art world that involved the re-
conceptualisation of the art-work from object to
performative process. For example, the practices of the
fluxus artists as well as performance art in general. But
Artaud has a way of resisting the inscription of parental
metaphors. His central concept of *cruelty* corresponds to
a necessity to create which is not the impulse of any given
artist but rather impulse itself. It is not a subjective
experience but one which traverses the subjective as other
sites of dispersion of the *jet* (sub-ject, ob-ject, pro-ject

etc.). Derrida, as always, is sensitive to these differentiations:

> The thought of the *jet* is the thought of the drive itself, of the *force* of the drive, of the compulsion and the expulsion. Of the force before the form. And I will try to demonstrate that it is the very thought of Antonin Artaud. Before all thematics of the *jet*, it is at work in the body of his writings, of his painting, of his drawings. And from the beginning, indissociable from *cruel* thinking.... (*FS*: 63)

The key element is the *jet* that precedes the abjecting of the work, after which the work is itself, of course, abject. At its core a *rejet* (reject/rejection) which never stops disturbing the frames of the aesthetic, and never stops disrupting the smooth surface of the subjectile. But it is a question once more of disposition, does one have the attitude of an artist generating representations, an objective abjecter, or, as Artaud observes in a Van Gogh self-portrait, "*cette figure de boucher roux, qui nous inspecte et nous épie*" with a "*regard qui enfonce droit*" and "*transperce*" (that face of a red-headed butcher, who inspects and watches us ... with a look that penetrates and pierces)? (XIII: 59). In other words, is one already a *jetée*, performing the part of an artist, or is one catapulted beyond oneself towards and through the oeuvre? On which side of the *jetée* should the true artist be located? The true artist like Van Gogh, Balthus, or Artaud will refuse to confide in a repressive and mythologised system policed by the fine arts and instead will set out for the infinite. Launching oneself into the non-finite, one refuses to be *jetée* or even the origin of a *jet*. One becomes *jet* and one's art also becomes *jet*. Through the subjectile, Artaud revokes the law of being and reinstalls the primacy of the *jet* as that which "*donne l'être à l'être*" (gives being to being) (*FS*: 74). It is perhaps just this primacy of the *jet* in painting which forms the central motif in Artaud's essay on Van Gogh.

> For Van Gogh will have been the truest painter of all
> painters, the only one who did not wish to surpass
> painting as the strict means of his work, and strict
> framework of his means. And on the other hand the only
> one, absolutely the only one, who absolutely surpassed
> painting, the inert act of representing nature, in order to,
> in that exclusive representation of nature, make a
> revolving force gush out, an element plucked straight
> from the heart. (ibid: 46)

From *within* the painting the force spurts *out*, the vital
energy seems not to have been diminished in the
transition through the subjectile. Rather than a simple
recording of certain subjects, which is the work of any
painter, Van Gogh also inscribes the process by which the
perception seized the object and annihilated it along with
the painter's subjectivity in the observation become
painting, and by which this observation, this thought of
the work as well as the work of thought, translates itself
through the physicality of the brushstroke. Artaud reads
Van Gogh's paintings as documents which trace this
process by which storms *freeze over* and become works. It
is as if Van Gogh had de-spatialised the frame and painted
in the medium of time instead, as a musician does.

Artaud claims that Van Gogh is a great painter because
he is a "marvellous musician." So it is a music, but not a
harmonic or even threnodic music, rather one in which
Artaud discerns various percussive sounds, forceful and
explosive: "*j'entends les ailes des corbeaux frapper des
coups de cymbale forte*" (I hear the wings of the crows
loudly beating cymbals) (XIII: 58). But it is not just the
music of the symbol, the black crows of death sounding the
death knell, that Artaud hears in these canvases; it resonates
from the figures themselves. And not just anyone can hear
these sounds, in fact one will have to learn how to hear
them. It is a problem of the inadequacies of the human ear:

> Thus, no-one since Van Gogh has known how to shake
> the great cymbal, the super-human gong, *perpetually*

superhuman following the repressed order by which
real-life objects ring out, when one has known how to
have the ear open enough to comprehend the surging of
their tidal-flow. This is how the light of the candle
sounds, how the light of the lit candle on the green
straw-bottomed chair sounds like the breathing of a
loving body before the body of a sleeping invalid. (XIII:
30)

It seems that painting has no generic sound quality, that it
depends on the particular tableau and the particularities
within them. And yet they "sound *like*," they are at once
unique and analogic, as Derrida notes. The objects sound
like breathing bodies in a situation so intimate it recalls
the viewer/listener to their voyeurism/eavesdropping. The
rhythm of the breathing bodies suggests the natural
vibration frequency that objects have but which are
usually too low or of an amplitude below the level at
which they might be perceived by the human ear. So how
does one proceed? To amplify nature or to perform
surgery on the ear? Van Gogh, it seems, did both. Artaud
settled for the subjectile.

## Treatments #2: Surgery

The figures on the inert page are silent under my hand.
They present themselves to me like millstones which will
never inspire the drawing, and that I could drill, trim,
scrape, file down, suture, unpick, tear to pieces, pull
apart and cut without the subjectile ever whimpering for
mummy or daddy.[4]

When the subjectile is rendered inert, the figures have
nothing to say. What is required is a type of surgery ... on the
subjectile ...? But the first phase of this surgery is the
anaesthetisation of the figures. They have become silent and
supine on the inert page: subjectilian. It is these figures
rendered subjectiles that Artaud will subject to surgical
procedures. When the subjectile is rendered inert it can have

nothing to say about the reconstitution of the subject. It will not complain when Artaud the surgeon begins his drilling, trimming and tearing apart of the (badly designed) body.

In most of Artaud's drawings this is the process we see at work. The disarticulation, dis-memberment of the body, juxtaposed with its metaphorisation as a coffin, the coffin of being. One of Artaud's epithets for himself in the period which corresponds to the production of most of these drawings is *"ANTONIN ARTAUD ... le non-cercueil"* (the non-coffin) (XX: 261).

The joints, especially the knees, are exploded, releasing the synovial fluid which had facilitated the body's articulation. The fluid that had never before been treated as a constituent of the subject, therefore never represented, once released from its prison takes the form that the draughtsman has created for it. This is the means by which Artaud as draughtsman takes back his body from the *system of fine arts* which had reinforced and repeated its abduction and misconstruction by the spirit of God.

> We sense fluids, *I subdue them*, I wasn't looking for a rare or unique material but something which was neither a body nor a material but which called forth a demonstration of the individuality which can neither be imitated nor touched by an other. I only need to paint myself full length, *that will suffice*. FULL LENGTH. *In a* FULL LENGTH *pieta*. If there are still imitators it's because my work is not finished. (XXV: 46)

By letting the body's fluid flow Artaud signals the advent of a representation of the body which is not conducted in the name of the sexual maladdress of God and which resists further thefts and representations of the body. But this work is not completed, can never be finished.

This construction of the pure and authentic body, the *corps propre* to come, is the interminable task which constitutes Artaud's revision of the subjectile as well as the role he never ceases to re-interpret as the protagonist of

cruelty. For Artaud it is "*le travail perpétuel que je suis*" (the perpetual labour that I am) (XX: 260). The cruelty here is that which is applied in regard to the subjectile, in the double sense of a physical brutalising and a restoring to itself. As Derrida explains, paraphrasing Artaud: "*Il faut en finir avec le subjectile. Et pour cela le déterminer, l'analyser en le faisant sortir de soi*" (One must finish with the subjectile. And for that you need to determine it, analyse it in making it depart from what it is) (*FS*: 102). Derrida describes the subjectile as "*l'objet transcendental = X*" (ibid.) which takes on whatever value is attributed to it. Artaud's quest here is to help it to find its own authentic value irrespective of the attribution, in which case it would have to leave its non-finite abode and become finite, hence the "*en finir avec*" (render finite). The analogy applies equally to the human body which has received its attribution from the spirit of God and is the embodiment of his/her judgement. Artaud's work here is the same, to make this judgement finite is to give it shape and therefore "*y mettre fin de ses propres mains. Chirurgicalement, pictographiquement.*" (to put an end to it with one's own hands. Surgically, pictographically) (ibid.). This is a combat with the received forms of the body, forms which testify to a misappropriation of the proper body prior to birth. But the combat is not an annihilation, not an armageddon of forms but an abreaction of them. One is always finishing *with* them, rather than finishing them off:

> Struggling against these malversations I stippled and chiseled all the angers of my combat, in view of a certain number of totem beings, of which only these miserable little specimens remain, my drawings. But there is something else: it is that this struggle in its *essence* does not cease to be concretely signified through lines and points. These points are sewn onto the page. these lines are what one might call *interstitial* lines. Interstitial they are, as if being held in suspense in the movement that they accompany, movement which rocks the breath. (XXI: 267)

Artaud's abreaction of the subjectile involves the concrete use of lines and points as well as the chiseling and stippling techniques, but they are scattered throughout an in-between space which is that of the indeterminate subjectile. But this in-between is also a temporal zone since these traces and marks are the frozen trails of the *jet*, the movement that they accompany. Suspended in time and space these interstices mark both the perforation of the subjectile, its penetration, and the restoration of its truth.

In the drawing *La Mort et l'homme* (Death and man) from April 1946 Artaud has sketched two stick-like figures, the hands of one figure in a superior position on the page bear the stigmata of Christ and are attached to two boxes which usually signify coffins in Artaud's pictography, the coffins of being, in other words the organic body. The other figure interposes itself between the boxes and consists of two parallel lines dividing the figure from head to foot. It is an image of the body as interstitial, as negatively infinite, intervening between two finite, closed boxes. Two images of the body corresponding to two sides of the subjectile, one dead and the other divided. But how can we perceive this imagery adroitly? Do we have the technology, or are we condemned by congenital ocular damage to mis-prise this sketch? Artaud left some instructions for the viewing of this piece which bring together some of the ambiguities I've been pursuing here:

> One must look at this drawing once more after having already looked at it once. I think it remains then not in space but in time, at that point of the space of time where a breath from behind the heart holds onto existence and suspends it, in viewing close up I would like it if one could find there that kind of unsticking of the retina, that quasi virtual sensation of a retina detaching itself which I had in unfixing the upper skeleton *in regard to its setting in my eye*. (XXI: 182)

This drawing requires more than just one look, it needs to be framed by two looks, two blinks of an eye. Two looks will mirror the experience of detaching a retina which will help in situating the figures correctly as far as their setting in the fluid interstices of the eye are concerned. These diffracting humours, no doubt infected by a certain divine world view, together with the opaque block on the surface of the eye and the faulty retina, combine to distort the projection of the image. Here an image of being and death, both of which are divided from themselves, inauthentic and diseased, note the cancerous cyst-like formations on the lower figure. In order to perceive this we need to be re-visioned (revised), to have our eyes seen-to, readjusted, not by adding a prosthetic lens but by detaching the retina. We need to be radically re-worked since the current system has rendered us inert subjectiles. We need to be reborn but not from the origin since the origin is already infected by being; the breath of God.

Towards the end of the Van Gogh essay Artaud describes the kind of eye that we need. It is Van Gogh's eye in a self-portrait and it reminds Artaud of the eye of a "*certain philosophe*" who Artaud perceives "*vivre en lui*" (to be living in him) at the precise moment at which he (Artaud) is looking at the painting. (XIII: 59). He speculates that it may be Nietzsche's eye which had the same "*regard à déshabiller l'âme, à délivrer le corps de l'âme, à mettre à nu le corps de l'homme, hors des subterfuges de l'esprit*" (look which undresses the soul, plucks the body from the soul, strips naked the body of man, beyond the subterfuges of the mind) (ibid.). It is a portrait of the eye on the verge of "*verser dans le vide*" (spilling into emptiness) but yet fiercely gazing (ibid: 60). It is not a passive eye receiving the image, it is "*parti contre nous comme la bombe d'un météore*" (aimed at us like the bomb of a meteor) (ibid.). It is not a subjectile, not a blank screen or retina for the reception of images, but an active, piercing force.

It was this eye that was the means by which Van Gogh

"*a situé sa maladie*" (situated his illness) (ibid.). His illness, which is the illness of anyone who can see it, is the illness born of being denied the infinite, of having the infinite be constructed as the negation of the finite. Artaud says that society '*a interdit*' (forbade) Van Gogh the infinite by making it unrepresentable, except in its negation through the detour of form and that it was this refusal that killed him (ibid.: 60, 61). Artaud reads all this in the eye of Van Gogh's self-portrait, that alien eye in the eye of Van Gogh which laid bare the truth of the body and separated it from the soul. If it was the eye of a philosopher it must surely have been that of a phenomenologist, and who more adept at such questions than Husserl? Or at least Husserl seen through the eye of Derrida.

In Derrida's analysis of Husserl he discusses the possibility of the authentic presentation *of* the self *to* the self in language which Husserl figures through the example of the monologue in which the self-representation is supposedly unproblematic and unmediated. It happens *im selben Augenblick*, in the same blink of the eye, or in the same instant, also translated as "at that very moment."[5] But Derrida intervenes in this moment of self-presence, disturbs the "primordial character of the living now" by pointing out the rather obvious fact, the all too obvious fact, that the *Augenblick*, the blink of an eye, has two discrete moments: an open eye and a closed eye: "There is a duration to the blink and it closes the eye."[6] The implication is that one cannot perceive oneself without the intervention of the Other, that primordial visions are always revisions and always tainted by the mark of the signifier: "This alterity is in fact the condition for presence, presentation, and thus, for *Vorstellung* in general."[7] There is no pristine expression that doesn't have to traverse the tortuous paths of language. (How naïve of Husserl to have thought otherwise!) If the original instant is divided there can be no return to the origin. The apparent naïveté of this observation of Derrida's is startling at first but a second glance reveals the many

forking trails to be followed in measuring up to this naïveté.

One of these trails leads back to Artaud, since if the *Augenblick* reveals the division of being, then a double blink of the eye will be needed to perceive that the eye is also separated from its true vision, a double blink which might also yield a truer perception of his sketch: "*trame d'un seul battement de cil.... Il faut regarder ce dessin encore une fois après l'avoir vu déjà une fois.*" (framework of a single blink of an eye.... One must look at this drawing once more after having already looked at it once) (XXI: 232). These phrases are adjacent in Artaud's text. The second glance follows the *Augenblick*. The blink constructs a temporal and spatial frame, a grid through which to perceive the primordiality of the trace, the stroke, the sketch. Derrida and Artaud are as usual very close to each other on this point but standing back-to-back rather than eye-to-eye. Artaud despairs of the very thing, the congelation of force in form, that Derrida is always so pleased to mollify and soothe Artaud's anger and energy carve through the subjectiles of his work; stipple and chisel all the angers of his struggle. But he never leaves it at that. Even the *sorts*, those fragments of torn paper, were carefully inscribed.

Pure action is never self-evident for Artaud and this is why he supplemented it with the double *Augenblick* of abreaction; the recollection that this moment is never simply this moment and that one is obliged to repeat oneself before one can claim one's essential authenticity. Abreaction is the reflection and refutation of the originary diversion that instituted *being*, the organic body, the law of representation; all the malversations of the spirit of God. It is why he wrote so many incandescent refutations of writing, sketched such adroitly clumsy images and called for a 'theatre of cruelty' rather than of war or politics. It was the recognition of the necessity of traversing the representation in order to have done with it, but never to finish it off ...

## NOTES

1   The title is taken from a phrase Derrida uses in his essay on
    Artaud's drawing which is the focus of this chapter: Jacques
    Derrida, "Forcener le subjectile," in J.
    Derrida and Paule
    Thévenin, *Antonin Artaud: Dessins et Portraits* (Paris:
    Gallimard, 1986) 55–109. Hereafter it will appear in the text
    as *FS* followed by a page reference. The phrase: "L'esquisse
    du jet" appears on the last page of this essay (*FS*: 105).

2   As Thévenin indicates in her notes, this description is
    impossible to place with respect to a given work but may
    legitimately refer to any of the drawings from Rodez from
    early 1946, including *La Maladresse*.... (XX: 340).

3   The English equivalent of "*jet*" does not adequately translate
    all of the demands that Derrida makes of the French term. A
    more inclusive translation would be 'jet/ject' to account for
    Derrida's puns on 'sub-ject', 'ob-ject'; 're-ject' and 'pro-ject'
    which for reasons of style have been avoided on this
    occasion.

4   Quoted in *FS*: 57, 99. Derrida gives no textual reference
    other than mentioning that the piece was written in
    February 1947.

5   Jacques Derrida, *Speech and Phenomena and other essays
    on Husserl's theory of signs*, transl. David. B. Alison
    (Evanston: Northwestern University Press, 1973) 49.

6   ibid., 65.

7   ibid.

# All Writing is Pigshit

*Lesley Stern*

I close the eyes of my intelligence and open my mouth to the speech of the unspoken.[1]

Artaud has a lot to say about the mouth. For instance:

and isn't the mouth of the current human race, following the recent anatomical survey of the contemporary body, this hole of being, situated right there at the outlet of the haemorrhoids of Artaud's arse[2]

And on another occasion he says:

I don't believe in father
in mother
got no papamummy
...
nothing inside or out
and above all no mouth to mouthe Being,
that sewer drilled with teeth.[3]

When Artaud opens his mouth words pour out, words that declaim, exhort, upbraid, accuse, insult, incite. Incendiary words and slimy words; words like bits of meat — fleshy and gristly — are chewed over, regurgitated, spat out, passed out as faeces transferred to the page. There is a motif that will recur throughout his work, an intimated relation between the mouth and writing. Writing for him is performative, it is close to speech, and to DOING. Writing then is about acting upon not about capturing or representing the world. And if writing has to do with the mouth, it is equally the case that the mouth has to do with

75

other orifices, but particularly the anus: to write is to shit, and writing is crap.

He puts it this way: *All writing is pigshit.*[4]

Artaud here sets a trap: if all writing is pigshit, to write at all, but particularly to write *about* this statement, to attempt an exegesis, is not only paradoxical but a real case of shitting in the wind. My initial impulse, when invited to contribute to this event, was to mimic Artaud's response when he was invited to attend a certain international conference. He wrote, "Let me say at once that I regard it as an excessive and misplaced honor to ask me to attend a conference "for the Defense of Culture"... [since] I see culture as a reality to be defeated." And since I am captivated by this statement — all writing is pigshit — then I should desist from writing, should be alert to Artaud's dictum: "I am stupid the moment I assume an air of discourse";[5] and moreover, since I think that the Artaud Industry is something to be defeated and not celebrated then it is nonsense for me to be here. But I come with purpose, sickened by the parsimonious plague of smart-arsed critics who caress and pamper Artaud's eviscerated being, who, like boutique bistro vultures, deviously pick holes in his body of work and chant endlessly about the 'body without organs' like an army of lice farting in politely orchestrated unison. Unlike those abject lily-livered worshippers I come not to praise him but to denounce, abuse and decimate his memory which after all isn't a memory but the spirit of Satan, or an electric impulse that even now is travelling through the auditorium, insinuating its way into your pea-sized brains, worming its message into your spongy cholesterol hearts. I am the Butcher in *The Butcher's Revolt* who says "'I'm sick of carving up meat and not eating it.'"[6]

I want to eat, and it's meat I want, I want to get to the "meat heart"[7] of the Artaud matter, it's meat I want, not the putrid piety of cabbage, nor the chunderous patchouli stench of chichi theory. Also, by the way and incidentally, I'm sick of rolling cigarettes and not smoking them. And

I'm sick of the merchants of moderation, the dick-headed spies and sniffer dogs and circus ringmasters and arts bureaucrats whipping up a frenzy of abstinence, all for this thing called 'the common good.' Conference organisers, puerile petty hitlers who fill the air with malodorous admonitions — thou shalt not smoke or talk over your allotted time or wank on the stage, and above all thou shalt obey the law of genre — they make me puke. And audiences like you lot, giggling daintily into your snot rags. I want to smoke. To eat meat and smoke. Instead, however, taking cognisance of the situation, I have prepared a lecture, a lucid explicatory text, I've rehearsed the argument, refined my thoughts, everything is clear.

I come with purpose. There is something that intrigues me, and there is a question that has seized me by the short and curlies. The intrigue is this: Artaud rails endlessly against speech and writing, against the failure of words — "all words are a lie," he says, "When we speak we betray our soul"[8] — but this never stops him from speaking and writing, on the contrary it seems in fact to provoke a veritable torrent of words, a tirade, a self-generating series of prolific diatribes. My question then is this: what is he *doing* when he writes "all writing is pigshit"?

One way of responding to these conundra is to talk about the "barbarism and disorder"[9] of Artaud's language — to see the tirades as mad, and to situate 'all writing is pigshit' precisely as a lunatic pronouncement, albeit an inspired epithet, Dadaistically resonant. You can go further along this route and celebrate (or even espouse and emulate), in the barbarism and disorder, a manifestation of the phatic, the gestural, the meaningless. In such a scenario Artaud represents a delirious state of pure semiosis and eternal becoming. But there is another way of approaching this barbarism and disorder, and that is to follow the lead given to us by Jane Goodall. In *Artaud and the Gnostic Drama*,[10] she retrieves for us a profoundly ludic Artaud, but also draws attention to the fact that this

ludic dimension operates in conjunction with what she identifies as a gnostic impulse and which she names as *heretical*. She identifies a remarkably sustained and systematic strategy in Artaud, and borrowing from her but veering off on another tangent I would like to hypothesise a systematically *revolting* Artaud. This is to suggest of course that he is both *in* revolt and that the revolt*ing* dimension of his speech and writing is impelled — as a sustained activity — by an informing and vitalising critique.

The element of critique can be discerned both generally and specifically. Generally speaking: in a marvellously inventive capacity for invective, a prodigious talent for putting into play the social insult; specifically speaking: in an equally lurid and obscene diatribe against God. The general and the specific are related, and they are related through the scatological. If you try to mimic or emulate this Artaud rather than the romantically deranged Artaud, something interesting emerges in the very process of putting-into-language. Insults, we commonly assume, entail adjectives, a preponderance of abusive and demeaning adjectives. However, Artaud's writing, though in general epithetically pungent, is not markedly descriptive. It *is* rich in gerundive potential and when he does use adjectives they tend rather to be mobilised as deictic insults, precisely as dialogically paranoid and often combative interpellations. Artaud shits on everyone, but above all he shits on God. He doesn't describe God, he summons him into existence and tries to obliterate his presence by shitting on him. So we could say that because Artaud uses shit as a weapon it automatically follows that writing is shit. A neat explanation and end of story. But there is more to it than this, a more convoluted and intriguing logic that has to do with the origin, the generation, and above all the affectivity of words.

When Artaud says:

I don't believe in father
                    in mother
got no papamummy

...
nothing inside or out
and above all no mouth to mouthe Being,
that sewer drilled with teeth

it's rather rich, this abnegation of the mouth from a man
who is all mouth. But to say he is all mouth is also to say he
is all holes, voided, a plethora of orifices. For Artaud it's
true that whilst the mouth is also the anus — a
haemorrhoided arse hole — it is also the vagina — a sewer
drilled with teeth. Reeling between the sink and the latrine
he chunders, shits, disappears up his own arse and fucks
with words. But he does all this in deliberate defiance of
God, in parodic and lethally assaultive mimicry. The
judgement of God consists in pronouncements, in his
writing of the world and the human body as a mirror image
of himself, as deriving therefore from a singular origin. He
designates a theological dimension to sex, to all generative
acts, for him each bodily hole is distinct, and the
distinctions specify a series of singular and proper
functions. When Artaud says "I don't believe in father in
mother got no papamummy," he is simultaneously saying 'I
don't believe in God, in gendered sex dedicated to
procreation and the iteration of God's image,' AND he is
saying 'I am God, I myself am the source of creation, I come
into being through autogenesis.' He doubles God. But he
also, in this act of doubling, perverts the theological
impulse, the tendency to nail things down, everything in its
proper place — in Artaud's universe there are no specific
holes for fucking, for shitting, for pissing, for speaking and
so on. This autocatalytic propensity is paradoxically not
about self-expression, nor is it about a Primal Hole, nor an
originary conception, nor about giving birth; it is about a
painful coming into being through pulling oneself inside
out, about continuously making something out of nothing,
and nothing out of something. Concomitantly it is a
struggle against the word of God, against the nailed-down
universe given us by God, and so it involves a bringing into
being of words that combat God's descriptive and

categorising impulse. Writing, then, is about *acting upon*, not about capturing or representing the world. And if writing has to do with the mouth, it is equally the case that the mouth has to do with other orifices, but particularly the anus: to write is to shit, and writing is crap: "There where it smells of shit it smells of being."[11]

There is another dimension to this struggle which, whilst related, is more frightening, and more painful. Artaud writes in order to stay alive, he writes against paralysis and silence. It is God's greatest monstrosity that he has screwed things up and he keeps on screwing and nailing, nailing things down, screwing Artaud's body and also driving nails into his bones. It is an attempt on a large scale to paralyse and silence. Artaud's greatest fear — and it is a threat that constantly haunts him — is that he will submit to paralysis and silence, that he will find himself in a world where there is only silence and "a kind of cold suffering without images, without feeling."[12] So he shocks and drugs himself — not in order simply to endure the world, but to struggle *with* language *through* the very medium of language, *with* the body *through* the very medium of the body, to act upon the way the world is conceived, to conceive the world anew, to stay alive. Out of nothingness he generates crap. Language is a drug, or as Laurie Anderson asserts (quoting Burroughs), a virus. It infests and it procreates heretically.

> I take opium in the same way that I am myself, without recovering from myself ... But I can do nothing unless I take into myself at moments this culture of nothingness.
> It is not opium which makes me work but its absence, and in order for me to feel its absence it must from time to time be present ... there are no words to describe it [this state] but a violent hieroglyph which designates the impossible encounter of matter with mind.[13]

Artaud's insults are violent hieroglyphs, his diarrhoeic streams of invective attest to an addiction to language, but not as a palliative, rather as a medium of contestation, as

the mobilisation of an impossible but absolutely essential encounter. He speaks and writes against God's tyranny (registered in the world as a horribly humanist complacency), and against cultural and political banality. He ups the anti, and he's keeping it up, pouring pigshit, for instance, on all those good burghers who in Australia in 1996 dilute dissent and distance themselves from protest, who say, with the reasonable conviction of the righteous, "We do not condone violence or encourage haemorrhoids, we are sober people and the protest rally today was well-planned by reasonable adults as a legitimate and peaceful demonstration of dissatisfaction; we are prepared to come to the party, to sit around the table, to enter into the spirit of negotiation, to break bread with you guys and crack open a bottle or two and come to an agreement. We utterly dissociate ourselves from the bad behaviour of a small and unrepresentative sector of the riff raff."

As a parting shot, here's a reminder of what Artaud has to say about that 'pious thing,' that sacred institution called Australian Literature:

The whole literary scene is a pigpen, especially this one.
All those who have vantage points in their spirit, I mean, on some side or other of their heads and in a few strictly localised brain areas; all those who are masters of their language; all those for whom words have a meaning; all those for whom there exist sublimities in the soul and currents of thought ...
are pigs.
Those for whom certain words have a meaning, and certain manners of being; those who are so fussy; those for whom emotions are classifiable, and who quibble over some degree or other of their hilarious classifications; those who still believe in 'terms'; those who brandish whatever ideologies belong to the hierarchies of the times ... those who still believe in some orientation of the spirit; those who follow paths, who drop names, who fill books with screaming headlines
are the worst kind of pigs.

... they are always the same old words I'm using, and really I don't seem to make much headway in my thoughts, but I am really making more headway than you, you beard-asses, you pertinent pigs, you masters of fake verbiage, confectioners of portraits, pamphleteers, ground-floor lace-curtain herb collectors, entomologists, plague of my tongue.[14]

## NOTES

1   Antonin Artaud, "Fragments of a Journal in Hell," *Artaud Anthology*, ed. Jack Hirschman (San Francisco: City Lights Books, 1965) 41.

2   Antonin Artaud, *Antonin Artaud: Oeuvres complètes*, tome III (Paris: Gallimard, 1961). Translation courtesy Edward Scheer.

3   Artaud, "Here Lies," *Artaud Anthology,* 247.

4   Artaud, "All Writing is Pigshit," *Artaud Anthology*, 38.

5   Artaud, "Here Where I Stand," *Artaud Anthology*, 204.

6   Artaud,"The Butcher's Revolt," *Antonin Artaud: Collected Works*, vol. 3, transl. Alastair Hamilton (London: Calder and Boyars, 1972) 42.

7   Artaud,"Fragments of a Journal in Hell," *Artaud Anthology*, 44.

8   Artaud, "Letter to Genica Athanasiou," 1922, *Antonin Artaud: Selected Writings*, ed. and introd. Susan Sontag, transl. Helen Weaver (Berkeley and Los Angeles: University of California Press, 1988) 19.

9   Artaud uses this phrase to describe his drawings in "The Human Face," *Artaud Anthology*, 234.

10  Jane Goodall, *Artaud and the Gnostic Drama* (Oxford: Oxford University Press, 1994).

11  Artaud,"The Pursuit of Fecality," *Antonin Artaud: Selected Writings*, 559.

12  Artaud, "There's an Anguish ..." *Artaud Anthology*, 32.

13  Artaud, "Appeal to Youth: Intoxication-Disintoxication," *Antonin Artaud: Selected Writings*, 338–9.

14  Artaud, "All Writing is Pigshit," *Artaud Anthology*, 38–9.

# The Last Pulse

## Artaud, Varèse and the Exhaustion of Matter

*Frances Dyson*

The last scene in *There is No More Firmament* — originally written as a libretto for Edgard Varèse's symphony, *The Astronomer* — was not intended to be the final scene. Like the symphony itself, the libretto remained unfinished. However its accidental finality is prescient — both for Artaud and for the generations that have inherited the nihilism of twentieth-century death culture. The unfinished text ends in a universal, utterly non-negotiable, and infinite silence:

*Sounds rush forward ...*
*Cold light reigns everywhere.*
*Everything stops.*[1]

Perhaps one of Artaud's "machines of instant utility,"[2] this scenario grinds existence to a halt. The turmoil and turbulence of the physical and metaphysical elements that Artaud has set into a closed and crazy orbit, constantly revolving around each other, unable to be set apart without falling back into a kind of helplessness, these elements are united at last in a resolute non-being. Life, theatre, necessity and matter are resolved; "Man, Society, Nature, and Objects" fall into a harmonious stillness — there is nothing more to say[3] (*TD*: 89). But how has this resolution come about? What has made it possible? Here, in microcosm, the chronology of that last but not final scene is instructive: sound rushes forward, cold light

reigns — then, and we might say, *only then*, "everything stops." But it is not that everything stops by mere accident — in this play, everything stops because of the transmission of a signal — what Artaud refers to as a "celestial telegraphy," and it is to this signal that sound and light, and indeed the very possibility of their presence, must give way.

Throughout his writing, Artaud brings into play a sequence of tropes: incantation, vibration, contagion and transmission. In this paper I want to look at the way sound rushes forward for Artaud, and to discuss, in the context of his collaboration with Varèse, how sonic projection lubricates the positioning of these tropes within a metaphysical machine — one that happens to precipitate the end of the world. Perhaps buoyed by Varèse's similar ideas for sound and music in the theatre, Artaud repeats this sequence in the profoundly pessimistic narrative of *There is No More Firmament*. And through a discipline that becomes increasingly anechoic and automatic, hoists it into the cosmos as an uncannily predictive schedule for the future.

Sound emerges for Artaud as a counter to the despised voice speaking language. As he prefaces *The Theatre and its Double*, it is "the rupture between things and words, between things and ideas and the signs that are their representation" that accounts for "the confusion of the times" (*TD*: 7). The voice speaking language is a manifestation of this rupture that representation installs. To escape language, to return theatre to its primal delirious, magical and revelatory state, to "make metaphysics out of language,"(*TD*: 24, 30) Artaud invents a new "concrete language," constituted by voice, music, gesture, volumes, objects movements and forces, "... intended for the senses and independent of speech"(*TD*: 37). This language expresses thoughts which are "beyond" the reach of spoken language, consisting of "everything that can be manifested and expressed materially," creating beneath language "a subterranean current of impressions,

correspondences, and analogies"(*TD*: 38). Recognising that words have the faculty of "creating music in their own right ... independent of their concrete meaning,"[4] Artaud includes "objective intonations" in his materialised "poetry in space."[5] In this space sound is treated like a physical object. It is "divided and distributed" while its ability to shock and shatter is used to "fascinate and ensnare the organs." The sound of this language is definitely not music, rather it "... wildly tramples rhythms underfoot. It pile-drives sounds. It seeks to exalt, to benumb, to charm, to arrest the sensibility" (*TD*: 91).

But if it seems that this language engages noise as its medium, Artaud makes sure to situate his sonic shocks well beyond the mundane: for this language helps the spectator to "consider language as the form of *Incantation*."[6] Via onomatopoeia for instance, the mechanisms of representation are disrupted, ordinary language is inhibited. Yet rather than a total disjunction between signifier and signified, speech is still able to "manifest something" through a non-arbitrary relationship between word and thing. The desire for this kind of non-arbitrariness is a common theme in Western philosophy. Plato, for instance, proposed the existence of an *ur*-language handed down by the gods, in which the 'legislators' of language invented words that would phonetically correspond to the nature of the thing, the "letters [phonemes] in a word expressing certain states of the thing such as motion, or shock."[7] In imitating the nature of the thing or event, the voice sonically re-presents its essence, creating a physical (because acoustic) resonance between the speaker and the thing spoken of. Names therefore 're-call' things through their very voicing, uniting word and thing through sound.

As it *sounds* the names given by the gods, the voice is described by Plato as an 'instrument' that evokes the essences of things which, as forms, are permanent, abiding, and not subject to change. This permanence is fixed cosmically in the music of the spheres, where sound

— having been rationalised through the harmonic system generated by Pythagoras' mono-chord — becomes the model for the governance of astronomical bodies. The cosmos becomes musical and vice versa. While Artaud's writings on sound, music and in particular vibration, could be read in terms of Platonic thought, like Varèse, the sound that he has in mind is nothing like the music of the spheres.[8] The essences that sound recalls are described as "principles" and "forms" by Artaud. They are the shapes, sounds, music, and volumes of an "essential drama" and are in no way intellectual. Rather, they evoke:

> ... states of an acuteness so intense and so absolute that we sense, beyond the tremors of all music and form, the underlying menace of a chaos as decisive as it is dangerous. (TD: 51)

So, beyond the 'tremor' of music, lies a chaos of Creation that is without division "without conflict," corresponding in the spirit to an absolute and abstract purity "beyond which there is nothing," the kind of nothing that Artaud conceives as "a unique sound, defining note, caught on the wing, the organic part of an indescribable vibration."[9] The vibration itself would resolve "or even annihilate every conflict produced by the antagonism of matter and mind, idea and form, concrete and abstract," it would be a vibration of which sound is the "organic part." (TD: 51–52).

But what is a vibration? Here is a term used to represent a transcendence of the material on the one hand ("beyond the tremors of all music") and, on the other, an engagement with the fundaments of raw, palpating life. The concept of vibration played an important role in the philosophies and aesthetics of the Futurists — with whom Varèse has been associated — and was elucidated by the philosopher Henri Bergson, whose influence on the avant garde — including Varèse — has been well noted. Bergson refers to matter, which is always in a state of becoming, as "numberless vibration,"

not atomic but imbued with and governed by motion —
"modifications, perturbations, changes of tension or of
energy."[10] Between presence and representation is the
interval between matter itself and our conscious
perception of matter, and in that interval all the artificial
divisions that go into constructing and representing
matter as a series of independent objects cast in an
infinitely divisible space and existing in a perpetuity of
instants are set in place. Vibration, this quintessentially
aural term, thus figures in a philosophy, or non-
philosophy, for which the phenomenality of sound and
the subjectivity of listening provide excellent metaphors.
In the phenomenology of Bergson and others, sound and
vibration also provides a counter to Platonic idealism,
which succeeds in uniting word and thing only via
reference to the demands of the deities.

It is no wonder then that Artaud goes back and forth
between the materiality and metaphoricity of sound —
between its ability to penetrate and vibrate, its
communicative function via the speaking voice, its
associations with music and the Pythagorean harmonies of
the cosmos, and its inseparability from noise. Artaud's
metaphor of vibration lacks the connotations of
transcendence that readers of twentieth-century mysticism
are familiar with, that probably informed Varèse with his
fascination for volatilisation and light. More importantly,
Artaud's interest in *noise* — etymologically linked to
nausea, odious air and rumour (spread as 'bad' sound) —
distinguishes his aurality from the pure, mathematical,
theological schema that Plato outlines and further embeds
it within the concept of contagion and transmission. The
sounds that Artaud envisages include glossolalic
utterances that completely disable the mechanisms of
meaning — primal or otherwise.[11] Very often, this sound
is less of an incantation or 'poetry in space' than the kind
of belch, rumble or spasm that indicates digestive or
cosmic transformation is occurring. With his pile-driven
sounds penetrating the organs, the body, the nervous

system, becoming an interior sensation, a delirium that is both subtle and demonic, Artaud's analogic equivalence between the theatre and the plague makes sound the organic part, not of a primal vibration, but of an intelligent contagion. Artaud likens the operations of this 'contagious delirium' to the action of subtle musical vibrations on the nervous system. However, rather than the organism shimmying to a higher plane of consciousness, the action is a revelation of, or opening to, the chaos that lies beneath all the "tremors of music."[12]

The concept of contagion is important here, since between the source and its destination there is no difference — the plague, like the vibration, like the Platonic incantation, transmits *itself*, in the present, without entering into repetition or representation. The plague therefore has a certain purity of being, one that also purifies being: it "shakes off the asphyxiating inertia of matter which invades even the clearest testimony of the senses" (*TD*: 31). For Artaud, just as the worst kind of sound is the voice speaking language, so too the worst kind of matter is human: "All the preoccupations [of theatre] stink unbelievably of man, provisional, material man, I shall even say *carrion man*." (*TD*: 42). Theatre's stench of man, its "preoccupation with personal problems" disgusts Artaud, because matter and objects relate to individual things, whereas forces, states, and intensities lack individuation and to some extent, avoid the possibility for representation. Sound occupies an intensely ambivalent position here as the material of both "proper," individuating speech and meaningless, affective babble — indeed it is upon this tension that western thought and the 'carrion' individual has been founded. For Artaud this tension is a source of continuous anguish. The materiality of sound allows him to avoid the separation that representation imposes, however, noise is itself inseparable from the nauseating stench of matter, which, like the voice, is inevitable as long as theatre is human.

## Matter as Hieroglyphic

While the concrete language of Artaud's 'theatre of cruelty' enables him to communicate directly to a "deeper intellectuality" (*TD*: 91), even so Artaud cannot leave the matter of humans alone. In his proposed 'theatre of cruelty' the spectators are 'conducted' "*by means of their organisms* to an apprehension of the subtlest notions"(*TD*: 81). His "carrion man" — spectator in an "inhuman" theatre that reveals or leads to, a "virtual reality" (Artaud's words, not mine) — exists only as a "stripped, malleable and organic head, in which just enough formal matter would remain so that the principles might exert their effects within it in a completely physical way" (*TD*: 49). The sound and light the spectators are immersed within[13] produces a state that, whilst trancelike, nonetheless "addresses itself to the organism by *precise instruments* ...."[14] Precision and control are key elements in Artaud's new language, as the intonations, the vibrations, movements and gestures on the stage and of the actors are deployed "on condition that their meanings, their physiognomies, their combinations be carried to the point of becoming signs"(*TD*: 89). The essential drama contains a kind of lexicon or a DNA for all possible dramatisations and consists of these contagious signs, collected and organised, which Artaud likens to hieroglyphs.

Speech now appears "as the result of a series of compressions, collisions, scenic frictions, evolutions of all kinds" and, within the phenomenality that such materiality bequeaths, it becomes a thing to be recorded, to be "*written down*, fixed in its least details, and recorded by new means of notation."[15] Artaud is unclear about the recording of this language — it could be accomplished through "musical transcription or by some kind of code" (*TD*: 89) but hieroglyphics provides a model. He writes:

> As for ordinary objects, or even the human body, raised
> to the dignity of signs, it is evident that one can draw

one's inspiration from hieroglyphic characters, [which will allow one] to record these signs in a readable fashion which permits them to be reproduced at will...

Warming to this, Artaud imagines that

> The spectacle will be calculated from one end to the other, like a code. Thus there will be no lost movements, all movements will obey a rhythm, and each character merely a type, his gesticulation, physiognomy and costume will appear like so many rays of light. (*TD*: 89)

Hieroglyphics would operate vibrationally "on all organs" and metaphysically "on all levels." However, unlike the theatre of cries, screams, gestures, matter and things, hieroglyphic theatre embraces the universe within the economy of the sign and uncovers a "passionate equation between Man, Society, Nature, and Objects" (*TD*: 89). Here a primal law operates with the precision of a metaphysical, ethical and aesthetic machine — a machine incidentally, that Artaud has named the 'theatre of cruelty.' In this world of states reduced to symbols, phenomena — such as sound and light — for which linguistic representations are lacking are coded (sampled?) and added to the world of objects. As contagion becomes transmission, matter is redefined in terms of the signal and bodies turn into beams of light.

## Artaud and Varèse

As Artaud clothes and codes his hieroglyphic characters in "rays of light," fragments of his strange collaboration with Varèse begin to fall into place. In its incarnation as *The One-All-Alone* Varèse describes an astronomer who rakes the sky with his telescope "... with such avidity that the stars grow progressively bigger and bigger and end up by absorbing him completely."[16] During this process he first becomes "a long ray of light" and then transmutes into a

god figure as rays of light radiate in all directions from his body.[17] The Astronomer reappears in "An Open letter to youth" which Stockhausen published in the *Journal Musical Français* of May 1968. In this article Varèse writes: "We are in a time when certain men of heightened consciousness are becoming so strong that they are approaching a higher form of life. Here on this earth."[18] In the vernacular of mysticism, the higher form of consciousness would be reached via a vibrational transformation that is both material, intelligent and cosmic. Varèse seemed happy with this kind of transcendence and had his Astronomer volatilised into interstellar space. He was unhappy, however, with Artaud's protagonist, the Scientist, whose existence is bluntly terminated along with everything else.

Like Artaud, Varèse was concerned, perhaps obsessed, with the effect of sound on the audience, with its capacity for violence and control, and also with its object-like projection in space. Describing *The Astronomer* as "an apocalyptic drama of hate and terror ending in an apotheosis of light," Louise Varèse writes of Varèse's desire to "make an audience feel the 'powerful joy' of an intense, terrifying, salutary emotion that would annihilate, at least momentarily, the personal ego."[19] In the final scene of Varèse's sketch, factory sirens and aeroplane propellers were to sound. Their 'music' was to be as strident and unbearable as possible, so as to terrify the audience and render it groggy. At that moment "... the powerful spotlights supposedly raking the sky up on stage would be turned abruptly down into the auditorium blinding the audience and filling them with such panic that they would not even be able to run away."[20]

'Made groggy' by sound before it is blinded by light, the earthly audience is finally paralysed by panic — while in a biblical rendition of complete stasis, the 'mob' on stage is turned to stone. The Astronomer, on the other hand, is volatilised into interstellar space, embodying the composer's desire for 'sound projection' — the fourth

dimension in music which Varèse explains as:

> that feeling that sound is leaving us with no hope of
> being reflected back, a feeling akin to that aroused by
> beams of light sent forth by a powerful searchlight — for
> the ear as for the eye, that sense of projection, of a
> journey into space.[21]

This space is not, however, soundless, as in the scenario
for *Espace* — which incorporated many of the ideas of *The
Astronomer* and was also never produced — for here
there are:

> Voices in the sky, as though magic, invisible hands were
> turning on and off the knobs of fantastic radios, filling all
> space, cris-crossing, overlapping, penetrating each other,
> splitting up, superimposing, repulsing each other,
> colliding, crashing. Phrases, slogans, utterances, chants,
> proclamations: China, Russia, Spain, the fascist states and
> the opposing democracies, all breaking their paralysing
> crusts....[22]

Becoming wireless, moving into an ether-eal ontology,
Varèse, his astronomer and his sound, does not have to
face the finality of non-existence. Artaud's Scientist
however, is denied this luxury.[23] He cannot simply
disappear into the futuristic, techno-spiritual space that
Varèse imagined because space is the place of matter, and
matter is irrevocably meaningful, 'carrion.' The solution is
the necessity — terrible though it might be — of cruelty.
"We are not free," writes Artaud, "*[A]nd the sky can still
fall on our heads.* And the theatre has been created to
teach us that first of all" (*TD*: 78, emphasis mine).

As the sky falls, space is eradicated. The space between
the human and the cosmos, between the spectator and
the stage, between the word and the thing. Without space
the sounds and noises, the onomatopoeic and glossolaliac
utterances that populate Artaud's universe lose their

echoic quality and are no longer a reflection or imitation of some thing or event. Without space there is no distance between the original and its reproduction, between being and representation, since materiality itself — even when it is as invisible, intangible, and ephemeral as sound — cannot take place. A reading of *There is No More Firmament* illuminates a series of processes in Artaud's hermeneutics which repeat this anti-spatial logic. The first process has physical matter giving way to states, energies and forces, adopting the phenomenality and immateriality of sound, while sound itself becomes more and more object like. *Sound rushes forward.* A second process transforms sound and light into code while developing a transmitted corporeality: the soul is reduced to a "skein of vibrations" (*TD*: 135) that are like the pulses of a signal. *Everything stops and starts.* A third process eradicates matter by dissolving the logical conditions for its existence — space and time — and *everything stops.* The final process extinguishes existence altogether through an act of automatic cruelty: *A cold light reigns.*

Similarly the first movement of *There is No More Firmament* begins:

> *Darkness. Explosions in the dark. Harmonies suddenly broken off.*
> *Harsh sounds.*
> *The music gives the impression of a far-off cataclysm; ...*
> *Sounds fall as if from a great height, stop short and spread out in arcs, forming vaults and parasols.* (*CW*: 2/79)

Here sound has a kind of materiality that allows it to "fall," and to form "vaults and parasols," creating an almost visible acoustic architecture. It is also individuated: "When one sound stands out, the others fade into the background accordingly."[24]

Having been produced as an object, sound then takes the form of communicative code transmitted over space: "*The sounds and lights break up into fits and starts,*

*jerkily, like magnified Morse.*" This pulse of sound and light becomes "the din and lights of a modern street intersection at dusk" — a site of continuous stopping and starting amidst rapid movement, a site of strict observance of signals, a site where people become pedestrians, and there is a certain reciprocal automation between the car and the body.

The actors on the stage form groups in which patterns appear with "varied and contradictory movements like an ant-hill seen from high up." The sounds of the city move rapidly from vocal "street cries" to "an infernal racket." The voices begin to indicate that something strange is happening to the sky, but their short exclamations are overtaken by "tornadoes of sound," heralding a prodigious, haunting voice from above that blurts out the beginnings of an announcement (*CW*: 2/80). Like a recording, it continually repeats but never finishes its message, like a ghost it is heard "as in a dream." The actors become deranged — reminiscent of scenes from the plague there is debauchery, a feeling of being on fire. The intersection and all it contains becomes a single whirring machine — it all stops and starts, goes on and off, and when it stops it is as if the flow of time itself ceases.

So already we have a correspondence between telegraphy, aurality and human automation propelled by the reductive formulae: on/off, stop/go. Automation is implicit in both Artaud and Varèse's desire for new (probably electronic) instruments that would bypass musical or linguistic meaning. In 1939 Varèse remarked that he wished for a musical instrument, a sound producing machine that "will reach the listener unadulterated by interpretation,"[25] and be able to read the new "seismographic symbols" that the "living matter of sound" requires for its notation. Similarly, as hieroglyphs, Artaud's actors are "raised to the dignity of signs" and therefore able to be recorded and then reproduced "at will." Signs also exist in the *being* of sound, as its objectification in space is realised through

the amplification, recording and reproduction that would accompany both Varèse's and Artaud's designs.

Throughout the second movement, news that the sky is falling is relayed through news-vendors whose announcements are again incomplete, abrupt, repetitive, assuming the rhythm of morse code with their distinct pauses signifying the *stop* that is often articulated during the narration of a telegraphic transmission. Gradually the full message is revealed. A scientist has discovered "celestial telegraphy," which has allowed him to establish "interplanetary language" (*CW*: 2/83). As a result the sky has been physically abolished, and the earth is about to crash into the planet Sirius. The crowd talks about energy, volatilisation, and the end of the world.

In the third movement, the sound of matter in its death throes occupies the stage. A woman with a huge belly enters while two men beat alternate sites with drumsticks (*CW*: 2/87). *The Internationale* is sung in the background reaching "titanic" pitch, the stage transforms into a "real beggar's alley" with hideously deformed creatures rising from the depths. "Every spasm, every belch of the dark chorus brings on a new wave of faces" (*CW*: 2/88). A character called the Great Pointer enters the stage and makes a speech "but the end of each phrase echoes on, ending in choruses which themselves end in unbearable yelps." Sound falls and fades into space, while speech degenerates into cacophony. All is reverberance and noise, space, corporeality, fetid matter.

In the final movement, speech becomes abstracted, initially through the ordering of music. A lone scientist and his colleagues discuss the discovery (of celestial telegraphy). We hear "intellectual castrati and scientific basses" and there is a "different tone from one group to the next, fluctuating, changing accentuation, pitch and speed, etc. etc." (*CW*: 2/90). Science and music join in what is evidently a catastrophic union for the sound of matter — indeed for matter itself. The Scientist is approached by some of the scholars who conduct a

conversation in sign language. The discovery is declared immoral by some, while others claim that science comes before everything else. They mention instantaneous radiation and connect it with the end of the universe. However, the scientist has no time for morality — he has already begun signalling. "There you are," he says:

*He rushes over to his apparatus.*
*Night comes on as the curtain falls.*
*Sounds rush forward, made up of the blast of several*
*sirens at the their highest point. Violent percussion*
*intermingled.*
*Cold light reigns everywhere.*
*Everything stops.*

As mentioned, Varèse was not happy with this scenario and the piece was never produced. Perhaps it was the lack of overt romanticism and idealism in Artaud's scenario that disappointed Varèse. Perhaps Artaud simply went too far in articulating the devastating but logical outcome his new mode of communication presupposed. Artaud's deployment of sound parallels that of Varèse too closely for a kinship not to be inferred. What happens to the body, and to sound, in the respective versions of the piece, provides a way of reading each through the other and situates the two artists along the utopian/dystopian axis permeating much of modernism.

Yet although Varèse also entered a state of suicidal depression following the failure of this piece and its progeny, *Espace*, to be realised, he was reluctant to extinguish physicality and aurality in order to close his mythic narrative. This is not to suggest that he objected to wirelessness — there are indications that telegraphy, or at least the transmission of signals, was at work in Varèse's conception of the piece. A sketch from 1928 includes the "Discovery of instantaneous radiation" — and the unexpected transmission of signals from Sirius. The communication is via prime numbers — Sirius transmits 1,3,5,7; the astronomer responds with 11,13; Sirius

answers with 17,19. Sirius, now aware of the earth's existence, threatens to destroy it. However, the signals, while sent as prime numbers, also come in musical waves. Varèse writes:

> Regular messages from Sirius. Mysterious — in musical waves (supple, fluctuating). The Wise Men study them. Perhaps it is the acoustical language of Sirius.[26]

These details reveal a marked difference between Artaud and Varèse in terms of the way they regard telegraphy, transmission and transmutation. In the causal chain of this narrative, catastrophe occurs as the result of the aggressive inclinations of Sirius and is only incidentally linked to the act of transmission. For Artaud, it is transmission itself that annihilates not only the cosmos but, more profoundly, the conditions necessary for existence. In Varèse's sketch, sonority is maintained throughout the transmission, whereas for Artaud the signal is *not* sonorous but electrical — it is a "celestial telegraphy" that extinguishes space and therefore sound. For Varèse the astronomer is unjustly attacked by the mob, and, as if by an act of grace, disappears into the ether. Artaud's scientist, on the other hand, is willingly suicidal. He acts with the kind of determination that Artaud associates with cruelty and his actions embody the absolute necessity that cruelty demands:

> Cruelty is above all lucid, and a kind of rigid control and submission to necessity ...
> In the practise of cruelty there is a kind of higher determinism, to which the executioner-tormenter himself is subjected and which he must be determined to endure when the time comes. (*TD*: 102)

In many ways Artaud's scientist simply taps out the final sequence of a series of instructions that have been fulminating in Artaud's metaphysics. In company with the eviscerated head of the spectator that would view Artaud's

virtual theatre, and the hieroglyphic actor who would perform on its stage, the scientist executes the only operation left to a universe in which extension is ultimately rendered, not in the form of objects, or states, or even symbols, but as code. The necessity for this transformation from thing to sign to data is guaranteed by the actual annihilation of space and time — which, in an implosive and backwards slip, removes the conditions for the very possibility of matter.

But is this the cruelty of a modernist nihilist — one who constructs for himself a metaphysics that can only be resolved through extinction? What about the executioner-tormenter whose actions have nothing to do with a "higher determinism" but whose motivation arises instead from a kind of compulsive resignation — the kind of resignation that is automatic, for which the promise of inevitable punishment is almost a side issue? What if this resignation is made possible in the first instance by the automatic system, the automatic pulse of the on/off? The scientist must first of all submit to the language or code of the order, and the response that the order demands: yes/no/stop/start/on/off. The scientist must have first of all resigned himself to accepting and understanding — to speaking and hearing — this language. And when this ordered sequence comes to represent not only things and individuals but states (like sound and space), then the conditions for life can be ordered and extinguished in an act of metaphysical succinctness that bears the logic of a universal physics.

The cruelty here is not in the act of annihilation, but in the supreme resignation that would allow even the conditions of life to become capable of fitting an equation for ordering. It is a resignation to the collapse of space and time (then, and only then, matter) via a series of blips, themselves the remains of a system of representation deemed untrue or unworkable. It is a resignation from the potential deceit of a voice speaking a language that is understandable by humans, and a transference of meaning

and responsibility to the encoding and decoding device of an apparatus which, like the vibration or the plague, transmits only itself, in the present, without mediation. It is a resignation to the inevitability of apocalypse through the rationalisation and computation of space and corporeality that has marked our era as 'virtual' and automated.

Artaud denies a contradiction between what would normally be considered dualities. The world and all matter as data, which is the apotheosis of scientific, representational culture, combines with the living spatiality, the here and now presence of the natural. And this denial is not simply bad faith on the part of Artaud. He is able to move between such poles without contradiction because the transmissional pulse and the sonic vibration are themselves concepts that belong nowhere — they belong equally in the synapses of his electroshocked brain as the cosmic tapping of a nervous scientist saying 'hi!' to the end of the world. The metaphysical tension of the pulse or vibration is the nanosecond between external and internal, on and off, here and there. It is the shortest possible interval between 'this and that' that allows difference to be maintained and the individual to remain cogent. Approaching zero space and zero time, it has a power for which the atomic explosion — 'instantaneous radiation' — provides both a good metaphor and a materiality that telegraphy exemplifies. But while the dot and dash of morse code is a fine mode of being for a signal, as Artaud has shown us, it becomes a problem when transformed into a compulsive twitch flicking the fingers of a scientist who realises he has nowhere else to go.

## NOTES

1    Antonin Artaud, "There is No More Firmament," *Collected Works*, vol 2, transl. Victor Corti (London: Calder and Boyars) 92. Hereafter cited as *CW*.

2    *CW*, XIII: 258–9 Cited in Stephen Barber, *Antonin Artaud: Blows and Bombs* (Boston: Faber and Faber, 1993) 151.

3    Antonin Artaud, *The Theatre and Its Double*, transl. Mary Caroline Richards (New York: Grove Press 1958) 89. Hereafter cited as *TD*.

4    ibid.: "I am well aware that words too have possibilities as sound, different ways of being projected into space, which are called intonations."

5    ibid. From the sound of words Artaud moves to symbols and signs, saying that these (cultural) signs "constitute true hieroglyphs": "This language which evokes in the mind images of an intense natural (or spiritual) poetry provides a good idea of what a *poetry in space* independent of spoken language could mean in the theatre." [my emphasis]

6    For Artaud, "to make metaphysics out of spoken language," is to make "the language express what it does not ordinarily express ... to reveal its possibilities for producing physical shock; to divide and distribute it actively in space; to deal with intonations in an absolutly concrete manner, restoring their power to shatter as well as really to manifest something ... and finally, to consider language in the form of *Incantation*." (*TD*: 46)

7    For instance, Plato believed that "the legislators" created letters which were "adapted to express size, length, roundness, inwardness, rush or roar." Plato, *The Dialogues of Plato*, transl. Benjamin Jowett, vol. 3 (Oxford: Clarendon Press, 1953) 30.

8    Artaud makes this point quite explicitly in the first movement of "*There is No More Firmament*" when he very enigmatically proclaims that his sounds "will be to Morse code what the music of the spheres heard by Bach is to Massenet's *Clair de lune*" (CW, 2: 79).

9    (*TD*: 52). Further on, Artaud evokes Plato's catalytic philosophy: "I think that the music of instruments, the combination of colours and shapes, of which we have lost every notion, they must have brought to a climax that nostalgia for pure beauty of which Plato, at least once in this world, must have found the complete, sonorous, streaming naked realisation: to resolve by conjunctions unimaginably strange to our waking minds, to resolve or even annhiliate every conflict produced by the antagonism of matter and mind, idea and form, concrete and abstract, and to dissolve

all appearances into one unique expression which must have been the equivalent of spiritualised gold."

10  Henri Bergson, *Matter and Memory*, transl. Nancy Margaret Paul and W. Scott Palmer (New York: Zone Books, 1988) 266.

11  For and in depth analysis of Artaud's glossolalia see Allen Weiss, "Radio Death and the Devil," in Douglas Kahn and Gregory Whitehead (eds), *Wireless Imagination: Sound, Radio and the Avant-Garde* (Cambridge, Mass.: MIT Press, 1993).

12  (*TD*: 26) "It is useless to give precise reasons for this contagious delirium. It would be like trying to find reasons why our nervous system after a certain period responds to the vibrations of the subtlest music and is eventually somehow modified by them in a lasting way. First of all we must recognise that the theatre, like the plague, is a delirium and is communicative."

13  "The sonorisation is constant: sounds, noises, cries are chosen first for their vibratory quality, then for what they represent." (*TD*: 81).

14  ibid., emphasis mine.

15  (*TD*: 111). In a flourish of mixed metaphors suggesting traces of techno-spiritualism and neo-Platonism, Artaud adds that: "The composition, the creation, instead of being made in the brain of an author, will be made in nature itself, in real space, and the final result will be as strict and as calculated as that of any written work whatsoever, with an immense objective richness as well."

16  Olivia Mattis, "Edgard Varèse and the Visual Arts" (Ph.D diss., Stanford University, 1992) 178.

17  ibid., 180–1, from the typescript scenario of *The One-All-Alone, A Miracle*, in Louise Varèse, *Varèse: A Looking Glass Diary* (New York: W.W. Norton & Co., 1972) 260. According to Mattis this scenario "was fundamentally autobiographical, and so it is of utmost importance that one of the protagonists's facets was pure light, while the antagonist's tool is an arrow that becomes a beam of light when fused with the light of The-One-All-Alone Here is alchemy at work in Varèse's oeuvre: the transmutation of man into Godhead from whose body 'rays of light radiate in all directions.'"

18  ibid. In footnote 49, Mattis cites Antony Beaumont, who notes that "The figure which Varèse called the Astronomer

can be traced back to Busoni's Faust." See Antony Beaumont, *Busoni: The Composer* (Bloomington: Indiana University Press, 1985) 35–6.

19  From "Statements by Edgard Varèse," assembled by Louise Varèse, in *Soundings* #10, ed. and published by Peter Garland, Berkeley, 1976.

20  Mattis, "Edgard Varèse and the Visual Arts," 178.

21  Varèse, Santa Fe lecture, 23 August, 1936. Cited in Mattis, ibid., 8.

22  Cited in Henry Miller, "With Edgar Varèse in the Gobi Desert," *The Air-Conditioned Nightmare* (New York: New Directions, 1945) 163–78.

23  Artaud's engagement with the wireless, on the other hand, left him silenced and earthbound, with the censorship of his *To Have Done With the Judgment of God* from radiophonic broadcast confirming his belief that the microphone, like the screen or the stage, is just another form of representation, sanitising and paralysing life. As he writes: "There is nothing I abominate and shit upon so much as this idea of representation, that is, of virtuality, of non-reality, attached to all that is produced and shown, ... as if it were intended in this way to socialize and at the same time paralyse monsters, make the possibilities of explosive deflagration which are too dangerous for life pass instead by the channel of the stage, the screen or the microphone, and so turn them away from life." (*CW*, XIII: 258–9). Cited in Stephen Barber, *Antonin Artaud: Blows and Bombs*, 151.

24  This appears after the line "Street cries. Various voices. An infernal racket," giving the impression that the sounds are also acting like individuals on the stage, whereas the actors are a conglomerate mass. (CW, II: 79).

25  Mattis, "Edgard Varèse and the Visual Arts," 128.

26  Olivia Mattis, "Varèse's Multimedia Conception of Déserts" *The Musical Quarterly* 76/4 (Winter 1992) 570. Mattis notes that these messages from Sirius were to be represented by that "otherworldy" electronic instrument, the ondes martenot.

# Libidinal Mannerisms and Profligate Abominations

*Allen S. Weiss*

Un coup de dés jamais n'abolit le hasard
mais un coup de langue le noue
et un autre le prononce.
—Antonin Artaud, *Cahiers du retour à Paris* (XXIV: 322)

"I am dead" (XV: 142; XVI: 301; XVII: 139).[1] This seemingly impossible enunciation, this existential oxymoron, operates in Artaud's last works as an expletive, in protest against that living death he suffered as a result of both of his schizophrenia and the pains of electroshock. As is often the case with tales spoken from the point of view of the dead (a literary genre still awaiting its codification and its avatars), narrative ambiguity and contradiction reign. It is precisely the self-reflexive possibilities of language that permit the enunciation of this impossible subject position; its elaboration will establish an arcane but crucial cultural deviation at the origins of our modernity. In *The Facts in the Case of M. Valdemar*, Edgar Allan Poe maintains this unperformable subject position in narrative suspense and existential equivocation: the sensuous disappearance of the dead is counteracted by the sensuousness of the grave; the otherworldly existence of the deceased is belied by the linguistic capabilities of the spirits. In "Analyse textuelle d'un conte d'Edgar Poe," Roland Barthes explains the profound meaning of this statement:

The saying "I am dead" is an exploded taboo. Now, if the symbolic is the field of neurosis, the return of the letter, which implies the foreclosure of the symbol, opens up the space of psychosis: at this point of the story, all symbol ceases, all neurosis too, and psychosis enters into the text through the spectacular foreclosure of the signifier: the *extraordinariness* of Poe is certainly that of madness.[2]

The "I am dead" of Poe's Valdemar, of Stéphane Mallarmé at the time of his psychic crisis of 1866, and of Artaud, instantiates a paradoxical enunciation. Does it signify dying, or death, or living death, or life-after-death? Barthes, again, explains:

...whence the fright and terror: there is a gaping contradiction between Death and Language; the contrary of Life is not Death (this is a stereotype): it is language. It is undecidable if Valdemar is living or dead; what is certain is that he speaks, without it being possible to ascribe his words to Death or Life.[3]

Whence Artaud's continual diatribe against the written text as detritus, as a tomb, as the very betrayal of life. Is this death a hyperbolic expression of extreme pain, or is pain an indicator of death, a textual exemplar of *vanitas*?

The pains of Artaud's schizophrenia were to be counteracted by electrically induced pain, which would account for a double source of death, of the disappearance of others and the world: the eschatological deliria of paranoia and the effects of extreme pain. Whence Artaud's question, "Why is an outside indispensible in order for me to remake myself before the blows of nothingness?" (XXIII: 81). In order to express the unexpressible, the ineffable, one needs to create icons; extreme pain and madness necessitate hyperbolic icons, such as God and the devil. There are also, of course, icons for death. Whence the equivocation between the iconography of the 'theatre of cruelty' and the iconoclasm

of Artaud's polemical, performative and theoretical stance. In "Aliénation et magie noire," a section of *Artaud le Mômo*, Artaud states that in order to "abject God" he wishes to place "a white page to separate the text of the book which is ended, from all the swarming of Bardo that appeared in the limbo of electroshock" (XII: 61). Is this empty page, this suppression of text, this silent void, a textual icon of death, or a gesture of iconoclasm?

As in the *via negativa* of Western mysticism, this paradox is constituted by both the total negation of predicates and the coincidence of contradictions, renunciations of logic typical of both mystics and madmen. Artaud's morbid psychic dynamism and "iconography" hinges on an all too human coincidence of opposites, where God is simultaneously "the monomaniac of the unconscious" (XV: 315) and "a fluidic emanation of my human body" (XV: 315). Whence the constant tension and contradiction in Artaud between the meaningless emptiness of the void and the absurd plenitude of God, between the perpetual psychic dispersion of libidinal force and the inevitable stasis of the idol as sign, between anarchy crowned and ritual repeated, between a spasmatic charismatics and a hypostatised sacred hieroglyphics. In the tradition of Pascalian theological anguish, Artaud poses the problem in *Pour en finir avec le jugement de dieu*: "He is offered two paths: that of the infinite outside, that of the infinitesmal inside" (XIII: 85). The chiasmatic intersection of these transcendental paths (that of mystic closure and psychotic rupture) is precisely what constitutes the human condition, the mystery of which was to describe Artaud's life, where the macrocosm of the cosmic void weighs infinitely upon the microcosm of the emptiness within.

Artaud's revolt against God and the Devil was a revolt of the body. Elaine Scarry's analysis of ascetic self-flagellation in *The Body in Pain* helps explain this mode of dramaturgy as,

> a way of so emphasising the body that the contents of the
> world are cancelled and the path is clear for the entry of
> an unworldly, contentless force. It is in part this world-
> ridding, path-clearing logic that explains the obsessive
> presence of pain in the rituals of large, widely shared
> religions as well as in the imagery of intensely private
> visions ... why in the brilliant ravings of Artaud some
> ultimate and essential principle of reality can be
> compelled down from the heavens onto a theatre stage
> by the mime of cruelty, why, though it occurs in widely
> different contexts and cultures, the metaphysical is
> insistantly coupled with the physical with the equally
> insistant exclusion of the middle term, world.[4]

God, for Artaud, is that malevolent difference that
insinuates itself within the body to separate the self from
itself, making of consciousness a schism in search of an
impossible plenitude. Already as early as his Surrealist
years, Artaud evoked God only in order to destroy Him
and to create himself, as he explains in *On Suicide*:

> If I kill myself, it will not be in order to destroy myself,
> but in order to reconstitute myself; suicide will be for me
> only a means of violently regaining myself, of brutally
> bursting into my own being, of forestalling the uncertain
> advances of God. By means of suicide, I reintroduce my
> own plan into nature, and instill for the first time the
> form of my volition into things.  (I**: 26)

By the time of his incarceration in Rodez, this inner
volition towards the voluntary death of creative suicide
will be doubled by an external principle of death,
imposed by the infinite will of God: private vision and
religious ritual, the physical and the metaphysical, meet in
the phantasms and pains of this man who was "suicided
by society." The willful incorporation of one's own death
into a necrophilic scenario of autofiguration shortcircuits
metaphysics and raises autobiography to the level of
poetry.

## II

"Thus when I *can grasp a form*, imperfect as it may be, I fix it, for fear of losing all thought" (I\*: 24). These words, written in a letter to Jacques Rivière, in 1923, proffer the core of Artaud's counteraesthetic, indicating both the spuriousness of the force/form distinction and the ontological primacy of the body in pain. In response to Rivière's formalist critique, Artaud responds:

> This scatteredness of my poems, these defects of form, this constant sagging of my thought, must be attributed not to a lack of practice, a lack of command of the instrument that I employed, a lack of *intellectual development*; but to a central collapse of the soul, a sort of erosion, both essential and fleeting, of thought, to the temporary nonpossession of the material benefits of my development, to the abnormal separation of the elements of thought (the impulse to think, at each of the terminal stratifications of thought, passing through all the states, all the bifurcations, all the localisations of thought and of form). (I\*: 28)

Such is an archetypically modernist aesthetic justification of shattered forms, logical equivocations, radical irrationalism, aleatory contingency, nonlinear temporality — attributes that will remain a constant throughout Artaud's work. Rivière responds with praise of Artaud's extraordinary self-diagnosis, claiming that his very style — a writing that is "tormented, tottering, crumbling, as if here and there absorbed by secret whirlwinds" (I\*: 34) — is remarkably successful in describing the state of his soul. Rivière, like Artaud, falls into the critical trap of the intentional fallacy, but from the other side of the equation: the irony is that Artaud believes that his suffering authenticates his writing, but that writing is always inadequate to life; Rivière, to the contrary, believes that the writing is an exceptional expression of the illness, rendering Artaud's suffering eminently communicable,

though there remain stylistic weaknesses. Writer and editor find themselves on opposing sides of what had become the incommensurable Western epistemological rift between expression and reception, between solipsistic incommunicability and communicative empathy, between radical alterity and community. Scarry explains the immediate motivation for such an apparent paradox:

> So, for the person in pain, so incontestably and unnegotiably present is it that "having pain" may come to be thought of as the most vibrant example of what it is to "have certainty," while for the other person it is so elusive that "hearing about pain" may exist as the primary model of what it is "to have doubt." Thus pain comes unsharably into our midst as at once that which cannot be denied and that which cannot be confirmed.[5]

Such recognition of pain entails the Nietzschean transformation of Cartesian doubt into modernist anguish and uncertainty. Crucial in reading these works, however, is the avoidance of reducing the text to a symptomatological index (a typical extrapolation of the intentional fallacy); for, in fact, the aetiology of the malady constitutes a necessary but insufficient hermeneutic condition, always subordinate to the *effects* of writing. This conflict or confusion of genres and narrative positions (already evident in *L'ombilic des limbes*) indicates the ontology of a labyrinthine, polymorphous, polyvalent, perverse subjectivity.

But this debate surpassed the literary, for at stake was Artaud's very existence, which was profoundly misunderstood by Rivière, as evident in the following analysis:

> That the mind exists by itself, that it has a tendency to live on its own substance, that it develops upon the personality with a sort of egoism and with no concern about keeping it in harmony with the world, is something that, it seems, can no longer be disputed. Paul Valéry

marvelously dramatised this autonomy of the thinking function within us, in his famous *Soirée avec Monsieur Teste*. Taken by itself, the mind is a sort of canker; it reproduces, it constantly advances in all directions. (I*: 34–35)[6]

For Rivière (following Valéry), pure thought would be total expenditure without obstruction or return, an infinite and empty convolution where the mind is unhinged by the absolute; thought attains form only through the obstacles it encounters. Rivière, attempting to place Artaud in the lineage of Poe (*The Raven*), Mallarmé (*Igitur*), and Valéry (*Monsieur Teste*), stressed this risk: "But where the object or the obstacle is completely missing, the mind continues, inflexible and defective; and everything disaggregates in an immense contingency" (I*: 36). He warns Artaud that as long as he lets his intellectual force "discharge itself into the absolute" (I*: 37), he will be beset by impotence, unrest and disorganisation; but once thought is led to its "close and enigmatic object," it will become condensed, intensified, useful and penetrating, and will consequently surpass all suffering and become communicable to others. What Rivière didn't understand was that, for Artaud, the pure presence of the body was both the absolute site of contingency and the source of psychic energy; for Artaud, both the force and form of expression is based on pain and the inner void.

The misunderstanding between Artaud and Rivière arose from totally incompatible notions of what constitutes the interiority of the soul: Rivière held to the purity of thought, however dangerous this might be, emblematised by *Monsieur Teste* [Mister Head]. For Artaud, to the contrary, interiority is constituted as an unsituatable, ever shifting and incommunicable corporeal void, "a fragile and fluctuating core untouched by forms" (IV: 18) circumscribed by pain — a pain constantly yet always inadequately expressed and redefined within language. On the inside there is *nothing*: consciousness is but a unity effected by transgression, rupture and

dispossession.[7] Artaud explained this in a latter of the same epoch to Max Morise, dated 16 April 1925; offering a critique of the Surrealist notion of revolution, he writes: "My sick mind prohibits these subterranean incursions, inter-spiritual, spatial-internal, I am perpetually at the edge of a small emptiness [*néant*], localised at a single point..." (I\*\*: 118) This monstrous version of creation *ex nihilo* prefigured the polemic of *Le théâtre et son double*, where in a rarely commented upon section Artaud takes up the issue of nothingness as crucial to his theory of language: "Every powerful feeling provokes in us the idea of the void [*vide*]. And the clear language that hinders this void also hinders poetry from appearing in thought" (IV: 86). Self-reflection was not to be an operation of pure mind or the basis of a mind/body split, but rather the profound amalgam of mind and body — even if the cost of this unity was that of perpetual pain and nonsense. For ever since Nietzsche's critique of Western metaphysics, it is apparent that the establishment of the existential *a prioris* that determine the paradigms of cognition depend upon the aleatory contingencies and accidents of material existence. Despite his hopes for Artaud's future, Rivière's ontological pessimism followed from his diagnostic: "Romanticism aside, there is no other escape from pure thought than death" (I\*: 35). Little did he know that Artaud would indeed choose (or be chosen by) death as the outcome of his struggle, which would entail the century's most extreme interrogation of interiorisation and most radical critique of representation. Artaud would personify the decadent declension of Romantic poetics and epistemology to a hyperbolically modernist solipsism.

Further consideration of the epistemology of pain will clarify this misunderstanding. Scarry argues not only for the inexpressibility of pain, but for the fact that extreme pain destroys the very possibility of linguistic expression. "Physical pain does not simply resist language but actively destroys it, bringing about an immediate reversion to a state anterior to language, to the sounds and cries a

human being makes before language is learned."[8] This explains the vicious hermeneutic circle entailed by the literary expression of pain: the greater the pain, the less adequate is any possible linguistic expression; yet the more severe the pain, the greater the need to express it.[9] Whence the origins of the double-bind which was to guide both Artaud's psychic and literary existence: the simultaneous need and impossibility of expressing an unexpressible suffering, circumscribing the inner psychic void and the outer cosmic emptiness, grasping the ineffability of mortal temporality. This double-bind evinces nothing less than the empirical/transcendental dualism at the core of human exisence, a project so eloquently characterised by Edward Scheer as the attempt to "abreact the impossible." In the referential shifts from expression as a trace of pain to the multifarious textual effects that this energetics of pain permits, an *oeuvre* took shape.

Artaud's expression of this double-bind would valorise the *oxymoron* (the *paradoxism* of antiquated rhetoric); his rhetoric was never one of irony (which would entail the exclusive disjunction of attributes and subject positions), but rather one of a contradictory and endless parataxis of inclusive disjunctions. In this epistemology without teleology, "It is the functioning of the organism one can call syllogistic that is the cause of all illnesses, by the door that it leaves open to the alternative: why, how, because, therefore, from which" (XXVI: 157–58). This claim, from the text of one of Artaud's last works, *Histoire vécue d'Artaud-Mômo, Tète-à-Tête*, is one of the very rare instantiations of Nietzsche's critique of metaphysics as outlined in *Twilight of the Idols*: "'Reason' in language — oh, what an old deceptive female she is! I am afraid we are not rid of God because we still have faith in grammar."[10] Artaud was, paradoxically, an anti-metaphysician whose major concern was to overcome the judgment of God, and a psychic realist who polemicised for an anti-psychological theatre, for whom the body would simultaneously be the origin of all force and a hieroglyphic sign.

> For words are cacophony and grammar suits them
> poorly, that grammar which fears evil because it always
> seeks the good, well-being, while evil is at the base of
> being, a painful plague of cacophony, a dreadful fever of
> disharmony, the scabrous pustule of a polyphony where
> being is good only in being's disease, the syphilis of its
> infinity. (XVIII: 115)

Cruelty has a duplicitous meaning: it is both hieratic
necessity and corporeal contingency, the weight of totality
and the pain of fragmentation, the agoraphobic anguish of
the infinite cosmic void and the claustrophobic fear of the
tomb, the respiratory choice between scream and
suffocation. As Artaud's writing would perpetually express
the body wracked by pains from multiple sources (nerves,
drugs, failed romances, editorial rejections, poverty,
hunger, medications, wartime privations, electroshock
and insulin shock therapies, demonic spells, divine
damnations), the sundry sources of pain provided the
origin of that chaotic psychic dynamism at the foundation
of his writing.

In the sepulchral *Ci-Gît* (one of Artaud's last works,
which might well serve as his epitaph, as the title implies),
Artaud posits the self as its own origin: "Me, Antonin
Artaud, I am my son, my father, my mother, and me ..."
(XII: 77). In the attempt to escape the anxiety of influence
and become a creator, the expulsion of God from the
unconscious was infinitely more difficult than
surmounting the Oedipal complex. Throughout *Agon* and
*The Anxiety of Influence*, Harold Bloom, following the
Lacanian assimilation of psychic operations to linguistic
forms, shows that ego defense mechanisms are modelled
on rhetorical forms, such that "the defenses are tropes."[11]
The quest for poetic priority is the manifestation of the
desire to be the absolute, uninfluenced origin of one's
own works, of one's own self. The poetic will is ego
defense. "Poetry is the anxiety of influence, is misprision,
is a disciplined perverseness. Poetry is misunderstanding,
misinterpretation, misalliance."[12] The writings of Artaud *a*

*fortiori* met these conditions, expressed by the depths of a morbid, mad solipsism: here is a poetics based on a foundational, and unrepresentable, misalliance of the self with itself. For Artaud, the solution to these problems, both corporeal and stylistic, is finally realised as a matter of concrete existence:

> A body perfectly *adjusted* to my being, to be more and more there. What hinders me? *Infinity*. Solution: to close oneself in upon one's present body with no other idea than to avoid suffering without any question, to burn all the metaphysical spectres of destiny. (XXIII: 27)

This solution was already stated as early as *Le pèse-nerfs*: "And I told you: no works, no language, no speech, no mind, nothing. Nothing if not a beautiful Nerve-Scale" (I*: 101). This nerve-scale would measure the pain at the core of his existence, the very pain that authenticated his writing, where the pathological modulations of an anxiety of influence reach hyperbolic proportions as a veritable anxiety of causality. The beginning of "Vers une xylophonie de l'obscène sur la conscience en agonie" is a litany of negations that begins to seal off the self through a poetic prophylaxis:

> I no longer believe in words,
>> in life,
>> in death,
>> in health,
>> in illness,
>> in nothingness,
>> in being,
>> in the eve,
>> in sleep,
>> in good,
>> in evil,
>> in virtue,
>> in vice,
>> in matter,
>> in spirit,

> in the real,
> in the surreal,
> in love,
> in hate,
> in the fantastic,
> in banality,
> in courage,
> in caddishness,
> in heroism,
> in cowardice. (XXIV: 9)

In the section of *Suppôts et suppliciations* entitled "Interjections" (XIV**: 13–16), he would extend this list of negations so as to effectively eschew all determinations and predications; for that which is indeterminable cannot be judged, whence this refusal of predication. While Artaud's solipsism eliminated all externally predicated genealogy, it also established a generative, private literary genealogy, those textual identifications by means of which Artaud chose his own predecessors and established his own tradition: Poe, Baudelaire, Nerval, those artists of madness, addiction, and suicide, of *misérabilisme* and morbidity.[13]

This negative determination of existence reveals how there can in fact be no definition of the key ontological invention of Artaud's final work, *Pour en finir avec le jugement de dieu*, the 'body without organs,' Artaud's final statement of how anatomy must be tranformed to save the soul. In order to escape from the judgement of man and God, as well as from the "limbo of a nightmare of bones and muscles" (I*: 117) revealed in *Fragments d'un journal d'enfer*, Artaud heralded the corporeal utopia of the 'body without organs,' a site where the body's torturous distortion, dismemberment and disappearance are precluded. Here, via recording and broadcast technology, voice is separated from body, signifier from signified, subject from socius, life from death. An iconophobia without limits, the 'body without organs' exists beyond all possible narcissistic identifications and projections. But is this body empty or

full? Does it express the microcosm of the dystopic void or the utopic plenitude of Being? Or is it but another corporeal emblem of the double-bind that structured Artaud's entire life and work?

In hypochondria, there is a condensation or metaphorisation of the pathologically cathected organ or body, which is subsequently exteriorised and objectified as a phantasmic projection.[14] As opposed to the *disjecta membra* common to psychosis, the 'body without organs' eliminates the object of cathexis, thus obviating the pains of this morose pathology; it does not enter into the mundane series of identificatory and projective phantasmatic exchanges, but conflates the interiorised partial objects with forms of subjectivity. Was the 'body without organs' Artaud's own body? Did Artaud ultimately have done with the judgement of God, or did God finally prevail in the end, stealing Artaud's voice yet again — this time not to have the spirit descend into a body wracked with pain and speaking in tongues, but rather to sever voice from body, transforming the voice into a morbid object and casting it out into the world, doomed to be forever lost in the infinite and terrifying expanses of the airwaves?

### III

In a famous paragraph of *Le théâtre et son double*, Artaud proclaims a new mode of theatrical speech, delirious, full of noncommunicative sonorous outburst:

> Abandoning occidental utilisations of speech, it turns words into incantations. It extends the voice. It utilises the vibrations and qualities of the voice. It desperately tramples rhythms. It crushes sounds. It aims at exalting, benumbing, charming, arresting the sensibility. It releases the meaning of a new lyricism of the gesture which, through its precipitation or amplitude in the air, finishes by surpassing the lyricism of words. It finally breaks the intellectual subjugation of language, by providing

> meaning with a new and more profound intellectuality,
> hidden beneath the gestures and signs, and raised to the
> dignity of particular exorcisms. (IV: 108)

Speech finds a new utilitarianism, allied to sorcery and
black magic, to the curative functions of language. Thus, if
theatre is to be like the plague, it also contains within itself
the curative magic that can abolish the disease: it is a
*théâtre de curation cruelle*.[15] The 'theatre of cruelty'
necessitates a new form of language, the archetype of
which is glossolalia: a performative, dramatic, enthusiastic
expression of the body; language reduced to the realm of
incantatory sound at the threshold of nonsense; speech as
pure gesture. Such glossolalia are not mere symptoms, as
Artaud explained to Dr. Ferdière at Rodez: "The ritual
liturgical exorcisms of the Catholic church are not deliria,
and there is a delirium that comes from the sacred and a
neuropathic delirium."[16] The sources and signification of
Artaud's glossolalia are fully heterogeneous, and only
occasionally contemporaneous with each other:
pathological outburst, liturgical chant, musical composi-
tion, poetry, magic; this glossolalia is exclamation,
vituperation, incantation, often declaimed for the sheer
sensual pleasures of speech and versification.[17] They are
not meaningless, unmediated, spontaneous outbursts, but
are endowed with a meaning as arcane, ephemeral, and
equivocal as Artaud's existential situation. Originating as a
private speaking in tongues within Artaud's religious
delirium, this glossolalia was first transmogrified into an
apotropaic incantatory technique, a veritable "curative
magic," to protect him from the gods and demons that
tormented him; and it was ultimately raised, through
textual performance and production, to the level of poetry.

The "fulminating order" (XIII: 69) he demands of his
own work especially includes the glossographia dispersed
throughout his texts. It is telling that in *Les malades et les
médecins*, Artaud's first radio broadcast, the glossolalia
differs in the manuscript, the broadcast, and the
published version.

Manuscript (XXII: 473):

cai i tra la sara
ca i tra la
sarada
ca i tratra barada
ara
a treli
sara

Publication (XXII: 68):

ca i tra la sara
ca fena
ca i tra la sara
cafa

Recording (XXII: 473):

ta te pa li
pe ta itera
ta te tiber
e ta te cri

Such transformations, substitutions, condensations and eliminations indicate that these glossolalia and glossographia are not spontaneous outbursts, but rather operate as stylistic and poetic figures, coherent with the exigencies of the 'theatre of cruelty.'[18] Furthermore, the patterms of rhyme, rhythm, assonance, consonance, syllabification, barbarisms, latinisms, and lacunae indicate the intense textual work behind these seemingly spontaneous apparitions. It is particularly significant that the glossolalia in the broadcast of *Les malades et les médecins* ends with *e ta te cri*, which in quotidian French proffers a neologism of strange self-reflexivity, roughly translatable as, "and your screaming yourself." This posture of writing and screaming oneself expresses a hyperbolic state of autoaffection, as well as prefiguring the screams that were to be an integral part of the *bruitage* in

*Pour en finir avec le jugement de dieu*, where noise is indistinguishable from poetry. The significance of such glossolalia is not univocally translatable, since it does not exist within a stable symbolic system, but rather circulates within a mobile site of ephemeral symbolisation; its flow of symbols and allusions does not depend on grammatical or syntactic articulation (the very guarantor of communicability) but rather on cruel differentiations and disarticulations; it is founded upon equivocation and disruption; it bespeaks a referentiality without veracity, a poetics without rhetoric; it offers a cure for the very existential conflicts it expresses. This is explained in Laurent Jenny's study of Artaud, *La terreur et les signes: Poétiques de rupture*:

> The glossolalia thus releases the conflict of forces from etymology, without proposing a solution to their drama, because it is freed from all concerns about totalisation and fulfillment. It knows that language, like the body, is a place of spacings and gaps. It nevertheless pursues, in its materiality, this divided and incompletable gestation that is the very work of being.[19]

It is also the work of poetry. This conflict of forces is central to the 'theatre of cruelty,' which overturns the traditional system of French poetry and poetics insofar as it valorises a certain poetic arhythmia, one in accord with the violent manifestations of his body in pain — manifestations which, according to the ontology of pain, would paradoxically lead to the destruction of poetry in a hyperbolic, tortured silent scream. Life maintains the constant dialectic between the apparent rhythm of the organic system (where the iambs of the heartbeat and the breath are traditionally deemed to be the sources of poetic rhythm) and all of the arhythmic incidents that beset that fragile regularity (stuttering, dyspnaea, irregular heartbeats, hyper- and hypotension, and so forth). Whereas Mallarmé sublimates death in the poem, dissimulating it in the vast folds and convolutions of

syntax and in obscurely cerebral allusions and allegories, Artaud desublimates death within a shattered syntax that delineates libidinal dynamics, corporeal and scatological neologisms, and endless repetition. The paradox is that the only possible outcome of this struggle of forces is death, which, like God and the void, cannot be represented, but only emblematised or allegorised, as by the iconoclasm of the blank page or aphasic silence; where there is life, to the contrary, there is the scream.

Such is a poetry of the *ictus*, defined by *Le Petit Robert* as: (1) in ancient versification, the beat of measure in verse; (2) in pathology, a morbid, violent and sudden manifestation or attack, as in *apoplectic ictus*; (3) in psychology, a dimming of consciousness under the influence of a violent emotion, as in *emotive ictus*.[20] As presented in *Webster's Third New International Dictionary*: (1) recurring stress or beat in a rhythmic and usually metrical series of sounds; metrical accent; (2) the place of the stress or beat in a metrical foot; (3) a beat or pulsation, especially of the heart; (4) a sudden attack or seizure, especially of apoplexy; a stroke. The etymology of the term is also revealing: from the Latin *ictus*, past participle of *icere* (to strike); akin to the Greek *aichme* (lance), *iktea* (wounded), the Lithuanian *iesmas* (spit).[21] This term, a veritable oxymoron unto itself, conflates the rhythmic regularity of beat in music and poetry with the morbid and mortal irregularities that can beset the human body and consciousness. Artaud writes of a state where, "there are no longer either words or letters, but one enters there through screams and blows" (XIV**: 30),[22] exemplified by his manner of declaiming his poetry at the end of his life: after having destroyed his writing table with the incantatory rhythmic blows of a knife and hammer, a huge block of wood was substituted for the same purpose.

A BODY,

no fear,

no impressions,

A BODY,

and blows,
blows,
blows, blows, blows,
and that:

IT OOZED,

the wall
of
cruelty
and of pain.  (XIV**: 13–16)

Speech is but a specific case of breath, a corporeal function through which a 'chaosmos' is scenarised upon and within the actor's body.

Artaud's is a cosmogony of inspiration, where breathing is tantamount to creation; as Jenny points out, "Artaud's 'arhythmia' is based on those abrupt openings out toward form, pulsations without measure which take place in a body without, however, adhering to it or carrying it away in their movement."[23] Whence the failure of representation and the limits of poetry: those spasmatic movements towards form, however powerful as an expression of the attempt to fix the fluctuating core of the soul, must fail, as the core is an empty marrow of pain. The theatre is both the double and the betrayal of life, thus the cruelty of its necessity.

Artaud's poetics entails the ultimate extrapolation of free verse, giving a new and dreadful meaning to the term "blank verse." With the solipsistic collapse of poetics, lyricism is totally interiorised and succumbs to the rhythmic vagueries of a body beset by contractions and explosions from within and without, finally constituting that "new lyricism of gesture" called for in Le théâtre et son double.[24] For Artaud, speech becomes gesture and lyricism becomes incantatory, no longer based on the stylised iambic cadences of the

breath organised into alexandrines, but as supple, fleeting, spasmatic and fragmented manifestations of libidinal chaos. Indeed, these libidinal mannerisms indicate that "Beings are incarnate poetry, and that's all" (XIX: 14). Here lyricism becomes lament.

# I V

For Artaud, his illness, his inner schism, was caused by sexuality, an ontological incompleteness characterised by the need for alterity. This condition is a curse of God:

> These are the essential things of the feverish state of the heart that were taken by Satan, by the spirit of God, to be transformed into sexual libido: the cut between man and woman, between self and others, between being and self, between soul and soul, between heart and soul. (XVII: 33)

One more illness to cure, one more gap to fill. Artaud's vision of eroticism, indeed, of his "incarnation," was always tainted by the *terribilita* of the sublime; all Romantic tragedy pales in comparison. For our existence, plagued by sinful, sexual seductions of the flesh imposed by God, loses its humanity within the theological phantasmagoria of heaven, limbo and hell.

> The anchored spirit
> screwed into me
> by the psycho-lubricious
> thrust
> of the heavens
> is what thinks
> all temptation,
> all desire,
> all inhibition. (XII: 13)

Yet how does one escape the judgements of both God and men, the temptations of heaven, hell and earth? Following his pathological metaphors, he writes: "The spirits took the

soul of the plague and of syphilis from me, and only left
me a body which is not the one that I wanted to make"
(XVIII: 117). It would be remade on the operating table by
scraping out the microbes of God, incrusted in the flesh
like syphilitic spirochetes, in order to purify the body that
is to be reconstructed without organs. "The same body, my
body, was remade a hundred times until it became perfect"
(XVI: 42), a body as provisional and unstable as the
fluctuating core of nothingness within it, a body adequate
to its own libido. This solution was double-edged: in order
to protect himself from malevolent influences, he had to
close himself off from the world and the heavens, whence
the 'body without organs'; yet this closure effectively
heralded the end of all poetry. This new body served as a
pure phantasmatic site, where an *Eros* turned upon itself
can satisfy the paradoxical conditions of selfhood and
alterity, illness and health, infinity and contingency, all the
while surpassing the nostalgic and narcissistic limitations
of physical love and human mortality. The stage was set for
the phantasmatic incorporation of the beloved, in her vast
multiplicity.

Within the equivocal confines of his soul occurred the
implosion of an ambiguous *Eros*, devolving toward the
impossible plenitude of origins: "I am man woman"
(XVIII: 93); "It is the sex that is the soul and the soul is a
sex and a heart. The feminine is the vaginal soul, the heart
and soul phallic, the two are in me" (XVIII: 20).[25] The
result was his hallucinatory *daughters of the heart* —
Yvonne, Caterine, Neneka, Cécile, Ana and little Anie
(XIV*: 13) — projections of worldly friends and imaginary
composites of desires; the beloved in the form of six
disparate entities. Artaud was to love his daughters not as
lovers, but as one must rightly love one's own creations,
oneself.[26] Yet, just as Artaud was not simply man, these
women were not mere women:

> I give my vaginal soul to my daughters with a little
> phallus, I keep the big phallus for myself with a shadow
> vagina, the hollow of my thighs. The real vagina of my

thighs is realised in the body of all my daughters with a little phallus of the heart. It is a little active body between the thighs that always wishes to work its way into the interior of the vagina in order to have itself made and to be a child. Desire never hindered anybody; doctrine hindered everybody. (XVIII: 20–21)

In a psychic mise-en-abîme, Artaud imparts to his own beloved, his daughters, the very same powers of autocreation and autoaffection which he claimed for himself. Whence that phantasmatic polysexuality which is a guarantee against the profligate abominations of God and demons, incubi and succubi.

In Artaud, *Eros* and *Thanatos* finally merge in an eroticism that abjects God in order to recreate the self. The demonic sexual torments he suffered were punishments of God, necessitating the exclusion of sex and love from his ethos.[27] Whence the divine abomination of sinful assassination attempts, where Artaud endured the slobbering lips that devoured him and sucked out his life, while he persevered against the demons and vampires that attempted to

> ...sweep me away in their sexual hyperaesthesia, their libidinous mannerism, their salacious erotic sensibilisation, their carnal obsession with the abject and infectuous flesh, their phallic copulative delirium, their concrete corporeal erotisation, their complete affective beastialisation, their total sexual corporisation, their crass hypodermic invagination, their integral erotic debauchery, their totally profligate abomination, their unveiled criminal fornication. (XXV: 205)

Just as the interiorisation and corporealisation of lyricism entails the collapse of the temporality of nostalgia — where the past becomes a function of the present, life and death are conflated, self and other are condensed — the rejection of a transcendental theology and ontology (the condensation of all possible teleology into an archaeology of lost origins) establishes a new, phantasmatic eroticism.

In their seminal article, "Fantasme originaire, fantasmes des origines, origine du fantasme," Jean Laplanche and J.B. Pontalis conclude by explaining that, "By situating the origin of fantasms in the *time* of autoeroticism, we have marked the liaison between the fantasm and desire. But the fantasm is not the object of desire, it is its scene."[28] While the prohibition of desire is the source of the originary Oedipal conflict through which identity is proleptically born, the phantasmatic scenarisation is also a defence mechanism utilising the psychic operations of projection, introjection, reversal into the opposite, denial. Thus such scenarisations are not only the source of identity formation (or pathological deformations); they are also, potentially, poetic and narrative tropes. They also evoke the lover's strategies of seduction. All this is true, *prospectively*, in the Oedipal domain.

But what can this possibly mean for Artaud, the man who described himself as an "unframed hole that life wanted to frame"? (XII: 19). In the *retrospective* domain of autofiguration, the phantasmatic scene is the 'theatre of cruelty': this is no place, an eschatological, morbid oxymoron of a dystopic utopia beyond all identification, predication and figuration. Here, where all libidinal mannerisms are profligate abominations, misalliance and misprision is the rule, style is equivalent to rupture and abjection, and writing offers little but a *memento mori*. Does this condition of virtual autoeroticism provide any possible common ground for wisdom? Does it offer a new rhetoric, however disjointed, for poetry? Is there any way that our fascination with this life and work can possibly be matched by an adequate empathy? Or are our words merely the joyful wisdom of sheer misrepresentation?

## NOTES

I wish to thank all the members of my Spring 1996 seminar on Artaud in the Department of Performance Studies at New York University, especially Leah Garland and Kurt Griffen

Dorschel, whose excellent presentations inspired certain directions of this text. I would also like to mention in this regard the superb doctoral thesis on Artaud written by Edward Scheer, *Abreacting the Impossible* — on the jury of which I had the pleasure to participate — which when published will prove to be a major statement on Artaud criticism.

1   All citations from Antonin Artaud are from the *Oeuvres complètes* published by Gallimard; volume and page indication are given in parenthesis in the text. Volumes I and XIV are published in two parts and are designated by single and double asterisks respectively. All translations are by the author. Though not utilised in this text for reasons of consistency, the two major translations of Artaud are: Clayton, Eshleman, ed. and transl. *Watchfiends and Rack Screams: Works from the Final Period* (Boston: Exact Change, 1995) and Susan Sontag, ed. *Antonin Artaud: Selected Writings* transl. Helen Weaver (Berkeley: University of California Press, 1988).

2   Roland Barthes, "Analyse textuelle d'un conte d'Edgar Poe" [1973], in *Oeuvres complètes* II (Paris: Seuil, 1994) 1671. Other examples of this genre would include Victor Hugo's *Les tables tournantes de Jersey* (and, beyond the strictly literary domain, all spiritualist transmissions from the afterworld), Gérard de Nerval's *Aurélia*, Edgar Lee Masters' *Spoon River Anthology*, and William Faulkner's *As I Lay Dying*, among many others.

3   ibid., 1669.

4   Elaine Scarry, *The Body in Pain* (Oxford: Oxford University Press, 1985) 34.

5   ibid., 4.

6   On the similarities and differences between *Monsieur Teste* and Artaud, see Louis Sass, *Madness and Modernism*, op. cit: 260–61, 289, 299; Laurent Jenny, in *La terreur et les signes: Poétiques de rupture*, argues convincingly for the radical opposition of these positions (Paris: Gallimard, 1982) 221–22. Valéry, as coeditor of the journal *Commerce*, was instrumental in the 1926 publication of Artaud's *Fragments d'un journal d'enfer*.

7   It is worth noting that Artaud's writings at Rodez were contemporaneous with Jean-Paul Sartre's work on *L'être et le néant*, which constitutes the major modern philosophical

statement equating consciousness with nothingness. The entire history of Western negative and antinomian theologies offer alternate instances, as does the Zen Buddhism which would be imported to the West during this century.

8   Scarry, *The Body in Pain*, 4.

9   Whence the appropriateness (however unwitting and ultimately ironic on the part of Rivière) of publishing but one of Artaud's poems in *Une correspondance*, entitled "Cri" [Scream].

10  Friedrich Nietzsche, *Twilight of the Idols*, in *The Portable Nietzsche*, ed. and transl. Walter Kaufmann (New York: Viking Press, 1968) 483. On the linguistic level, this critique of pure (Kantian) rationality which reveals how the structures of language determine the structures of thought was analysed in Émile Benveniste's study of the metaphysical implications of Indo-European languages, in *Problèmes de linguistique générale* (Paris: Gallimard, 1966); a problematic which also received an Anglo-American theorisation based on a study of the Hopi language, known as the "Sapir-Whorf hypothesis," presented by Benjamin Lee Whorf, in *Language, Thought & Reality* (Cambridge, Mass.: M.I.T. Press, 1956). Jean Dubuffet makes the same argument in the context of *écrits bruts*.

11  Harold Bloom, "Freud's Concepts of Defense and the Poetic Will" *Agon: Towards a Theory of Revisionism* (New York: Oxford University Press, 1982) 139. See Allen S. Weiss, "Formations of Subjectivity and Sexual Identity" *Perverse Desire and the Ambiguous Icon* (Albany: State University of New York Press, 1995) 73–97.

12  Harold Bloom, *The Anxiety of Influence* (New York: Oxford University Press, 1973) 95.

13  Poe, Baudelaire and Nerval — along with Van Gogh among the painters — form the core of this genealogy, though other major influences are cited, most often Hölderlin, Lautréamont, Nietzsche, Rimbaud (XIV*: 187–8). Specifically in regard to the 'theatre of cruelty,' Artaud writes in *Histoire vécue d'Artaud-Mômo, Tête-à-Tête*: "The theatre of cruelty does not date from today, and throughout all time there had been great characters ho took part in it: Euripides, Sophocles, Aeschylus, Chaucer, Ford, Cyril Tourneur, Villon, Baudelaire, Gérard de Nerval, Edgar Poe, et qui sait peut-

être Mr. or Madame or Mademoiselle, in any case the unapproachable Count of Lautréamont" (XXVI: 191). See also the very different list (XXIV: 165), which, however, also begins with Baudelaire, Poe and Nerval.

14  See Victor Tausk, "On the Origin of the Influencing Machine in Schizophrenia" *Psychoanalytic Quarterly* (1933) reprinted in *Incorporations: Zone* 6 (1992), eds Jonathan Crary, Michel Feher, Sanford Kwinter, Ramona Naddaff, 560ff.

15  Paule Thévenin, "Antonin Artaud dans la vie" *Antonin Artaud, ce Désespéré qui vous parle* (Paris: Seuil, 1993) 125. Thévenin's writings on Artaud are indispensible for grasping the genealogy, recitation, editing and reading of his work. We must remember that the plague allegorised in *Le théâtre et son double* follows the pattern of the double-bind: there is the black plague, the bubonic plague, which mortifies and decomposes the exterior of the body by poisoning the inner humors; and there is the white plague, which does its deadly work within, never revealing death on the surface.

16  Antonin Artaud, *Nouveau écrits de Rodez* (Paris: Gallimard, 1977) 83.

17  On the libidinal aspects of speech, see Ivan Fónagy, *La vive voix: Essais de psycho-phonétique* (Paris: Payot, 1983), especially the chapter on "Les bases pulsionnelles de la phonation" 57–210; also, see Allen S. Weiss, "From Schizophrenia to Schizophonica" *Phantasmic Radio* (Durham: Duke University Press, 1995) 9–34.

18  In the notes to this text, Paule Thévenin suggests that "During the recording, Artaud wasn't preoccupied with what was written, and improvised" (XXII: 73). This was certainly the case, but the very meaning of "improvisation" is here in question: it is certainly not to be understood on the model of unmediated Surrealist spontaneity, but is rather akin to most musical improvisation, where the results are based on previously acquired structures and talents. Thévenin's writings on Artaud's modes of incantation support this supposition. Further evidence for the *a fortiori* poetic aspects of Artaud's last works would include: transformations in the dramatic quality of his voice and performance (evident in the differences between the performances of *Aliénation et magie noire* and *Pour en finir avec le jugement de dieu*, where the voice of Artaud is transformed into an icon of

madness); changes in the pronunciation of the glossolalia
(with their Greek and Turkish inflections) from standard
French intonation: see the note on the pronunciation of the
glossolalia by Paule Thévenin in *Artaud le Mômo* (XII: 276);
the numerous experimentations with different versions and
different placements of glossographia in the texts.

19  Jenny, *La terreur et les signes*, 264.

20  *Le Petit Robert* (Paris: Littré, 1972) 86.

21  *Webster's Third New International Dictionary*, vol. II,
(Chicago: Merriam Webster Co., 1966) 1122.

22  Thévenin, *Antonin Artaud, ce Désespéré qui vous parle*,
64–5.

23  Jenny, *La terreur et les signes*, 228.

24  For an epistemological justification of the gestural primacy
of speech, see Maurice Merleau-Ponty, *Phenomenology of
Perception*, transl. Colin Smith (London: Routledge & Kegan
Paul, 1962), especially the chapter on "The Body as
Expression and Speech," 174–199.

25  While the symbolic significance of Antonin Artaud's name
has often been analysed, for example in Allen S. Weiss,
"Psychopompomania" *The Aesthetics of Excess* (Albany: State
University of New York Press, 1989) 121–25, little has been
made of his middle names, Marie Joseph, which is
particularly significant as it combines male and female,
human and divine, parent and child, via the names of the
two parents of Jesus.

26  See Artaud's letter to Gilbert Lély (Sade scholar), dated 27
December 1946, entitled, "La vielle boîte d'amour ka-ka"
(XIV*: 147-51), a response to Lély's request for a text on
love for a special issue of *Variétés*. Here Artaud claims that
he no longer has anything to say about love, which he now
finds to be a false idea, since "I never found love, except in
myself." He specifically denounces what he calls the
alchemical notion of love, as valorised by his major
influences: Nerval, *Roi de Thulé*; Poe, *Éléonora*; Baudelaire,
*La martyre*, *La charogne*, and *Le voyage à Cythère*.

27  Artaud comments on his rationale for this anti-erotic
asceticism: "Insofar as I am concerned, my dear friend, I
already stated that the best means of getting rid of the
demons that torment us and make us ill is to remain chaste,
because it is the practice of sexuality that summons the
demons to us, and that creates maniacs, neuropaths,

perverts and criminals. All demons are obscene lubricious ideas which in the course of time have deranged the human brain, and I believe that it is this idea that Freud had at the bottom of his mind when he created the scientific term 'libido', which incriminates sexuality as the cause of all pain and all evil." *Nouveau écrits de Rodez*, 84–85.

28   Jean Laplanche and J.B. Pontalis, "Fantasme originaire, fantasmes des origines, origine du fantasme" *Les Temps Modernes* 215 (March, 1964) 1868.

# This Sewer Drilled with Teeth

## The S Bend and the Vantage Point

*Bill Schaffer*

### The anxiety of effluence

As Freud formulated it: *filth is matter in the wrong place.*
It is precisely because there is no intrinsic definition of
filth that we require a cultural history of its management.[1]
For filth is not simply a function of substance, but also of
signs and borderlines, especially of that most uncertain
and shifting boundary that divides self from not-self. No
other poet or thinker has more persistently explored this
infra-territory between the sense of self and the place
where it is lost than Antonin Artaud.

It is a matter of no small significance, in this context,
that two toilet doors play a cardinal role in Jacques
Lacan's account of that most important principle in his
own theory of subjectivity, namely: *the agency of the letter
in the unconscious.* In the essay of that name, Lacan
recounts a childhood memory of a little boy and a little
girl who, although seated in exactly the same train
carriage, at exactly the same time, experience themselves
as having arrived at two very different destinations. The
boy declares that his train has just pulled up at a station
known properly as 'Gentlemen'; the girl swears that it is
in fact called 'Ladies.'[2] Thus it is, Lacan informs us, that

the apparently inanimate signs posted on each of the toilet doors manage to address themselves directly to the two children, with an address that tells the addressee who he or she will have always been. "The Letter," Lacan insists elsewhere, "always reaches its destination": from now on, each child must choose one door or the other. This arbitrary opposition between sexual identities, between Ladies and Gentlemen, must be accepted as if it were a call of nature that, in calling, assigns the subject to his or her own nature, even if the opposition of identities which it imposes has no natural foundation and is completely indifferent to the singular sufferings and ecstasies of either child.

All of which assumes, of course, the completion of a tremendous traumatic labour through which the normalised child learns to identify itself with a body organised around the signifying function of the genitals, thereby reducing the potential proliferation of its polymorphously perverse modes of sexuality to one of just two, one of which more or less cancels the other. For Artaud, as we shall see, Lacan would be in error insofar as he seems to assume that this alien law that divides us from ourselves in giving us to ourselves is in some sense "not natural."[3] For Artaud, nature is already alien in itself. The structure of this violent reduction of potentiality which determines human possibilities in terms of an abstract and alien law was for Artaud already planted within us at birth, before any merely social or symbolic imposition of identity, in the very organisation of our bodies. And it is a structure which takes us beyond the toilet doors, beyond the laws of the signifier and sexual difference, down into the undifferentiated world of shit and shitting.[4]

There can be no life without production of waste. It is a process which defies any simple partition of 'within and without'. When I shit I want to free myself of that which is killed by my life: what I risk seeing and smelling is my life already dead; my life already lost to me. The 'clean and proper body' is never truly independent or pure: in one

way or another, it is attached to all kinds of apparatuses, material and social, which penetrate and interfere with it, making it conform to their demands. The modern toilet, which the S-bend makes possible, must be recognised as the great seat of western rationality, for in a mouth to mouth feeding ritual it takes the subject's own 'death' and spirits it quickly away through the miracle of the waterseal pipe. Deceptively simple in design, utterly familiar when we contemplate it, there behind and between our legs, the S-bend is a paradoxical opening which closes itself by means of the very flow which proves it is always open.

The S bend thus imitates — at once guarantees and deconstructs — the integrity of the body whose expulsions it eagerly sucks up and re-expels into the general economy of the sewer. In its structural twist it embodies a logic: the logic by which a pure and proper body produces itself. For this sublime bend, like and unlike my very own body, possesses neither an inside nor an outside. The S-bend reinforces the division between private and public space, but it does so precisely by opening the one into the other. In a moment of discreet ecstasy it connects me to my own future in the form of a flow of undifferentiated shit, even as it seals me off from the unbearable stink of non-differentiation and delivers me back into the privatised, or rather *privitised*, security of my proper limits.

In Baron Haussman's aspirations for universal hygiene, formulated at one of the defining moments of modernity, we can see that the human body itself provided the model for a city rationally designed as a whole, as a living organism defined above all by the organised circulation of internal flows allowing the system to communicate with all its parts and to manage for itself the elimination of its own waste, that is, to manage and defer its own death. But we can also deduce, by inversion, that the model for a clean and proper human body had itself become that of a city which rationally integrated the management of its own waste, thereby objectively reinforcing the subjective

sense of a sovereign point. These two spheres, the bodily and social, the private and the public, literally intersect at the S bend. The S bend negotiates my relation with infinite waste; with the death that comes out of me, and therefore with the other that lives in me. And it is in this connection that the thought of Antonin Artaud — who demanded an experience of pure life, yet never ceased to find shit and death within and beyond himself — becomes unavoidable.

### And God Moved Upon The Waters ...

I too once had a vision of the countenance, that famous countenance which beheld not the countenance; but this primordial countenance was no countenance at all but rather a huge arsehole; for the arsehole not the countenance is the cavity out of which all the things in this world have issued. To be continued in the next issue.[5]

Where Baron Haussmann, hero of Parisian hygiene, modelled his ideal sewers on the workings of a clean and proper body, Antonin Artaud reversed the analogy and inverted the norm: he experienced the organisation of his own anatomy as a sewer, his body as a rotting pit of truth. He swore that at the very moment of his own birth — his own expulsion and production — life had been stolen from him in advance. In his quasi-gnostic vision, cosmic creation was understood as a malevolent joke, endlessly repeated at the moment of human birth: ontogeny as recapitulation of the disaster of cosmogony. In such a gnostic universe, an ignorant creator God, himself entirely dependent on the absolute priority of the infinite formlessness in relation to any possible form, mistakes himself for a pure point of originating intention, while the bodies of his human subjects are subjugated in advance to a 'vantage point' modelled on the image this same

drunken cosmocreator entertains of himself.[6] Men are made in the image of God, indeed, but this is an empty image which reflects nothing but the empty arrogance of a God who, in a kind of materialised hallucination, would isolate himself as the origin of all form, giving himself the pretence of savouring himself in the very fragrance of creation, feeling himself contracted in a single, indivisible point.

For Artaud, the creator was therefore the destroyer, but never in any transcendental sense implying a coincidence of reconciled opposites. There was no reconciliation in Artaud's dramatics, only the clash of an absolute antagonism, a total conflict, like the clash of the vertical and horizontal in a human skeleton, which Artaud saw as a crucifix to which we are nailed at birth. Destruction and creation could thus find no mutual balance in Artaud's vision: destruction was seen rather as the truth of creation. Cosmic creation was for him nothing but the reflex evacuating motion of an ignorant God who does nothing but destroy by locking us into a world of given forms.

> There is a compulsive eruption of God in our being that we have to destroy with that being, in everything touching that being, and that has become an integral part of its substance, and that nevertheless will not die with it. There is that irreducible contamination of life, there is that invasion of nature which, through a play of reflexes and mysterious surrenders, penetrates better than we can into the principle of life.[7]

In Artaud's gnostic dramaturgy, the judgement of God penetrates the body in advance and organises it into organs dedicated to digestion, circulation, and evacuation, making all its diverse parts and possibilities slaves before a 'whole' which they are made to serve; an evil abstraction or 'vantage point' that dominates the body in the same way that an evil God lords it over creation, in the same way, indeed, as Baron Haussmann controlled his Parisian

sewers or Corbin's modernist aesthete enjoyed, through perfume, the sensation of feeling himself reduced to the indivisible, invisible, invulnerable and central vanishing point of olfactory experience.[8]

From the letters to Rivière to the late text 'Here Lies,' Artaud passionately repudiated any assumption that the attainment of selfhood is evidenced inwardly by the sensation of thinking and perceiving from a single, indivisible point — for him, this point was always the site of originary dispossession. "All those who have vantage points in their spirit, I mean, on some side or other of their heads," wrote Artaud, "are pigs."[9] They are pigs because they eat shit, the shit of God, which expresses itself as the assumption of a vantage point. For Artaud, who sustained a continuing fascination with the life of Ucello, the 'mad perspectivist,' it is this perspective illusion of a given vantage point from which the subject exercises its innate sovereignty which must be smeared out, wiped away, eliminated. Artaud never ceased to assert that he experienced himself only as the *repeated failure of such a point*: that he had always already been *double-crossed* by the limit between life/death. Summoned into this world by a God he could never finally separate from himself — this is perhaps precisely the measure of originary theft — only in order to find himself already absented, degraded and betrayed, swaddled in rags of flesh and buried in decomposing matter. Always already 'corpsed' — and forced to write, i.e., to be 'flayed alive' by the self that thieves the self by allowing the existence of self: "God has flayed me alive/during my entire existence/and has done so/uniquely because of the fact that/it is I/who was god/truly god."[10]

The hierarchical organisation of the human being in all its functions around an imposed illusion of identity, allegorised by Lacan in his parable of the toilet doors, is thus for Artaud the result of having been shat by God, and the proof of this is to be found in the shit which compulsively erupts from within ourselves. The

perspectival point which supposedly crowns the human subject is just so much shit. Shit is the truth of creation; shit is what remains, the true result. Shit is therefore the exemplary product, exemplary of the meaning of production as such, and shitting is the exemplary activity of a body dominated by digestion and moved by a feeble hunger that can be satisfied in eating — that is, by the judgement of God. As Jane Goodall paraphrases it:

> A kind of duel of judgements takes place in what is to be the last act of Artaud's gnostic drama. God's own law is the shaping of nature itself that forges the human anatomy and microbially determines the biological life of human beings. Those who fail to throw off the judgement of God produce *le caca* ...[11]

From which it follows, in Artaud's words:

> I have to have/a whole/body which/which isn't/a spiritual body/but a man's body/which moreover is not a being/which is the true body/of the absolute slash/how will this body be made?/ It will be made in such a way/that the problem of the elimination of matter/will be in it originally eliminated.[12]

We are ourselves S-bends. Before any exercise of choice or reflection, physical hunger compulsively opens us up and uses our bodies to create shit. Shit is like the degraded, parodic return of repressed formlessness in a universe — in a body seemingly dominated by forms and vantage points. While a well known nursery song reminds us that the hip bone is connected to the thigh bone, and so on, mention is rarely made that the mouth is connected to the anus, the teeth to the sphincter — yet this is the very possibility of life.[13] Today we can easily imagine monitoring the live images that might be sent back to us by a miniaturised camera which could survive the fantastic voyage through our alimentary canals, giving us the unique pleasure of seeing ourselves from a turd's

eye-view. We know that during this vicarious internal helter- skelter we would never cross a definitive threshold from outside to inside: we would only ever encounter a continuous, pulsating opening, from which we would finally be sent flying.

If all our traditional values nonetheless imply the abstract separation of the anal and oral orifices, the organs of speech and defecation, Artaud's ironic response was to identify the most elevated speech with shit. For him, the two orifices fed each other perpetually and automatically in a kind of S-bend that connects expression and evacuation, the divine and the filthy, afflatus and flatulence, so long as we remain content with reproducing the given within ourselves. As we have been reminded more than once during the course of this conference, Artaud was thus not afraid to write that *all writing is pigshit*. In other words, all the great works of our culture, which we might imagine collected in some vast, universal *digest*, amounted for him to something worse than nothing, something doubly shitty: the shit of shit-eaters. Foremost amongst the perpetrators of this indelible crime that is the written are all those 'pigs' who, in speaking and writing, assume a vantage point for themselves.

This declaration, which is not at all isolated within Artaud's work in its explicit determination to reduce the highest expressions of culture to nothing better than excrement,[14] might be taken to betray the extreme, self-cancelling nihilism of his project. If all writing is excremental, then why write or ask anyone to read? Why go on producing written works, when one has already written them all off in advance? Such would be a simple formula for dismissing the work of Artaud, evacuating it in a single motion, or at least for confining interest in his work to the level of a case study, the reasoned analysis and recuperation of an unreasoned discourse which did not, could not, have known what it was saying.

But Artaud can only be construed as a simple nihilist, caught in the vice of an unavowed contradiction, at the

cost of ignoring another thread that runs continuously throughout his work: the repeated affirmation of his belief in the need to believe. Artaud believed in belief and he believed in life, but a life that could not be taken for granted.

Two quotes from Artaud's Manifesto, *The Theatre and its Double*:

> We need to live first of all; to believe in what makes us live and something makes us live — to believe that whatever is produced from the mysterious depths of ourselves need not forever haunt us as an exclusively digestive concern.[15]

> We must believe in a sense of life renewed by the theatre, a sense of life in which man fearlessly makes himself master of what does not yet exist, and brings it into being. And everything that has not been born can still be brought to life if we are not satisfied to remain mere recording organisms.[16]

To digest and to record: these are two names for the processes by which humans reproduce the given within themselves. Two euphemisms for dispossession by a God who would use our bodies to evacuate himself. No one can fairly say that Artaud failed to take seriously the question of belief. But paradoxically, it was just for that reason that he was compelled to reduce all the highest works of culture, all the most revered objects of belief, to the status of waste. To cry 'shit to the spirit!' For Artaud could only believe in a life that would need us in our embodied suffering; a life that would need us precisely because it would *not* be given in the world; a life driven by a hunger that could not be satisfied by any kind of eating, profane or sacramental.

If the demiurge of the gnostics disastrously repeats and embodies his own arrogant misrecognition of himself in the lives of human beings, then the very fact that what is thus repeated is a kind of mistake, an effect of ignorance,

implies the possibility of escape through the release of formless energies and virtual potencies. In a cosmos ruled by an imposter God, the highest creative aspiration would be the will to destroy created order. Artaud's belief was not, therefore, a banal matter of believing in nothing, but rather of believing in the need to generate an indigestible *figure of nothing through which we must pass* in order to begin thinking. In *The Theatre and its Double* he tells us that "every real effigy has a shadow which is its double." These paradoxical shadows, as I understand them, would be something like a form's invisible memory of impossible futures, its potential to become something unrecognisable, the ghosts of futures not given. Artaud thus saw his own role in the 'theatre of cruelty' as first of all a matter of "directing shadows." His performance would provoke an awareness, a cruel consciousness of these shadows or pure virtualities which double every given form, and to that very extent escape the cycles of production and digestion, giving the infernal machinery that God has installed within us nothing to chew upon.

For Artaud any form of art which is content to represent the real, express a natural impulse, or seek simple human recognition is necessarily excremental, because it is servile and merely reproductive: it takes what it is given to eat, turning the subject into a conduit, an S-bend for the disposal of the already given. Artaud's duty as a writer is for that very reason inexhaustible: it is the idea of a pure, generative act of writing, singular, irreducible to representation, neither reproducing nor reproducible, which he affirms; it is the *fact* of the written, which is always already caught up in an economy of reproduction, which appals him. The need to write thus follows from the fact that all writing is pigshit, *and at the same time*, the fact that writing is pigshit follows from the need to write.[17]

This stark paradox need not be read as the symptom of a tragic failure of psychological consistency, but as the motor of a dramatic perpetual motion machine which

Artaud challenges us to build out of our bodies. As Jane Goodall has well emphasised, in devoting himself to endless struggle with an antagonistic creator-God, Artaud *dramatically creates himself* as absolute adversary of the law. In our terms, he thereby defies the very cycles of production and evacuation which he at the same time denounces as absolute and unavoidable within himself. He produces himself as the indigestible anti-hero of non-production, but only at the cost of repeatedly spitting out any possible form in which he might consume himself, recognise or accept himself as something given in the world. His apparent assertions of identity are thus always stratagems, violent and ironic acts of erasure, directed against identity, against lineage, genealogy, and all the frameworks of belonging, including of course, surrealism, which confer meaning upon the human body and establish it within a defined space. Artaud felt all these connections as so many S-bends pouring pollution into his wounded and absolutely singular, inexpressible body. The very late poem 'Here Lies' is exemplary of this tendency (which is already observable, I believe, in the letters to Rivière):

As for me, uncomplicated
Antonin Artaud,
no one can touch me
when one is only a man
                              or
                                      god.
I don't believe in father
                                      in mother,

got no papamummy

nature
mind
or god
devil
body
or being

life
or nothingness,
nothing inside or out
and above all no mouth to mouthe Being,
that sewer drilled with teeth.[18]

Here, in a gesture which promises never to swallow anything given to it, mummy and daddy, a "normal" procreative couple who have fulfilled the laws of sexual difference, are repudiated, flushed away, under the name of "pappamummy," the name of a monstrous amalgam, an unspeakable indifferentiation. From this perspective, a perspective which actively severs itself from all support, a belief is not worth holding unless it embraces the impossible, since the possible is just a name given to the anticipated outcome of what is already given, and what is already given has no need for the opening of thought. "I am he," wrote Artaud, "who in order to be must whip his innateness."

Jacques Derrida has convincingly demonstrated the extent to which Artaud's language is thoroughly contaminated, through a sort of unavoidable reflux, by the very metaphysics of presence and purity to which it opposes itself. In so doing, Geoffrey Bennington points out, Derrida has not set out to rob Artaud of his desire by reducing it to a mistake, but rather to show that it is impossible.[19] But the possibility that Bennington does not make explicit is that this impossibility is precisely what Artaud lucidly affirms in performatively dividing himself against himself: that it is precisely this double-bind which becomes the motor of Artaudian, all-or-nothing dramatic conflict. Artaud's interest, after all, was not a philosophical interest in reconciling one's discourse with its own conditions of possibility — an interest which Derrida (arguably) at once affirms and subverts — but an ironic, dramatic, gnostic interest in refusing any possible reconciliation; in squandering all interest at once, just once, unrepeatably, without any support. In creating, that is, "*the true body of the absolute slash.*"[20]

The 'theatre of cruelty' would thus be fatally opposed, in Artaud's words, to "our petrified idea of a culture without shadows, where, no matter which way it turns, our mind (*esprit*) encounters only emptiness, though space is full."[21] It would be the painful responsibility of the 'theatre of cruelty' to awaken us to this prevailing emptiness, by assaulting our minds with the experience, again in Artaud's words, of "a new generation of shadows, around which assembles the true spectacle of life." In so doing, the theatre envisioned by Artaud would solicit the emergence of something monstrous and unrecognisable that *needs us in order to come*: something that would look like shit to those who speak from the elevated positions of our culture, but would in fact reveal these spokespersons as themselves nothing but conduits for the propagation of spiritual crap.

## (E)Sc(h)atology

If Artaud denounced the dispossession of human bodies under the name of a shitting God, he celebrated a positively cruel and ironic experience of dispossession under the name of plague. Plague, as Artaud imagined it, was not primarily a biological fact, but a spontaneous spiritual event. In our terms, it acts like an affirmation of the fact at once mimed and disavowed so ingeniously by the S-bend: the fact that in life every point of closure must also be an opening, every inside must always already communicate in some essential, unavoidable way with its outside.[22] As Artaud conceived and welcomed it, plague would be the great enemy of the spirit of organised digestion which inspired Hausmann in creating his subterranean double of daylight Paris. It would bring on the *vortex of life*: an unstoppable reflux that would threaten to shatter all recognisable forms from within themselves. Enthusing over the outbreak of plague phenomena, Artaud testified that "at that moment theatre is born ... i.e., an immediate gratuitousness

prompting acts without use or profit."[23]

In contradistinction to the originary violence of a God who takes our bodies hostage in advance of our births, plague is celebrated by Artaud as a spontaneous force of delirium that also takes hostage of the body, but this time holds it hostage from the grip of God himself, as represented by the ordered structures of civilisation and the teleologies of nature, withdrawing the body from any possibility of control from a human 'vantage point'. The plague is not for Artaud something that comes from outside the limits of bodies, social or individual, as might an objectifiable agent of contagion. It may be hallucinated as such by humans desperate to reinforce and protect the limits of bodies, the divisions between insides and outsides, but from Artaud's esoteric perspective it is in truth an uncontrollable volatility which comes from within forms, like an alien erupting from the chest in a SFX sci-fi movie, to catastrophically undo the very distinction between inside and outside. The plague's most remarkable property is thus that it is amplified and propagated by any attempt to confine and control it, as notably demonstrated by the fate of those concerned citizens who, in Artaud's fable, quarantine themselves within a sealed and guarded fortress, only to find that they are nonetheless soon overwhelmed by the fever, even as their loyal guards stationed outside remain miraculously unaffected.

Those who insulate themselves succumb; those who expose themselves survive. This kind of plague thus spreads purely by the powers of irony and unconscious mimesis — these are the lines it follows, rather than those of the merely physical vectors described by modern epidemiology. Medical science, which is a practice of objectifying and quantifying repeatable events, of definition and partition, could have no chance of detecting, let alone of describing or controlling the virtual, shadow aspect of the plague at once evoked and invoked by Artaud. Plague, for Artaud, is the activation of a metastatic, liquefying, disorganising potentiality that is always already dormant

within the body of its victims — not so much as a content held within an interior, but rather as the very instability of the divisions between interiors and exteriors. Its real home is neither within nor without, but across and between; it can invade and dissolve any form, thereby expressing the everlasting power of formlessness in its struggle with the given. Such a force cannot be contained within any form or locality: it is a wild movement across separating limits, an uncontrollable trembling which capriciously turns forms and bodies inside out, letting their fluid contents flow into the world and interfere with each other, as graphically underlined by the whirling, writhing, bursting, pustulant, bodies that litter Artaud's plague landscape.

Artaudian cruelty, which necessarily involves the reduction of the created world to shit, is nonetheless not fundamentally vindictive; it is not directed primarily towards others, but rather  towards that which, sealed by the judgement of God, is too easily recognisable within oneself. The plague is not in any sense an expression of sadism by one towards another. It is not a face to face violence, but an affirmation of that inhuman violence which announces the unrecognisable and destroys all secure enclosures — destroys the very idea of security. Which announces, in other words, the other within myself, death within life. 'Cruelty' of this kind is unquestionably ethical, in the sense that it gives itself an unlimited responsibility. It is a performative violence that does its duty to the virtual, and it does so in the hope of awakening a sense of hunger that cannot be exhausted; so that humans may become "more than mere recording mechanisms." What it affirms, what it believes in, is not given reality, nor is it the possible, but the impossible: a state that could not be recognised in any given terms: the advent of the unrecognisable, which, in a final paradox, is for Artaud already the factual state of our own bodies, once they are released from domination by a deceived and deceiving God.

This final twist is profound. On the other side of a

world of shit, beyond everything given, what Artaud apparently believes in is a light that, without judgement or regret, beyond any possible distinction between subject and object, public and private, contents and container, would show the body as a fact; a mass of potentiality no longer determined by the judgement of God, no longer defined in relation to any 'vantage point' that would impose and maintain itself through that spirit of organisation we associate with a healthy human body:

> there is no inside, no spirit, no outside or consciousness, nothing but the body as it is seen, a body which never ceases to be, even when the eye that sees it falls. And this body is a fact. Me.[24]

This is a very different body to that exceedingly clean and proper one which, as Samuel Weber has vividly reminded us, one of the foolishly self-confident victims of Artaud's plague preens before a mirror, shortly before it too bursts open to the waves of universal reflux. This narcissistic body enjoying the reflected sight of itself, which might as well be the body of Corbin's connoisseur of fragrances, drinking in the sensation of his own invisible invulnerability, is clearly a world away from the tortured body of Artaud, which is a body seen by an eye that anticipates and avows its own fall, the loss of any vantage point. A body without origin, in either the generative or geometrical sense. But, at the same time, this is almost the very same body, a fact which is proven the moment it succumbs to the plague, which is to say, the moment it succumbs to the death living within itself. The same body, but this time a body that is literally unable to 'contain itself'; a body alive with a life that is no longer opposed to death, like the life of the plague itself. Given before the given. A body seen under a light that shines from the other side of the S-bend.

This shadow body of the plague, which has opened up completely and severed itself from any origin, is itself shadowed and inverted within Artaud's discourse by the

image of a body that has closed all its orifices, once and for all, in originating itself: a hermetic body from which "the problem" of elimination has been "originally eliminated."[25] This would be the very figure of that impossible state of purity which, as Derrida reminds us, Artaud promises himself in the very act of denouncing all available forms of purity, just as the plague-body might be taken to express that infatuation with death which we are so often told lies at the heart of Artaud's promise. But in the dramatic conflict of these two shadow bodies, their very irreconcilability, this promise performs its own impossibility.

The shadows shadow each other, virtualising each other's virtuality. Shadows of shadows are invoked against the shit of shit-eaters. The impossibilities divide, redouble, and multiply, plague-like, without ever reconciling or converging upon a vantage point. From out of this generative performance, "signalling through the flames," there emerges a "figure of nothing": the cruelty of a thought that, giving us nought to eat, would force us to begin thinking.

## NOTES

1  To work on this assumption is not, however, to necessarily disqualify Artaud's insistence, to be explored shortly, upon the ahistorical, ontological, indeed cosmic significance of shit as the truth of biology. The invariant, biological imperative of defecation provides the background against which historical comparisons may be read, which may in turn throw a different light on the 'meaning' of that imperative. Shit, in its very meaninglessness and indifferentiation was, for Artaud, the most 'meaningful' thing on earth. Throughout this paper, Artaud's belief in an extra-biological, trans-organic force of life, the betrayal of which, within our created order, is marked by the fact of shit, will be treated as a radically unfalsifiable, unverifiable hypothesis. It will be a matter of seeing what this hypothesis allows us to imagine about the

nature of our 'experience', rather than of testing the hypothesis itself in terms of empirical demonstrability.

2   Jacques Lacan, *Ecrits* transl. Alan Sheridan (London: Tavistock, 1977) 152.

3   I make this comparison between Lacan and Artaud in order to emphasise the extent to which Artaud addresses questions about the emergence and subversion of subjectivity which have become familiar for anyone acquainted with contemporary thought, whilst at the same operating with what remains an extremely unfamiliar model of the subject and its possibility. Nonetheless, the qualifications of 'insofar' and 'seems' with regard to Lacan's assumptions about thresholds are considered and deliberate. The question is complicated to the extreme by the retroactivity of the symbolic as conceived by Lacan; by the role of the 'real' in relation to the imaginary and the symbolic in later Lacan; by the question of foreclosure; and by the structure of Lacanian 'logical time,' which relates precisely to the crossing of thresholds. For a discussion of logical time which also touches upon two Lacanian maxims which would be decisive in any encounter with Artaud — that God is not dead, but rather unconscious; and that what is crucial in the emergence of subjectivity is not the deceiving other hypothesised by Descartes, but the deceived other (gnostic tradition would affirm both propositions simultaneously: God is both deceived and deceiving), see the meditations around the 'Father, can't you see I'm burning' dream: in Jacques Lacan, *The Four Fundamental Concepts of Psycho-Analysis* transl. Alan Sheridan (New York: Norton, 1981) 56–60.

4   This world has a history, inextricably a history of the organisation of human bodies, which provides a revealing background against which to read the gnostico-scatological thematics which recur throughout Artaud's text. In *Transforming Paris: The Life And Labours Of Baron Haussmann* David Jordan tells how Victor Hugo was taken on a tour of the old Paris sewers while writing *Les Misérables*. Hugo was overwhelmed by the experience. He found in this subterranean labyrinth a sort of accidental, but essential, revelation; in Jordan's paraphrase, he found there "an underground universe where the myriad distinctions that give social coherence vanished." Recalling this negative

epiphany, Hugo wrote: "The sewer is the conscience of the city. All things converge and confront one another there. In this ghastly place there are shadows, but there are no more secrets. Everything takes on its own shape, or at least its definitive shape. One can say this for the refuse heap — it is not a liar ... All the filthiness of civilisation, once out of commission, falls into this pit of truth where the immense social slippage ends up." David Jordan, *Transforming Paris: The Life and Labours of Baron Haussmann* (New York: Maxwell, 1995) 272.

5    Antonin Artaud, "On the Kabbalah" *Artaud Anthology*, ed. Jack Hirschman (San Francisco: City Lights, 1965) 114.

6    See Giovanni Filorama, *A History of Gnosticism*, transl. A. Alcock (Oxford: Blackwell, 1990).

7    Quoted in Jane Goodall, *Artaud and the Gnostic Drama* (Oxford: Clarendon Press, 1994) 30.

8    Alain Corbin, *The Foul and the Fragrant; Odour and the Social Imagination* (London: Papermac, 1996).

9    Antonin Artaud, "All Writing Is Pigshit" *Artaud Anthology*, 38.

10   Quoted in Derrida's "La parole soufflée," in Jacques Derrida, *Writing and Difference* transl. Alan Bass (London: Routledge, 1978) 181.

11   Goodall, *Artaud and the Gnostic Drama,* 208.

12   Artaud, "Here Where I Stand," *Artaud Anthology* 203–204.

13   A memorable evocation of this connection between mouth and anus is of course to be found in Bill Burrough's *Naked Lunch*, when the talking arsehole eats its way through the pants and starts demanding equal rights with the head. In contemporary popular culture this connection is made to (sporadically) hilarious effect in Jim Carrey's appropriately titled *When Nature Calls*, in which his character, Ace Ventura, has a penchant for talking and singing opera through his butt ('arsehole o me o ...').

14   This tactic is everywhere evident in the work from the early poems like *The Umbilicus of Limbo* to the later works such as *To Have Done with the Judgment of God*, and there are many examples in both of these.

15   Antonin Artaud, *The Theatre and its Double*, transl. Alan Sheridan (New York: Grove, 1979) 7.

16   ibid., 12.

17   This aporia of *iterability* is, of course, at the heart of Derrida's reading of Artaud. One of the provocative motifs

that emerges from Jane Goodall's indispensable book, and which also repeatedly came into focus during the *100 Years of Cruelty* conference, is a challenge to this post-structuralist tendency, as she sees it, to reduce Artaud's ideas to symptoms of impossibilities imposed by language. While Goodall is clearly right, however, in pointing out the extent to which the gnostic resonances of Artaud's text have previously been neglected, for the sake of making his evil demiurge function as a mere metaphor for the necessary precedence of language in relation to any subject, I do not believe this observation in any way disables Derrida's own approach to Artaud. Goodall has shown that Derrida's reading is limited, unquestionably, but this does not mean that it is flawed in some unacknowledged way. In fact, Derrida is explicit that his interest is one of *reducing* Artaud's text. He does so by reading Artaud in terms of a certain field of comparisons, including the history of philosophy and the work of Nietzsche (a move to which Goodall strenuously objects). Goodall, however, also inevitably reduces Artaud's text, this time by reading it in the context of the history of gnostic thought. But Artaud declared that all writing is pigshit. Neither context, Derrida's nor Goodall's, is determined intrinsically or exclusively by Artaud's texts: the explicit and implicit references to gnostic precedents in Artaud are no more definitive or authoritative than the explicit and implicit references, for example, to Nietzsche to be found there (which Goodall is forced to dismiss as misleading). Both contexts allow for powerful reductions of Artaud: neither can claim to be exclusively licensed by his precedent. Moreover, both ultimately resist reducing Artaud to any antecedent. Goodall finally sees Artaud in terms of a revolt against gnosticism, while Derrida unequivocally declares that "Artaud is not the son of Nietzsche." From our perspective there appears no real reason to 'decide' between these two different approaches, except perhaps a dramatic one, and I have accordingly divided myself between both influences in writing this paper. See Jacques Derrida, "La parole soufflée" and "The Theatre of Cruelty and the Closure of Representation," in *Writing and Difference* transl. Alan Bass (Chicago: University of Chicago Press, 1978).

18   Artaud, "Here Lies," *Artaud Anthology*, 247.

19  Geoffrey Bennington and Jacques Derrida, *Derrida* (Chicago: University of Chicago Press, 1993) 159–60.
20  Artaud, "Here Where I Stand," *Artaud Anthology*, 203–4.
21  Artaud, *The Theatre and its Double*, 12.
22  See Derrida, "The organ: place of loss because its center always has the form of an orifice. The organ always functions as an embouchure." *Derrida*, 186.
23  Artaud, *The Theatre and its Double*, 24.
24  Goodall, *Artaud and the Gnostic Drama*, 189.
25  Artaud, "Here Where I Stand," *Artaud Anthology*, 204.

# The Logic of Delirium

## or the Fatal Strategies of Antonin Artaud and Jean Baudrillard

*Alan Cholodenko*

> [T]he theater, like the plague, is a delirium ... The plague takes images that are dormant, a latent disorder, and suddenly extends them into the most extreme gestures; the theater also takes gestures and pushes them as far as they will go ...
> —Antonin Artaud[1]

> Since the world drives to a delirious state of things, we must drive to a delirious point of view.
> —Jean Baudrillard[2]

In response to the question of the 'relevance' of Antonin Artaud to contemporary culture and thought, I will attempt to call forth and analyse Jean Baudrillard's Artaud and to substantiate their more generalised interrelations.[3] Though there is as yet no literature on the subject, the connections between the two are profound, enabling us to add Baudrillard to the list of contemporary French thinkers — Michel Foucault, Jacques Derrida, Gilles Deleuze, Julia Kristeva — strongly influenced by Artaud.

Both Artaud and Baudrillard are provocateurs in the fatal sense of the term. They issue a challenge to 'reality,' as their work constitutes a defiance, an outbidding, a leading astray — in a word, a Seduction — of 'the real', summoning 'reality' to appear the better to make it disappear as an apparition. They are performers, in the sense of enacting what they describe. Baudrillard writes:

"It is not enough for theory to describe and analyse, it must itself be an event in the universe it describes."[4]

This is axiomatic for Artaud. Artaud performs his 'theatre of cruelty' in, with, and as his writings and in, with, and upon his own soul, mind and body, making them and him a theatre of war. He is the 'theatre of cruelty' incarnate — if incarnate is taken to mean not only body but mind and soul — a theatre of passion, intensity, frenzy, agony. As for Baudrillard, his hyperrealist, hyperrational works are themselves as writings complex, subtle performances of that of which they write, shimmering with an exquisite, seductive surcharge of artifice, irony and humour.

While Artaud is nothing if not passionate, intense and frenzied, he at the same time mobilises a set of complex, contradictory, rigorous logics, which could be called the logics of illogic, the logics of delirium, the logics of fatality, of fatal theory — or rather, in Artaud's case, fatal theatre.[5] Furthermore, I would propose that, though Artaud is hot and explosive and Baudrillard is cool and implosive, they are nonetheless mobilising the 'same' logics, the 'same' systematics, the 'same' strategy, with the 'same' end in view (necessary precautions noted).

# I

In an interview, 'Fractal Theory' (1990), Nicholas Zurbrugg asks Baudrillard, "Would it be fair to say that your writings are often quite poetic in spirit?," to which Baudrillard replies: "Yes, it's true there's this other link with literature — with a less disciplinary language. It's true that my first writings were much closer in spirit to those of Artaud, Bataille, Rimbaud, and so on."[6] In fact, Artaud turns up everywhere in Baudrillard, significantly in the crucial 'middle' texts that mark the turn in Baudrillard's writings away from a "'sociology' contra sociology" to a fatality, a fatal theory — what could be

called a cruel theory. So while Bataille and Nietzsche are often acknowledged and easily recognised as major and abiding influences on Baudrillard, Artaud can be seen as another such influence. This is underlined in an interview (conducted in 1984, published in 1987)[7] in which Baudrillard not only explicitly addresses Artaud but, anticipating Jane Goodall, ties the Christian heretics — the Gnostics and the Manichaeans — and their dualist, non-dialectic view of the universe to Artaud and ties them both to his own dualist, non-dialectical world view and logics.[8] Baudrillard does so by situating his own position as anterior and antagonistic to Descartes, as fundamentally irrational and as "more closely related to a certain kind of Manichaeism."[9] He ties his Principle of Evil to Descartes' evil demon and ties both to the principle adopted by the 'heretics' throughout the history of Christianity, that is, that "the very creation of the world, hence the reality of the world, was the result of the existence of the evil demon. The function of God, then, was really to try to repudiate this evil phantom — that was the real reason why God had to exist at all."[10]

Characterising Descartes' project as an attempt to rationalise and confirm the reality of the world — to 'realise' the world — and thereby resolve the conflict between doubt and reality so that the subject can be confirmed in his reality, achieving a reconciliation between the subject and himself and between the subject and the world, Baudrillard takes the inverse tack, that of 'heretical' Christianity, for whom this evil demon or phantom goes under the name of Demiurge, the evil cosmocreator.[11] Baudrillard allies his principle of Seduction, of Evil, with the Manichaean vision that "the reality of the world is a total illusion; it is something which has been tainted from the very beginning; it is something which has been seduced by a sort of irreal principle since time immemorial."[12]

For Baudrillard, one has to invoke the absolute power of illusion, as the heretics did, basing their theologies on

the very negation of the real, on the non-reality, hence non-rationality, of the world. The Manichaeans for Baudrillard "believed that the world, its reality, is made up only of *signs* — and that it was governed solely through the power of the mind."[13] Against the Cartesian dream of 'realising' and reconciling, for Baudrillard there exists a radical antagonism: there is no possibility "at all of reconciling the 'illusion' of the world with the 'reality' of the world."[14] To believe otherwise would be absolutely utopian. Of course, for him illusion is "not simply irreality or non-reality; rather, it is in the literal sense of the word (il-ludere in Latin) a *play* upon 'reality' or a *mise en jeu* of the real. It is ... the issuing of a challenge to the 'real' — the attempt to put the real, quite simply, on the spot."[15]

Baudrillard then turns his attention from Descartes to semiology in the interview, but in so doing refinds what he has just left, for his characterisation of the project of semiology seems at one with that of Descartes in attempting to produce meaning as a repudiation of Seduction, of Illusion, of Evil. It is in this effort to wed semiology to Descartes that Baudrillard invokes Artaud as one who shares a vision of a world "where illusion or magic thought plays a key role," a world in which "the signs evolve, they concatenate and *produce themselves*, always one upon the other — so that there is absolutely no basic reference which can sustain them ... On the contrary, *reality is the effect of the sign*. The system of reference is only the result of the power of the sign itself."[16] Artaud for Baudrillard shares the vision of "a fundamental antagonism between the sign and reality," the sign being "precisely that which operates against reality, not for it."[17]

In this way, Baudrillard turns to Artaud, as he does to Manichaeism, to challenge all projects, including Descartes' and semiology's, of rationalising, materialising or 'real-ising' this world. He makes Artaud his exemplar of the "savage power of the sign ..., this 'cruel' capacity that the sign has to 'erupt'..." and to 'illusion' a world that is

irreconcilable to and for the subject. He makes Artaud his exemplar of the destiny, not the history, the domestication, of the sign. He makes him his exemplar of the sign as cruel, as that which not only brings reality into being but operates against, not for, it. That is to say, he makes Artaud the exemplar of what he takes as sovereign: Seduction, Illusion, destiny, fatality, irreconcilability, Evil — the evil demon, the Demiurge, and his Principle of Evil.[18]

The association on Baudrillard's part of Artaud with Seduction, irreconcilability, Evil, with the world as total illusion, is quite suggestive. It enables us to do something intriguing and cruel, something that Baudrillard nowhere himself does, that is, to conceptualise Artaud as not one Artaud but two Artauds: Artaud the Reconcilable and Artaud the Irreconcilable. The former is associated with the Principle of Good (the search for reconciliation, salvation, cure, domestication, destination and the end of the agonistics of his dualist, doubled nature in the 'real-ising,' the production, of the fullness of authentic being and the restoration to theatre of the fullness of authentic theatre analogous to the fullness of the Pleroma in the Gnostic cosmogony), therefore with Descartes and semiology. The latter is associated with the Principle of Evil (the seduction of any project to materialise this world, the impossibility, the utopia, the artificial paradise, of such a 'real-ising,' the inescapability of destiny, radical irreconcilability, Seduction, Illusion and radical exoticism), therefore with heretical Christianity. Of course, this association with the Principle of Evil works very much to the advantage of Artaud the Irreconcilable, since Evil is itself the principle of irreconcilability.

On this score Artaud the Irreconcilable is eloquent: "In the manifested world, metaphysically speaking, evil is the permanent law, and what is good is an effort and already one more cruelty added to the other."[19] For Artaud here, cruelty and evil are interchangeable terms. Cruelty/evil is sovereign in the world created by the Demiurge, making cruelty/evil necessary and necessity cruel/evil. Cruelty/evil

is manifested in the inseparability and indistinguishability of good and evil, good already charged with and contaminated by evil.

Artaud's declaration that his true self was stolen from him at birth and doubled by an evil self is analogous to what Baudrillard says of the world — that it was seduced, that is, led astray, diverted 'in' its origin, before it was produced. At the same time, the belief on Artaud's part that he could produce his true, authentic self and end his alienation would be for the other Artaud, the irreconcilable Artaud, utopian thinking condemnable in the same terms as Baudrillard condemns all who would seek to produce, to 'real-ise,' to be reconciled with themselves, as he condemns all who would seek to produce, to 'real-ise,' to be reconciled with the world, against the total radical illusion of the world, its great game of putting into play, its artifice, its irony, its humour.[20] Such effort would be, in Artaud the Irreconcilable's terms, "one more cruelty added to the other." Yet nowhere to my knowledge does Baudrillard make explicit such a condemnation of that Artaud, the reconcilable one.[21]

Wherever Baudrillard defends his sovereign principles of Seduction, Illusion, Evil, wherever he associates theatre and himself with "a sort of Manichaeism,"[22] he is in some way mobilising and defending Artaud — the Irreconcilable one (as that Artaud might be thought to be defending Baudrillard). Significantly, this role for Artaud in Baudrillard — that of the Irreconcilable — is already in play nascently in Baudrillard's first reference to Artaud in his first book, *Le Système des Objets*, where he describes "the world of ancient objects" as "theatre of cruelty and of the drives."[23]

## II

But if Evil is Baudrillard's characterisation of cruelty, how does this correspond to Artaud's own formulation of it? In *The Theater and Its Double*, it is the sovereign principle, animating force and feeling of theatre as of life. Indeed,

for Artaud, cruelty, life and necessity are interchangeable terms.[24] It is a malice, a fatality, a fatal strategy of things against the human, which the theatre "has been created to teach us ... first of all."[25] Its lesson is that "We are not free. And the sky can still fall on our heads," and that "life ... exceeds all bounds and is exercised in the torture and trampling down of everything...."[26] It is a violent rigour and rigorous violence which Artaud explicity links to a kind of vitality and to Gnosticism:

> I employ the word 'cruelty' in the sense of an appetite for life, a cosmic rigor and implacable necessity, in the gnostic sense of a living whirlwind that devours the darkness, in the sense of that pain apart from whose ineluctable necessity life could not continue; good is desired, it is the consequence of an act; evil is permanent.[27]

Cruelty, this highest determinism, is thereby linked to Evil as that which defines creation — of world, life and theatre — for Artaud.

Not only is Artaud's notion of cruelty of the greatest import to Baudrillard, who takes it as analogous in so many ways to his notion of Evil, so too is Artaud's attachment of that notion to theatre, for theatre is a major concern for Baudrillard, especially as his first order of simulacra is a world of theatre. Baudrillard explicitly addresses theatre in parallel with the increasing degradation of the world, using theatrical terms to define the turn from the scene to the obscene.[28]

In his schematising of the orders of simulacra in terms of theatre in *Les Stratégies fatales*, Baudrillard treats the first order of simulacra of theatre in terms of Baroque theatre, an "extravagance of representation" producing theatrical illusion, where the "scenic illusion (of the stage) is total ...: by virtue of machines, artifact, technique and counterfeit the real is challenged according to its own rules."[29] But then — and in parallel with Baudrillard's macrocosmic vision of the passage from first to second

order simulacra — starting in the eighteenth century, theatre is captured in the trap of representation, becoming "loaded with the 'real' ... and the naturalist form wins out. The stage trades the prestige of metamorphosis for the discreet charm of transcendence. The critical era of theater begins, the contemporary of social antagonisms, psychological conflicts, and of the critical age in general." Against this movement of theatre in such a second order 'real-ising,' Artaud is singled out by Baudrillard as wanting

> to save the theater by tearing it from the decaying scenario of the real, anticipating the end of representation, and reinjecting it, by virtue of cruelty, with something prior even to illusion and simulacrum, something of the savage operation of sign upon reality or of the lack of distinction between the two that still characterizes theaters of the unreal (the Peking Opera, Balinese theater, and sacrifice itself as a scene of murderous illusion).

The 'originary' 'place' Baudrillard assigns Artaud is again in evidence. In this statement, Baudrillard figures not only a 'beyond simulacrum' but a 'beyond illusion' — something to my knowledge unique in his work. And it is figured in and through Artaud as the pure, savage, cruel sign, the sign itself/himself of the cruel capacity of signs to erupt. And if for Artaud, cruelty, life and necessity are interchangeable terms, theatre is interchangeable with them, which means that it is not only the mise en scène for the event, act, manifestation, revelation, perpetual emanation of cruelty but is itself these, itself cruel, itself life, itself necessity.

Hence, Artaud's protest on behalf of theatre and life against contemporary Occidental theatre and life, both of which he felt to be exhausted, petrified, inert, perversions of what both should be. Occidental theatre was separated from life even as it provided merely "a servile copy of reality,"[30] showing the public nothing but "the mirror of

itself."[31] This is theatre reduced to everything true theatre is not, a banal, quotidian form presenting things in psychological, social, humanist and individualist terms and subordinating mise en scène to word and text. This theatre is a renunciation of true theatre, which for Artaud is first and foremost metaphysical, based in religion, myth and mysticism, whose "true purpose ... is to create Myths, to express life in its immense universal aspect, and from that life to extract images in which we find pleasure in discovering ourselves."[32] In this way theatre reveals not the familiar but the unfamiliar, not the known but the unknown, the great secrets of the universe, as it deals with Creation, Becoming and Chaos, addresses total man and anchors in him "the idea of a perpetual conflict and of a spasm in which life is lacerated at every minute, where all in creation rises up and exercises itself against our state of constituted being" [my translation].[33] For "like the plague the theater is the time of evil, the triumph of dark powers that are nourished by a power even more profound until extinction."[34] All true theatre must recover the "terrorizing apparition of Evil which in the Mysteries of Eleusis was produced in its pure, truly revealed form [and] which corresponds to the dark hour of certain ancient tragedies."[35] All true theatre has a sacred charge: to reveal evil in the world. All true theatre is a theatre at once of blood, violence, paroxysm, invective and ecstacy and of implacable rigour and necessity.[36]

Therefore, into this Occidental theatre without theatre and life without life, Artaud would reinject cruelty in order to revive and reanimate them as well as restore the lost continuity between them. In this way the prostituting of the idea of theatre will end as the only value of theatre is restored — "its excruciating, magical relation to reality and danger."[37] In this way theatre as "the magic of the real"[38] — as "true illusion"[39] — will return. In this way, against art for art's sake, art will rejoin life. Indeed, theatre will "make itself the equal of life"[40] as it is brought to life and life to it. Moreover, as the title of the book

signals, it is not theatre that is the double of life but life that is "the imitation of a transcendent principle with which art puts us back into communication."[41]

In his war against aestheticism, Artaud declares: " ... if there is still one hellish, truly accursed thing in our time, it is our artistic dallying with forms, instead of being like victims burnt at the stake, signaling through the flames."[42] Artaud stands against forms and for forces, against the inanimate and for the animate, against disinterested spectatorship and for passionate participation in the conflict. And he knows that in such a cruel conflict, "there is a kind of higher determinism to which the executioner-tormenter himself is subjected and which he must be *determined* to endure when the time comes."[43] For "'*theater of cruelty*' means a theatre difficult and cruel for myself first of all."[44] In being composed of two arguably irreconcilable Artauds, 'Artaud' made of 'himself' a 'theatre of cruelty.' Given 'his' conviction that 'he' was robbed of 'his' true self at birth and doubled by an evil one, 'his' life engaged him as protagonist and at the same time antagonist in a perpetual and cruel agon.

It is Artaud's 'theatre of cruelty' that defines theatre for Baudrillard, as anti-representational, anti-naturalist, anti-realist, anti-moralist, anti-psychological and anti-social. His description of the theatre of the second order of simulacra — "the naturalist form" — accords with his description of "the zone of the real" which defines in general that second order. For Artaud, such a theatre is the complete betrayal of what true theatre is. For Baudrillard, the situation is more complex as, though it is a falling off from sacred theatre, it still possesses certain admirable qualities.[45] What lies beyond the second order simulacra of theatre in the third is "the pure and empty form of theater which plays with the pure and empty form of the real," where theatre is everywhere except in theatre and everything is in theatre except theatre. Here the scene of theatre is replaced by the obscene, where everyone is an actor and spectator in an acting out devoid of illusion. Of this form of anti-theatre,

Baudrillard declares: "Everywhere a stage disappears, and everywhere the poles that sustained intensity or difference are stricken with inertia."

Significantly, it is Artaud that Baudrillard also mobilises as the sole last attempt to fend off that passage beyond the first order of simulacra of theatre in his essay "The Precession of Simulacra." Here Baudrillard augments his characterisation of Artaud's theatre, in the process playing a gambit we have already noted in Artaud — declaring the Good to be only one more cruelty added to that of Evil, making the Good even more cruel than Evil. In this case, it is simulation that, as mode of 'real-ising,' is so defined by Baudrillard:

> The reality of simulation is unendurable — more cruel than Artaud's Theatre of Cruelty, which was still an attempt at a dramaturgy of life, the last flickering of an ideal of the body, blood and violence in a system already sweeping towards a reabsorption of all the stakes without a trace of blood. For us the trick has been played. All dramaturgy, and even all real writing of cruelty has disappeared. Simulation is master, and nostalgia, the phantasmal parodic rehabilitation of all lost referentials, alone remain [sic]. Everything still unfolds before us, in the cold light of deterrence (including Artaud, who is entitled like all the rest to his revival, to a second existence as the referential of cruelty).[46]

In this third order of theatre, Artaud is resurrected, albeit artificially, as lost referential in a simulation of theatre, a situation which for Baudrillard is more cruel than Artaud's own theatre. Here, there is no more drama, no more theatre, no more illusion, only the ecstasy of total exposure "in the raw and inexorable light of information and communication."[47] Here, where there is no more Artaud, obscenity begins for Baudrillard.[48]

Baudrillard provides a compelling reason for *100 YEARS OF CRUELTY* and its return to Artaud. This would not, and in any case could not, be a return to Artaud as

merely "the referential of cruelty." It would be an irrecuperable return, in accord with Artaud's 'theatre of cruelty' as the theatrical performance of the impossible. It would be a return of ineluctable, implacable necessity — at once a return of cruelty and cruelty as return — one that defines the return as such for Baudrillard: to be "absorbed in a recurrent fate."[49]

### III

Although theatre, which means Artaud's theatre, no longer exists as and in theatre for Baudrillard, he suggests that if there is any place where one might now still find Artaud's theatre, it is in terrorism. In other words, he sees theatre as having passed into another figure of the transpolitical: the hostage and the terrorist. And he writes of this in an essay whose title once again marks the importance of Artaud to Baudrillard: "Our Theatre of Cruelty."[50] At once pure form of spectacle and pure symbolic form of challenge, this theatre opposes to the violence, power and order of the real the superior power of an implosive, virulent energy that absorbs, neutralises and short-circuits the former.

But if theatre for Baudrillard has passed into terrorism in the West, it persists for him as it did for Artaud in non-Western theatre. To his two examples in *Les Stratégies fatales* — Peking Opera and Balinese theatre (the latter being Artaud's very model of Oriental theatre) — Baudrillard adds the example of Buto. Describing Buto as "the theatre of revulsion," he makes that description specific: "these larval, twisted, electric, immobile bodies, but, even then, always in a state of mental electrocution, as Artaud would say."[51] Further, he finds in Buto, this theatre "of wild frenzy," not only a game of Seduction — something singularly associated with himself — but something singularly associated with Artaud (and with himself therefore) — "the whole secret of cruelty: signs

which knot together instead of unravelling and which rivet your eyes to the ground."[52]

But Artaud lives on in a further form, one that is traditionally associated with theatre. In his 1994 essay "Andy Warhol: The Snobbish Machine,"[53] Baudrillard inscribes Artaud by transposing the nature, terms and implications of his characterisation of Artaud's theatre to the domain of art and aesthetics. Of that domain he comments earlier, in a manner already marked by his treatment of theatre: "Art has always been a simulacrum, but one which had the power of illusion ... Art was once a dramatic simulacrum where illusion and reality played an antagonistic game. Now it is only an aesthetic prosthesis."[54] In the 1994 essay, Baudrillard contrasts art and aesthetics as "the reign of the conventional management of illusion" — that of the conditional simulacrum — with that domain in which "the cruel manifestation of this total illusion of the world" is accepted and "delirious effects of illusion ... as extreme phenomenon" are cultivated — that of the unconditional simulacrum, which Warhol illustrates for Baudrillard.

Within Baudrillard's terms, I would propose Artaud as a precursor to Warhol, another non-artist who short-circuits the 'reality' of the world. If for Baudrillard Duchamp made everything art and Warhol made everything non-art, Artaud would be an unconditional simulacrum, like Warhol.[55] He not only exemplifies the first order of simulacra but goes beyond that to something prior to simulacra, for this is what Seduction, Illusion, Evil, cruelty are for Baudrillard.[56] But he would be an unconditional simulacrum *in a superior form*, what lies beyond not only simulacrum but Illusion — the pure, savage, cruel sign — fatal to non-art as to art. Thus, at stake in Artaud's work is a challenge by theatre to art and aesthetics as simulacra. Baudrillard's notion of theatre as prior to simulacra is at one with his notion of what the aim of art itself once was, that is, to posit the power of Illusion against reality, to seduce reality, even as his

notion of theatre as prior to Illusion goes beyond that.[57]

But here I would need to make a qualification. Given my proposition of two Artauds, 'he' would be both unconditional — prior to art — and conditional — committed to art. This is a way of saying that 'he' bridges the space between Seduction, cruelty — the Principle of Evil — and the orders of simulacra — the Principle of Good, as he does earlier between the first and second orders of simulacra. Insofar as the unconditional is a superior power to the conditional — as Seduction is to simulation — it would still be as fatal to art as Artaud the Irreconcilable is to Artaud the Reconcilable.

Thus, in terms of the relation of Artaud to the aesthetic conventions of our culture, including modernism and postmodernism, we need to acknowledge his relation to the premodern (indeed, to the primal). As well, I believe we would profit from an acknowledgement of that agonistic split within 'Artaud' — Artaud the Irreconcilable as 'opposed' to Artaud the Reconcilable. This allows us to say, for example, that while Artaud the Reconcilable would be the one who attached himself to the Surrealists and their aspiration to a grand reconciliation, as Breton's manifesto so cogently attests, Artaud the Irreconcilable is that Artaud who broke with the Surrealists, who was always antagonistic to them. So if one Artaud was drawn to Surrealism, another was simultaneously and always already drawn away from it, seducing the first one, more surreal than Surrealism itself.

# IV

Baudrillard and Artaud share the delirious logic, dynamics and strategy of Seduction, challenge, defiance, radical irreconcilable antagonism (agonistics), reversibility, ecstasy — that process of pushing things to their limits where they at once fulfil and annihilate themselves (which process Baudrillard also calls hypertelia). Repeatedly in

*The Theater and Its Double*, Artaud invokes this logic as the way in which cruelty, the plague and the theatre work. It is only through destruction that the cruelty of creation perfects itself, and vice versa, at once fulfilling and annihilating themselves, and with them their creator.

Here Maurice Saillet's characterisation of Artaud as "a soul torn between heaven and hell, a soul that can find the meaning and fulfillment of its perfection only in its own disaster"[58] has a powerful resonance. For Artaud, cruelty, plague and theatre lead "things to their ineluctable end at whatever cost."[59] The director, "having become a kind of demiurge" — again the Gnostic inscription — has at the back of his head "this idea of implacable purity and of its consummation whatever the cost."[60] And in a letter to Breton of 1937, Artaud gives a compelling articulation of the ecstatic process:

> The point, since we are alive, is to live by denying life, to look at things from the place where they rise and not from the place where they lie flat on the ground, to look at them from the place where they are going to disappear and not from the place where they are established in reality ... [61]

This ecstatic process of denial, defiance and challenge is what Goodall describes as Artaud's homoeopathic counter-strategy;[62] but I would propose an electro-magnetic model necessarily more destructive, a fatal strategy opposing like with like that provokes and pushes the other to its limits where it is at once completed and annihilated, along with the provoker/pusher (Artaud). Here lies the crucial distinction between critical theory and fatal theory, a distinction Baudrillard makes, allying his work with the latter, as with Artaud's fatal notion of theatre. For theory to be an event in the universe it describes, Baudrillard declares, it "must partake of and become the acceleration of this logic;"[63] and by doing so, it is fatal not only to what it outbids but to itself.

This is to say that Artaud and Baudrillard not only privilege sovereign forces that exceed the human, they seek to hyperconform to them. For Artaud, that sovereign force is cruelty, framed in terms of the Gnostic drama and ancient theatre. For Baudrillard, it is Seduction, fatality, the Principle of Evil — drawn, as we have proposed, from heretical Christianity and Artaud. And as theatre is the vehicle of that force for Artaud, theory is its vehicle for Baudrillard. For Artaud, theatre is not the double of 'reality,' 'reality' is in a sense the double of theatre; and the only reason for theatre is to challenge and defy its 'double' and antagonist 'reality', the world, the Demiurge, to exceed themselves, and in so doing, to destroy themselves. Similarly, for Baudrillard, theory is not the double of 'reality', 'reality' is the double of theory; and the only reason for theory is to challenge and defy its 'double' and antagonist 'reality', the world, to exceed and annul themselves. In a way inscribing heretical Christianity and Artaud, he writes: "Theory is simply a challenge to the real. A challenge to the world to exist. Very often a challenge to God to exist."[64]

Thus, the sole 'strategy' of Artaud and Baudrillard is their sole 'principle' — "extreme action, pushed beyond all limits."[65] And what is the end in view of such a challenge? Artaud uses theatre as ceremonial, as rite, to put, Baudrillard declares, "an end to the system of the real: such is the real cruelty, which has nothing to do with blood."[66] In so defining Artaud's notion of cruelty, Baudrillard allies it with the goal of his use of theory — to push the system beyond its limits, to seduce the system of the real.

In sum, what attracts Baudrillard to Artaud is what he sees as Artaud's dualist, non-dialectical Gnostic vision of the world as agon between Good and Evil in which the latter has the upper hand; the fundamental condition of agonistic radical irreconcilability of self with self and self with world; and the necessity to challenge, defy and provoke reality to the limit in order to end it. It is also the

way Artaud challenges the naturalist form of theatre of his era, promoting a vision of theatre as ceremonial, ecstatic and incendiary, as 'true illusion' and as itself an impassioned actor in the cosmic drama of the destiny of the world, a vision that defines theatre as it does theory for Baudrillard.

In view of the profound ways in which Baudrillard's work doubles Artaud's, as Artaud's doubles Baudrillard's, I propose that it may well be Baudrillard who, among those thinkers we associate with 'contemporary thought and culture', most keeps faith with the spirit of Artaud, which is for Baudrillard as for me that of the cruelty of irreconcilability, the ineluctable power of Evil, the violent turn of Seduction. Their sovereign forces, as sovereign, cannot but apply to themselves, as they both declare, in that irreconcilability resembling the other. Theirs is a resemblance that is cruel, a seductive delirious resemblance seducing the possibility of a final, definitive judgement of each of them as it does of what binds them.

If for Baudrillard the whole secret of cruelty is the way signs knot together instead of unravelling, we might say that the whole secret of cruelty — as of Seduction and Evil — is the way Artaud and Baudrillard knot together — 'individually' and 'jointly' — instead of unravelling. The knot of this relationship cannot be unravelled. Baudrillard and Artaud are not only absorbed but knotted in a recurrent fate, an eternal complicity.

## NOTES

1   Antonin Artaud, "The Theater and the Plague" *The Theater and Its Double* transl. Mary Caroline Richards (Grove Press: New York, 1958) 27.

2   Jean Baudrillard, *Epigraph to La Transparence du Mal: Essai sur les phénomènes extremes* (Paris: Editions Galilée, 1990).

3   This is not to say that there are not other such figures for Baudrillard, including Nietzsche, Bataille, Rimbaud,

Baudelaire and Hölderlin.

4   Jean Baudrillard, "Why Theory?" *The Ecstasy of Communication*, ed. Sylvère Lotringer and transl. Bernard and Caroline Schutze (New York: Semiotext(e), 1988) 99. *The Ecstasy of Communication* is the English translation of *L'Autre par lui-meme* (Paris:Editions Galilée, 1987).

5   The systematicity of Artaud's thought is compellingly articulated by Jane Goodall in her book *Artaud and the Gnostic Drama* (Oxford: Clarendon Press, 1994). The term "the logic of Illogic" is one Artaud himself uses to describe his "lucid unreason," as in "Manifesto in Clear Language," in Susan Sontag (ed.), *Antonin Artaud: Selected Writings* (Berkeley: University of California Press, 1988) 108.

6   *Baudrillard Live*, ed. Mike Gane (London: Routledge, 1993) 166.

7   Jean Baudrillard, *The Evil Demon of Images* (Sydney: Power Institute Publications, 1987). Baudrillard did this interview with Edward Colless, David Kelly and myself.

8   Anyone who has read the opening paragraphs of Baudrillard's *Fatal Strategies* would already sense how crucial Artaud's dualist, non-dialectical view is for Baudrillard, for in those paragraphs he declares that "the world is not dialectical — it is sworn to extremes, not to equilibrium, sworn to radical antagonism, not to reconciliation or synthesis..." See *Fatal Strategies*, ed. Jim Fleming and transl. Philip Beitchman and W.G.J. Niesluchowski (New York and London: Semiotext(e)/ Pluto, 1990) 7.

9   Baudrillard, *The Evil Demon of Images*, 43.

10  ibid. 43–4.

11  In *Artaud and the Gnostic Drama*, 30–1, Goodall notes that Artaud comes close to echoing Descartes' speculation of an evil genius, but whereas Descartes finds a way to exile that demon through faith, Artaud maintains "the dramas of dementia and gnosis in which [he] becomes embroiled with increasing passion" (31). Baudrillard takes Descartes' evil demon and relates it closely to the Demiurge of the heretical Christians, introducing that evil demon into the title of his lecture and book *The Evil Demon of Images*, just as he incorporates it in the titles of the three sections of "Les Strategies Ironiques" in *Les Stratégies fatales*.

12  *The Evil Demon of Images*, 44.

13  ibid.

14  ibid., 45.

15  ibid., 45–6.

16  ibid., 47.

17  ibid., 48.

18  Baudrillard articulates his notion of the Principle of Evil in
    *Les Stratégies fatales* and *The Transparency of Evil*.

19  Antonin Artaud, "Third Letter on Cruelty," *The Theater and
    Its Double*, 103.

20  See Anne Laurent, "This Beer Isn't A Beer," *Baudrillard
    Live*, 184.

21  Subsequent to my writing this essay, I attended the session
    on Artaud at The Drawing Center in New York City, 16
    November 1996, organised by Sylvère Lotringer, at which
    Lotringer interviewed Baudrillard on his relation to Artaud.
    At that session Baudrillard read aloud an early text he had
    written on Artaud and Alfred Jarry, a text that set Artaud in
    simple opposition to Jarry, Baudrillard allying himself with
    the latter, with the former much the loser in the
    comparison. In my terms, the Artaud that Baudrillard
    painted in that early text was Artaud the Reconcilable,
    nowhere else to be found in the Baudrillard corpus. As far
    as I can tell, that Artaud was 'forgotten' until that evening,
    when he was no sooner resurrected by Baudrillard than
    Baudrillard declared that he 'doesn't believe there is a real
    opposition between Jarry and Artaud' because 'both are
    anarchists who deal with nothingness, with the nullity of the
    world'. After this abrupt about face, Baudrillard spoke of the
    Artaud I term Artaud the Irreconcilable. In a sense the very
    process of the reversibility and transformation of Artaud in
    Baudrillard's writings was repeated by Baudrillard that
    evening.

22  Anne Laurent, "This Beer Isn't A Beer," 184. In response to
    Laurent's question, 'The theatre against hysteria?,'
    Baudrillard declares: 'You have said it. In other words, I
    would like to go back to the "principle of evil" as I described
    it in *La Transparence du Mal*. I would like to go towards a
    sort of Manichaeism.' I would suggest that for Baudrillard
    this is in a sense to go nowhere since he had abandoned
    neither his allegiance to the Principle of Evil nor his
    association with 'a sort of Manichaeism.'

23  *Le Système des Objets* (Paris: Denoël/Gonthier, Editions
    Gallimard, 1968) 67. The English translation botches it,

using the words 'seems like a theatre of cruelty,' thereby losing the specificity of the reference. *The System of Objects*, transl. James Benedict (London: Verso, 1996) 55.

24  Artaud, "Third Letter on Language," *The Theater and Its Double* 114.

25  Artaud, "No More Masterpieces," *The Theater and Its Double* 79.

26  Artaud, "Third Letter on Language," 114.

27  Artaud, "Second Letter on Cruelty," *The Theater and Its Double*, 102.

28  In that part of *Fatal Strategies* entitled "The Obscene," in the section "Figures of the Transpolitical."

29  "The Obscene," "Figures of the Transpolitical," *Fatal Strategies*, 61–2. My quotation of this text over the next pages is from pp. 62–3 of this English translation of *Les Stratégies fatales*.

30  Artaud, "The Theater and Cruelty," *The Theater and Its Double*, 86.

31  Artaud,"No More Masterpieces," 76.

32  Artaud, "Third Letter on Language," 116.

33  Artaud, "Le Théâtre de la cruauté (Premier manifeste)" *Oeuvres complètes* (Paris: Gallimard, 1976–) IV: 89.

34  Artaud, "The Theater and The Plague," 30.

35  ibid.

36  Oriental theatre, particularly that of Bali, exemplifies many of the features of theatre for Artaud, continuing the mystic mythic drama of signs, gestures, affects, where word and text are subordinated to the effects of mise en scène.

37  Artaud, "The Theater of Cruelty (First Manifesto)" *The Theater and Its Double*, 89.

38  Artaud, "Dossier du Théâtre et Son Double," *Oeuvres complètes* IV: 218.

39  Artaud, "The Theater of Cruelty (First Manifesto)," 92.

40  Artaud, "Third Letter on Language," 116.

41  Artaud, "Dossier du Théâtre et Son Double," IV: 242.

42  Artaud, "The Theater and Culture," *The Theater and Its Double*, 13.

43  Artaud, "First Letter on Cruelty," *The Theater and Its Double*, 102.

44  Artaud, "No More Masterpieces," 79.

45  He regards it as both transcendental and critical; and in terms of the latter, he sees merit in the separation of stage

and audience.

46  Jean Baudrillard, "The Precession of Simulacra,"
    *Simulations*, transl. Paul Foss, Paul Patton and Philip
    Beitchman (New York: Semiotext(e), 1983) 72.

47  Jean Baudrillard, "The Ecstasy of Communication," *The
    Ecstasy of Communication*, 22.

48  Likewise, in the section "The Hyperrealism of Simulation" in
    "The Orders of Simulacra," *Simulations*, 141, Baudrillard
    describes one aspect of the hyperreal third order of
    simulacra in terms of theatre. The example he gives to
    measure how the world has passed beyond the spectacle
    and the spectacular into the total spatio-dynamic 'theatre' of
    complete environmental and tactile communication of the
    Center of Sexual Leisure is precisely once again that of
    Artaud. In this new 'theatre', aesthesis (the ability to feel
    sensations) has replaced aesthetics. Baudrillard writes: "We
    can think of the total theatre of Artaud only with black
    humor, his Theatre of Cruelty, of which this spatiodynamic
    simulaton [sic] is only an abject caricature. Here cruelty is
    replaced by 'minimal and maximal stimulus thresholds,' by
    the invention of 'perceptive codes calculated on the basis of
    saturation thresholds'. Even the good old 'catharsis' of the
    classical theatre of the passions has become today
    homeopathy by simulation. So goes creativity."

49  Jean Baudrillard, "The Passion for Rules," *Seduction*, transl.
    Brian Singer (New York: St. Martin's Press, 1990) 148. This
    is the English language translation of *De la séduction* (Paris:
    Galilée, 1979) 203. See *Seduction*, 147, on the eternal
    return, which raises the question: does Artaud not return
    (in) Baudrillard, and vice versa?

50  Jean Baudrillard, *In The Shadow of the Silent Majorities ...
    Or the End of the Social*, transl. Paul Foss, Paul Patton and
    John Johnston (New York: Semiotext(e), 1983).

51  Jean Baudrillard, *Cool Memories*, transl. Chris Turner
    (London: Verso, 1990) 133.

52  ibid. 134.

53  Published as Jean Baudrillard, "The Plastic Inevitable,"
    *World Art*, vol. 1 (1996) 46, as well as *"Le snobisme
    machinal"* in Baudrillard, *Le Crime parfait* (Paris: Galilée,
    1995) and "Machinic Snobbery," *The Perfect Crime*, transl.
    Chris Turner (London: Verso, 1996).

54  Jean Baudrillard, "Beyond the Vanishing Point of Art," *Post-*

*Pop Art*, ed. Paul Taylor (Cambridge, Mass.: MIT Press, 1989) 184.

55 Of course, insofar as Duchamp made the banal aesthetic, he also made the aesthetic banal, thus making his relation to Warhol a more complex one than is here articulated. The scope of such a relation lies beyond the purview of this essay.

56 Given Baudrillard's 1991 recasting of the relation of Illusion to simulacrum, posing the former against the latter in all its forms and orders, his choice of the term "unconditional simulacrum" introduces for me a confusing note, since it seems to rejoin what he was at pains to separate, or at least introduces another irreconcilability. Baudrillard's 1983 characterisation in *Les Stratégies fatales* of Artaud's cruelty as prior to simulacrum seems to have been influential in this recasting, especially as Baudrillard also characterises it as prior to Illusion.

57 So if Warhol is "the snobbish machine," would Artaud not be "*le corps délirant*" — the delirious body (not what might be thought to be the Warholian body eclectic but the body electric, but where the word 'body' must be understood to include mind, soul, etc.)? '*Le corps séduisant*'?! At this point a fascinating question arises since Baudrillard claims that no artist can image his (Baudrillard's) work. Insofar as Warhol and Artaud would not be artists according to him, might they do so?

58 Artaud, "In Memoriam: Antonin Artaud," *The Theater and Its Double*, 147.

59 Artaud,"Third Letter on Cruelty," 103.

60 Artaud, "Third Letter on Language," 114.

61 Sontag (ed.), *Antonin Artaud: Selected Writings*, 408.

62 Goodall, *Artaud and the Gnostic Drama*, 107–8.

63 Baudrillard "Why Theory?," 99.

64 Baudrillard, "Forget Baudrillard: An Interview with Sylvère Lotringer," in Jean Baudrillard, *Forget Foucault*, and Jean Baudrillard and Sylvère Lotringer, *Forget Baudrillard* (New York: Semiotext(e), 1987) 124–5.

65 Artaud, "The Theater and Cruelty," 85.

66 Baudrillard, *De la séduction*, 171.

# The Art of the Crack Up

*Sylvère Lotringer*

Most lives follow a recognisable pattern that takes them, more or less smoothly, from birth to death. There may be an occasional crisis, but then one picks up the pieces and proceeds toward some sort of meaningful resolution — or to the next breakdown. The 'specific causality' of Artaud's life (which extends to his work) is that it broke down almost from the start and exhausted itself at every single point. "I don't tell a story," Artaud wrote a producer, "I simply drop one image after another, and you won't hold it against me if I only send you a few pieces."[1] Artaud only held together when he fell apart.

## The Will to Madness

It matters little in the long run how Artaud's final delirium came about. "There is no point in trying to give exact reasons for this infectious madness," he himself wrote of the plague. It would be "as much use trying to find reasons why the nervous system after a certain time is in tune, with the vibrations of the subtlest music and is eventually lastingly modified by it" (TD:16). Artaud's break-up with Cécile Schramme in May 1937 wasn't the reason for his delirium, just the last straw. It triggered something far bigger in Artaud's mind, a heightened state of consciousness that enabled him to see with utmost clarity the momentous events that still eluded ordinary perception. Indeed, Artaud would have been *mad* if his delirium hadn't made him more attuned to the world's madness. It allowed him to see, as if it had already

175

happened, the scourge liquefying society's barriers: order disappearing, clashes erupting, struggles intensifying as bodily fluids waste and the mind, like the disease, "moves on to the widest possible scale." "What does it mean?" Artaud wrote André Breton, using the prophetic tone of *The New Revelations of Being*, which had just been published: "It means that the world has come to an end, that all the forms of life are killed and the only alternative is to accelerate the abolition of forms...."[2]

In his study of President Schreber's Memoirs, Freud remarked that ideas of a world-catastrophe often occur during the "agitated stages" of paranoia, when every kind of love or recognition have failed and the patient's subjective world is abruptly coming to an end. Then the internal catastrophe, is projected outside as a way of restoring some degree of intensity to the world, even if this involves in the patient feelings of persecution and hostility. Paranoid constructions, Freud went on, are not a sign of the disease, they signal on the contrary that a process of recovery is under way.[3] (I am not assuming here that Artaud was a paranoiac, merely that he experienced paranoiac episodes. Freud himself recognised that paranoid symptoms are often combined in any proportion with paraphrenic or schizophrenic phenomena.)

Artaud's theatre never had any use for individual psychology and I don't see why his own disease should be treated differently. The cruelty he orchestrated on the stage as well as on his own body always went beyond his personal predicament. It was a question raised to the culture at large, as Lacan once said, that the hysteric's body was a question mark addressed to the entire medical establishment. This also holds true for his delirium. Freud never denied anyway that "the paranoiac perceives the external world and takes into account any alterations that may happen in it, and the effect it makes upon him stimulates him to invent explanatory theories."[4] Whether or not these theories actually account for the alterations

that are happening in the world is what makes all the difference between pathological symptoms and a visionary apprehension of contemporary reality.

Artaud's vision of the end of the world was certainly in keeping with the internal collapse he was experiencing, but the "Destruction of the World" was effectively the order of the day. The "Fires of the Furious Spirit" which he perceived were already engulfing whole nations. Signs of the Apocalypse were not difficult to find either: on 13 July 1937, fights were erupting in Paris; on 25 July the war in China took on a catastrophic turn ("because," Artaud wrote, "the 4 dates which come after that represent the square root of the visible, the world of reality"). In Spain, Franco was crushing the Republic. Revolutions, bloodshed were happening everywhere. The transmutation of values had begun, and it would be "fundamental, absolute, terrible."[5]

These were the revelations that kept pouring out of Artaud and they demanded instant action on his part. Just like Christ, Artaud urged all his friends to take sides. Those who were with him would be spared. As for the rest.... And then, St. Patrick's cane in hand, he embarked for Ireland. St. Patrick was the first Christian missionary to defy paganism in the fifth century and successfully manage to convert the people of Ireland. The explicit purpose of Artaud's journey was returning the saint's cane to the Irish. But his real drive was to force his destiny and redeem his badly damaged career by a heroic gesture.

A state of "perpetual fulmination" seemed to have possessed him at the time, but he kept intensifying it even further: "This anger which uses me and that with every passing day I learn to use better for my own purposes, it has to mean something. In my anger I am not alone, believe me," he wrote André Breton. "There are people around me who speak to me and who give me orders ... To consent to burn as I have burned all my life and as I am timing right now means acquiring the power to burn as well and I know that I was meant to burn and I believe

I can say now that few angers can reach where my own
anger will rise ... Between the anger of a furious spirit and
the devastating force of all the fires there's in fact no
DISTANCE."[6]

It was the *Enraged One* who was speaking. His anger
was taking him way beyond his own failures and
limitations. It was power. Artaud had advised actors to
build emotions into entire selves the way boxers build
their muscles. These emotions were not their own, but
could be mobilised at will for specific purposes. Artaud
was now doing just that. His anger was helping him build
an "affective organism" distinct from his own. This is what
his delirium, ultimately, was about: he was raising above
himself to the point of sacred fury. For the first time he
felt in control of his own life. He was so angry that he
could respond instantly to the slightest provocation.

It mattered little whether he was being fair or not,
what side he was with, and what cause he was fighting for.
He had reached this heightened state of fury that cut
through everything like a knife. And he would maintain
this state whatever the cost, wildly swerving from pagan
gods to God Almighty, from lyrical effusion to absolute
hatred, hitting Left and Right with some kind of intense,
liberating jubilation: "Tell them that I shit on the republic,
on democracy, socialism, Marxism, idealism, materialism,
dialectical or not. I shit on the Popular Front and on the
Government of Popular Union, I shit on the International,
1st, 2nd and 3rd, but I also shit on the idea of Fatherland.
I shit on France and on ALL the French ..."[7] It was a
roaring fire that devoured both him and the world and it
would leave absolutely nothing behind. He certainly was
as he claimed to be "a dangerous man because I don't fear
anything."[8]

This is indeed the way he appeared to the people who
approached him in Ireland. All through his Gaelic
expedition Artaud was in such a state that he would pick
fights everywhere he went. He was ready to explode at the
slightest touch, the way fanaticised crowds all over the

continent were being heated-up to the point of murderous fury.

Artaud found the perfect excuse to explode in the person of Lise Deharme, a wealthy socialite who had tried to help him raise money for his Theatre Alfred Jarry a few years before. It bad been an impossible task, of course, Artaud openly showing his contempt for the patrons of the arts gathered at her home to hear his pitch. Lise Deharme, nee Meyer, was a whimsical, flirtatious, but ultimately elusive woman and writer. She happened to be the "lady of the glove," Breton celebrated in *Nadja*, alluding to the pale blue suede glove she had pinned on the wall of the Surrealist Bureau as a card after her first visit. For a few years, fuelling his poetic fire, Deharme became Breton's exclusive extra-marital obsession which, embarrassingly, never went anywhere. Before leaving Paris, Artaud had a heated argument with Lise Deharme who doubted the sincerity of his pagan beliefs in a plurality of Gods and called him a "mummer" and a "quack." The first "spell" Artaud sent from Ireland was fired at her.

## Spells of Madness

Spells [*sorts*] are pieces of paper filled with cabalistic signs, black smears and vehement injunctions that Artaud would quickly scratch down in a fit of rage and randomly burn through with a cigarette. The message he sent Lise Deharme was incredibly abusive: "I'll ram a red-hot iron cross in your stinking Jewish sex and then I'll MUMMER on your dead body to prove to you that there still ARE GODS!"[9] Artaud's reaction was way out of whack with the argument that had triggered it — all the more so that, just a few days later, no doubt influenced by the devout atmosphere prevalent in Dublin, Artaud himself renounced his pagan gods to embrace the God of his childhood.

Their argument, in reality, was far less theological than political. It also happened to involve André Breton, in a complicated way. Lise Deharme flirted with the revolution and approved of the Spanish anarchists, just like Breton. Now Artaud had publicly broken up with Breton in 1929, strongly disagreeing with his desire to turn the Surrealist group over to the Communists. Breton had publicly stigmatised Artaud as a madman. The two men had finally made up after Artaud came back from Mexico and from then on Artaud treated Breton with unabashed admiration, building him up as a God, a true visionary, a *poète maudit*, unrecognised, if not persecuted, in short, an exalted version of himself.

From Ireland Artaud kept sending Breton a stream of fawning letters endowing him with a truly mythical stature. Yet he didn't hesitate to enclose his virulent spell to Lise Deharme in one of his letters to Breton. It is difficult to believe that it was not an act of hostility towards Breton, whose *amour fou* for Lise Deharme was well known. Was Artaud trying to draw a wedge between them, or force Breton to rally to his side, as he had enjoined all his friends to do? Anaïs Nin believed that Artaud was a homosexual, and Artaud's delusion of emasculation, his 'Redeemer' fantasy, his overestimation of Breton (as Dr Schreber deified Professor Flechsig) would neatly fit Freud's interpretation of paranoia. Artaud's excessive reverence toward Breton, was in any case, definitely suspect. At the very least, it showed a definite ambivalence. But maybe it was an extreme case of what Artaud called "absolute radical humour." (OC, III: 80) Artaud may have perfectly realised that Breton still considered him a madman, and upped the ante accordingly to catch him at his own game. Who, if not a madman, would have claimed for years to come that Breton had made a heroic attempt to rescue him from the hands of the police, in Le Havre and was killed by a machine-gun? Breton's attraction for madness, but his distaste for madmen (and madwomen) was not a secret. It

is the subject of *Nadja*. True to himself, Breton refused to pay Artaud a visit after he was transferred from Le Havre to the St-Anne asylum in Paris, alleging that Artaud didn't need anyone any more (it is Jacqueline Breton who ended up going to St-Anne instead). After the war Artaud managed to tell Breton to his face that he, Breton, had been killed in Le Havre. What could Breton do but flatly deny the fact? Artaud never spoke to him again after that.

Like a number of young women who hung around the Surrealist group — Cécile Schramme, her friend Sonia Mossé, but also Breton's first wife, Simone Kahn — Lise Deharme happened to be Jewish, and Artaud's anger against her immediately took on ominous overtones. Artaud wasn't especially anti-semitic, actually far less than most of his contemporaries, but he didn't have to dig very far in his own background to find fuel for his sudden hatred. With the delirious syncretism common to all antisemites, Artaud accused Deharme of plotting with the Left *and* with Jewish *and* Catholic capitalism, and predicted she would be publicly massacred for having spread the word around that he, Artaud, was a fake.

This terrible prediction, fortunately, remained unfulfilled. Artaud wasn't quite as lucky with another spell which, for reasons still unclear, he sent to Sonia Mossé, another young painter and dancer with whom he had a brief affair after breaking up with Cécile Schramme. Artaud once confided in Jacqueline, who was also Sonia Mossé's friend, that he had an "insoluble" problem. He couldn't decide if Sonia would still love him knowing that he couldn't "OR WOULDN'T WANT TO" have sex with her. This was hardly a new problem for Artaud, in any case not of the kind that warranted a death sentence. Yet the spell Artaud sent Sonia unleashed on her as well the force of death: "You will live dead, you won't stop dying and going down," he fulminated in his message.[10] This didn't prevent Sonia Mossé from visiting Artaud while he was transferred to the Ville-Évrard asylum, near Paris. Later on, in October 1943, Artaud sent her a warm letter

from Rodez (Sonia had also been a patient of Dr
Ferdière). But Artaud's letter arrived too late. Sonia had
just been deported to a concentration camp in Germany.
She died shortly after in a gas chamber.

Artaud intermittently sent a number of these spells
over the next few years, either to protect his friends
against the coming disaster, or explode in the face of his
enemies, and they were innumerable. Although, strictly
speaking, Artaud's spells are not artworks, being aimed at
one person only, they were the essence of his art which,
like magic, instantly does what it says. "Magic always exists
for dissatisfied men," Deharme happened to write in one
of her dream-like stories. And she added: "Actually,
everything is magic. This pack of cigarette, this magnifying
glass ... "[11] And it is true that magic can dwell in anything.
Artaud warned Anne Manson, a young journalist he had
met a month before, to hang on to her fountain pen. "It
will protect you and this one you can definitely touch" (an
allusion, among other things, to his virile cane).[12] Clearly
Artaud was dissatisfied when he left for Ireland, but there
certainly was a huge satisfaction in smearing and burning
Deharme in his mind. This frenetic message, though, like
the ones to come, wasn't meant to exhaust itself into an
action, as a murderer's rage perpetrating a crime loses
contact with the power that inspired it. Like the actor's
fury, "totally penetrated by feelings without any benefit or
relation to reality," it achieved the force of a true epidemic
by detaching itself from the actual action. (TD: 49).

The spells were precise, rigorous, and utterly
devastating. They burned everything on their way, like a
prairie fire, including the one who started it. That was, in
any case, the perfect answer to Lise Deharme's threat of
having Artaud "burned like a sorcerer," which happened
to be his most ardent desire. Although Deharme's anger, it
seems, had been quite violent as well, it couldn't possibly
reach where his own anger rose ... "Just as it is not
impossible that the unconsumed despair of a lunatic
screaming in an asylum can cause the plague," Artaud

wrote in 1933, "so by a kind of reversibility of feelings and imagery, in the same way we can admit that outward events, political conflicts, natural disasters, revolutionary order and wartime chaos, when they occur on a theatre level, are released into the audience's sensitivity with the strength of an epidemic" (TD: 21).

"Very violent and very nasty and dangerous to himself and to others" was the diagnosis that was thrown back at Artaud after his arrest in Le Havre.[13] Artaud was that, and more. Utterly broke and unable to pay his keep, he expected to be given hospitality in a monastery, having just received the Holy Communion. And he became enraged when he was refused entry. The famous cane was lost in the scuffle. The next day he found himself locked up in the Mountjoy Prison in Dublin. One week later, he was shipped back to Le Havre and this would have been the end of that if another fight had not erupted on board with two crew members he accused of being in cahoots with the police. This decided his fate. Upon arriving in Le Havre, he was carried away in a strait-jacket to the local psychiatric ward with the diagnosis of "persecution mania" and "hallucinatory crisis."

## Sinister Years

In October 1937, Artaud was started on the long bureaucratic journey that was to take him from Le Havre to Rodez. On his mother's request, he was moved from the local asylum at Sotteville-les-Rouen to Sainte-Anne in Paris, where he was subjected to round-the-clock surveillance. The diagnosis was basically as before: delirium of the paranoid type, ideas of persecution, fear of poisoning, split personality. Dr Jacques Lacan examined him and judged him "fixed" for life; he would never write again, he concluded. Artaud was moved in a strait-jacket to a more permanent home, Ville-Évrard, in a nearby suburb, where he was mostly left to rot for the next four years.

For the first ten months of his stay Artaud appeared to have been relatively well treated. It is during this period that he sent his last series of spells, at least the ones that have been found. But his mental condition hadn't improved. He was besieged by demons who attacked him every night. His shrieks and exorcisms were so loud he had to be put in a private room. He felt invaded by Doubles he called Bohemians or Initiates. Initiates were everywhere and secretly ruled the world behind empty figureheads. Sexuality was their most powerful weapon. Artaud's friends and doctors alike hosted bad and good Doubles who constantly fought each other and often exchanged roles. It is at that time that Artaud struck up a friendship with Dr Léon Fouks, a young intern who paid him frequent visits, taken in by the patient's rich and complex "confabulations." In May 1939 Artaud handed him a protective spell written in purple ink and coloured pencils. Most of this spell was occupied by circling clusters of signs which were crossed vertically by a red pencilled strike standing for divine light. Symbols of space and time were floating on both sides among angels of the Apocalypse. The inscription itself sat at the bottom of the paper, which was burned at random. Artaud would also occasionally send Dr Fouks injurious letters addressed to HIS own Double, which added to the confusion. The best protection against Doubles, though, Artaud claimed, was providing HIM with a special kind of drug, "Heroin B," which would give him the strength of breaking any spell. This didn't prevent him from trying to procure some opium from Anne Manson. The young woman tried to sneak in some, but visitors were meticulously searched, and Artaud never managed to get any drugs. The best way of warding off Initiates, of course, was to remain chaste and Artaud became furious when he believed Anne Manson, during her visit, had been raped by the two Head Psychiatrists. The next day he gave Roger Blin, a close friend and comedian, a vengeful spell in large regular handwriting, but with coloured pencil and watercolour addressed to Anne Manson. It threatened to

hollow out and burn the marrow of her alleged
persecutors. The spell itself was copiously burnt on several
sides and across the writing.

It has often been said that Artaud was spared the war,
that he remained cut off from the world, locked up in his
own madness, twice irresponsible. Nothing is further from
the truth. Artaud's delirium had a lot to do with the
monstrous travail that was bringing the culture on to the
brink of disaster. His paranoid universe, of conspiracions,
mind snatching, body replicants, secret poisonings,
persecutions, of cosmic fights between demonic forces
and divine will, were easily matched by the world outside.
In September 1939 the panzer corps rolled over Poland
and the war broke out. For Artaud "IT WASN'T WAR, BUT
APOCALYPSE." He wasn't far from the truth. Is it
surprising then that he would immediately send a spell to
the Chancellor of the Reich, slyly exhorting him, as a
powerful Initiate, an agent of evil, to get on with it and
roll over France as well? "Parisians need you," he wrote,
threateningly, reminding him that they had met in 1932 at
the Romanische Cafe in Berlin to discuss strategy around
a military map. (The spell was simply written at the back
of a letter, with two big burns right in the middle of big
cabbalistic signs). Then Artaud added that "the purulence
of French Initiates has reached a paroxysmic spasm,"[14] but
that Hitler knew it didn't mean that he understood what it
meant. However formidable his might, Artaud believed,
Hitler could never be the Prince of Destruction since only
Christ himself could be that. Christ could destroy the
World because He was doing it out of a huge force of love.
To be cruel, one had to be enlightened, and Hitler wasn't
enlightened. He was just this brute force. All the Antichrist
could do with his power of destruction was to play into
the hands of God. This was the Higher Design the
Enraged One had been chosen to reveal to the World in
the name of Jesus Christ. But this Christ wasn't the Christ
worshipped by the Catholic Church. He was the One
whose mission was to return Christianity to the

Catacombs. Because without Death there could be no
Rebirth. And it wasn't madness to believe that, Artaud
reminded us, "IT WAS FANATICISM." The horrible
circumstances that we are experiencing, he wrote, "are
indeed CRUCIAL, but not politically; they are so
RELIGIOUSLY ..."[15] Artaud knew that the war, any war,
was a religious war.

Artaud experienced the war in other ways as well. The
black plague that was devastating Europe affected him in
his body as well. After most of the hospital personnel left
for the army the situation at Ville-Évrard degraded
steadily. Patients were regrouped in overcrowded
dormitories, most slept on the floor. On June 14, 1940 the
Germans entered Paris and Artaud's friends scattered.
Artaud expected the worse. He read in the papers about
the massacre of mental patients in Poland. But the
Germans merely showed up for a quick inspection and
left it up to the French themselves to finish up the job.
Soon after, funds for psychiatric hospitals were cut off.
Food became an acute problem. It wasn't long before
psychiatric hospitals turned into death camps. From Ville-
Évrard, Artaud let his mother know that he was in a
desperate condition. "I am wasting away with despair,
weakness, fatigue, starvation, and especially ABUSE ... I
live here in the throws of death ... and reading your letters
I see that you have not REALISED the complete horror of
my situation."[16] Marthe Robert, who visited Artaud in
Ville-Évrard, remembered it as a charnel house. "Patients,"
she said, "were dropping like flies."[17] Forty thousand
mental patients died in French hospitals during the war,
and Artaud would certainly have died as well if Robert
Desnos, alarmed by his extreme condition, hadn't
managed to have him transferred to a safer hospital down
south directed by one of his friends in Rodez. (Desnos
himself died in a concentration camp one year later.)

It took half a century for the truth about the "soft
extermination" to come out in the open. Yet, curiously, it
is Artaud in Rodez that has captured the imagination and

become the focus of endless controversies. Why? For one, most of the letters and administrative documents pertaining to this period in Artaud's life are either lost, inaccessible or as yet unpublished. They would make drab reading anyway, grey and depressing like the Occupation. The story of resistance and liberation, of resilience to adversity, of genius overcoming madness started much later. It presented an upbeat version of life redeemed, of art triumphant. It was the stuff of myths, and myths were Artaud's natural element. But there was nothing mythical about Ville-Évrard. Like the Vichy regime, it had no redeeming value.

When Artaud made it to Rodez in February 1943, he was a "living corpse." Years later, when the news about the death camps started trickling down, he made a point of hammering home the connection: "I wouldn't have dared talk to you about your deportation in Germany in 1942," he wrote a friend shortly before leaving Rodez, "if circumstances hadn't put me like you in a CONDITION of deportation ... because not only was I a DEPORTEE, but I was institutionalised as well ..."[18]

## The Shock Of Rodez

The Rodez asylum was located in the French free zone temporarily spared by the Germans. The director of the asylum, Dr. Gaston Ferdière, while in Paris, had rubbed shoulders with the Surrealists. He knew who Artaud was, and gave him a special treatment. He invited him to share his table, giving him a room of his own and food in bearable quantity. A poet himself, Dr. Ferdière would never have called Artaud's scribblings "graphorrhea," as previous psychiatrists had done. The fact is, Artaud didn't seem to write anymore — no one realised that his considerable correspondence WAS his writing. Dr. Ferdière worried that the poet had turned into a vegetable.

At first Artaud was elated to have found in the doctor a friend. Dr. Ferdière had some anarchist ideas, and contacts with the resistance. But in him the petty bureaucrat often took over. He intercepted Artaud's mail, withheld his royalties, autocratically decided on his patient's fate. His criteria of normality, somewhat loosened up in the capital, had become rather provincial. His patience with Artaud's idiosyncratic behaviour quickly wore thin. Artaud had, of course, all kinds of intricate ways of breaking spells, chasing away demons and temptations: he would spit behind the back of Dr. Ferdière's wife, curse his assistant's wife, who was shamelessly pregnant, scratch a special point on his back, screw the top of his head, sniffle, sneeze, groan and mumble, break into a loud song or launch into endless tirades. Although not exactly 'normal,' none of this made Artaud "violently anti-social, dangerous for public order and the security of people," as Dr. Ferdière later alleged, responding to relentless attacks from Artaud's friends.[19] Artaud claimed that he had been unfairly punished for practicing some of the exercises of "affective athleticism" he had recommended in the *The Theatre And His Double*. Ironically, the volume was becoming quite a success in Paris. But Dr. Ferdière wasn't convinced. The overall picture was bleak. The man was obviously blocked, a prey to endless delusions. Since 1941 Artaud believed that Artaud had ceased to exist and another man, Antonin Nalpas (his mother's maiden name) occupied his body. In his long and confused attempt to shake loose of his identity, Artaud identified with all sorts of people who had anticipated his own predicament, Jesus-Christ one day — but the real Christ, Antonin Artaud, not the crank who was being worshipped by the church as Jesus-Christ; then Solomon, St. Hippolytus, Anaximander, Alexander, St. Jerome or to Antoneo Arlaudor, alias Arlanopulos, a Greek character born of an officer who died of syphilis; he even became the Irish citizen who had mistakenly been arrested in Dublin in lieu of Antonin Artaud. These

delusions were not as new or mad as they would seem at first. Oftentimes Artaud had identified in his work with a number of names in history, Paolo Uccello, Abelard, St. Francis, Heliogabalus, André Masson, scores of other artists, writers or saints he considered his natural allies: Van Gogh, Lautréamont, Gérard de Nerval, Edgar Poe. Having never felt comfortable in his own body, he often traded his for those who had anticipated his own predicament. This is what he used to call a "mental drama," and it was at the root of his theatre. Mental drama was bleeding over his life, but it was just one step further in the same direction. For Dr. Ferdière, that was typical "paraphrenia," meaning that Artaud could be quite rational about things, and suddenly drift into convoluted fabulations that he seemed to be taking at face value. But one never knew for sure. Was Artaud really serious when, after the war, he told André Breton to his face that he had been killed in Le Havre, trying to rescue Artaud from the police? Some of these delusions were an extreme example of the kind of "absolute radical humour" he appreciated in the Marx Brothers. And maybe he didn't know himself when he was just playing at being Artaud, which could be a definition of madness.

Dr. Ferdière was convinced that a judicious mix of Art-therapy and electroshocks could restore to Artaud some of his creative powers. Both techniques were quite new at the time. Seismotherapy was known in Europe, but had hardly penetrated in France. Dr. Jacques Latremolière, the intern in charge, was writing his dissertation on the electroshock treatment. Artaud still being weak, Art-therapy was started first. That was Dr. Ferdière's pet project, and he skilfully attacked it from several fronts, first asking Artaud to respond to a poem by Ronsard, "The Hymn to the Daimons," which echoed Artaud's delirium. The patient's answer, barely two months after he had arrived in Rodez starved and prostrated, was encouraging. Later on, Dr. Ferdière commissioned the asylum priest, L'abbé Henri Julien, a connoisseur in English poetry, to

help Artaud translate poems from Shelley, Keats, Southwell, or Lewis Carroll, and these often turned into texts of his own darker vein. Early on Dr. Ferdière also put him in touch with Frederic Delanglade, a painter who had recently emigrated to Rodez, and both encouraged Artaud to draw with charcoal and coloured pencils. Artaud's first drawings, however, only came after he was administered two series of electroshocks.

Electroshocks are a controversial form of therapy, the damage they cause on the brain remaining mostly undefined. It is a spectacular treatment which throws patients into violent convulsions, then in a temporary coma out of which they emerge in a very confused state. This condition may last for weeks and involve a partial loss of memory, meant to help patients "reconstruct" their personality. Each time Artaud was subjected to electroshocks, and he was given five series, fifty-one shocks in all over a two-year period, he would stop writing for weeks. They would turn him, he said, into "an absent who knows that he is absent and spends weeks looking for his own being, like a dead person beside a living person who is not him anymore, who requires his return and yet forbids him to enter."[20] In their early applications, patients were not "prepared" beforehand and convulsions often provoked significant damage. Artaud immediately fractured a dorsal vertebra and kept complaining of horrible pains even after recovering in bed for two months. He remained terrorised by the prospect of renewed electroshock application and never forgave his psychiatrists for having administered them in spite of his protests and supplications.

Yet each time they seemed to have brought a marked improvement in his mental condition. In September 1943, Artaud recovered his own name and his incentive to create. Soon after he wrote his first text, "Kabhar Enis — Kathar Esti," a mystical commentary on what is left of the Infinite, which is God, in language. Glossolalia, which suddenly appeared in his writing, was this "transcendental

language" in which something of God's Word can still be manifested. Pressed by Ferdière and Delanglade to draw from imagination, Artaud started his first series of charcoal drawings in February 1944, where similar concerns are perceptible. The first two untitled pieces are a meditation on the problem of Creation and Redemption, the unbridgeable "beat" that exists between Heaven and Earth, which Evil has come to fill. In both drawings the World is a finite place, a piece broken off from God and promised to Death. The Eternal above offers a more complex and sublime version of the Nothingness below, white and triumphant crosses standing in the sky among signs of the Infinite. A few spare black crosses on earth merely signal the solitary death of a Being or the sacred horror of a skull lying on ancient burial ground, closely corseted by signs of Destruction. In the third drawing, the short sword Artaud had been given by a Cuban sorcerer on his way to Mexico is represented along the same vertical axis, the blade aimed at the world down below while the handle is raised like a cross with its three hooks and seven knots attached. It is the sword of the Apocalypse. It was getting even nearer every day. The actual sword had just been returned to Artaud, and the hooks could be seen as well in the first drawing mixed with signs of Infinity right below the geometric pile of sword-like crosses.

Artaud had returned to Catholicism with a fanaticism that shocked even Dr. Latrémolière, who himself was a devout Christian. As for the priest, Henri Julien, he happened to have strong reservations about Artaud's compulsive urge to confess and kept avoiding him like the plague. Even in this region still redolent with Albigensian beliefs, Artaud's fiercely Manichaean outlook seemed pretty extreme. Like Freud, Artaud saw sexuality everywhere, but condemned it in absolute terms. He was aching for an angelic form of conception that would put an end to the abject needs of the body. Sexuality was Artaud's lightning rod, the only firm anchor for an

otherwise endlessly shifting cosmogony. He kept inventing systems of political and religious bewitchment of cosmic dimension in order to account for what for him remained inadmissible: that he, Artaud, like everyone else, had human desires. In the following months, Artaud's ideas of a world-wide conspiracy instigated by the Initiates, which involved exerting "sexual black magic" on his own body, reasserted themselves and with them his peculiar exorcising rituals. Once again he felt that he had lived successive lives and was now harbouring in his own body another conscience different from his own. As a result, from May to December 1944, he was forcibly subjected to another series of shocks, two in May–June, twelve in August. And this time it was his religious beliefs they started shaking.

Artaud was gradually getting cured of his faith, but not of the religious impulse or the "intentions of purity" which formed its unshakeable foundation. Every night an army of succubi and incubi drawn from people of all races and nations were coming to overwhelm his consciousness and submit his body to obscene manipulations. It is during that transitional period that he started the big coloured drawings which are his first consistent attempt to create a new body of work out of the disaggregation of his own.

What strikes at first in the pieces he made in January 1945, *L'être Et Ses Foetus, Jamais Réel Et Toujours Vrai, L'immaculeé Conception, La Pendue*, is the proliferation of lightly pencilled figures, each separate, which simultaneously occupy the entire surface of the paper. *L'être Et Ses Foetus* is the teeming Laboratory of the Flesh where a monstrous delivery of organs is being orchestrated, foetuses, penises, bones, viscera, erected breasts forming a grotesque body in exoscopy around two copulating couples intertwined flat on their back right in the centre of the drawing. The verticality of the surface, like their bodies, is reinforced by "sentences inserted in the forms in order to precipitate them."[21] This is the first of the "written drawings"

which attempt to crystallise on paper the various means, verbal, rhythmical, graphic, ideographic involved in the construction of a CRUEL scenic space. As happens in Artaud's theatre, the "anal crime of being" that was being enacted on this unlikely stage had to be presented in the most concrete way, LANGUAGE INCLUDED, everything deliberate and compressed, with the strict impersonality of gestural hieroglyphics. And the busy surface, pulsating and anarchical at first glance, precipitates in a rigorous composition around the action that is being consummated. Clusters of broken glossolalic expressions come to relay horizontally the long vertical sentences that run parallel to the monumental bone-like columns standing in attention on both sides of the "uterine viscera." The copulating bodies are surrounded by rows of sun-like pictograms, or enticing female bodies in various stages of decomposition. Down from the centre a first couple is crudely represented, graffiti-like, in some sort of rigid, death-like embrace around a prominent vagina out of which a foetus has just been expelled; the other couple higher up is barely suggested, a pure meeting of reproductive organs encased in a coffin-like shape or a more machinic device suggesting the unnaturality of any genesis. Like the "other stage" of the unconscious, *never real and always true*, sexuality is always the matrix of all possible forms. The half-fast embrace right at the centre in its unbalanced symmetry explodes all around in emblematic replicas, what seems to be a row of sacred scrolls higher up, decomposed pieces of flesh on the side, a totemic trunk of a man to the left, figures whose rebus-like quality is reinforced by the pun in the title, ART/RA-TEE.

In February 1945, Artaud stopped making his large drawings for five months and began the Rodez Notebooks. These were an intense outpouring of self and cultural analysis written at the speed and pitch of automatic writing. Scribbling constantly, school "cahiers" stuffed in his pockets, Artaud filled some 3000 pages of these notebooks before his death. Drawings and pictograms became an integral part of the text, which Artaud described

this way: "I still write, but personal psychological notes which turn around a few remarks I've made on the depths of the human unconscious ... its secrets and repressions ..."[22] What Artaud discovered in the depth of the human unconscious was that the self is not tied down to a unique perception, it is no longer unique, or experienced in an absolute corporeal space, it is scattered throughout the body. Human beings can sometimes be a knee and sometimes a heart, or a foot; sometimes they can be urine, and sometimes food, or sperm, or idea. Furthermore, Artaud went on, they don't have to be SCATTERED in their own body, but lie in the outside of things, around their body, "like a dead person forgotten by his body and swimming around his body," beside it, beyond it, without it. "The being who doesn't experience himself as the whole of himself doesn't make the error of identifying with this himself, spirit, idea, conception, notion, which floats in one point of the body, instead of being himself his own body and at every moment all his body."[23] If one were to abandon all religious ideas and dogmas, one would discover that it might in fact be possible to experience the soul directly. So on 1 April 1945 Artaud officially renounced the Catholic faith and all religious beliefs. Free of any faith, Artaud was now looking for a soul that could be the body, a body that could be the soul.

In September 1945 he began to draw again and continued drawing until he left Rodez the following year. The last series of Rodez drawings all chronicle a search for a new anatomy on which to ground "the sobbing music of the soul" (OC, XVIII: 73). In *Couti L'anatomie* the human body is no longer unique, or confined in its own space, at the centre of the drawing one can see two legs raised toward the sky like a tree or acrobatically suspended like a torso on the coccyx. The soul is no longer an abstraction, it is nailed in the holes of the two feet and fighting its way down, painfully, through the legs leaving bloody traces in its wake. By a paradoxical movement, raising itself up from bone to bone and box to box, the soul wages an

upward battle to root itself far below, in what appears to be a formless body part, or a truncated torso which stands precariously on the ground like a twisted column of flesh. On both sides of the torso, the shoulders are lying each in their own boxes of bone, except that the complete body so far denied is now shown twice lying down in a diminutive size inside of each shoulder, a naked woman on one hand, a male body on the other. Other organs are also scattered outside, the red case of the heart to the right enclosing another upraised being and a "totem of being" (XXI: 267) to the left falling like a rocket toward the left shoulder box. In this series of drawings, language has all but disappeared in favour of a complex ideographic vocabulary mixing a variety of cultural traditions: Egyptian sarcophagi, pre-columbian figures, prehistoric inscriptions, Indian totems, mechanical diagrams. In many of these pieces coloured chalk has also been introduced as a marker of intensity, the brown indicating the fragility of the flesh, the bloody dots emphasising the sobbing struggle of the soul. The sexual organs stand apart, the close up of a penis caught between two sets of female organs. Their blue colour suggests the horror of scatological existence.

But there are no red dots on sex; obviously the soul doesn't dwell there much. Although Artaud is making a powerful statement about the perception of the human body and the nature of the soul, his humour is also perceptible in the flippant reversal of bodily values, identities, and positions as well as in the multiple visual punning. The bleeding heart is red, the tooth is uprooted, the torso is twisted, total bodies are enclosed in body parts, sexual parts are cut from the rest. This is the 'body without organs,' the affective athleticism of the schizophrenic soul. Yet there's a sense of mischievousness as well — schizo-humour — in Artaud's offhand way of reconfiguring the body so that sex itself is disembodied, or worse: quarantined.

Experimenting on the human body simultaneously

opened up the possibility of a new design for the drawings themselves. Why should drawings draw uniquely on their internal composition when their source of energy may lie elsewhere as well, in the breath, voice, dance, in all the emotional "muscles" that the artist had to build in order to extract from the hand a gesture that will crystallise all the forces scattered outside of the paper? The challenge to the body-image suddenly called into question the purely aesthetic criteria of drawings, their image-value as 'successful art objects.' If what counted most was not the finished product, but the emotions that preside at their elaboration, drawings should cease to stage themselves as drawings, and present themselves instead as a *document* of everything that had to be eliminated in order to be what it became. Any drawing gives access to the emotion that generated it, but that emotion has to be recreated for oneself, one has to "look and understand what is INSIDE" the drawing (XXI: 266) Only by keeping intact "the piteous awkwardness of the forms"(XIX: 259), their rough edges and intensive features, can the drawing resist the pull of ideas that would irremediably smooth them away. It is at that point that Artaud began to suspect that, for the first time in years, he had managed to do 'something special' comparable to what he had achieved in his books and in his theatre. And he began to take them seriously for his art as well as for his future income, hoping to be freed, soon, from Rodez and back with his friends in Paris.

## Paris Portraits

One of the conditions Dr. Ferdière imposed upon Artaud's release was that he be financially independent. A prestigious benefit performance and the auction of works by well-known artists and writers took care of this. As soon as he arrived in Paris, Artaud took residence in the private clinic of Dr. Achille Delmas, in a Parisian suburb,

from which he could come and go as he pleased. Artaud covered the walls of his room with haunted drawings and, hammer in hand, could be seen nailing his poetry away onto a tree stump.

Artaud's old demons, spirituality and sexuality, were still there, though, and in *The Return of Artaud, le Mômo* (1947), he addressed the scandal of his uncalled-for conception. Back from Rodez, his indictment of society had become far more strident, compounded with an intense aversion to psychiatry. In *Van Gogh, The Man Suicided By Society* (1947), Artaud gave a step-by-step analysis of the way psychiatrists insidiously manage to crush genius in their patients. In this light Van Gogh's self-mutilation makes perfect sense: Van Gogh cooked his hand, severed his ear and shot himself in the stomach not out of guilt, but to reclaim his own body.

Mutilation doesn't have to self-inflicted. Time also attacks the body as an acid attacks a plate, but in a more subtle, gradual, impersonal way. Emotions also have this devastating effect. One of the last drawings Artaud did before leaving Rodez, in May 1946, was called *The Blue Head*. It wasn't exactly a portrait, although Artaud focused his attention on a woman's face. The woman, in fact, is barely recognisable so distorted are her features. It is a portrait of the distortion itself. Blue is the colour of fear, and terror is directly caught in a silent shriek. The project was rather paradoxical: making the portrait of an affect. Affects being faceless, they don't belong to anyone, and can also lift any face for their own purpose, turning them to their own faceless face — just an intense emotion which brutalises the features and provokes a temporary mutilation. But this alteration doesn't reclaim anything, the affect blows furiously over the face and leaves no trace behind. There's no doubt that there is in *The Blue Head* a good deal of the terror Artaud himself experienced as he was strapped to the electrodes. The distortion that catches the mouth in a silent maelstrom, the poked skin, the blue and pink hair hanging limply on the side like an arm that

has just been shot, the trembling of the lines, the smearings of the surfaces, the black spots sprouting everywhere, this is the kind of disease that cannot be resisted. Inscriptions framing the drawing at a distance from a column of glossolalia indicate the name of Artaud's "six daughters of the heart still to be born: Anie Faure, Catherine Chile, Neneka Chile, Cécile Schramme, Yvonne Allendy, Ana Corbin" — a family according to his heart, made of all the women who ever loved him selflessly. They were at his side at the time he was reversing and reinventing for himself his own genealogy.

Portraits always bring out affects in the faces and this is what they all share, this impersonal element that goes through them in various ways, and from them to the eye who observes them, and keeps stripping their features bare. "For someone like you or me who are used to interrogate the daily mask of everyone and follow its metamorphosis, it is easy to detect in the consciences that face us the presence of a gnawing worm that no external war nor any army will get us rid of. Since they are all armies of the fleeting self which stomp over everybody's conscience."[24] Artaud's portraits started with his self-portrait, but it is significant that other faces or bodies are present as well at the bottom of his, poked by the same marks, repulsive and deadly like his own with one eye looking blankly and the other wide open in the direction of the viewer. The face reveals no emotion. It is pitiless. Emotion itself is glaring at us, the casualty of fear, or time, or pain, or life. The forehead is broken down by a monstrous vein, like a crack, the skull already showing through, the worm already gnawing at the flesh from inside. The other faces are crowded right under, a holed out mass.

Artaud's face is not frozen in front of a mirror, it is exhibiting itself blindly to our gaze. It doesn't hide anything, it is death on the march and this is where cruelty comes in. Portraits are not a rendition of affects, they are the process by which they are caught into a distinctive form. The more precise and inflexible the destruction, the

more powerful the emotion that flows from it to us. This is not just a representation of someone's face, this is a silent shriek in our direction. It forces us to confront our own mortality in a panic state. Virtually all the portraits Artaud made, those of people he knew well or loved, those he hardly knew, are as much his own doubles as those of the people themselves. They don't present a portrait, they attack it where they are the most vulnerable. Like Artaud's Notebooks, or the dismembered bodies he drew in Rodez, they provide him with some personal psychological notes on the depth of the human unconscious, its repressions and secrets unknown even by the usual self. Artaud had become aware that the Other of the self is his worst enemy because it imposes a mask of sociality over the face. Artaud's drawings are an attempt to tear down the mask, and this has always been the purpose of his theatre as well.

## Postscript

Artaud's answer to the fury of the world was his 'theatre of cruelty.' And there was indeed a lot of cruelty in the world. But the kind Artaud advocated wasn't synonymous with blood or murder. Unlike the various forms of totalitarian sadism that were being born at the time, it was a form of controlled violence to which the torturer himself was to be subjected as well. The 'theatre of cruelty' was a rigorous attempt to substitute stronger symbolic ties for the ones that were collapsing everywhere. In essence, Artaud asked from the theatre to reinvent life from the bottom up, tapping old Myths to ground instincts that were already running amok. One could only reclaim death by engulfing darkness and evil in a cosmic celebration of life.

Suffering was Artaud's first 'theatre of cruelty,' and would be the last, after he renounced the theatre for a much wider stage.

## NOTES

1   Antonin Artaud, *L'Ombilic des Limbes* (Paris: Gallimard, 1968 [1927]) 61.
2   Artaud, "Letter to Breton," July 1937.
3   Sigmund Freud, *Case Histories II the 'Rat man', Schreber, the 'Wolf man', a case of female homosexuality* (Harmondsworth, Penguin, 1979) 208, 209.
4   ibid.
5   These are taken from *The New Revelations of Being*, OC: VII.
6   Artaud, "Letter to Breton," 30 July 1937.
7   Artaud, "Letter to Anne Manson," 15–16 September 1937.
8   Artaud, "Letter to Anne Manson," 2 August 1937.
9   Spell for Lise Deharme, 5 September 1937.
10  Spell for Sonia Mossé, 14 May 1939
11  Lise Deharme, *"Le vrai jour" Farouche à Quatre Feuilles* (Paris: Grasset, 1954) 73.
12  Artaud, "Letter to Anne Manson," 23 August 1937.
13  This material is found in Thomas Maeder, *Antonin Artaud* (Paris: Plon 1978).
14  Spell for Hitler, September 1939
15  Artaud, "Letter to Annie Besnard," 14 March 1944.
16  Artaud, "Letter to his mother," 23 March 1942. In Maeder, *Antonin Artaud*, 227.
17  Conversation with the author.
18  Artaud, "Letter to Pierre Bousquet,' 16 May 1946 OC XI: 268–91.
19  Gaston Ferdière, "I treated Antonin Artaud" *La Tour de Feu* #63, 64, Jarnac (1959) 35.
20  Artaud, "Letter to Dr Latremolière," 6 January 1945, OC IX: 12, 13.
21  Artaud, "Letter to Jean Paulhan," 10 January 1945, OC XI: 20.
22  Artaud, "Letter to Henri Thomas," 7 January 1945, OC XI: 18.
23  Artaud, "Letter to Jean Paulhan," 10 September 1945, OC XI: 103–4.
24  Artaud, "Letter to Jean Paulhan," 10 January 1945, OC IX: 20.

# Anguish

*Lisabeth During*

## 1 (Murmurs)

The state of innocence eludes philosophers, never more so than now. Metaphysics reeks; the fumes come not, as we used to think, from the relics of a disgraced divine, but from a contamination closer to home. For centuries impurity has been kept at bay through a heroic struggle to tell 'this' from 'that', the 'one' from the 'other', the form from the formless. Now, however, there are few in philosophy who expect felicity from the resistance to ontological contagion; indeed there are those who welcome it.

When did we realise that the human condition was litter? Nietzsche imagined that for creatures ignorant of resentment against time and existence, creatures unlike ourselves, the abomination that is memory and spirit would be merely a vague rumour. Life could be clean. But Artaud, born corrupted, knows that it is Being itself which pollutes. Where the self is supposed to be, he has something else: anguish. Instead of a body, a "stinking gas which forms inside me" (XIII: 95).[1] Opium is his cogito: poison as it is, it summons his mind to a point of crystallisation at which consciousness becomes just possible, giving to the drug-taker not yet the evidence of life but at least an authority, as he puts it, over his own anguish.

Perhaps he has been talking to the philosophers. Between Heidegger, Blanchot and Bataille, the suspicion of taint returns to the way we find ourselves in the world.

Augustine and the Gnostics found a godless world and
called it pain. For the moderns, that space was empty
from the start: shadowy, cloying, insidious. Being haunts
the world like the smell of a leftover meal. Levinas says of
it that it murmurs, rustles like sound in the night but
there are no sounds; dank, almost nauseous, "a heavy
atmosphere that belongs to no one."[2] It is an ugly thing,
this swarming, indeterminate menace, this Being without-
a-world. Anxiety in the face of death is well beyond it;
compared to this, crime would be a relief. The
metaphysicians of anguish tell us that we live on the
ground of a nullity. Artaud does not disagree. He writes in
*The New Revelations of Being* (1937): "For one does not
know that one is no longer in the world until one sees
that the world has left you."[3]

For the Greeks, mortals were either defiant or weak;
for the modern Europeans, they are sleazy. Secondhand in
a world which has never been new, the modern
philosophers took their sulkiness for a condition of
existence: they borrowed the language of anxiety from a
tradition of Lutheran piety. And with it they took on the
Augustinian vision of the world without God: suffocating,
shapeless, obtrusive. Modern pain is, therefore, different
from tragic laceration, for which suffering is the payment
mortals owe to existence: moderns suffer because the
world is empty; there is nothing left to abandon. If,
despite that, there is the unfortunate surplus we call
being, it is no more than an anonymous insinuation, an
impersonal, ambiguous 'there is' which disgusts and
fascinates. For where we live has the density of a void,
stripped of the blessed interruption of finitude. This is the
metaphysicians' last thesis: the unworlding of the world.
Artaud's example is its most extreme extension. From a
place in the mind very close to the unimaginable murk,
from an anguish acid and cold, over-saturated and black
like a hoard of insects, he keeps sending back reports,
letters, literally, from the front. Although it would be
presumptuous to assume that these were meant for us, it

has been philosophers who have recognised themselves in the vivid descriptions of an intellectual catastrophe. Artaud's anguish belongs to philosophy.

## 2 (Metaphysics)

Why did man invent metaphysics? It was in protest against an impurity so profound that evil and nature could not be told apart, an impurity where the generative and the decomposing mingled with each other in some obscene parody of the sacred.[4] Anguish was the furtive companion of this invention, although the philosophers involved believed that, in releasing thought from the confusions of nature, they had stumbled on inexplicable joy. It must be anguishing to take on the moral responsibility for the world, to bring into being a cut that says 'this and not that,'[5] substance as opposed to attributes, soul and therefore not flesh. The anguish of the parturition of metaphysics is something the philosopher would like to forget. It is not something to think about. Yet anguish does not, on that account, disappear from philosophy, leaving reason unscathed. Wherever there is thought *and* a finite thinker, wherever there is corporeality *and* consciousness, the possibility of anguish makes itself felt.[6]

Angels, we assume, don't know anything about it: they do not suffer the sickness of being 'badly made'; God is not their antagonist. But our metaphysical anatomy is such that anguish is its most faithful confidant. Yet as close to us as it is, do we know anything about anguish? What has the history of metaphysics forgotten, and can the traces of those forgotten screams, with which anguish brought transcendence into the world, can they be brought to light? Blanchot put the question to Artaud in *Le livre à venir*: Can anguish think?[7]

In claiming Artaud for metaphysics I do not want to turn him into a symptom, an example, a case: something very hard to avoid. And I do not want to urge too easy an identification between the pains of metaphysics, which are

after all my subject here, and the works of anguish with which Artaud has littered and lit up the world. For suffering from anguish is easy. It is bringing anguish, alive and dripping, into the world which takes all the force a mind can give. Blanchot's words about the poetry of speechlessness are worth remembering. The writer is a writer, says Blanchot, because fundamental anxiety has revealed itself to him. He writes out of loyalty to dread, and Blanchot does not ask us to distrust his fidelity. Yet:

> It seems comical and miserable that in order to manifest itself, dread, which opens and closes the sky, needs the activity of a man sitting at his table and forming letters on a piece of paper.[8]

### 3 (Wonder)

Is anguish an affect? Or it is rather the evaporation of affect? These are questions which psychology tends to answer in circles: Silvan Tomkins says that the compound 'distress-anxiety' is the affect that destroys affect, as much by an over-stimulation of the nerves as by an autistic withdrawal.[9] Kristeva explains that it is the psychic representation, "of energy displacements caused by external or internal traumas."[10] Like schizophrenia, which it sometimes accompanies, anguish drives psychologists to talk in contradictions. A better approach to anguish might be expected from the ontologists of moods, the phenomenologists. Theirs, however, is a project barely underway. The relations which philosophy enjoys with the moods are still only very poorly understood, and we find it difficult to recapture the confidence of the ancient classical teachers, with their belief in philosophy as the pursuit of happiness or in the therapeutic refinement of the passions. I already stated that philosophy begins in dread. But does thinking ever take its bearings from wonder, from joy? Is the life of reason painful or pleasant?

Modern philosophy began in one particular kind of emotional excitation. Descartes found the philosophic passion closely connected to the physiological mobility of the brain. In wonder, the soul experiences a sudden surprise "which causes it to apply itself to consider with attention the objects which seem to it rare and extraordinary."[11] Avoiding the places hollowed out by habit and the repetition of impressions, the agitation which is wonder inclines us to a receptivity towards the new, the rare, the unknown. "Those who have no natural inclination towards this passion," writes Descartes, "are usually very ignorant."[12]

My suspicion is that modern metaphysics, metaphysics since Hegel, has lost that openness to agitation. In an earlier metaphysic, idealist as well as empiricist, novelty was the necessary stimulus to the work of knowledge. In Kant's analytic of the sublime, a moment of rapture, even of stupefaction, provoked by the presentation of an idea too large or too powerful to be thought, was followed not by paralysis but by the acceleration of cognitive movement. Novelty was a tonic, essential to the health of the mind. Kant goes further: there is something restorative in the spasms of mental breakdown, the cramps of headache or the lapsus in which the powers of thinking are temporarily blocked or checked.[13] After their constriction and impasse, the vital powers surge forth again with greater energy. Hence the advantage brought to the exercise of the mind from contemplating difficult, obscure, or unfamiliar presentations: the infinite, on this account, causes not dread but a higher state of excitement and pleasure.

The idea of the infinite, Kant wrote, is never presentable as such. But it is *felt* in the striving of the mind towards a plethora, an expenditure, which no judgement or concept can capture. That striving is at once pleasure and pain, "I am glad to the brink of fear," Wordsworth says. Agitated but not overcome, the self, aroused by what exceeds it, recognises a power in itself which nature can

never explain, never know: that power is its moral power, our share in the supersensible; it takes us out of nature without alienating us from what might be ours. Kant is sure that this arousal, shattering as it may be, does not remain an agony, because the self is free and can enjoy the sense of its own freedom, its dispropriation from the realm of intelligible nature and its abandonment in the infinite spaces, spaces of thought without images, aspiration without bounds. This is not simply an experience of terror. It is ecstatic.

It strikes me as not irrelevant to ask, here, in this conference, why wonder, why excitement, are now so rarely claimed as moods of metaphysics. It may be true, again, since and probably because of Hegel, that some of the work that used to be done by metaphysical speculation is now done by art. In that brief period from Kant, by way of Nietzsche, to the Surrealists and the avant-garde, art began to think philosophically. Wonder, astonishment, these were not what academic philosophy was in a position to promise. Greyer than grey, it no longer recognised the rare, the unknown, as its quarry. So art, performance, now promoted from a merely mimetic and derivative function, took over the task of thinking; the negativity that was the constant restlessness of thought in Descartes, Kant, and Hegel, was too unreliable to serve the aims of a philosophy dedicated to realism, critique, and the more pragmatic ends of instructor to the sciences. But art could afford wonder, and shock; it no longer had to legitimate itself by its power to retain or rival the past; it could expend itself in making things new and strange.

## 4 (Hegel)

Lacking wonder, the moods which stimulate the philosophic are narrower, perhaps more concentrated in scope. Melancholy has had a long history as a muse to abstract reflection as we know from the remark of a Mr.

Oliver Edwards to Samuel Johnson that appears in Boswell's *Life*, "I tried to be a philosopher but cheerfulness kept slipping in." This association is, if anything, reinforced by modernity, where even the madness of depression and schizophrenia is taken to have metaphysical potential. Dread, fear and anguish are the affective states in which the philosophic propensity comes over one, when mere life is somehow pallid and jejeune. To become spirit, Kierkegaard believed, you need dread. Dread is the sign that I am no longer innocent, that I no longer simply dream, that now I exist in my sensuousness as something alien, more than sensuous.[14] In dread intervenes consciousness. Kierkegaard reports: dread is finitude become conscious. An angel, an infinite being, could not know dread. The animal, even with its sharpness of attention to a world perpetually on the prowl, might know anxiety, but dread, we suspect, is beyond the creaturely also. It is a metaphysical emotion because it pushes us into the space of inescapable ambiguity.[15] Within the natural world, the world of sensuous longing and hovering anticipation, dread introduces the metaphysical. In other words, it makes you dizzy. It cuts away the net.

Despite his aversion to the infinite spaces, Hegel did not ignore the potential of vertigo. Fear, he reminds us in the *Phenomenology*, is the beginning of wisdom.[16] Unglued by apprehension, waiting for an unspecified menace to extinguish my fragile hold on the world, I come to understand the constancy of loss. Yet in fear my powers of reflection are paralysed. I cannot imagine the new, the elsewhere, the otherwise. As the threat recedes, my mood modulates; released from the immediacy of fear, I am now oppressed by the emptiness left behind, I sink into dejection. The absence of threat is disappointing; perhaps I have been deceived. I do not want so quickly to relinquish the object which menaced and concerned me. In sadness I continue to keep it close to me; my grieving is a kind of acquaintanceship; the loss grows familiar. This describes a

possible training of the Hegelian dialectician, who passes from joyful certainty to skepticism to speculation. In pursuit of this ascetic discipline, the dialectician lingers, as Hegel says, with the negative: his journey passes through a night, in which all memories of a living world are cut off from me; thought and being do not know each other at all. But the night is passed in dreams, and daylight brings back thought. Melancholy is the guardian angel of this philosopher's night. Kristeva, in a mood not far from the Hegelian, calls it philosophy's 'mute sister.'

But there are those who are further advanced in anguish. Hegel knows this for certain in Berne and Frankfurt, before writing the *Phenomenology*: this prize is awarded to those who suffer from the Unhappy Consciousness. Athletes of anguish, pioneers of the nomadic route which leaves the city, hence reason and love, lighting out for the territories, the Theban wastes, the desert, the unknown. Abraham is the first to go; hard-hearted, inconsolable, sure of his god and of his separation. In separation he has had a lot of practice; and his is an art Rilke will recommend to the lover as well as to the artist. But Hegel is not impressed:

> The unhappy consciousness is the tragic fate of the certainty of self that aims to be absolute. It is the consciousness of the loss of all essential being in this certainty of itself, and of the loss even of this knowledge about itself ... it is the grief which expresses itself in the harsh saying that 'God is dead'.[17]

> Death is the painful feeling of the Unhappy Consciousness that God Himself is dead. This hard saying is the expression of innermost self-knowledge, the return of consciousness into the depths of the night in which 'I=I', a night which no longer distinguishes or knows anything outside of it.[18]

As we know from Bataille, Hegel chose to forget how to suffer. In his new world of dialectic, he left it to others,

and at times he left it to God: they, the Abrahams, the devotees of the unconditional, will mark the stations on the exhausting road Spirit travels. And their anguish, taking them all the way to destruction, is necessary. Spirit needs it, and we, observors of the dialectic, need it at second hand. Pain is put to work, and the cry of separation, of unintelligibility and loss, under Hegel's modernising gaze, becomes pathological.

Hegelian negativity, violent as it is, skirts the edge at which the Unhappy Consciousness and the Beautiful Soul disappear. A certain family of affects tutor the Hegelian apprentice, they accustom it to death, but do not break its spirit, its will to be transformed. If fear startles and immobilises philosophic activity, in the dejection which replaces it, the philosophic spirit settles into its habits. It learns the inevitability of dialectical reversal. Habituated to melancholy, I become lucid, attentive to the imminent collapse or attrition (attenuation) of meaning, life, work. Expecting loss as day looks forward to night, I am prepared for the tricks of dialectical reason; its upheavals do not shock me.

Melancholy trains me for the infinite deferrals of certainty in which the skeptic is adept; it loosens my attachment to the ideas and images I have struggled to bring to life: those ideas, the beloved offspring of the intellectual, whose memory is so short. "In his doubtful moments the depressed person is a philosopher," writes Kristeva.[19] She does not note the converse: that the philosopher is, when skeptical, a melancholic. Melancholy is an exercise in separation, hence in a sense which is probably no more than that of the everyday, it belongs to my 'being-towards-death.' In melancholy I rehearse mourning over myself: I may flee in the face of the death which is my own possibility, but my melancholy refuses the tranquillisation of distraction, refuses the temptation to cover up that certain Fact.

## 5 (Heidegger)

Heidegger's Dasein also suffers in a way I could call exemplary for philosophers. Dasein suffers from Being in the world, and from the fact that its being in the world is being towards the end. Hence it is always in a mood. What oppresses Dasein in Angst is not this or that, but nothing and nowhere, the world itself. "That which threatens is already there, and yet nowhere: 'es ist schon 'da' — und doch nirgends'; it is so close that it is oppressive and stifles one's breath, and yet it is nowhere."[20]

> In anticipating the indefinite certainty of death, Dasein opens itself to a constant threat arising out of its own 'there' ... There is a certain mood or state of mind (Stimmung) in which this threat is held open, in which the threat is not covered over with definite images of menace which I can fear or defy, but remains a loss unveiled, ambiguous even if certain, free in its emptiness, this mood is called Angst."[21]

Angst, like anguish, is enigmatic. But it must not be confused with anguish. Its phenomenology is quite separate; its narrative leads away from Artaud's "suction like rise of anguish ... which approaches and withdraws, each time more vast, each time heavier and more swollen" (I*: 147).

This is the history of Angst as educator that Heidegger tells. Within the world itself, I choose immersion, I am absorbed; I share the panic of those who flee from a more disturbing disclosure, who seek concealment in the busy talk and concerns of the 'they.' But this subterfuge is fragile; it cannot withstand the experiences which, even in the everyday, strip meaning from everything I do: boredom, distraction of mind, fear, make it clear to me that the vacuity is not external to myself. The nothing that I flee is the nothing which I should embrace as my own. Hence the enigmatic, inauthentic selfhood in which Dasein is fallen learns through trauma and annihilation what itself is. Angst

refuses the false solutions of metaphysics. Nothing can console it, because it has no object.

The passivity of everyday being breaks down in anxiety, which is a privileged disintegration, an internal incubation of the philosophic. Angst is more primordial than fear, which living creatures share. Angst knows what ordinary knowledge does not know, about ambiguity, about the uncanniness of freedom and the exposure of embodiment. But Angst, compared to the anguish which furrows the self differently, take Dasein only provisionally out of the world: what Heidegger's Angst is meant to reveal is the proposition which Artaudian anguish is right to denounce. This is the proposition that Being can be understood in a way that shortcircuits the metaphysical.

If Heidegger is right, lingering in Angst helps us to understand that the menace to our being does not come from here or there, without or within. Rather we live in exile from being because the questions which would have opened being up to us have been covered over by metaphysics' dualities of spirit and form, the word and the body, work and life, the self and the Thing, the alien and the authentic.

The choice then is to destroy: to unthink metaphysics, to loosen up its joints, as he puts it early in *Being and Time*.[22] With the example of Artaud in front of us, in particular that of Derrida's Artaud, we can imagine an alternative to Heidegger's thinking of Being, a larger space prior to all dissociation, a space prior to all articulation, a space of Becoming which Artaud named Theatre. This would also be a metaphysics, one that claims to be beyond alienation, and which Derrida locates as on the way to Difference, or the Heideggerean 'Duplizität'. By creating spaces of impossible conjunction where blood and transcendence, freedom and control, angel and puppet, circulate without cancellation, spaces too dense to admit of the cuts of separation, a post-Heideggerean Artaud seems to avoid or to transgress a certain metaphysics. This is the metaphysics Derrida describes as

the metaphysics of metaphor, of memory and ressentiment, of man and representation, a metaphysics whose memories are darkened by nostalgia. That metaphysics is the one Derrida credits him with the intention to destroy. The other, the second, is the one he creates, or, according to Derrida, is fatally complicit with. The 'theatre of cruelty' is a new space of Danger, of anguish, an affirmative metaphysic:

> By virtue of this rejection of the metaphorical stance within the work, and despite several striking resemblances there (here, the passage beyond man and God), Artaud is not the son of Nietzsche. And even less so of Hölderlin. The theatre of cruelty, by killing metaphor (upright-being-outside-itself-within-the-stolen-work), pushes us into "a new idea of Danger." The adventure of the Poem is the last anguish to be suppressed before the adventure of the Theatre. Before Being in its proper station.[23]

Beyond Dasein's existential Angst, the Angst which flees, is a mood of affirmation: here, perhaps in the 'theatre of cruelty,' there is anguish without negation, pain without the lessening of affect or life. This is a physical anguish that tosses me into rapture and makes sure that I do not sojourn there. Bataille calls this state 'communication.' Nietzsche approved of it as the suffering which has not yet been spiritualised, when mankind "was not yet ashamed of its cruelty, when seeing others suffer did one good and making others suffer even more."[24] Much of the immediacy of Bataille's communication, much of the affirmation of that innocent animal in Nietzsche's imagination which knows no Angst, survives in Artaud's 'theatre of cruelty,' an anti-dualist metaphysical theatre, a theatre of immanence, a theatre "restored to its level of pure and autonomous creation, under the sign of hallucination and fear."[25]

## 6 (Artaud)

We are not yet able to attend as well as we should to the destiny of Antonin Artaud. Neither what he was, nor what happened to him in the domains of writing, of thought, and of existence — none of this, even if we knew it better, could provide us with signs that would be sufficiently clear. There are, however, some partial truths we should establish for the moment: that he had the gift of an extreme lucidity that tormented him; that he was constantly concerned with poetry and thought, and not with his person in the manner of the romantics; that he exposed himself to an exigency of disruption that put into question the givens of every culture, and in particular those of the contemporary world.[26]

In a few strange texts from the mid-1920s, Artaud offers his anguish as a kind of notebook, a steady observation of the lacks which are his literature. *The Umbilicus of Limbo*, *The Nerve Scales*, *Art and Death*, *Fragments of a Journal in Hell*, supplement and pillage from his correspondence, in a barrage of complaints, precise, pitiless but repetitive. Why they figure in a series of philosophic variations on the theme of anguish should already have been intimated. Their interest must be greater than that if they are to justify more than a casually psychiatric curiosity. And it is their narrowness rather than their ingenuity, their depth of field, which makes them compelling. They test out the changes, the combinations and sequence, made possible by a limited family of terms, terms poetically inert and, in isolation, lacking in resonance: cold, ice, theft, wind, space sulphur, hand, detached eye, rootlets, vegetable masses, tongues, liquids, points, sky, breath.

Over a four year period, from January 1925 to 1929, these designators are attached, detached, set in place, until an entire ontology, a system of nature and mythology, fills in the space of the author's missing thought, his *pensée volée*. For Artaud, to be in anguish does not mean authority is renounced. Anguish

represents the desire to think one's own world into existence, to be the author of one's own birth, the classic claim of the metaphysician, an assertion we cannot be sure has failed. But the victory over non-meaning, over dilution, over the absence of continuous thought, is won with assistance. Essential to these experiments with anguish is a drug. Opium for Artaud is his Orphic pass key to that metaphysical plane which is extensive, serene and absolute, which does not differentiate between dead and living, which does not accept "the scandal of thought separated from life." This is the plane that the Clairvoyant also occupies.

This metaphysical plane, or atmosphere, or mass, "shelters," as Derrida cannot fail to point out, "an indestructible desire for full presence." But, if Artaud is right, it is here that metaphysics is not naively alienated or undone by difference, say, by the difference between living and dead, anguish and purity. Rather, this plane is a place not beyond anguish but representing a second anguish, an anguish he sometimes calls "sweet" or "indifferent." Framing his anguish is a membrane of repose and intelligence, for whose gift he has to thank his narcotic. The anguish of opium sits in these texts beside the murkier, more unbearable anguish of the self unreconciled to his birth. In the prose of the 1920s Artaud, unreconciled, keeps revisiting his own death. But it is in the image of the narcotic experience that he creates a second anguish, one that bears the possibility of a metaphysics which would not be that of the imposter, intruder God. One cannot avoid hearing in his words a claim to something like authenticity, the right of Artaud to possess his own thought as a "result of the emptiness I carry within" (I*: 114). It is a work of creation, not just of destruction. Artaud describes his struggle to form a "thought that will hold, an image that will stand upright, at least a metaphyiscs of disaster and failure" (ibid: 139).

In the latest of this series of prose poems, *Art and Death*, the title of which refers to a text given as a lecture

at the Sorbonne (22 March 1928) on the theme of death-in-the mind, is the text *Qui, au sein des certains angoisses ...* (Who in the thick of a certain anguish ...). It is strongly Surrealist in its imagery and in its unaccustomed romanticism, even erotic optimism. But its initial hypothesis, in which the living mind-body is experienced as a virtual death, is recognisably grotesque. It illustrates the way anguish is, in this metaphysician, not a negation but a form of impossible immanence, a presence which has always already arrived, an occupation. I would like to conclude by reading this short piece closely. For an organism to live, to be ensouled, Artaud argues, nervous activity must extend all the length of the body just as veins which must carry the blood. This immanence of the mind through the limbs and organs means that the mind is not to be imagined as a substance single, self-same, free of location, like the Cartesian mental substance. Pressed into the body like wind forced through pipes, the mind, in the living, is a giant contraction. In the dead, the contraction is reversed: it is a distension swelling in wave after wave which puffs you out as if by some intolerable bellows (*un insupportable soufflet*).

But this happens not just for the dead, and indeed their difference from the living is hard to locate. There are those called alive who have known this already; their deaths repeat and repeat, like the recurrence of all ancestors in the newly awakening senses of the child, confused and terrified by a monumental parade of their dead which the adult hardly sees. The death-in-life is called anguish. It approaches and occupies the body, each time seeming to stretch its extension to the limit of endurance, then recedes, producing sensations described as "shattering" and "marvellous." It is a rubber band, "*un élastique*," that when stretched, suddenly hits you in the throat. Flexible but taut, stronger than the contractions in which you left the womb, this contracting band seizes at last your head, forcing it back into that now hopelessly restrictive opening. And your head is grown out of its

proportions, swollen and engorged under the skin, it writhes to escape but in vain. And like the anguish in the earlier texts, in the "Umbilicus of Limbo" and the "Nerve-Scales," this pumping and pushing machine, elastic and inflating, which resembles the lungs and cervix as viewed by an intelligent Martian, this anguish strikes at the stomach as well, producing acid, burning sensations.

The horrible image of a death that revisits its own birth, is, in the text, identified with a dream which the dreamer does not for a long time succeed in recognising as his own. Writhing in and against this state, whose mixtures of the asphyxiating and the "melodious" suggest the opium dream, the dreamer struggles with a violent jolt to pull himself free. The dream, just like the anguish, provides an access to death, an access which is the secret goal of every mystical exercise. In a footnote of unusual limpidity, Artaud describes the philosophical conditions of this ascent to "the more exalted states of mind": the overthrow of appearances, the confusion which nonetheless does not extinguish the surging force of thought, "everything that upsets the relations between things by giving the 'pensée bouleversée' an even greater vision of truth and violence." But to live is to break free of this dream, even while remembering it, which itself is anguish, and the living man 'withdraws his soul with a violent gesture (*avec brutalité*) and is thrown back onto the naked plane of the senses, in a bottomless light" (I*: 127).

The anguish of Artaud does not bring metaphysics to a halt. But neither does it leave open the old discredited hopes for a volatilisation of the flesh, for that flight into the spiritual, or to the reconciled, which spurred Nietzsche into revolt against the ascetic system-makers of the world, and which may unhappily be revived by claiming Artaud for religion. It is the dignity of Artaud to insist on control, on economy, on necessity, as opposed to the Surrealist flight into chance, or charm. He keeps the fact of anguish alive as a question, a doubt which, as he says in "Nerve Scales," "inhibits contacts with ordinary

reality and allows more subtle and rarefied contacts, contacts pared down to a core which ignites but never breaks" (I*: 82). That image of thought as concentration, thought as rigorous, skeptical and minute, thought not failing even in the despairing recognition that "it is so hard to stop existing, stop being inside something," (ibid: 98) is an image of a kind of victory.

Lucidity is a strain, a tension, a struggle to the limit of the spasm, which Descartes' *prise de conscience*, Hegel's flux of negativity, and Kant's transcendental unity of apperception do not recognise, which the idealist release of thought from the conditions of embodiment makes too easy, and which even the corrected images of the knowing subject in phenomenology do not account for. The fight to think to the end of an idea is probably the hardest thing you can do in philosophy. It would be in tribute to Artaud, as I read him, that anguish be given back to philosophy as one of its most becoming names. It is something philosophy has often chosen not to know. Often it has chosen to ignore its own dependence on those lacerations which produce the written text, the metaphysical system. The guiltiness of creation, of which a writer like Blanchot speaks and a sacrifice like Artaud's witnesses, should not so easily be subsumed into philosophy's endless good conscience. The memory of anguish — the thinker's sacrifice to lucidity — must haunt the philosophic reader's innocent play among these gaping words, Artaud's victorious texts.

## NOTES

1   References to Artauds's writings in the Gallimard edition (*Oeuvres complètes*, Paris, 1976–) are given by volume and page number in the text. Volumes I and XIV are in two parts, designated *(Part 1) and ** (Part 2).
2   Emmanuel Levinas, *Existence and Existents*, transl. Alphonso Lingis (Dordrecht: Kluwer, 1988) 58.
3   Antonin Artaud, "The New Revelations Of Being," *Antonin*

*Artaud: Selected Writings*, transl. Helen Weaver, ed. Susan Sontag (Berkeley and Los Angeles: University of California Press, 1976) 414.

4    See Vladimir Jankélévitch, *Le pur et l'impur* (Paris: Flammarion, 1960).

5    Hegel called such a primal division the 'Ur-teil' or 'judgement.' Cf. G.W.F. Hegel, *Werke in Zwanzig Bänden*, Bd. 8, (Frankfurt am Main: Suhrkamp, 1970) 316.

6    Philosophy is homesickness, says Heidegger, quoting Novalis. "In the philosophic concept, man, and indeed man as a whole, is in the grip of an attack — driven out of everydayness and driven back into the ground of things." To philosophise is to be caught up in "the struggle against the insurmountable ambiguity of all questioning and being." Martin Heidegger, *The Fundamental Concepts of Metaphysics*, transl. William McNeill and Nicholas Walker (Bloomington: Indiana University Press, 1995) 21.

7    Maurice Blanchot, *Le Livre à venir* (Paris: Gallimard, 1959) 45–52.

8    Maurice Blanchot, *The Gaze of Orpheus and other literary essays*, transl. Lydia Davis (Barrytown, New York: Station Hill Press, 1982) 6.

9    Silvan Tomkins, *Shame and its Sisters: a Silvan Tomkins Reader*, eds Eve Kosofsky Sedgwick and Adam Frank (Durham and London: Duke University Press, 1995).

10   Julia Kristeva, *Black Sun: Depression and Melancholia*, transl. Leon S. Roudiez (New York: Columbia University Press, 1989) 21.

11   Rene Descartes, "The Passions of the Soul," art. 70. *The Philosophical Works of Descartes*, vol. 1, transl. E.S. Haldane and G.R.T. Ross (Cambridge: Cambridge University Press, 1931) 362.

12   ibid., art. 73, 364. See also Luce Irigaray's fine reading of Descartes on Wonder in *An Ethics of Sexual Difference*, transl. Carolyn Burke and Gillian C. Gill (Ithaca: Cornell University Press) 72–82.

13   Immanuel Kant, *Critique of Judgement*, transl. Werner S. Pluhar (Indianapolis: Hackett, 1987) #23.

14   Soren Kierkegaard, *The Concept of Dread*, transl. Walter Lowrie (Princeton: Princeton University Press, 1957) 64–72.

15   ibid., 37–40. See also Blanchot, "From Dread to Language" *The Gaze of Orpheus*, esp. 9–16.

16 Hegel, *Werke in Zwanzig Bänden*, Bd. 3, 153.
17 Hegel, *The Phenomenology of Spirit*, transl. A.V. Miller (Oxford: Oxford University Press, 1977) 455.
18 ibid., 476.
19 Kristeva, *Black Sun*, 6.
20 Martin Heidegger, *Sein und Zeit* (Tübingen: Max Niemeyer, 1984) 186.
21 ibid., 266.
22 ibid., 22.
23 Jacques Derrida, *Writing and Difference*, transl. Alan Bass (London: Routledge and Kegan Paul 1978) 185.
24 Friedrich Nietzsche, Essay II, *On the Genealogy of Morals*, transl. Walter Kaufmann and R.J. Hollingdale (New York: Random House, 1967) 67.
25 Antonin Artaud, "On the Balinese Theatre," in Sontag (ed.), *Antonin Artaud: Selected Writings*, 218.
26 Maurice Blanchot, *The Infinite Conversation*, transl. Susan Hanson (Minneapolis: Minnesota University Press, 1993) 293.

# The Skin of the Unconscious

## Artaud and the Paradox of Love

*Patrick Fuery*

The human skin of things, the derm of reality — this is
the cinema's first toy.
—Antonin Artaud

### The *Dispositif* of Love

The paradox of love develops, to a large part, from its
unique relationship to certain epistemological variations
and hermeneutic tensions. At one level it is essential — the
amatory *eidos* we might say — that love seem to be beyond
interpretation and even signification. To be in love, Lacan
and countless others remind us, is to be mad. And madness
defines itself and is defined as a beyond to systems of
meaning. The resistance to meaning is the compelling,
seductive nature of love. Often love is at its most
interesting, most desired, when it cannot be understood
and openly resists all understanding. Yet at another level
love is always about meaning and interpretation. Any and
every utterance of love is an utterance about and towards
interpretation. We can make no sense of love, and love
itself is without sense; yet love is that which produces a
compulsion to make signification. There are a number of
factors which contribute to this situation of the paradox of
love. Love at once demands interpretation and resists every
attempt to do so; love demands a sense of trust and belief,

and yet the lover is amongst those subjects most fraught with doubts, driven by a constant need for confirmation. No matter how strong and consistent the signs of love are, they are never enough. We crave the outpour of these signs, so that each one can be collected and pasted into an unending discourse. Why else does our culture depend on, and produce, so many signs of love? And this discourse of love knows no boundaries — from the filial and platonic to the sexual and erotic; from the heterosexual to the homosexual; from the spiritual to the physical. Each manifestation of love contains within it this double bind of a resistance to meaning and interpretation, and a requirement that it engages in the production of meaning, that it attempts to confirm meaning and interpretation. Furthermore, each act of love, each sign read by the lover, contains confirmation and denial because each signifier is read so carefully and teased apart so thoroughly. The lover is the surgeon who mistrusts the scalpel as it probes the body of the loved.

Part of the paradox of love is that we cannot experience the act of love itself. Instead we experience objects and signifiers of love. If love is part of the Other then, in a Lacanian sense, what we encounter are the *objets petit a* in our attempts to experience love — they are, if you like, *objets petit a(mour)*. Although they share little in terms of a homogenising grammatology, what is suggested here is that we can speak of a *dispositif* of love which allows such objects to be brought together. The term *dispositif* is a reference to Lyotard,[1] which inflects it in a particular manner. At one level we can read this as the apparatus of love — or those objects which are drawn into, enlisted in the cause of, the amatory discourse/ polylogue. *Dispositif* can also be read in terms of the investment in love, or the investment of love. This is part of the positivity so essential to the term. This sense of investment is derived from Freud — the cathexis of the psychical motivation. Such an investment conflates the subject's desire with love, just as Lacan argues that what

we desire is desire itself, so what we love is love itself as it finds us through its signifying practices. In doing so we, as subjects of love, are bound to the *dispositif*. Once such a psychic investment is made our subjectivity becomes part of, and cannot escape from, the discourse.

What is to be achieved in utilising such a construction and articulation as the *dispositif* is that we may read certain objects as part of the apparatus of love, noting their investment and the requirements of cathexis. And the object of concern here is Artaud's theatre and love. If the *dispositif* of love is to include something like the ''theatre of cruelty,' then that same theatre must be read as an act of love. A potential site of resistance to this is intentionality. Does Artaud intend his 'theatre of cruelty' to be an act of love? Whilst avoiding a simplistic transposition, it is argued here that what motivates much of the 'theatre of cruelty' is love. It can be seen as an act of love, thus its positivity negates the difficulties of power. For Artaud is clear that although the 'theatre of cruelty' is about power over the audience, it is also about empowering that same audience. This is the double bind of love — the lover must constantly negotiate the powerlessness of being in love, and the power that love produces. This is part of the 'disturbing anguish of love'[2] that Artaud evokes in "No More Masterpieces." This moebius strip of power, which enables the 'theatre of cruelty' to avoid being some sort of torture instrument that disempowers, works because of the underlying motivation of love.

Love as theatre may seem an uneasy simile, especially for lovers, but Artaud continually insists that his theatre is also an uneasy one, breaking with the placid and moribund situation of mainstream drama. It cannot, therefore, ever be simply the representation of love — an enacting of signs of love — but it must rather be a theatre that acts like love and on love. Artaud's plea is straightforward in this regard: "If theatre wants to find itself needed once more, it must present everything in

love, crime, war and madness" (TD: 65) and "We want to make theatre a believable reality inflicting this kind of tangible laceration, contained in all true feeling, on the heart and senses" (ibid.). Artaud's cruelty, like love, is positive and yet deeply disturbing; it is active rather than passive, unpredictable rather than established or formulaic. Most significant of all, however, is that it is based on cathexis, for without psychical investment the 'theatre of cruelty' would be no different from the dramatic that Artaud defines as oppositional to his project.

The significant contrast that Artaud makes in this sense of theatre and its subject matter is between what he describes as 'everything in love' and 'everyday love.' In the "Second Manifesto for a Theatre of Cruelty" it is the search for a "poetic state of mind" and a transcendentalism (TD: 81) in that list which includes "love, crime, drugs, war or insurrection" (ibid.). For Artaud such a list makes perfect sense, but for most others it is a curious juxtapositioning. Except for love, all the others on the list (and the next item is the 'theatre of cruelty') are clearly anti-social, have negative connotations, and represent damage and destruction. Gone is any sense of (Freudian) repression and the overseeing, controlling force of the superego. Artaud's plea is for an unrestricted flow — a pleasure principle beyond reserve. The two strategies we are presented with to make sense of this curious list are: firstly, for Artaud, love has the same sorts of connotations that criminal action, drugs, and acts of violence have. In this sense it must be an anti-social act positioned beyond the law of social order. The second interpretation is that these items on the list share nothing in themselves except the audience's desire for a different state of consciousness. Either way, love and the 'theatre of cruelty' occupy socially liminal positions within an Artaudian schema. They must necessarily be anti-social (in order to fulfill the revolutionary design) and yet they must also be accepted into the social order of things as legitimate systems of thinking and feeling. We must recall that

Artaud desired a theatre for the masses that would prove to be as popular as cinema and the music hall. That love leads this list is significant for it is the one thing of all these that everyone has encountered, it is the most readily identifiable to all, it declares its sense of desirability. Any of the others we may know of vicariously, some we might be participants in — but love is the most known and least knowable. Artaud's list would suggest that it is this range of differences between love and the others that the 'theatre of cruelty' must acquire and utilise. And as with all the items on the list, we must be aware that we can be both victims and perpetrators of each one. Like the 'theatre of cruelty,' love is particularly good at it making us feel powerful and powerless, torturer and the tortured, at the same time.

If the 'theatre of cruelty' is love and enacts love, if it must employ love to challenge the audience and the whole apparatus of theatre, then it must also specify a particular type of love. As Artaud put it: "... a secret strength which wins the audience over, just as a great love wins over a soul ripe for revolt" (OC, IV: 109). One way we can approach this is through some of Artaud's ideas on the actor. Compare, for example, how Artaud speaks of the actor's role, and how much this sounds like a description of the lover. To begin, for Artaud the actor is "*un athlète du coeur*" (OC, IV: 154) — with a physicality ruled by emotion. More than this, the actor "thinks with his heart, for his heart holds sway" (TD: 89). Artaud refuses the division of feeling and logic, of mind and heart, in much the same way the issue of madness has been problematised by poststructuralism in its relationship to knowledge. The actor and the lover interpret the world through the heart, producing meaning through emotion. What is perhaps the most curious aspect about this idea is that Artaud seems to believe in a true and faithful love. The actor must be loyal — how else can Artaud have a sense of "adulterous love" (TD: 92) potentially caused through the power of his scheme of

breathing? The actor must be a faithful lover, or else any trust in this theatre will be lost, just as a lover can lose the loved one.

I do not wish to extend such comparisons between Artaud's use of and for the actor and the role of the lover, for to do so would endanger the argument with thoughts of enamoured audiences swooning for an actor on the stage or screen. This would be to miss the point and take the idea of the *dispositif* in a totally different direction. This type of emotional bondage does take place of course, but Artaud's strategy seems to lie not in creating a form of transference, but rather utilising desire. In his own performances, Artaud strives to create this, confessing that when he performs he wants "to feel the bodies of men and women — and I mean *their bodies* — throb and quiver in harmony with mine" (OC, IX: 78). This is not the site of adoration, or a one-way flow from either actor or audience to the other, but a form of amatory *Aufhebung*.

What I mean by this is not supposed to sound like a pattern or sequential 'progression' of Artaudian practice. What it suggests, however, is that by locating something like processes of the 'theatre of cruelty' in terms of the *dispositif* of love, all the participants are committed, through the cathexis, to a variation of the *Aufhebung*. In doing so the amatory codes, the practices of theatre and the subjectivity of audience and performer, are subjected to the three actions of this Hegelian dialectic, namely negation, preservation, and uplifting. Old orders are negated (love and theatre themselves are negated), elements of both are preserved, and the consequence is an elevation to a higher order — one that originates and is sustained not externally, but from within: "Theatre will never be itself again, that is to say will never be able to form truly illusive means, unless it provides the audience with truthful distillations of dreams where its taste for crime, its erotic obsessions, its savageness, its fantasies, its utopian sense of life and objects, even its cannibalism, do not gush out on an illusory make-believe, but on an inner level" (TD: 70–1).

## Daughters of an Incestuous Heart

So far the type of love dealt with here has be presented as operating (ideally) as intentionally positive yet anti-social because of its disruptive effects and demands. This next section will focus more on the struggle with erotic love that is so dominant in Artaud's works. Such a shift will lead to an idea of love which has a much more complex relationship to anything we might wish to specify as positive, yet has such a sense in its range of the *dispositif*. Of course it is difficult to summarise Artaud's attitude towards the erotic; perhaps the only single clear statement we can make in this regard is that Artaud is never consistent. At times he seems to need a pure, perhaps almost religious, love — one that will save him from the world, and perhaps himself. His letters are filled with such pleas and declarations. He wrote to Génica Athanasiou of his "need of angels" because he had had enough of hell;[3] he wrote to Anaïs Nin describing his love as a type of religion; he wrote to Anie Besnard, calling her his beloved angel. At other times Artaud's attitude towards love and eroticism is much less positive, with any sense of the religious being a source of pain and anger. To examine these shifts and dynamics, the approach here is, once more, to consider Artaud's sense of eroticism as part of the *dispositif* of love. To do so this next part will consider three texts — one of Artaud's, and two that he seemed to be fascinated by. First though, a reference to Artaud's idea of the daughters of the heart.

In one of his letters Artaud wrote: "I thought a lot about love at the asylum of Rodez, and it was there that I dreamed about some daughters of my soul, who loved me like daughters, and not as lovers—me, their pre-pubescent, lustful, salacious, erotic and incestuous father; and chaste also, so chaste that it makes him dangerous" (OC, XIV*: 48). This powerful declaration is not as far removed, or as radical a shift, from much of what we find in earlier works by Artaud. It does mark a sort of sexual

manifesto — a revelation of sexuality that pushes Artaud towards an eroticism he clearly needs, but also despises at the same time. The daughters love him as a father, but he is full of erotic and passionate desire. This is a quality that we find recurring throughout Artaud's life and work. This desire for lovers that are sexual, desirable, erotic and at the same time incestuous and chaste is Artaud's idea of salvation. Yet this salvation is, in itself, a source of damnation. To see how this operates in an earlier part of Artaud's life we can turn to his fascination with a painting.

Artaud declares that Leyden's painting of *Lot and His Daughters* "is what theatre ought to be" (TD: 26); but what, for Artaud, does this painting represent? In his description and analysis, we find the combination of sexuality, eroticism and love that would inform much of Artaud's ideas on relationships during his years at Rodez. The very subject matter of Lot — with its highly moralistic and complex attitude towards desire — feeds into Artaud's ideas on eroticism and love. It is also a fascination based on the idea of a consciousness which is the contemporary of Artaud: "Here we see the deeply incestuous nature of this old subject which the artist has developed in sexual imagery, a proof that he has fully understood all its deep sexuality in a modern way, that is to say as we would understand it ourselves. A proof that its deeply sexual but poetic nature did not escape him any more than it did us" (TD: 24). Artaud touches on two points that we find recurring in later works: that sexuality both assists and hinders the analytic processes; and that the relationship between sexuality and the poetic is a psychic and cultural problematic. For Artaud, there is knowledge and insight to be gained from the erotic, but at the same time this is a knowledge that, like Lot and his daughters, seduces towards evil and punishment. One attempt to negotiate this is to distinguish between sexuality/eroticism and an aesthetics. That something can be sexual and poetic at the same time presents difficulties for Artaud in the painting, but at other times there seems to be the assertion that one is not possible without the other.

Similarly, at certain times Artaud demands a separation between love and sexuality; in a letter to Anne Manson he wrote: "Love binds Humans together, Sexuality drives them apart. Only the Man and the Woman who are able to come together above and beyond all sexuality are strong" (OC, VII: 244–5); and in a long letter to Peter Watson in 1946, Artaud is very specific to mark out the difference between love and eroticism. It is perhaps a little simplistic to argue that Artaud retained a positive sense of love, contrasting it to the negativity of the erotic. To a certain extent this is true. The letters from Rodez are filled with outpourings on the relationship of sex to sin, of the evil of flesh, and the suffering caused through the erotic; at the same time Artaud was convinced that it was through the love for him of the Daughters of the heart that he would be rescued and saved. The complication is, once more, derived from Artaud's ideas of the incestuous. It is almost as if incest offers Artaud the solution for a love that can be erotic and yet beyond the sexual. By declaring these women daughters, Artaud, like Lot, becomes the guest at the prostitutes' banquet (TD: 24). Such a position accommodates the sense of guilt and repulsion for sexuality, and the need for its qualities as a signifier of love.

Another text which deals with incest, and seems to fascinate Artaud, is Ford's 'Tis Pity She's a Whore. The manner in which Artaud describes Giovanni is nothing less than deep admiration and perhaps a desire for that position. For Artaud this lover is as follows: "He does not hesitate or waver for one instant, thereby demonstrating just how little all the barriers mean that might be set up against him. He is heroically guilty, boldly, openly heroic. Everything drives him in this direction, inflames him, there is no heaven and no earth for him, only the strength of his tumultuous passion ..." (TD: 19). For Artaud, the love between Giovanni and Annabella is the "final rebellion, explemplary love without respite" (TD: 19). Ostensibly, Artaud is using Ford's play to define and illustrate his ideas on how the theatre should affect the

audience and artists. Yet so much of what he describes reads as a manifesto on sexuality, erotics and love; and just as we witness during and after the years at Rodez, these are emotions tied to the demand for freedom.

The lovers in *'Tis Pity She's a Whore* represent not simply unrestrained passion for Artaud but "true freedom" which is dark and always bound up to the sexual (TD: 21). And this is perhaps another reason why Artaud finds incestuous love so compelling, for it offers a site of resistance and rebellion to the social order. What he admires in the lovers is their capacity to love outside of the restrictions of cultural praxis and moral codes. Even to the point, or especially at the point, where Giovanni rips out the heart of Annabella. We gasp at that act of love, whilst Artaud celebrates it because, as Giovanni declares, it is an act of defiance against social restraint. It is this sense of true freedom that underlies much of Artaud's feelings on both theatre and love. It is interesting to note that in one of his last letters to Breton the list which once contained the word love (along with crime, etc.) now has rape: "I live possessed, smothered, defiled day and night by incubi and succubae which only stem from the general faith in esoterism built on theft, rape, and on crime ..." (OC, XII: 184). Giovanni and Annabella, for Artaud, avoid this plight because of the dark true freedom of their love. Yet this is contrasted with the incestuous rape in *The Cenci*, where the father is punished by the daughter. As with so much of Artaud's ideas, incestuous love releases and condemns. This also places into context somewhat Artaud's distinction of love from eroticism as a "search for a vacant state" (OC, XII: 236).

The final text I wish to consider in this section about this strange notion of incestuous love is the early work "Le Jet de sang." Incest features much less overtly here, but the presence is still undeniable. This play begins with the exchange between the two lovers:

*Young Man*: I love you and everything is beautiful.

*Girl* [in a quickened, throbbing voice]: I love you and everything is beautiful.
*Young Man* [lower]: I love you and everything is beautiful.
*Girl* [lower still]: You love me and everything is beautiful.
*Young Man* [suddenly turns aside]: I love you.

The young man's final declaration of love in this opening passage ("I love you, I am great, I am lucid, I am full, I am solid") sounds remarkably similar to Artaud's interpretation and defence of the lovers in *'Tis Pity She's a Whore*. Existence and presence — such ideals of phantasy for Artaud — take place through formations and declarations of love, but here a love based on incest. And the confirmation — if we can be speaking of such a thing in this surrealist text — comes in the exchange between the Wetnurse and the Knight. The Wetnurse becomes upset when she realises these lovers are fucking. The Knight responds: "And what the fuck if they are fucking?," to which the Wetnurse responds "Incest." This mid-point in the text marks the change from what begins as romantic love and ends with a scorpion-infested vagina, the young man flying off with the prostitute, and the epiphany of the girl as to what the young man really wanted — the Virgin.

The young lovers of "Le Jet de sang," Giovanni and Annabella, and Lot and his daughters are variations on the same theme of incestuous love that swings between amatory types: the romantic, parental, erotic, passionate, asexual. However, within this dynamic we witness the operation and effects of *Aufhebung* once more. For each of these types of love are preserved, negated and combined within the single act in Artaud's scheme of things. They offer sites of resistance because they operate outside of the conventions of social order and cultural formations of love itself. This is why incest holds such power for Artaud; it is a forbidden form of love that operates on a highly problematic premise of power. Like the plague metaphor for theatre, it foregrounds the tenuous balance of power in relationships between

subjects; it gives the participants the chance to gain power, or at the very least witness its effects, and those same subjects and participants become united because the moral codes of the social order refuse the lovers. Perhaps it is not the issue of incest that attracts Artaud but rather, like his demands not to simplify cruelty, this represents something that will disturb a culture. In this sense he is not as far removed from Freud's cultural interpretations of the Oedipus Complex as may first seem to be the case. For Freud, incest represented the fundamental point of origin for social law, and also the fundamental desire. Such a conflict is well suited to Artaud's schema. This is also the point that ties Artaud's sense of love to a certain postmodernity. So much of the politics and impetus of postmodern theory and textuality is derived from a struggle to understand power and provide sites of resistance against institutions of power. From Foucault's studies of power, to Lyotard's ideas on the challenge and destruction of Grand Narratives; from Cixous' laughing Medusa to Derrida's aporia — power and its centrality has become the contested site. Read in this way, Artaud's incestuous love as a usurper of disempowering processes parallels Lacan's idea that the demand and desire of incest at "the deepest level structures the unconscious."[4]

## The Skin of the Unconscious

The impossibility of the title of this final section returns us to the paradox of love. This time, however, the paradox shifts from one with hermeneutic echoes to one derived from certain moments of passion. What these different paradoxes of love share is a dependency on opposition. At no point can we safely or comfortably state that the relationship between love and meaning/interpretation can be or is resolved. This is because it holds to itself the necessary function of opposition. This is not some recourse to Saussurean opposites, where one is defined

through its opposition to the other. Rather, love and meaning/interpretation require the other in order to exist as they do — as potent devices in cultural and individual psyches. The borromean knot of love as unknowable and uncertain ties it and returns it continually to issues of how meaning itself functions and influences. Such is the relationship that operates in this sense of the skin of the unconscious.

Of course it is impossible for the unconscious to have skin, so what sense are we to make of this? Firstly, this is the Lacanian unconscious — granted a problematic name to evoke in a paper on Artaud, but unavoidable within the discussion. We are, then, dealing with the skin of the unconscious, and the skin of the Other — a relationship of desire. As Artaud puts it, this time about the conscious: "it seems that consciousness is bound in us to sexual desire and to hunger" (OC, XIII: 96). Before we continue with this point it is important to note what the function of the skin is and how we might speak of it in terms of the unconscious.

## The First Myth of the Skin

The first myth of the skin is that it is whole, that it stretches across the internal organs, surrounding us and forming us into a body. Skin is ultimately folds, tears and holes. It is a seam/seme because it marks the moment of joins and constantly generates meanings from such points of abutment and fusion. What constitutes skin is not the smooth texture wrapped around muscles, organs and fluids, but absences — the tiny and large lacunae from and into which we see, smell, taste, discharge, ejaculate, spit, ingest, bleed, shit. It is at these points that we define the limits of our skin, and therefore the nature of skin itself. It is these folds and holes that form the *semiotique* of the discourse of skin, because it is precisely at those points that the idea of completion and wholeness is questioned and disrupted.

Artaud wants to assist the moments of the *semiotique* of skin through the 'theatre of cruelty,' "a theatre which cuts into the flesh" (OC, V: 112–13). Here the 'theatre of cruelty' is a theatre of blood. Artaud's extraordinary metaphor of having to shit blood through his navel combines the liminal fluids of life and death (blood and shit) with the site of the body that is both a part of the self, and a part that comes from another. This knot of skin denies the myth of completion just as Artaud argues that another knot — the anus — is what constitutes the site of masculinity (OC, XIII: 230). For Lacan the unconscious is, as with this definition of skin, constituted of holes.

## The Second Myth of the Skin

The second myth of the skin is that it is solid rather than fluid, that liquids sit on its surface, and we can wipe it dry. Skin is constantly absorbing, producing, altering liquids. Skin itself is more fluid than solid, and it needs these fluids to exist and to be defined. It is the liquidity of the skin that declares its existence, because it is the fluid that marks the distinction between the self and the Other, and at the same time it is the possibility of them being conflated. The skin as fluid allows for the possibility, but perhaps not the event, of such an inmixing. The fluids of the body — sweat, tears, blood, sperm, vaginal liquids, spit — become the transformed versions of the body, passing through and over the skin in order to be.

## The Third Myth of the Skin

The third myth of the skin is that is defines limits, that it puts boundaries on our subjectivity by binding organs, fluids and the unconscious so that it is within our self. The skin not only stretches into folds within itself, it also stretches out to blend and merge with others. In this

sense the skin is that which allows the internal to become external, and for aspects and moments of the unconscious to become manifest. For Artaud the body is essential. It was the starting point for much of his ideas on theatre, and so linked directly to his ideas on creativity. It was a source of pleasure and pain, of defining his existence in the world and causing the angst of that existence. The long poem entitled "To Have Done With the Judgement of God" contains many lines about the body, concluding with a grappling with the suffocating notion of the body's existence:

> It's because I was pressed
> right to my body
> right to the body
>
> and that is when
> I blew it all up
> because no one ever
> touches my body.
> (OC, XIII: 97)

From this, then, to the skin of the unconscious. Artaud's skin has become one of the ways that his unconscious has been mapped, scrutinised, examined. From the handsome, striking features of the young Artaud — but even here the skin reveals the desires from the unconscious — to the ravaged, undisguised skin of the Artaud after Rodez. We can know nothing about Artaud and his work, but to gaze at these images ties us immediately to his unconscious.

The lover's skin is, like the face of Artaud, tied to their unconscious. Bodies brought together, skin rubbed against skin, fluids exchanged and mixed, the tangle of limbs, the probing of holes with tongues, fingers, organs and fluids so that they become defined as moments of subjectivity. All of this relies on the drive of desire which originates from the unconscious and is played out on the skin of corporeality. Of the *dispositif* of love, it is the skin

which signifies a certain acceptance of the loved one because it is on and in the skin — its holes, fluids and dissolves — that love is given a momentary taste of existence as the signifier. Not that this is to argue that it is only at the point of embodiment that love can be declared as existing; rather, this manifestation in skin marks a point among many possibilities where the unconscious is allowed a certain transgressive demonstration. One of the postmodern moments of love is this rendering of the unconscious through skin so that the unconscious itself takes on the appearance of skin.

No one touches Artaud's body because no one touches his unconscious.

## NOTES

References are to the *Oeuvres complètes* by volume and page number. Volumes I and XIV are published in two parts and are designated by single and double asterisks respectively.

1   Jean-Francois Lyotard, *Libidinal Economy*, transl. Iain Hamilton Grant (London: Athlone Press, 1993).

2   Antonin Artaud, *The Theatre and Its Double*, transl. Victor Corti (London: Calder, 1993) 56. Hereafter referred to as TD in the text.

3   Antonin Artaud, *Lettres à Génica Athanasiou* (Paris: Gallimard, 1969) 116.

4   Jacques Lacan, *The Psychoses* 1955–1956, transl. Russell Grigg (London: Routledge,1993) 68.

# Artaud in America

*Douglas Kahn*

Voyage to the Land of the *50% Less Cruel*. Although Artaud never travelled to the United States, he did visit the Americas and learned enough of the Tarahumara people to side with them, for instance, in his radio production *To Have Done with the Judgment of God*, against the entrepreneurial and militaristic mob north of the border. This is not to say that he hated all things American; avant-garde theatre in Europe often found sources of inspiration in the vitality of American culture. The type of physical humour found in Marx Brothers movies, for instance, was very interesting to him, just as long as the humour itself was removed to get to the core of its physicality. Yet on trans-Atlantic balance, whatever he made of the United States, artists in the United States would in due time make much more of him.

Beginning in the late 1940s American artists borrowed from him in every manner conceivable, and regularly came up at least one dispassionate step short of the deification or delectation more typical of his European reception. True, some continental-style connoisseurship exists today, where romances and metaphysics of his evacuated organs are distilled with little nose for pain or politics, but this came fairly late in the game, after Artaud had been filtered through French post-structuralism, whereupon it became difficult to determine where a theorist left off and an Artaud began, especially during a colectomy. The Artaud of an earlier reception arrived in America unaccompanied by other authorities; his texts were more readily raided, misread and then tossed wantonly into the blender with other sources. Very few of them had the image of Artaud

during his famous performance at the *Vieux-Colombier* theatre on 13 January 1947, where his shriveled countenance was indelibly etched into the consciousness of so many French intellectuals. In the United States during the 1950s and 1960s there was less an image of him than of his ideas, and it proved just as easy to recast his ideas as it did to revivify his image. For American artists Artaud would serve variously as the promoter of a new technical theatre, of a new communal theatre, a champion of shutting-up and shouting out, the text book example of the romantic artist and the purveyor of *no more masterpieces*, the barely sober madman railing against psychiatric institutions and psychiatrists, critic of post-war politics or peddler of apolitical rites, the traveller in search of revelatory hallucinations, render of complacency, mender of art and life.

Artaud in America? The most common scenario begins with M.C. Richards' translation, *The Theatre and Its Double*, published by Grove Press in 1958, through which Artaud's ideas were then taken up for a significant but brief stint by experimental theatre, most notably by *The Living Theater*. Richards had in fact sent Julian Beck and Judith Malina, the founders of *The Living Theater*, a prepublication manuscript in 1958, but it was not until 1963 with the production of *The Brig* that they openly incorporated Artaud's ideas into their work.[1] As a consequence, Artaud becomes associated with theatre of a distinctly cathartic and Dionysian cast, or shouting out in the vacuum of an existential void, and he becomes associated with the 1960s. There are several problems with this scenario. First, because he was used and dropped in the 1960s by theatre his artistic provocation is seen to have been exhausted, when in fact there are any number of artists from the time who integrated his ideas into the core of their work and subsequently, neither publicly nor privately, discarded him, just as there are still to the present day many more Artauds to construct and use. Second, there were other influential texts by Artaud translated prior to Richards' translation of

*The Theatre and Its Double,* and among these texts could
be counted nearly half of the same manuscript published in
1953. Third, it was the 1950s not the 1960s where the
earliest embrace of Artaud took place, in two places
conspicuously outside theatre: the new music ranks of
David Tudor and John Cage and the literature of the Beat
writers Carl Solomon, Allen Ginsberg and Michael McClure.
Tudor used Artaud to play the piano better and Cage used
him in a very non-cathartic form of composition and
performance; the Beats were more interested in Artaud the
poet, a political poet nonetheless; and McClure and others
were to mount an Artaud-inspired theatre several years
before *The Living Theater.* Instead of the one Artaud he was
a whole host of Artauds. With the following I would like to
examine these two early spheres of influence, in new music
and among the Beats.

## Musical Artauds

Artaud's American presence began in force when the
translation "Van Gogh: A Man Suicided by Society"
appeared in *The Tiger's Eye* 7 (March 1949),[2] a journal
with overlapping concerns of surrealism, existentialism,
the imagism of William Carlos Williams, and Abstract
Expressionism. This proved to be fortuitous timing for
underscoring the romance of Jackson Pollock just as he
was reaching his stride, pacing above his canvases.
Indeed, throughout the 1950s art world vernacular the
name of Pollock would often accompany the name of
Artaud: tortured by art, struggling with the body,
signifying with gesture, under the influence, dead early.
Nevertheless, it was John Cage, with his well known
antipathy toward Pollock and all ego-driven artistic
pursuits, who was to produce one of the earliest concrete
manifestations of Artaud's influence. His introduction to
Artaud, however, was through the pianist David Tudor,
who had incorporated Artaudian ideas of violence and

physicality into his performance. Moreover, this proved to
be the gateway through which M.C. Richards would be
introduced to *Le Théâtre et son Double* and decide to
undertake her famous translation, which would be read in
prepublication manuscript by Beck and Malina and so on.

During the Spring of 1949, John Cage and Merce
Cunningham visited Europe. At the urging of Virgil
Thomson, Cage introduced himself to Pierre Boulez, and
they went on to become over the next five years close
trans-Atlantic allies in the cause of new music. Cage
returned to the United States with a number of Boulez
compositions under his arm, including the notoriously
difficult *Second Piano Sonata* (1948) which he took upon
himself to get performed. When his first choice did not
work out he gave the score to Tudor, whom he had met
during the autumn of 1949 through the dancer Jean
Erdman, whose husband was the noted mythologist
Joseph Campbell (whose own collaboration with Cage
was in the offing). Tudor, an unknown at the time, was
very confident of his skills but the Second Sonata proved
to be beyond his prowess. With a dedication for which he
would later become known, he taught himself French in
order to read Boulez's writings to find a key to the piece,
a key he would find in an article entitled "Propositions" in
which Boulez wrote:

> Finally, I have a personal reason for giving such an
> important place to the phenomenon of rhythm. I think
> that music should be collective hysteria and magic,
> violently modern — along the lines of Antonin Artaud
> and not in the sense of a simple ethnographic
> reconstruction in the image of civilizations more or less
> remote from us.[3]

Tudor went to Gotham Book Mart in New York City
and left with a text of *Le Théâtre et son Double* (1938).
According to the primary authority on Tudor, John
Holzaepfel, Tudor found a passage in Artaud's book
which corresponded directly to Boulez's enthusiasm,

where the *hystérie et envoûtement collectifs* took tangible
form in the practices of trances and music cures heard
audibly on ethnographic recordings.

> I propose then a theatre in which physical images crush
> and hypnotize the sensibility of the spectator seized by
> the theatre as by a whirlwind of higher forces.
> A theatre which, abandoning psychology, recounts the
> extraordinary, stages natural conflicts, natural and subtle
> forces, and presents itself first of all as an exceptional
> power of redirection. A theatre that induces trance, as the
> dances of Dervishes induce trance, and that addresses
> itself to the organism by precise instruments, by the same
> means as those of certain tribal music cures which we
> admire on records but are incapable of originating among
> ourselves.[4]

Tudor took this as an encouragement to a certain type of
performative violence, one with a temporal immediacy
quite contrary to the types of duration involved in trance,
but not contrary to the immediacy produced by a trance-
like abandon. What he was abandoning were the
conventions of musical time and continuity which stood
between him and Boulez's *Second Piano Sonata*. Artaud
provided the violence and physicality needed to enter
another type of time.

> I recall how my mind had to change in order to be able to
> do it. ... All of a sudden I saw that there was a different
> way of looking at musical continuity, having to deal with
> what Artaud called the affective athleticism. It has to do
> with the disciplines that an actor goes through. It was a
> real breakthrough for me, because my musical
> consciousness in the meantime changed completely. ... I
> had to put my mind in a state of non-continuity — not
> remembering — so that each moment is alive.[5]

For our purposes here, the crucial feature of Tudor's
embrace of Artaud has to do with the role that Tudor
himself played in the formation of American avant-garde

music in the second half of the century, a role described convincingly by Holzaepfel. Because of Tudor's prowess and uniqueness as a performer of often daunting new music, he became closely associated with Cage, Earle Brown, Morton Feldman and Christian Wolff. This was definitely not a service role, since they felt compelled to compose at a level of difficulty and innovation to meet the challenge of Tudor's virtuosity. As Brown put it:

> I think we all felt that about David — that we were *boring* him. "What can we do next that he *can't* do?" I think we all felt he had a low threshold of boredom; he just breezed through these pieces, then seemed to ask, "What next? Give me something *really* to do."[6]

Artaud's writings contributed to Tudor's virtuosity, Tudor's virtuosity propelled the course of the "New York School" of composition and the Cagean aesthetic, and these in turn played an important part in the direction of a number of arts in the second half of the century. In this way alone one could find Artaudian traces throughout the 1950s and beyond. Tudor's role has been underplayed no doubt due to his reticence at both self-promotion and even social interaction, despite being a performer of great intensity.

Cage, on the other hand, was intensely public in so many ways. Thus, despite the fact that it was Tudor who introduced Artaud into American avant-garde music and encouraged Cage to read *Le Théâtre et son Double*, it was Cage who most energetically encouraged others to take notice of Artaud. He was already fluent in French when he began to read Artaud in earnest, and his reading of Artaud occurred at what proved to be a very auspicious time in his career. As he wrote to Boulez (22 May 1951):

> I have been reading a great deal of Artaud. (This because of you and through Tudor who read Artaud because of you.) ... I hope I have made a little clear to you what I am doing. *I have the feeling of just beginning to compose for*

*the first time.* I will soon send you a copy of the first part of the piano piece. The essential underlying idea is that each thing is itself, that its relations with other things spring up naturally rather than being imposed by any abstraction on an 'artist's' part. (see Artaud on an objective synthesis)[7]

The italicised sentence, Cage's own emphasis, was an assertion of confidence and resolve from someone already known for having an abundance of both. Indeed, the years 1951 and 1952 were indeed exceedingly important in Cage's career for the development of his mature thought as evinced in a number of breakthrough compositions: *Music of Changes* (which used the *I Ching*), *Imaginary Landscape No. 4* (for 12 radios), *4'33"* (the *silent* piano piece), *Water Music* (Cage's first theatre piece), and *Willams Mix* (the audiotape piece which departed from the compositional tactics of *musique concrète*). It was also in 1952 that Cage, inspired by a triangulation of the Huang Po Doctrine of Universal Mind, Marcel Duchamp's aesthetics of indifference, and Artaud, produced a performance piece at Black Mountain College. The event itself called upon the participation if not the talents of Charles Olson, M.C. Richards, Robert Rauschenberg, David Tudor, Merce Cunningham and others, and what might have happened exactly depends upon which of various accounts from the participants and observers you read.[8] It would become commonly known later in the 1950s as both the "Black Mountain event" and, rightly or wrongly, as *the first happening.* One of Cage's accounts went like this:

At one end of the rectangular hall, the long end, was a movie and at the other end were slides. I was up on a ladder delivering a lecture which included silences and there was another ladder which M.C. Richards and Charles Olsen went up at different times. ... Robert Rauschenberg was playing an old-fashioned phonograph that had a horn and a dog on the side listening, and

David Tudor was playing the piano, and Merce
Cunningham and other dancers were moving through the
audience and around the audience. Rauschenberg's
[white] paintings were suspended above the audience.[9]

Cage's fascination with Artaud may seem odd; after all,
by the early 1950s he had set himself against the heated,
gestural assertions of the abstract expressionists in favour
of a cool invocation of immaterial worldliness, and
despite being lovers with a dancer, his own comportment
was guarded and seemingly out of touch with Artaudian
corporeality. Cage's bodily restraint did not, however,
contradict the specific attention within *The Theatre and
Its Double* given to the technical considerations of
constituting theatre from various artistic forms.

....we got the idea from Artaud that theatre could take
place free of a text, that if a text were in it, that it needn't
determine other actions, that sounds, that activities, and
so forth, could all be free rather than tied together; so
that rather than the dance expressing the music or the
music expressing the dance, that the two could go
together independently, neither one controlling the
other. And this was extended on this occasion not only to
music and dance, but to poetry and painting, and so
forth, and to the audience. So that the audience was no
longer focused in one particular direction.[10]

Artaud's stance against the dominance of speech must
have been especially attractive to Cage, since it was
consistent with his own diminution of "literal" meaning
through the musicalisation of sounds (even though
musicalisation was just as ready to remove the affective
body from performance). Cage's technical disposition
toward Artaud was evident in his lesser motivations as
well, e.g., because Artaud had "made lists that could give
ideas about what goes into theatre. And one should
search constantly to see if something that could take place
in theatre has escaped one's notice."[11] In contrast to
Tudor, who was equally attracted to the technical

implications of Artaud and fused them in performance with an impassioned corporeality and metaphysics of violence, Cage was interested in the more patently formal attributes in service of a theatre of things and events.

While in residence at Black Mountain College, Cage and Tudor brought Artaud's *Le Théâtre et son Double* to the attention of M.C. Richards who decided to translate the work into English. As her translation progressed she gave readings to small groups of individuals; in attendance during one of these sessions was Barney Rossett, who decided to publish the translation with his fledgling Grove Press, although the publication would not appear until 1958. Around the same time as her readings, i.e., circa 1953, a number of her translations appeared in the journal *Origin: A Quarterly for the Creative*, and other parts of her manuscript circulated privately prior to publication.[12] Allen Ginsberg also cited her translation of "The Theatre and the Plague" (a chapter not published in *Origin*) in his journal in April 1956.

> *Theatre & Its Double* — Antonin Artaud/M.C. Richards Translation/ 'our nervous system after a certain period absorbs the vibrations of the subtlest music and in a sense is modified by it in a lasting way.'/ Example of ignuschizoid perception.[13]

Artaud's presence was also felt among the ranks of *happenings*, indeed, most of Cage's comments on Artaud were occasioned by discussions about happenings. Allan Kaprow, the key figure in their development, was positioned between the romance of Pollock and the disinterestedness of Cage. His work had developed first within the fervent milieu of Harold Rosenberg's *action* and the kinaesthetic and hallucinatory *delirium*, if not *hystérie et envoûtement collectifs*, of Pollock's paintings. His first happening was produced while attending Cage's class at the New School of Social Research, after hearing about the Black Mountain event from Cage. Although, as his essay "The Legacy of Jackson Pollock" demonstrated,[14] Kaprow

could easily disentangle the valuable artistic provocations of Pollock from the prevailing romantic figure of Pollock, this did not prevent a group of dead artist phantoms from being marshalled against him by others in the early 1960s.

> According to the myth, modern artists are archetypal victims who are "suicided by society" (Artaud). In the present sequel, they are entirely responsible for their own life and death; there are no clear villains anymore. There are only cultured reactionaries, sensitive and respected older radicals, rising up in indignation to remind us that Rembrandt, van Gogh, and Pollock died on the cross (while we've "sold out").[15]

Kaprow wanted the art-and-life nexus from Artaud but refused to suffer the suffering. Other *happeners* sported their own attitudes toward Artaud and, however conflicted these might have been, Michael Kirby could inventory the field in his 1965 book *Happenings* and propose that "Some Happenings are the best examples of Artaud's Theatre of Cruelty that have yet been produced."[16]

### Beat Artaud

The other early sphere of influence occurred among the Beat writers, first with Carl Solomon and Allen Ginsberg and then more passionately with Michael McClure. Unlike the Cage-Tudor Artaud who was the apolitical, pre-Rodez man of theatre, the Beat Artaud began primarily with the post-Rodez, anti-psychiatric, anti-American poet. The Beat Artaud first made his way around one psychiatric institution in particular on the East Coast, then was introduced to the West Coast at the famous Six Gallery reading in San Francisco (13 October 1955), famous for being where Ginsberg first read *Howl*, for unwittingly being the official launch of the Beat Generation and, as more recently recognised, famous for inaugurating

ecological poetry in the United States or, as McClure has
said, "the Beat Generation will be remembered as the
literary wing of the environmental movement."[17]

Ginsberg's own encounter with Artaud's texts and the
figure of Artaud started when he checked into the
Columbia Presbyterian Psychiatric Institute (PI) in June
1949, whereupon he met fellow resident Carl Solomon —
Artaud devotee. Ginsberg's *Howl* was, of course,
dedicated for Carl Solomon and their first meeting at the
PI became so legendary the legend pestered Solomon like
a bad rash for years.[18] Right after the war, Solomon joined
the U.S. Maritime Service and, in 1947, jumped ship in
France. He soon found himself circulating among avant-
garde circles where he happened to witness along with
hundreds of others Artaud's three-hour performance at
the *Vieux-Colombier.*

> Artaud was being described by a small circle of Paris
> admirers, some in very high places in the arts, as being a
> genius who had extended Rimbaud's vision of the poet
> seer. His name was even described by one admirer,
> known as "the Alchemist," as Arthur Rimbaud without the
> HUR in Arthur and without the RIMB in Rimbaud.[19]

Of course, Artaud had a particular relevance for
Solomon once he was, as they say, institutionalised, and
especially after he was subjected to a ruthless series of
insulin shock treatments "... forcibly administered in the
dead of night by white-clad, impersonal creatures who
tear the subject from his bed, carry him screaming into an
elevator, strap him to another bed on another floor."[20] An
entire range of intellectual pursuits were tolerated, "Yes,
in mental hospitals patients still dance and dream hazily
about the nurses. Others discuss anything from Artaud to
Schweitzer and Oleg Cassini and some still wave their
rumps."[21] All was tolerated, all except investigating the
functioning of the institution itself, an activity which
necessarily took on a clandestine character, e.g., Solomon
read a book on shock therapy cloaked in the cover of

Anna Balakian's *Literary Origins of Surrealism*.[22] The
Artaud text most relevant to Solomon's situation, from the
very beginning of his term in mental institutions, was "Van
Gogh: A Man Suicided by Society"[23] which, in the *The
Tiger's Eye* translation, he passed onto Ginsberg.
Artaud's Van Gogh essay was one of the texts which fed
into *Howl*, the most salient feature shared by the two texts
being a vehemence against psychiatry. Artaud castigates Van
Gogh's "improvised psychiatrist" Dr. Gachet in the same
way he publicly vilified Dr. Gaston Ferdière, the Director of
Rodez, during the *Vieux-Colombier* performance, and this
anti-psychiatric attitude was channelled through Solomon
in the PI into Ginsberg's best known poem. Indeed, the
proposition within Artaud's Van Gogh text — "There is in
every lunatic a misunderstood genius who was frightened
by the idea that gleamed in his head and who could find an
outlet only in delirium for the stranglings life had prepared
him."[24] — seems to animate *Howl* from the very first line:
"I saw the best minds of my generation destroyed by
madness, starving / hysterical naked...." Indeed, Ginsberg
candidly cited "Van Gogh: The Man Suicided by Society" as
one of the main texts informing *Howl*.[25]

Another Artaud text known to Ginsberg in the early
1950s also figured into *Howl*, albeit a bit more obliquely.
While citing the influence of Artaud's Van Gogh text,
Ginsberg also writes that "Artaud's physical breath has
inevitable propulsion toward specific inviolable insight on
'Moloch whose name is Mind!'"[26] While high on peyote
(October 1954) he looked out the window from his
apartment on Nob Hill in San Francisco and saw Moloch, the
figure which went on to dominate part two of *Howl*,[27] in the
looming spectre of the Sir Francis Drake Hotel. The simple
fact that Ginsberg was high on peyote at the time can also be
traced to Artaud, specifically, another text given to him by
Solomon: "... by 1952 we already had the experience of
peyote partly as a result of translations of Artaud's *Voyage au
Pays des Tarahumaras*, which appeared in *Transition*
magazine in the 40s, and Huxley's *Doors of Perception*."[28]

While Ginsberg recited *Howl* at the Six Gallery, Michael McClure, who had read his own poems earlier in the evening, was in the audience. Years later, he remembered sitting there *wondering* whether *Howl* was a "bourgeois Artaudism," a *flattened out* Artaud in a long poem style of *To Have Done with the Judgment of God* and Shelly's *Queen Mab*.[29] It is unlikely that Ginsberg was operating with a working knowledge of *To Have Done with the Judgment of God*, Artaud's censored radio piece from 1948. McClure was referring to the script, not the recording, which circulated around San Francisco's Bohemian locus of North Beach in the mid-1950s. It had been translated by Guy Wernham who, well known for his 1943 New Directions translation of Lautréamont's *Les Chants de Maldoror*, had fallen from grace a bit by the mid-1950s and was working as a bartender in North Beach. A frequent visitor to Ginsberg's apartment, Wernham was included in the roster of the first draft of *Howl* as the person "who rapidly translated the Songs of Maldoror and threw himself/on the mercy of Alcoholics Anonymous." Despite his personal acquaintance with Wernham, Ginsberg did not place *To Have Done with the Judgment of God* on his reading list until December 1955, about six weeks after the Six Gallery reading. It is even less likely that it contributed to the writing of *Howl*, considering the bulk of the poem was written months before the reading.[30] McClure may have heard Artaud in *Howl*, and may have heard a political post-Rodez poet, but it was the anti-psychiatric Artaud of "Van Gogh: The Man Suicided by Society." Besides, following Ginsberg's habit of generously crediting his sources, at a later date he would praise *To Have Done with the Judgment of God* for its critique of American militarism and commodity culture (diary note dated 13 April 1961):

You are me, God—
Artaud alone made accusation
against America.[31]

Another reason McClure remembered hearing Artaud in Ginsberg's *Howl* was because, more than any other Beat, he had an ear out for Artaud, experiencing such kinship that he felt he could have been Artaud's younger brother.

## McClure and Artaud

McClure's first encounter with Artaud's writings had been in 1952 or 1953 while, as a university student in Arizona, he was searching the library for material on peyote. He had long been in the habit of scouring libraries and used bookstores for obscure bohemian tracts. He moved to San Francisco in 1953 with the intention to study with Clifford Still, not to learn painting, but to learn how he might incorporate a gestural impulse into his poetry, to get the body onto the page and the words off, a desire naturally aligned to Artaud's work as well. Artaud had already attained mythic status in San Francisco, so McClure had little trouble in being exposed to a number of texts and, not knowing French, in seeking assistance from others: the poet Philip Lamantia had strong links to the Surrealists since the 1940s; Kenneth Rexroth, patriarch of the San Francisco Renaissance was translating Artaud at the time; and Joanne McClure, his wife, translated a small portion of *Voyage au Pays des Tarahumaras* for Wallace Berman's little mag *Semina*.[32] Most significantly, Guy Wernham gave McClure his translation of *To Have Done with the Judgment of God* prior to the Six Gallery reading.[33] With this familiarity McClure could hear the text in *Howl* and, perhaps more surprisingly, Artaud could be heard in McClure's own environmentalist poems at the reading.

At the reading McClure read poems formed by his politicised brand of naturalism he would come to know in two years time as *ecology* or *environmentalism*.[34] "The Mystery of the Hunt" related to his early discovery of nature in the Bay Area, the scent of lemon verbena in someone's garden, sea otter games in the surf, "... small things/That when brought into vision become an inferno."

"For the Death of 100 Whales" was a response to the machine gunning of 100 killer whales by American sailors at a NATO base in Iceland. With regard to a third poem, "Point Lobos: Animism," McClure recounted how his preoccupations in these early years would contribute to the deepening experiential basis of his mammalianism and meat science:

> I was overwhelmed by the sense of animism — and how everything (breath, spot, rock, ripple in the tidepool, cloud, and stone) was alive and spirited. It was a frightening and joyous awareness of my undersoul. I say *undersoul* because I did not want to join Nature by my mind but by my viscera — my belly. The German language has two words, *Geist* for the soul of man and *Odem* for the spirit of beasts. *Odem* is the undersoul. I was becoming sharply aware of it.[35]

He attests to this poem in particular as having been derived from his fascination with Artaud's writings. Of course, McClure did not need Artaud to be interested in animism, or ecology; he was attached more precisely to an *undersoul* viscerality in Artaud's writing: "In their direct statement to my nerves, lines of Artaud's were creating physical tensions, and gave me ideas for entries into a new mode of verse."[36] There was also a mystical, revelatory component in "Point Lobos: Animism" of becoming inextricably situated among natural forces, derived from "one phrase of Artaud's [which] fascinated me: 'It is not possible that in the end the miracle will not occur.'"[37] However oblique an Artaudian visceral writing and mystical optimism might have contributed to McClure's developing environmentalism, it was more significant that there was nothing in Artaud's thought which McClure perceived as being contrary to the direction he was taking. Indeed, if we go back to read Artaud ecologically, which is an approach immediately suggested neither by his writing nor its reception, there arises the possibility that Artaud could have very well

acted as a legitimisation for these early stages of ecological poetry in the United States. In *To Have Done with the Judgment of God*, the text in McClure's possession at the time of the Six Gallery reading, we can find a contemporary animism, where animality moves to spirit to microbes and atoms,[38] all the while being accompanied by a scathing attack of the United States as a society slave to the imperative where:

> new fields of activity must be created,
> where all the false manufactured products,
> all the vile synthetic ersatzes will finally reign,
> where glorious true nature will just have to withdraw,
> and give up its place once and for all and shamefully to all the triumphant
> > replacement products
>
> ....No more fruit, no more trees, no more vegetables, no more ordinary or
> > pharmaceutical plants and consequently no more nourishment,
> but synthetic products to repletion,
> in vapors......[39]

Ecology, for McClure, was something to be understood through countless and untold experiences of one's own body, and this understanding itself took place among the efforts of other male artists in the United States during the 1950s. The body that had been ravaged by World War II and the Korean War, put into cold storage by homegrown Christian puritanism and unfulfilling jobs, rendered self-conscious in the light of nuclear annihilation, took on another incarnation altogether with the likes of Jackson Pollock who threw his entire body into the open act of his painting; Charles Olson who wrote the breath into poetic line; Charlie Parker who blew intellectual life into a legacy of improvisation; and Robert Duncan, the Beats and other writers whose declaration of gay sexuality and culture closed the door on the closet behind them. That Artaud,

someone generally perceived as wanting to get rid of his body, might become associated with these activities of the body was not without contradiction, and certainly did not escape McClure who, speaking of his fellow poets among the San Francisco Renaissance and the Beats, stated that Artaud "was truly a great gnostic, anti-body poet. Although we were all body poets, we looked to Artaud as our immediate ancestor."[40] Although it might seem difficult to maintain such a paradox today, in the repressed context of 1950s America any attention to the body was refreshing, and even though Artaud wished to shed his body, his incredibly prolonged discourse around the moment of this desire rendered the body ever-present, if not desirous itself.

Artaud's abdication of his body could also be understood as being complicit with the 1950s, as an elaborate form of the masochistic and sacrificial Christian body, channelled and denied, or a fragmentation of the body commensurate with an exhilarated post-war commodity culture, or the isolated attention on the human body which has bred the trodding destruction of species and environments. Indeed, McClure looked upon the Artaudian body as impassioned but asexual, whereas he himself called forth the intensities of eros, sex and animality. McClure thought that Artaud invoked the body like Van Gogh, portioning parts of the body off from one another so that they might be dispensed with as easily as an ear lobe, in effect a scatological preoccupation which resulted in, as McClure puts it, "the meat falling off the bones as shit."[41] The result was a body which fell away from itself, from other bodies, other mammalian bodies, inhabiting a metaphysical zone which itself had fallen away from the earth. McClure refused to carve up his body as though it were meat for the montage, nor to isolate it from any other influences. He wanted to keep meat intact, the body hospitable to mammalian, worldly and cosmic energies, forces, voices and potentialities coursing their way through. McClure was not advocating a solipsistic

incarnation of the world, or a narcissistic focus on the body, but a situation in which "one has to move *in* to move *out*," i.e., the more one discovers his or her own biological being then the more value that person can be to people and other creatures around them.[42]

McClure was initially interested in Artaud the poet; however, during the late 1950s in response to *The Theatre and its Double*, he took Artaud's lead and became a playwright, and eventually well-known for such plays as *Josephine the Mouse Singer*, *Gorf*, *Gargoyle Cartoons*, and especially *The Beard*, which gained notoriety through a fierce censorship battle. McClure moved to theatre after he began to conceive of his poetry as a transcribed voice easy to move off the page and onto the stage. These poems, which would eventually be collected in the pages of *The New Book/A Book of Torture* (1961), a book containing poems written to his body influences Pollock, Olson and Artaud.

> I was convinced by Artaud that texts were needed for the theatre and that it would be the poets who would write these texts. I was inflamed with his idea of theatre, and the theatre of cruelty.... But on reading Artaud, I looked at the poems that I was writing and I thought that the poems were voice notations (These would be many of the poems *The New Book/A Book of Torture*.) I said, "Ah, this voice notation can be adapted to theatre!"[43]

One of his earliest plays was called *!The Feast! for Ornette Coleman!* (1960) and was written alternating between recognisable poetic speech in English, and a mammalian tongue McClure called *beast language*.[44] It is not an interspecies language, but a mammalian communication based upon a commonality of meat, with a voice that, as McClure says, "comes right out of my muscles."[45] It did not develop out of any linguistic preoccupation but was instead borne by two visions; the first one giving him the idea for *!The Feast!* "went off like a light bulb over my head — like in the cartoons. Flash,

flash, flash! And I saw the whole play and I started to write it down in beast language with thirteen characters drinking black wine and eating loaves of French bread."[46] The second vision came in the late summer of 1962 when he sensed a ball of silence in the lower head and thoracic area in which "there were swirling 99 poems in a language other than English,"[47] poems that came from a "swirling ball of silence that melds with outer sounds and thought."[48] Unlike the beast language dispersed among the 13 characters of *!The Feast!*, these poems were much more personal, and the writing itself a spiritual process which matured with each poem. Gathered under the title of *Ghost Tantras*, they were written "in kitchens and bedrooms and front rooms and airplanes and a couple in Mexico City;"[49] No. 39 was written the day Marilyn Monroe died (6 August 1962), and the last one was being completed just as the filmmaker Stan Brakhage called on the phone. This is what McClure would have recited to Brakhage over the phone:

<div align="center">

99

IN TRANQUILITY THY GRAHRR AYOHH
ROOHOOERING
GRAHAYAOR GAHARRR GRAHHR GAHHR
THEOWSH NARR GAHROOOOOOOOH GAHRR
GRAH GAHRRR! GRAYHEEOARR GRAHRGM
THAHRR NEEOWSH DYE YEOR GAHRR
grah grooom gahhr nowrt thowtooom obleeomosh.
AHH THEEAHH! GAHR GRAH NAYEEROOOO
GAHROOOOOM GRHH GARAHHRR OH THY
NOOOSHEORRTOMESH GREEEEGRAHARRR
OH THOU HERE, HERE, HERE IN MY FLESH
RAISING THE CURTAIN
HAIEAYORR-REEEEHORRRR
in tranquility

LOVE
thy
!oh my oohblesh!

</div>

It may be asked whether McClure's beast language
with its corporeal and cosmic energy, its Reichian
*biological language*, and its animality was derived in any
part from Artaud's own emphasis upon vocables and
vocalisations, from Artaud's glossolalia or screaming.
Notable instances of glossolalia appeared in both the Van
Gogh essay and *To Have Done with the Judgment of God*
and, although it was incantatory and scatological, McClure
had no way of knowing it was actually, in his own words,
*shriekalalia* or *copralalia* before listening to the
recording of *To Have Done with the Judgment of God*
several years later. Indeed, McClure would not hear the
recording until 1968 when the poet and artist Jean-
Jacques Lebel sent Ginsberg and himself copies liberated
from the vaults of the *RDF* in Paris during the events of
May 1968. If what was at stake was a simple removal or
diminishment of meaning, then McClure had long been
aware of Ball, Schwitters and Arp, at least since picking up
old copies of *Transition* in used book stores in Lawrence,
Kansas, before moving to San Francisco. In retrospect,
McClure understood the tradition of sound poetry as
largely the result of a European rationalism acted upon by
an equally European negativity. Although it was easier to
sense the body at work in Artaud's glossolalia, and indeed
some of the words allude to various body parts and
substances, there was a reliance upon Greco-Roman-like
words and an overall religiosity which conformed to other
traditions where glossolalia was a form of talk
understandable to the Judeo-Christian God but not to
humans, transcending the body and the mundane, let
alone the bodies of other mammals.

McClure acknowledges his European roots, however he
considers beast language much more a product of the West
Coast of the United States looking toward Asia, its back
toward Europe.[50] He did hold out Artaud as an exception,
however, since unlike the sound poets he could look to
Artaud and still look to Asia at the same time. It was not
immaterial that Artaud himself sought sources of inspiration

among many other cultures, including Asian cultures, but ultimately it was not crucial. In his short celebration of *To Have Done with the Judgment of God*, entitled "Artaud: Peace Chief" from *Meat Science Essays*, he wrote, "We, new creatures, must accept the admissions of Artaud and tantric Shakti texts such as *The Serpent Power* and all images of reality and body."[51] For McClure there was no surface similarity between Artaud and beast language, but a common source announced by the position of both Artaud and beast language in proximity to Kundalini, body practices and the body in general.

Thus McClure had already registered Artaud's influence in both poetry and theatre before the 1960s began. By mid-decade, on the heels of the translation of *The Theatre and Its Double*, America was feverishly embracing all things Artaud: *The Living Theater* and other actors, directors and playwrights were shouting his name, while the publication of *Artaud Anthology* by City Lights Books signalled his status among poets. McClure was not lost in the shuffle, indeed, in 1964 Carolee Schneemann could write to Jean-Jacques Lebel in Paris, joining McClure and Artaud in a commonality of meat, with a prospectus for her performance piece *Meat Joy*.

There are now several works moving in mindseye ... *Meat Joy* shifting now, relating to Artaud, McClure, and French butcher shops — carcass as paint (it dripped right through Soutine's floor) ... flesh jubilation ... extremes of this sense ... Smell, feel of meat ... chickens, fish, sausages?[52]

Some would eventually reject and move on from Artaud; more still integrated his ideas and example lastingly into the core of their work. Whatever the execution of Artaud's influence in the decades following the forgotten decade of the 1950s, he had bled into the very corpuscles of the American avant-garde and inspired some of their most bohemian activities. But these experiments, however radical, were still notably less cruel than the original.

# NOTES

1   Pierre Biner, *The Living Theater* (New York: Horizon Press, 1972), and John Tytell, *The Living Theater: Art, Exile and Outrage* (New York: Grove Press, 1995). The anarchist polymath Paul Goodman, an important ingredient in *The Living Theatre*, situated Artaud in America in this manner: "In his *Theatre of Violence*, Antonin Artaud declares that theatre is precisely not communicating ideas but acting on the community, and he praises the Balinese village dance that works on dancers and audience until they fall down in a trance. (For that matter, the shrieking and wailing that was the specialty of Greek tragedy would among us cause a breach of the peace. The nearest we come are adolescent jazz sessions that create a public nuisance.") Paul Goodman, "Pornography, Art and Censorship," originally published in Commentary (March 1961), included in *Format and Anxiety: Paul Goodman Critiques the Media*, ed. Taylor Stoehr (Brooklyn: Autonomedia, 1995) 81.

2   Antonin Artaud, "Van Gogh, the Man Suicided by Society," transl. Bernard Frechtman, *The Tiger's Eye* 7 (March 1949) 93–115, excerpted in the appendix of Ann Eden Gibson, *Issues in Abstract Expressionism: The Artist-Run Periodicals* (Ann Arbor: UMI Research Press, 1990) 181–204.

3   Originally published in *Polyphonie 2* (1948) 65–72, cited in John Holzaepfel, "David Tudor and the Performance of American Experimental Music, 1950–1959" (Ph.D. Diss., City University of New York, 1994) 31–32. My information on Tudor is indebted to Holzaepfel's research. On Boulez and Artaud, see Peter F. Stacey, *Boulez and the Modern Concept* (Aldershot: Scolar Press, 1987) 22–5.

4   Antonin Artaud, *The Theatre and its Double*, transl. M.C. Richards (New York: Grove Press, 1958) 22.

5   David Tudor interviewed by Austin Clarkson (1982), cited in Holzaepfel, "David Tudor," 33.

6   Brown interviewed by Holzaepfel (1992), ibid., 45.

7   John Cage, "Letter from John Cage to Pierre Boulez" (22 May 1951), *The Boulez-Cage Correspondence*, ed. Jean-Jacques Nattiez (Cambridge: Cambridge University Press, 1993) 96. My emphasis.

8   See Martin Duberman, *Black Mountain: An Exploration in Community* (New York: Anchor Press, 1973) 368–79.

9  Michael Kirby and Richard Schechner, "An Interview with John Cage" *Tulane Drama Review* (T30), 10/2 (Winter 1965) 53, reprinted in *Happenings and Other Acts*, 53.

10  Interview with Emma Harris (1974), cited in John Cage, *Conversing with Cage*, ed. Richard Kostelanetz (New York: Limelight Editions, 1988) 104.

11  Michael Kirby and Richard Schechner, "An Interview with John Cage," 54.

12  *Origin: A Quarterly for the Creative* 11 (Autumn 1953), included the following sections: "Preface: The Theatre and Culture," "Staging and Metaphysics," "On the Balinese Theatre," "Let's Have Done with Masterpieces," "The Theatre of Cruelty (First Manifesto)," "The Theatre of Cruelty (Second Manifesto)."

13  Allen Ginsberg, *Journals, Mid-Fifties: 1954–1958*, ed. Gordon Ball (New York: Viking Press, 1995) 96. Those wishing to understand what *ignuschizoid perception* might be, please refer to Ginsberg's poem *Ignu* in *Collected Poems, 1947–1985* (London: Penguin 1995) 203–5.

14  Allan Kaprow, "The Legacy of Jackson Pollock" (1958), *Essays on the Blurring of Art and Life*, ed. Jeff Kelley (Berkeley: University of California Press, 1993) 1–9.

15  Kaprow, "The Artist as a Man of the World (1964)," ibid., 48–9.

16  Michael Kirby, *Happenings* (New York: E. P. Dutton, 1965) 35. The introduction is reprinted in *Happenings and Other Acts*. Other American Happeners with Artaudian connections include Claus Oldenburg, see Barbara Rose, *Claus Oldenburg* (New York: Museum of Modern Art, 1969) 27; and Al Hansen: "My goal ... is to involve the ideas of all my favorite people — Artaud and John Cage and Ray Johnson — in a total theatre project in which things which weren't possible before will be done." Al Hansen, *A Primer of Happenings & Time/Space Art* (New York: Something Else Press, 1965) 109.

17  Cited in Daniel Barth, "NY Beats 2" *Beat Scene* 21 (1995) 5–6.

18  "Didn't Ginsberg and I go through all that nonsense about Dostoievsky some fifteen years ago and then it was about three hundred years old. What do you want me to say? Moo? Goo? Or moo goo guy pan??" From Carl Solomon, "Age: 36," *Mishaps, Perhaps* (San Francisco: City Lights Books, 1966) 8.

19  Solomon, "Artaud," ibid., 13–4.

20  ibid., 37.

21  Solomon, "Another Day, Another Dollar....After the Beat Generation," ibid., 12.

22  Solomon, "Report from the Asylum: Afterthoughts of a Shock Patient," ibid., 42.

23  In his "Letter to Governor Rockefeller" (25 February1962), Solomon wrote: "I am content that I am the American Mayakovsky and have been all but suicided by the society (read Van Gogh "The Man Suicided By Society" by Antonin Artaud)," ibid., 27.

24  Antonin Artaud, "Van Gogh, the Man Suicided by Society," 189.

25  Allen Ginsberg, "Model Texts: Inspirations Precursors to HOWL," (Appendix IV), in Allen Ginsberg, *HOWL: Original Draft Facsimile, transcript & Variant Versions, Fully Annotated By Author, With Contemporaneous Correspondence, Account of First Public Reading, Legal Skirmishes Precursor Texts and Bibliography*, ed. Barry Miles (New York: Viking Penguin, 1987) 175.

26  ibid., 175. In 1968 Ginsberg placed Artaud's "physical breath" and cries in the context of Charles Olson's idea of putting the breath in the poetic line. Cf. Allen Ginsberg, *Composed on the Tongue* (San Francisco: Grey Fox Press, 1980) 40.

27  Ginsberg, *Journals*, 61–2.

28  Ginsberg, *Composed on the Tongue*, 76. Ginsberg could not have known of Aldous Huxley's "The Doors of Perception" in 1952, since it was written about an experience in 1953 and not published until 1954.

29  Interview with the author, Berkeley, California (5 April 1995). This should not be construed as a sudden lack of generosity towards *Howl* on McClure's part. He has repeatedly praised the poem and recognised its status as an emblem of a new era: "Ginsberg read on to the end of the poem, which left us standing in wonder, or cheering and wondering, but knowing at the deepest level that a barrier had been broken...." *Scratching the Beat Surface* (New York: Penguin, 1982) 15.

30  Ginsberg, *Journals*, 215.

31  ibid., 195. The same day he had also written, "Artaud expresses himself/like a can of spy-being,/exploded,"

(195–6). On this point McClure concurs: "If you look at *To Have Done with the Judgment of God* today, it's exactly about the Cold war, exactly about the state of Europe and America in those days." Michael McClure, *Lighting the Corners* (Albuquerque: University of New Mexico, 1993) 168.

32 Antonin Artaud, "Seven Short Poems," transl. Kenneth Rexroth, *The Black Mountain Review* 1/2 (Summer 1954) 8–11, reprinted in *Artaud Anthology*, ed. Jack Hirschman (San Francisco: City Lights Books, 1965) 208–11.

33 Wernham's translation was eventually published in *Northwest Review* 6/4 (Fall 1963) 45–72. The University editor responsible for publishing the translation was fired. See Michael Schumacher, *Dharma Lion: A Biography of Allen Ginsberg* (New York: St. Martin's Press, 1992) 412.

34 See interview with Michael McClure, *The San Francisco Poets*, ed. David Meltzer (New York: Ballantine Books, 1971) 252. "I met Sterling Bunnell in 1957 and before that I thought in terms of biology or natural history or physiology or morphology. Sterling introduced the concept of ecology to me."

35 McClure, *Scratching the Beat Surface*, 26.

36 ibid., 24.

37 ibid. McClure here refers to the first line of a poem published in *Origin: A Quarterly for the Creative* 11 (Autumn 1953) 131, the same issue in which a large portion of Richards' translation of *The Theatre and Its Double* appeared, five years prior to its publication by Grove Press.

38 See Antonin Artaud, *To Have Done with the Judgment of God*, transl. Clayton Eshleman, *Wireless Imagination: Sound, Radio and the Avant-garde*, ed. Douglas Kahn and Gregory Whitehead (Cambridge, Mass.: MIT Press, 1992) 327.

39 ibid., 311.

40 McClure, *Lighting the Corners*, 168.

41 Interview with author.

42 McClure, *Lighting the Corners*, 11.

43 McClure, *The San Francisco Poets*, 254.

44 *!THE FEAST!, for Ornette Coleman* was first performed at the Batman Gallery in San Francisco (22 December 1960), and first published as a *Floating Bear* pamphlet (1961) and reprinted in Michael McClure, *The Mammals* (Berkeley:

Cranium Press, 1972).

45  Interview with author.

46  "Cartoon light bulb: a truly American visionary mode! We can only imagine what accompanied Edison's idea for the light bulb." McClure, *The San Francisco Poets*, 251–2.

47  Interview with author.

48  Michael McClure, "Introduction, (1964)," *Ghost Tantras* (San Francisco: Four Seasons Foundation, 1969) n.p.

49  ibid.

50  To this day McClure finds it odd and inappropriate that his *Ghost Tantras* have been placed by some in the context of European sound poetry. Artaud's glossolalia has suffered the same fate.

51  Michael McClure, "Artaud: Peace Chief," *Meat Science Essays* (San Francisco: City Lights Books, 1966) 94–5.

52  Carolee Schneemann, letter to Jean-Jacques Lebel responding to an invitation to create a happening for his Festival of Free Expression, reprinted in *Happenings and Other Acts*, ed. Mariellen R. Sandford (London: Routledge, 1995) 255.

# Artaud: Madness and Revolution*

## Interview with Julia Kristeva

### by Edward Scheer

**ES:** Professor Kristeva, in your earlier work in the early to mid 1970s Artaud appears as a spectral figure, haunting the pages of *Polylogue* and *La Révolution du langage poétique* and really only coming into focus in the essay 'Le sujet en procès' from 1972. How did you 'discover' Artaud after your earlier work in linguistics? and would you say that your own work, particularly 'Le sujet en procès', was in some way influenced by Artaud's ideas and, if so, how would you describe and account for his influence on your work at this stage?

**JK:** Yes, I think in the course of my work Artaud hasn't had much to do with linguistics, he has more to do with the place of madness in the contemporary world. After '68, the values of our western society were shaken and particularly with regard to the place of the subject in the modern world, and its meaning. Now it happens that an experience like that of Artaud carries enormous risks, because the calling into question of subjective unity, and the questioning of normative sense, leads to psychosis, and it is in this questioning that I encountered Artaud. In my readings you will readily locate positions of revolt. When you interrogate the non-sense of consciousness or the non-sense of norms, you will easily find the place of Artaud. But at that time, it was especially due to Madame Paule Thévenin, as someone who was concerned with

Artaud personally, and to whom we owe the publication of his letters and manuscripts, that I discovered the then little known texts of Artaud. Madame Thévenin kind of carried the flame for Artaud as a living witness. It was also at this time that the theoretical groups formed around the revue *Tel Quel* in Paris met in a room in the Rue de Rennes, where we had various talks on limit experiences, aesthetic limit experiences, in Mallarmé and Artaud especially. So the *Tel Quel* group became the site of a very intense interrogation of this experience of Artaud.

Then there was also the colloquium at Cerisy where I spoke on Artaud and Bataille. It would be possible to situate the place of the interrogation of madness at that precise moment as a moment of dissidence against the norm, against that kind of flaccid consensus which we used to call 'bourgeois', but which was also that of a society which did not question itself. At that time there was also a movement of the radical anarchist type which, it seems to me, embroidered madness, and, with due respect, I would situate the work of Deleuze and Guattari in this movement. There was what one might call a romantic tendency to rehabilitate madness. Then there was this other tendency of the *Tel Quel* movement which I think was more rigorous and which consisted of interrogating madness without shirking the drama, the risk and the proximity with death.

So it was in this context that I wrote 'Le sujet en procès' and because in those days I felt that it was important to affirm the necessity of a subject's unity, as a kind of guard-rail against a generalised destructiveness which leads to death. On the other hand, it was important not to lose the negative element, because Artaud set himself up as someone who rejected education, the church, the institution of literature and likewise whatever was classical in the theatre, and in poetry. Artaud interrogated these in order to have done with language and the unity of consciousness. He set up this tug of war with possibility, where on the one hand there was the

chance of speaking to people who came to hear him or of writing books and sending them to the *Nouvelle Revue Français*, and on the other hand there was an experience of non-sense, for example in the texts composed of glossolalia which mean nothing and are totally explosive, which are no longer language but pure drive. So it was this kind of balancing act that he was trying to sustain with regard to values — whilst exposing himself in an immense rage against others and against himself — that I was examining and was attempting to go along with.

**ES:** 'Le sujet en procès' was of course first of all a conference paper at the Cerisy-la-Salle colloque on Artaud and Bataille in June/July of 1972. There was also a symposium on Nietzsche at the same time. It seemed from outside France especially that Artaud scholarship declined after this landmark event while writings on and around Bataille and Nietzsche boomed. How would you account for this?

**JK:** Yes ... I'm not sure if what you're saying is true, though it probably is as far as University studies are concerned, perhaps because with Bataille and Nietzsche there are more concepts, more explicit references to a knowledge and the Universities are more comfortable in this domain. But I don't have the impression that Artaud lost his image or his interest for people in general. When I say people in general I mean of course those on the fringe, the students and young people who are the unsettled elements of the social body.

There were exhibitions. I will always remember the first exhibition that Mitterrand attended just after his election. I was there. It was the Artaud exhibition at the Beaubourg Centre (1986) and I ventured to say to him — because I've always had a mischievous streak — I ventured to ask him "Mr. President, don't you think that this art work of Artaud's that you are in the process of inspecting is completely irrelevant to socialist art?" (The

Socialist Party had just taken power.) He replied with an expression that I would rather not repeat right now, but which had the sense of: "We are led to re-think what socialist art might be, namely that it may no longer have anything to do with socialist realism ..."

But the young people that I come into contact with through my University work have always been interested in Artaud. I am still supervising theses and there have been three or four really good ones recently, coming from very different horizons, from France, Japan, Canada ... These students are interested in Artaud's glossolalia, for example, the psychotic experience, the relation to the body.

Then he has also attracted attention in regard to the enquiry about the Institution of French Psychiatry. There have been recent revelations about the treatment of the mentally ill during the war: that poverty had very seriously impacted in the psychiatric hospitals and that people in the hospitals were given practically nothing to eat. Evidently Artaud endured this kind of treatment.

There were also texts in the press which, while directly concerned with the case of Artaud, among others, tried to alert the public to this kind of extradition and maltreatment of psychotics during the war. So in several domains, the presence of Artaud is very much alive. So for me, in the area of the University, whether there are more or less conferences, isn't really of such significance. I find that there are other antennae in the social network which pick up on him, but evidently not on TV screens at peak viewing time. Artaud's is an upsetting position, a serious and painful one. Especially if you understand madness, not as some 'Open sesame' but as a burning torment, as a risk of destruction and death, and evidently people who are prepared to run this risk have to be, in a way, extremely stable in order not to succumb to that destructiveness and therefore to be capable of bringing out a message or a lesson as far as other people are concerned. Then this supposes individuals who are

simultaneously very fragile and extremely strong.

**ES:** This piece, 'Le sujet en procès', seemed to encounter Artaud from so many different perspectives at once, that as one critic said of it, you seemed to 'saturate the object of theory.' The cubist format of this essay nevertheless returns to the same matrix of images: the process of the subject, which you have explained in so many different interviews we won't address it again now; the *rejet*; and the *chora*. Artaud, in the theatre texts, and in particular in regard to the Balinese dancers, discusses the idea of a type of intelligible economy of signs beneath language, "*créer sous le langage un courant souterrain d'impressions, de correspondances, d'analogies.*" This type of formulation, and there are so many in Artaud, echoes the notion of the semiotic chora. Did you see Artaud as a pioneer of the type of disruptive poetic language you were making a space for at that time? I ask this in response to that aspect of Artaud which always seems to have anticipated theoretical investments in his work, the correspondences between his systematic abreaction of any formulation, "not tolerating the very thing it is so clearly expressing," as Bataille noted, and the fundamental characteristics of the *rejet*. To what extent are you still interested in these ideas, what is their place in your thought now?

**JK:** Yes, Artaud has enabled us to understand that literature is not only a text, but that it is an experience. It supposes a huge task of adjusting words, phrases and sounds, but embedded in this text is an experience which embraces the body of the subject and its relation to the other. And in this embrace a traumatic state is revealed. Now when one speaks of trauma, one usually thinks of a great pain, of an excess, but an excess of what? An excess of delirium, of desire, of passion, of drive. And how do these phenomena manifest themselves? Well, through gestures, vocal gestures in particular: that is, screams which smash words and phrases and create an extremely

violent and turbulent music, a music which translates a
certain bodily dynamic. So we find ourselves in a modality
of signification which Artaud called a 'motility,' a revolving
movement. It resembles a dance which mobilises gestures,
but which mobilises the voice as well. And so poetry has
always mobilised these components that I've called a
'semiotic chora,' this dimension beneath the surface of
signification.

When we listen to a poem we hear alliterations, a
rhythm, a song. But in so called classical poetry these are
quelled and harmonised by a certain code: so we say that
rhythm 'x' comes from the Greek tradition of poetry,
rhythm 'y' comes from the Romantics. Well, Artaud breaks
with all of that and explodes the rhythmic quality which is
in direct contact with the drives and with passion. That's
why he's more in collusion with the traumatic and the
archaic.

The semiotic chora can be understood as what the
child, for example, possesses before being able to speak,
and we can all bring to mind the image of a child who
cries, or screams, or smiles but who does not yet speak
and who signifies something with these vocalisations. And
we can also bring to mind images of pathological states of
hallucination or of catastrophic anguish, where an
unsustainable 'signification' is revealed through glottal
spasms or gestures. This is not a signification which
language can translate word by word, phrase by phrase.
So it is this whole dimension,  the unnameable place of
the passions and drives, linked to the energies of the
body, which Artaud  attempted to translate.

I would like to cite several phrases from Artaud which
throw some light on these questions. The first example is
from the "Notes for a 'Letter to the Balinese'": "Everything
is in motility, so like the rest, humanity has grasped only
the ghost." So we are in the domain of the spectral, of
representation, of the image and there is this underlying
motility linked to trauma and the drives. "There is no
fabric, consciousness doesn't come of weaving, but from

the barrel of a firing canon." And there we are fully into that kind of traumatic intensity where the psychotic flounders and where Artaud manages, floundering all the time, to find a language: "... and where nothing has any value except through the force of shock and collision, without it being possible to attribute to anything the quality of logic or recognised dialectic ... because reason drives away the spiritual aspect and the ascendancy of the mind, from which it takes form, volume, tone, radiance."

Or again, still in the 'Letter to the Balinese': "The vertical rotation of a body which has always been constituted and which, in a state beyond consciousness never ceases to concentrate and solidify through the opacity of its substance and its mass."[1]

Ok, so what I'm interested in here is what he calls that state of intensity, a state beyond consciousness. In other words, he manages to recover these traumatic archaisms through a kind of regression. But consciousness is there, working as a probe that's attempting to plug into the traumatic, the chora. Certainly there is a relation between Artaud and psychosis, but one really must not identify it with clinical madness. He is, I believe, someone who has had an heroic experience, and one which, though undeniably psychotic, bears witness, and so he crosses over. He is a voyager.

ES: Does Artaud still represent for you the model of revolutionary *signifiance*, the theorist as terrorist? Has the ground shifted in relation to Artaud for you? It may be difficult at first glance to identify Artaud as a a practitioner of *jouissance* given the relentless negativity of much of his writing. But there is a vibrant ludic quality to his work, its "incandescent language" as you described it once (in an interview), its systematised laughter which links it with the type of jubilant sublime you identified in Céline and Lautréamont. Is this type of *jouissance* still a revolutionary experience for you, should it still comprise one aspect of the practice of radical reform?

**JK:** Yes, the question of revolt is one which always concerns me, whether or not Artaud is concerned, though of course he always follows in its wake. I have just finished a series of lectures to be published under the title *The Sense and Non-sense of Revolt*. It seems to me that we live in a society where the place of revolt is increasingly compromised. We are in a society of the spectacle, of complacency, of show, where everything has to be easy and where limit experiences, experiences of anger and rejection are very quickly banished. You don't see them on TV, even in what you might call recuperated or banalised versions. I think it's extremely important to re-valorise these experiences of rejection and discontent. In my lectures over the last two years I took up three other authors who appear less radical than Artaud, but who pose the question of revolt somewhat differently. They are: Sartre, with the theme of nausea and negation, and negativity, "Being and Nothingness"; Aragon in his Surrealist period with the impasse of Communism; and Barthes the demystifier, who presents another form of revolt.

But Artaud appears to me to be someone who is continually fascinating and so I will undoubtedly return to him. We are in a time when we need to be aware that revolt is a jouissance, because when its tragic aspect finds forms of expression they become forms of a major dissidence, of a great non-conformity, and this really is a great joy, and one which is interior. It learns to live with its wounds, to render them bearable and to allow others to move on and to live with theirs. Artaud was conscious of being a rebel. He says this in ... I think it's in the "Manifesto for an abortive theatre"... at least it's in one of the later texts, no, it's definitely in "Anarchy and Art": "The social duty of art is to give voice to the anguish of its time."

Therefore the problem is not one of psychotic retreat into some kind of bubble in which you relish your own trauma, but of sending out that pain like a probe to

irradiate the social space: "The artist who doesn't shelter the heart of his era at the depths of his own heart, the artist who ignores the fact that he is a scapegoat, that his duty is to magnetize, to make the wandering furies of the era fall on his own shoulders in order to discharge psychological sickness, is not an artist." I find that absolutely contemporary and completely topical.

**ES**: Returning to the concept of heterogeneous contradiction which has been the focus for a lot of recent argument on your work and to the question of the *'autre économie'* in Artaud, the economy of the drives that resists reading but is nonetheless intelligible, glimpsed through the ruptures in the symbolic material. How do you approach this topic now? Is it still a vital component in understanding the politics of poetic language, given that poetic language is certainly no longer an activity that enjoys the kind of theoretical sanction that it did at the time you wrote your doctoral thesis?

**JK**: I am thoroughly partisan about this idea of the heterogeneous. What does it mean? It means that when we encountered literature 30 years ago now, we inherited a continent, the continent of literature, which is a cabinet of curiosities. It's not Artaud but someone like Mallarmé who says that literature is what binds everything together and professors of literature make their glosses, sometimes a few social problems are transplanted in the process and one has the impression of shifting sands ... On that point, when this University where we are now, Paris 7, was created, we said that literature is language and we are going to try and see how it is done, what is the craft, what is the technique? And so we changed literature into text. Fine. We gained many things, much precision, but as I said at the start, literature is a text because it is an experience. Now to argue that it is experience means that the one who goes through the experience, as in Artaud, works in heterogeneous strata. We end up, once more,

back with our notion of the heterogeneous. What is it? It is the representation of the drives, of that motility, the force which Artaud described. If theory doesn't account for this double register, signifier/signified on one side and the heterogeneity of passion/drive on the other, then we are talking at cross-purposes, making crosswords. Psychoanalysis teaches us to hear in the discourse of the patient on the couch not just the linguistic meaning but the meaning of the passions. And if we are deaf to this, we can produce nothing of any interest. And I must insist that this notion of heterogeneity is fundamental to the Freudian conception of language. We tried, with Lacan, to evacuate the drives and they have returned in full force in a contemporary psychoanalysis which is concerned with states of passion.

**ES:** It seemed that the power of obscenity in Artaud and Céline attracted you in *La Révolution du Langage Poétique* and yet you tended to avoid quoting any of it. Would you now agree with Artaud when he says that "*Il ne reste à la poésie que de se réfugier dans l'obscénité*" (the only thing left for poetry is to seek refuge in obscenity)?

**JK:** I'm not sure that I avoided quoting them. It seems to me that when I've quoted Céline, in particular, there was no shortage of obscenities. That said, there's a kind of complacency with the obscene that I don't want to revisit. In making those reflections it was not my purpose to attract people in search of the obscene: they can find that in the sex shops and amongst other hard-core devotees. No. So where do we find obscenity now? As regards feminine experience, obscenity can be a level of the erotic. I'm about to publish a book called *Possession*, a detective novel: it's the story of Gloria who has various sexual relationships, but also of the detective, Stephanie de la Cour, who describes her erotic life, discretely enough, but I hope without any lack of intensity. But it

seems to me also that the obscene is not compatible with the sentimental, with sensibility. There's very little accommodation in the modern world for sensibility. We're stressed, we're under pressure, we're caught up in the image. The image fascinates and is fleeting and leaves no opportunity for the tactile, for sound, for taste, for all those sensory experiences no longer available in the sex shops, but which make up a universe that is particularly a universe of women, and which seems to me obscene but in what sense? Well, in that there's no place for it. Sensibility, I find, is becoming obscene.

**ES:** It seems that Artaud's ideas on revolution, which he debated with Breton for over 20 years, are a long way from the Maoist influenced discourses of *Tel Quel* in the 60s and 70s. Was it a perverse project, in retrospect, to link Artaud the '*sujet en procès*' with the 'subject who says I'; and don't these two types of subject cancel each other out?

**JK:** The maoism of the French and of western youth in 1968–70 has nothing to do with Mao. It's a western version of rebellion and rejection. It's important to understand that and not take an anachronistic view. There's the evolution of Chinese society and the place Mao came to occupy, of dictatorship and dogma, a sort of local Stalinism in Chinese colours. There's also an attempt to be national, to do socialism in a Chinese way; it was in this cause for example that Mao tried to break up the Chinese Communist Party, to launch an attack on the party apparatchiks, on the young, on women, and so on. Well, that's a story. In sympathy with it, there are some young bourgeois and not so bourgeois westerners, French, German, English, who are suffocating in their own countries and who say: that's enough! There's an attempt to discover a kind of violence, for which we have to seek out our own national versions of revolt. So then there's an attempt to explore the memory of our civilisation. Hence

our rebel elders — Bataille, Artaud, etc. And after making the analogies with maoism, there were the texts of Mao, who read Hegel, who read in terms of contradictions and who insisted on the negative. But those were French constructions. These were the utopias which had nothing to do with localised Chinese dogmatism. Then it came to the test when we all went to China. We rapidly came to understand that the Chinese weren't nearly as revolutionary as we'd imagined. And they subscribed to discourses that were really soviet, although they were ready enough to speak ill of the Soviets. So there was a pretty rapid retreat from all that. But something that also needs to be said — because *Tel Quel* has been stigmatised as some kind of official organ of maoism — is that we weren't partisan. We didn't belong to a maoist party, nor were we proto-Chinese maoists, in the sense of following the dogma from Peking. We were "cultural" maoists. My own maoism consisted of taking a course in Chinese and learning to write Chinese so as to be better equipped to immerse myself in a tradition which, I thought, had more place for women. It was all about trying to acquire some kind of non-European subjectivity that belonged really to our own utopian dissidence from western norms. It was a way of interrogating the West by means of the East.

**ES:** In the discussions subsequent to your presentation at Cerisy you were asked by Guy Scarpetta about what he perceived to be the clinical tendency of your approach to Artaud, describing it as an "*exploitation du rectum*" in reference to your passages on the anal drives in Artaud, "*la violence du plaisir anal*." In so much Artaud scholarship, as indeed in his own work, the question always resurfaces of the violence of clinical discourse. How do you respond to this criticism of psychoanalytic discourse in relation to Artaud, who is perhaps the strongest opponent of this method in the history of avant-garde literature?

**JK:** I'm not sure I quite understand the question. There are a number of elements: there's Artaud's stand against psychoanalysis, and there's an intervention which is that of the gentleman you refer to and whose appearance in this interview surprises me a bit because we are, I think, in a University context and the person in question is some sort of journalist who gets in with different literary sects in order to be seen and seems to me un-interesting in the discussion we're having. But I'll take the opportunity to say that there's a kind of facile element that's spreading now in the media which presents itself in the form of a refusal to ask yourself any questions. You set yourself up to talk about novels, or to talk about Artaud, or about some painter, but you don't do any interpreting. You don't want to know. You make decorative commentaries. You appropriate Artaud in order to say: "There now! I have a really good understanding of all this, and I congratulate myself on Artaud's behalf." But you don't want to interpret, perhaps because you don't want to get your fingers burned with the suffering of Artaud. It seems to me that this journalist to whom you allude ... he's scared of anality, but that's his problem. It shocks him and he says: "Bravo Artaud. What a guy. Art will save us all!" But it's a bit hard to see why. Now, when you pose the question "why," you get into analytic interpretation.

This is one of the reasons psychoanalysis is starting to get marginalised. Because we're living in a downbeat era and people just don't want to know. Curiosity is shut down. You take a pill rather than embark on an analysis and you say: "There, I won't feel so low if I swallow a few tablets." Or you can get into those techniques, which involve learning some behaviour: when I'm in a state of anxiety, and I have to go through some test — for example, to get a job — well, I'll go and learn a particular set of behaviours and that way I'll fool the boss; but I'm not going to ask myself questions about where I'm heading, about my unhappiness, and so on. So, all these discourses are only at first base and they marginalise analysis, which requires lots

of effort, and involves a certain curiosity.

That's by way of a bid for the rehabilitation of psychoanalysis, and a reaction against a broadly American tendency which consists in saying ... that Freud is old stuff, that it's a dated discourse and that it can be abandoned in favour of neuroscience, or cognitive and behavioural techniques. I think, on the contrary, that because psychoanalysis concerns itself with corporeal fundamentals — and with biological limits, the foundations of the psychical, the extremes of abjection in all of us — well, it arouses fear. As for Artaud, it's true that he encountered psychoanalysts who, instead of treating his pain, tried to lay on him some kind of esoteric poultice by talking about various kinds of esoteric or spiritualist ideologies. And Artaud, with his acute awareness, found this disingenuous. He was, if you like, against this normalising psychoanalysis which presented in the guise of a discourse of the sacred. And there was also the in my view entirely sane defence of a psychotic — which he also was, there's no point in hiding that — before an analyst who was trying to talk to him about his illness. And it's well enough known — I'm familiar with it also as an analyst — that in such a case you provoke what's called the negative transference. Without this negative transference, this denial, this battling out — if the patient fails to rebel against his therapist — there's no therapeutic process. So these are, I think, two ways of partially explaining Artaud's negative reaction. No doubt there are others.

**ES:** In 'Pouvoirs de l'horreur' Artaud appears once more as an abject, in a visceral language which recalls the nexus with Artaud and your own writing. You describe Artaud as an "I overcome by the corpse." The texts you proceed to quote here are a curious selection of fragments from the first volume of *Suppôts et Suppliciations*, a letter to Henri Parisot from 6/12/1945, and one to Breton from 14/1/1947. In these Artaud abreacts the crucifixion, it was Antonin Nalpas who was crucified and not that imposter Jesus etc.

And again your writing is delicately poised around these ideas to measure the degree of their departure from a subject, the dimensions of their straying. Artaud is again an uncanny example of the concept of abjection. It seems to me that Artaud abjects language in precisely the ways you delineate, he spits it out, it makes him feel nauseous. He turned retching into poetry, an abject poetry. But the passage is so brief and the essay moves on to Céline. I wonder how it might have evolved had the book not strayed from Artaud ... What texts, or more broadly, what aspects of Artaud would you have explored?

**JK:** I wouldn't say that Artaud presented as an abject being. The abject is the one who gets involved with abjection, who takes pleasure in abjection. Artaud skirts that terrain, just as Céline does in a different way. So if I took up Céline, it's because in the process of skirting abjection, Céline fell into it. Notably, through his anti-semitic pamphlets. In Artaud's case, these slips are more minor. We know that he wrote a letter to Hitler that he never sent. There's a proximity to abjection, but it's actually a way out of abjection. When he spits out his meaningless words, when he shrieks, when he says "I gargle with my caca," it's mad but also extraordinary, this kind of intimacy with the filth of the human being that passes along the throat, because you can actually give voice to it, this filth. He's much further from abjection than many of us who don't want to know about such things and who make ourselves up and go on TV and say banal and insipid things. So this isn't abjection at all; it's the only true catharsis.

**ES:** In this year of commemoration for Artaud, how do you think future generations should remember him?

**JK:** I think there are a number of avenues — it should be left to everyone to find their own. That might be the best homage we could render him, to solicit the inventiveness

of each of us. But personally I think of two things. The
first is to re-read him; to take the texts and read Artaud,
read him on the stage, or in bed, in privacy. And the
second is a leaning back towards psychosis. There are
plenty of people around us who are in psychiatric
hospitals — children, adolescents, students, many of
whom come to university and then spend periods in
hospital — whom we can help. It's an incitement to
restore to psychosis its pain, which shouldn't be
embellished, and at the same time to let people who
suffer from psychoses find some form of integration, a
voice and a reception. I think that the message you can
take from Artaud is something that extends far beyond
aesthetics and literary experience.

### NOTES

\*    This interview was conducted by Shan Benson on behalf of
     Edward Scheer on 2 July 1996 at the University of Paris 7.
1    These quotations from "Notes for a 'Letter to the Balinese'"
     appear in *Tel Quel* 46 (Summer 1971) 10–34. As was often
     the case with this journal, the references were not supplied.

# Breaking Through Language[*]

## Interview with Mike Parr

### by Edward Scheer and Nicholas Tsoutas

**ES:** You've talked before about the importance of Artaud to your earlier work, so maybe we could take a more specific line of questioning relating to abreaction, the idea of acting out traumatic episodes so that you get a degree of control over them with the consequent discharge of affect. This is also, as you know, an elaborately performative idea which suggests a way of negotiating presence in performance through the agency of something absolutely authentic. This is fundamental to what Artaud wanted to achieve as a performer and a writer, and also something which seems to conceptually and performatively pervade your own work Mike. Probably from ...

**MP:** (Mike interjects) — Seventies, yes.

**ES:** Probably the seventies rather than the eighties, but is there still an abreactive component to your performance work, in an Artaudian sense?

**MP:** There obviously is in the piece I did for Nick here, "The White Hybrid," at least in terms of tasks and limits — it was a hell of a chore — but also, say, the piece that is causing quite a controversy at the moment down at the Art Gallery of New South Wales,[1] the Bride piece, or even the "Unword" performance I did in Perth last year ... in

which I'm the bride and it's the dreadful striptease and I get down to bra and panties and, at this point, I use the scalpel and I cut all these words, these kinds of words I'd been hoarding for years: *Father, sister, God* ... and *word* itself and *arm* and things like this. So I cut these words into my body with the scalpel ... What I'm really aware of in a work like this is, and in all the bride series, is that there is this sort of manifestly shambolic symbolic order on one hand and there is this kind of incomplete body on the other. I would put these two levels of incompletion together. It's a sort of fission or fusion situation. So while in many of the bride performances there is a kind of a stasis, a routine that wears the image down, there are these occasions when the bride is much more paroxysmic. Where there is this eruption and the whole image is sort of torn apart. So, in regard to abreaction, I'm using two phases with this key image of the bride.

The other pertinent thing to say in this regard is that I have always been derisive about the idea of theatre. I have always in a sense performed myself, but this performance of the self is absolutely tautological in a sense. I felt I had to re-insert the idea of institution and so I took this bride as sort of derisive institution, of the feminine, of the notion of exchange and sacrifice. I constructed her as a sort of screen, I remain manifestly the performer and she is a kind of cosmetic overlay. It's almost as though in the more static bride performances, it's almost as though she is kind of sleeping on my body. So I remain very interested in the idea of disrupting symbolic order, but I don't do that as aggressively perhaps as in the 1970s because too much has become intelligible to me. There is a lot of thought and intentional structure interposed into my performance constructions. I've got very interested in the business of the point of view, this separation of the real and its re-representation. So in that respect it is different to the work of the 1970s but the abreactive, this breaking of the image, remains very important to me. So that recurs you know.

**ES:** I think about abreactions as ongoing, as an 'abreacting' or a continual acting out of things. It"s not really the psychoanalytic concept of discharge of affect but it's the process of anticipating the captures of the symbolic, acting out the traumas of that capture and finding a break, so it's not just naïvely trying to break through something, it's acting out the process of ... (Mike breaks in)

**MP:** Yes, that's right. It's because these compressed hysterias — and they *are* something like this — *are* ultimately linguistic, you know they're kind of failed symbols. They're not residues, they're precipitates out of the symbolic orders. They are failed encounters with symbolic structure. That's how I see it. So yes, in that respect I am completely in accord with you.

**NT:** Does that go back for the works of the seventies as well?

**MP:** See, the genesis of the works in the seventies is very important. This is where I get fazed by some of the recent commentary. I mean it does two things. It doesn't take into account the context for that kind of work, and secondly it forgets what Australia was like twenty-five years ago. I'd come down from Queensland very naïve, a farm boy really. And my performances were preceded by sort of psychotic episodes. I had one bad one in the late sixties and Tess was with me then, we were unmarried, came home one evening with a close friend of mine and somehow or another I got carried away with a razor. There was blood everywhere ... I wasn't trying to suicide, I was somehow or another opening a body and I think years and years later a whole story has emerged and has obviously to do with having a disability, but I went into hospital. In my family it was just that I was born with one arm ... but it's like this miraculous act of God. You know, you were born with one arm and I went into hospital in

1973 or '74, I can't remember when it was now, and had an operation on my stomach and when I was being prepared for this the doctor picked up my arm and said ""What do we have here?" You know ... um ... well "What is that?" and he said "That is clearly a scalpel mark." You will see that in a photograph of Tess and me in the Art Gallery of New South Wales.[2] There is this clear scalpel mark down my arm here and he said "It's a very good clean job," you know, so I confronted my mother and she said "After you were born prematurely I didn't see you for four weeks after the birth." She said, "When I did see you, you were all swaddled up. You were put into some sort of intensive care." But she never knew what had happened and it was all hushed up. What had obviously happened — and now there is a lot of evidence, I've gone into this — what has clearly been established is that it was some kind of distortion. At my birth they took the opportunity to clean it up. And I think my father knew about it, it's one of those enormous kind of missing links in the family and it's caused an incredible amount of damage in a way between the members in the family. So this was the case.

So in the late sixties when I had this sort of breakdown and I got into myself with a scalpel, or a Stanley knife actually, and started cutting myself up, it obviously had something to do with it but I didn't know what it was at the time. I just thought I was going nuts. I came home and I was in this ballooning state, I was sort of euphoric actually. I recovered and in the early seventies these ideas began to come back, you know, and I got these incredible compulsions to do things to myself. I had this ... I had this idea I would gargle with a stone and I would stop myself from choking but I kept becoming terrified that the stone was going to block my wind pipe and I was going to die. But I couldn't stop myself from having this thought, it was a kind of a compulsion. So I began to write these thoughts down because I thought I could get rid of them and I began to think it was all a problem of language, that I had been writing poetry and it was real shit. It was romantic and

**Mike Parr** *Pale Hybrid (Fading)* 1996.
Photograph: Paul Green. © Mike Parr.
Reproduced with permission.

diaphanous, it was all beside the point and I had this idea
that I had to return to facts. I began to write these impulses
down in the most clear way I could and it helped. I would
write these things down and it became the series of works
in early 1971 and through 1972, called *The Hundred And
Fifty Programs And Investigations*. I kept adding to them
and I put these works up in the *Inhibodress* gallery in 1971
and they were reviewed. Don Brooks said to me in the
paper, "this is an example of conceptual art" and talked
about it in terms of sort of meta-statement and its
relationship to surrealism and so on.

This is conceptual art, but it was an incredible moment
because once he said it was conceptual art I realised that I
had a kind of licence. I had this idea after the show that I

could invite people back and we could perform these things. So right after the show ended, the first night after the show ended, we sent out a notification to everyone that we were going to do a ... we didn't call it a performance, it was going to be an 'idea demonstration.' This is what we called it. So they came back. This is the one where there was the instruction on the wall that had been arranged for a friend to bite into your shoulder. Now he or she should continue biting for as long as possible or until their mouth is filled with blood, until they're choking in other words, and so Peter Kennedy rolled up my sleeve and began biting into my shoulder. I just had this incredible intuition that I had to, in a way, resist all the impulses to black out because if I did the audience would intervene. I had this simple idea that I had to cope with what was happening to my arm, which was being bitten off in my mind I suppose, and keep the audience at bay. So I had two tremendous tasks to complete. So it was like ... um ... I had to impose on the audience the silence that had been imposed on me in the years I had grown up. All this becomes clear as I'm talking. I have not said that before ... what I have just said now. So he bit into my shoulder and I literally kept the audience at bay. I was kind of shivering like mad and they couldn't intervene and some people fainted and at the end of the performance, there was this kind of explosion and everyone moved to fill this sort of gap with incredible questions and arguments amongst themselves and self-reproach and 'this is a monstrosity,' but 'why did we allow it to happen?' So everyone was totally confused. In that moment for me the idea of a kind of performance was born, because I suddenly felt as though I had transferred everything into the audience and created a tremendous division within them, a kind of schizophrenia, in the audience. So that the kind of amputations that were racking me had all been transferred into the audience and they were being cut up by the impact of the things they could see, of the action. I think this was for me the crucial

moment. We went on to do numbers of these which are the works that are in Fate that is currently at the Art Gallery.[3]

Then I had to defend it as art, so then we started to try and find a context and we started talking about Acconci and so on but these works were very different from him, you know Vito Acconci would do these pieces where he would walk to the end of a pier with a cat in a bag or he would lie under a ramp in a gallery and people would hear noises and so realise the instruction was that he was masturbating and so on. But my pieces were more overt than that and I think it's very interesting when I look back at that film, there are twenty-eight pieces on it. It's the sense of that reiteration of a kind of amputation which is constant, cutting the leg ring, branding the word *artist*, using tack lines to measure up my leg. All of these kind of things, and they were all about enacting wounds in a prescribed way. I needed this as I had to always focus these wounds in an elegant way, the wounds had to be elegant. I had to be able to control the wounds. I didn't want them to flood and spread across my body and result in this incoherent situation that had happened in the late 1960s. So that's the genesis of these two pieces.

**NT:** Just thinking back, when you took everybody back after the exhibition opening to do the performance of the bite piece you were conscious of the audience and the realisation then dawned on you that you were actually pushing it all out onto the audience. The notion that it was an audience creates a very different sensation to the action you were doing in the idea demonstration ... and just thinking back now, doubling it, watching it again twenty-five years later, what is taking place when we re-watch? I was just thinking ... Tony Bond in the interview said there are moments when he can't look anymore.[4]

**MP:** And I'm still very gleeful about that. I feel that ... really ... I enjoy the thought. In a way these works have

been reborn through video projection and there has been this enormous hiatus of 10 or 15 years where they haven't been shown because the films wore away and were fragile and so on. But they've had this rebirth through video and I could never countenance the idea of them being on monitors. I've always resisted that and it's never happened, I would never allow the works to be shown just as television. I realised I think quite clearly that television is completely domestic. It just consumes everything. Everybody just 'mogadoned' in front of television. We have all got the same type of attention span. So with the video projection there is this kind of abrasive directness again.

I feel I am very — I have a very aggressive feeling about audiences a lot of the time. In many ways I kind of loathe the art world. I loathe its basket weaving as I call it, you know what I mean, its knitting, its post-modern solipsisms, its neoisms. So I really don't like any of that. So I don't mind going back to these things if I can make them abrasive again. I don't like the idea that art can be softened away into the Symbolic. It can be kind of traduced as a sort of ... I don't know?

ES: Representation of something, rather than an experience ...

MP: That's right. It's very important to keep that. This is my idea of performance art, and Nick we have this in common perhaps.

NT: In a sense, when you look at these works the abreactions are like transfers of that trauma that gets played out so that everybody there ...

MP: Well it's very specific you see, it's very specific. This is where the elegance was important. Wound by measurement, you know, X amount of body, brand yourself with the word *artist*. All these things that are very

specific: reopen old wounds, sew them up again. They're very specific ... they're linguistic in a way, they're kind of primitive words.

**ES:** They're articulations, aren't they?

**MP:** Yes, yes they really are. This is a bizarre kind of symbolic order. It's like there was this mess at the end of my arm so it's cut away because it is the 1940s. It's at the end of the war, you know what I mean, everything has to be kind of reordered and getting people into suburbia and into boxes, into neat situations is terribly important. It's not something you are going to tell anybody about, you're not going to explain to the woman who has just given birth, you just do it. And this is pervasive to this society. It's mythic. It's a delusion to believe this has gone away, it's got worse. I really believe this, the media is a tremendous imposition on us. Its gargling, gurgling nonsense, its kind of, its specious, alcoholic representations ... they're ... absurd ...

**NT:** That's why I was just curious about the word 'audience' because what is happening to those teeth in your back or arm or whatever can't be represented, there is no space for...

**MP:** No space for repeatability ... I just stood there in the room in the Art Gallery (where the videos of the performances were screening) just after the show opened and there were people and they all just started (MP begins making aggressive and flustering sounds and actions). So I joined in (shouting) "outrageous!" I said "isn't it disgusting," "disgusting" (everyone laughs) ... (with a smugness in his voice) I couldn't help myself, it was fantastic (more laughs).

**NT:** Is it that there is no other place?

**MP:** Yes, it can't be represented in a sense, it's the bottom line.

**NT:** I think that's a very interesting aspect in an Artaudian performance, that extremity, pushing it to where the body has no more choices left.

**MP:** That's right, that's right.

**NT:** And the lack of choice is what you suddenly focus on and when I look at the biting or cutting a name into your leg, suddenly you're not representing it ... it's actually body to body transfer.

**MP:** Yes, that's right.

**Mike Parr** *Pale Hybrid (Fading)* 1996.
Photograph: Paul Green. © Mike Parr.
Reproduced with permission.

**NT:** I find that very interesting. I see it on ... on video or when I see you cut your chest and things like that, you're actually transferring ... it's like all the bodies come together.

**MP:** That's right.

**NT:** ... And our realisation happened up here somewhere (NT points to his head), and it is very traumatic, it's very traumatic.
(MP and ES agree)

**MP:** But it's very specific, because it's condensed and it's like the beginnings of a kind of sign. It's like a sign being transmitted.

**ES:** Surgery on the sign, surgery on the Symbolic ...

**MP:** Yes.

**ES:** These are all Artaudian metaphors. Hearing you talk there about this kind of vibrational sympathy it seems as though those experiences of yours were very close to Artaud's conceptualising of cruelty as an immediate and essential act, and that their mechanical reproduceability now in video doesn't seemed to have lessened that ... in terms of the power of those moments. But on the other hand it doesn't seem pure experience, it doesn't seem to have escaped from representation absolutely because they are still very precise experiences, not random: areas of the body are chosen to be re-worked; you didn't want to flood your body with blood; it had to be recognisable somehow as a sign.

**MP:** That's very important, it had to be specific. This is something you see ... this is the key in fact. This is why I get irritated when people conflate my work with the Viennese *Aktionismus*. I didn't know about actionism in

1972. I knew nothing about the actionists. But I do know about them now. Between 1975–77 I lived in Vienna for a while. But I mean, their kind of work is like a sort of ... it's sort of theatrical smorgasboard. It's very good in its own way. I mean it's kind of a ... it's a sort of a Wagnerian thing almost. It's 1960s happenings in the most exasperated way and it's action painting and so on, and when I say action painting I mean the use of liquids and so on, and the make-up and the simulations. All of those people: Schwarzkopf, Muhl and Brus were doing simulations. So it's this kind of very dramatic theatre. I've been part of Nitsch pieces and it's all that kind of oompa-pa music ... the neonazi component and this festival or carnivale business because if you go out to the castle ... it involves the whole community. The new wine is drunk and they slaughter a few pigs. It's a bizarre sort of Austrian festival as the slaughter of the pig is a very peasant thing to do.

I have a wife who has a mother that writes letters about going out to the farm to do the pig killing. To make blood sausages and they eat it all and ... I got very sick eating blood sausage. This milieu couldn't be more different to what I'm trying to do which is very specific. It's all about amputation. It's about using the body and the cutting I'm doing is exactly like dividing up words. That's what I feel it's about and language is very important ... cutting the words into my body is very important.

**ES:** Is this a way of asserting control and reasserting your own design into the world, giving things the shape of your will?

**MP:** I think it is something like this. I had the feeling that language produces a kind of silence. That explanation/translation actually produces a silence. It's a migration away from the substances that the words are constituted out of, if you like. So I wanted to deal with language and it may have had something to do with this feeling I'd had up to that point of 35 years of silence and misconstrual, or

evasion really. I think that was part of the impulse. But it spread and I saw the evasion everywhere.

NT: That Austrian stuff understood itself as the perfect endgame of the theatre. They approached the theatre in a very pure way. They understood the space between the real and its representations. In a sense that's why to some extent the corporeal was important to them. But here one gets the feeling that we're talking beyond the body, and though it's happening on the body, it's beyond the space of its physicality, that you're reminding me that the pain of the bite or the pain of the burn or the cut is actually ... it's almost telling us about the space away from the body. Where the body doesn't exist anymore. It's another state of being ...

ES: The imagined body.

NT: ... the imagined body or the extended body.

ES: The body's double.

NT: Well, if you go into Artaud ...

ES: Well he talks about all that stuff all the time.

NT: That's why I think Artaud works subliminally ... operates throughout all those scars. It's as if it's ... so physical it becomes an experience *outside* the body.

MP: Yes, but it's interesting too because what I know of Artaud is this mysticism. This is one of the kind of problems of the situation because in the notebooks I wrote in the early 1970s I became very anxious about this sort of mysticism: the idea that when you cut open your body somehow God looked out, ran out ... flowed out in this kind of way ... and what worries me about Artaud is this latent fascism. What happens is that if God flows out

of the body you can cork the body back up with this
dreadful order and there is a sense in which he was
dreaming of this dreadful order. When I think of a play
like *To have Done with the Judgment of God* when he
talks about the Americans and artificial insemination ...
keeping the semen from the boys ... to produce a race to
fight a sort of intergalactic war in the future. It's like ...
this is the struggle with God.

**NT:** But I guess context is really important for Artaud and
although here, in thinking through your work, there is
that doubled space which has an Artaudian context, it also
goes beyond it and reminds me of the limits of the body.
But in order to understand these limits of the body you
must understand what goes around it as well, and the
body is diminished to some sort of context. That's where I
find your work interesting. When I was in an audience
watching a video of your arm chopping piece I was aware
that nobody was watching. I was the only one watching it
and 60 people were shying away from it. I found that very
fascinating because what it is saying is that as an action it
is operating in a bigger field than just your body.

**MP:** It was, and then it became another way of incarcerating
me because people started to say this just about your body,
you're reliving this trauma and it's therapeutic ... but I really
began to wonder about that because then I really began to
think, with the "arm chop," that I didn't know what it was
about. Then if you notice that after it there was this
monologue. I started talking to people and it was sort of
staccato, its structure is very interesting ... chopping off the
arm produced this kind of resonation, and it kind of got into
my language and created all these hiatuses. It produced all
this hyphenation, it disrupted the syntax. So all the words
came out in a kind of isolation ... they were like beads
strung along this residual thread of the situation that had
been produced ... and ... I thought this hyphenation is very
interesting and then when I wanted to cut the heads off the

chooks with great precision and hang them up on the hooks with my father, I got him to cut off all the heads. Well, it's very interesting, isn't it? He cut all these heads off and it produced this terrible sound which I amplified because they kept shuddering on the iron rods. So I looped it and looped it so that this kind of mad sort of St. Vitus dance began to emerge produced by all these shaking bodies without heads. I started to think ... it begins in the removal of part of my body but then it extends the gap ... the hyphenation extends into language and I started to think that this staccato sequence enters language and shakes it. I wanted these vibratos. I wanted to amplify them because what I think the symbolic does is ... well the representational is like smearing margarine on a wall. It covers everything up and makes it soft and plausible. I wanted to shake these representations up, but this is a cultural operation. I wanted to use my experience, not to be confined to my own experience. I wanted to say it had caused a tremendous paralysis of the symbolic, this symbolic was this paralysed script that we handed around the family, like automatons, like at a religious meeting.

**NT:** That perfect body is about order. We understand order through the perfection of the body and it's interesting that you say it goes onto the question of language the moment the body is disordered. The moment the body is disrupted ... or revealed ... as cuts or bruising etc., it seems that the logic of language doesn't have an order either.

**MP:** No ... I think this is very true ... this is very interesting ... yes, yes.

**NT:** As soon as the body is reduced to a disorder it cannot respond in the sense of linguistic order, it has to break up and regroup and redefine ... There is too much order located in a definition of a body. It's interesting that fascism always wanted to produce the perfect body ...

**MP:** Yes, the perfect body, that's right.

**NT:** ... And in order to produce the perfect body it had to view itself in that grid ... with all the helmets and all the theatricality of it.

**MP:** And what they're doing when they're producing the perfect body, they are actually producing facsimiles. It's the culture of the copy again isn't it?

**ES:** That's what Theweleit talks about in *Male Fantasies*,[5] when he talks about the white terror that slaughtered thousands of women and children across Europe in between the wars. They were terrified of flows, terrified of blood and menstrual flows and bodies that didn't conform to certain images. So they had to produce more and more abjection in order to purge themselves of their own fears. In Artaud it's the opposite, it's the perfect body, the fake facsimile body, that he's suspicious of. His late drawings are an explicit critique of this type of body which he links to a certain type of art.

**NT:** When I look at Artaud's pictures and to some extent when I look at your pictures, it's also not abstraction that he is doing ... I almost get the feeling that he's holding the pencil like that (gestures as if holding a knife) and he does it like he's attacking his image but ...

**MP:** This is what I do with the plates ...

**NT:** ... There is no sense of order when it comes down to it. His style of presentation is subject to all sorts of irrational uses of languages. The impossible language comes into it, the language that operates in and around the conventions of language ... I think that what Artaud was doing when he was attacking the conventions of language was identifying what imprisoned him, what kept him hostage ... The impossibility of him being able to communicate what was

so deep in there (gestures) required a total deconstruction based on a loss of faith in language.

**MP:** Yes, it's very interesting what you're saying. It's making me really think now. I think with the self-portrait project ... what's happening there is something like this ... I've always said that the self-portrait is just a container. I mean it is very interesting when people say for argument's sake that last show with the mirror self-portraits ... that they look like Artaud's drawings. Well this is an extraordinary moment because I produced thousands of self-portrait drawings. I can remember in 1991 when I was taken by Roslyn Oxley to the art fair in Cologne and this guy came up to me when I was hanging my self-portraits and he pointed to one of them and said "You've ripped off Jim Dine" (laughs from interviewers) and he got really upset. I thought this was hilarious. So I had produced thousands of self-portraits and everyone says they're all a good likeness. They're an amazing likeness Mike, but at the same time everyone says they look like someone else. Isn't it amazing, well it looks like Artaud or it looks like Jim Dine.

**ES:** The unique and the analogic at the same time.

**MP:** That's right, and it's interesting in the context of a self-portrait project, isn't it ...

**ES:** ... and how do you create a figure for that, that's precisely what we're talking about, isn't it? The performances as well are unique moments which somehow have resonances and repercussions and develop analogies with other people. So that you have the strange situation of a room of people who just can't bear to look at a representation of something because it is too direct ...

**MP:** ... and then they start talking about something else (laughs). Start talking about art history or something.

**NT:** It's actually an attempt to categorise things.

**MP:** But this is the translation that I'm talking about, this is the kind of ... pernicious aspect of culture. It is always this *glacé* translation. It's the cosmetic ... it's always this kind of application of make-up to create these kinds of interchangeable dummies. This is the problem of language ... that it creates these kinds of shonky representations. It's the momentum of exchange that constructs meaning rather than what is represented.

**ES:** The momentum of exchange ...?

**MP:** Yes, the momentum of exchange. Language works like the stock market. You get all these interchangeable models within so called postmodern cultures. That's how the media is, it's all about elision. Nothing is allowed to interrupt the process of inter-representation as it were, if you think about it. You can slip across the world through Bosnia and floods in China and massacres in South America and it's like this greasy montage. It's this kind of cosmetic veneer.

**ES:** A flattening of experience ...

**NT:** I think this one of the traumas of language, it's totalising capacity to imprison. Language can't talk about that coil that's burning your flesh. It can descibe it ...

**MP:** It can describe it but it can't talk about it.

**NT:** In a sense the work is a refusal of language (MP agrees) ... and I find that a fascinating moment in Artaud's project and in your own. His was a total experience of refusal and a sense of violence and refusal ... everything from psychoanalysis to chemicals and electricity. He was in a project to completely *refuse* everything, whereas the media wants to keep *explaining away* things. There are points

where you can't explain the smell of burning flesh or the feeling of vomiting out colour, so there is nothing to replace that ... nor can you theatricalise it. In a sense that notion of real becomes such an abstract thing to society.

**MP:** It's very interesting too because ... even listening to you talk now I get very excited when I start thinking very specifically about marking the body. The more specific it is the more intensely excited I become. If it's like drilling a tiny hole in my leg, I get very excited at the prospect of that. It's the specificity, it's like surgery, the tremendous precision at which time I feel that I'm most deeply disrupting the linkages in language. I don't want to do it in a general way, I want to do it in a very aggressive, specific way. That's when I had the idea of trying to isolate words to stop them from shifting.

**ES:** Artaud does this as well. (NT agrees) He has this system of anathematised objects. He goes through them in some of the later works and in some of the exercise books where he wrote things there are these long lists of words and things about which he says "no more this no more that ...," and often they're religious figures or parts of the body, or highly specific medical terms ... he says things like "we'll have no more suppurating glands" (laughs). He lists them as if to annihilate their power over him and he's exerting his rights as an artist to redefine that particular physical substance, that experience, but also his right as an artist to redefine the function of language in its roles of defining and naming.

**MP:** It's to stop the schizophrenia of translation (NT agrees).

**ES:** Yes, he's always aware of the connection between translation and betrayal. As Jane Goodall points out in her book, *traduction* is French for *translation* but in English it means *betrayal*, and Artaud is really concerned about

translation as an act of betrayal, so when he translates those works from Lewis Carroll he makes no attempt to translate them at all, he actually writes something completely different (MP laughs) that no-one can understand. It's not French or English or anything. Whereas Carroll wrote texts with pormanteau words which were, you might say, playful but half-hearted versions of a new language, Artaud went all the way as if to say 'this will look like nothing else.' This 'translation' can be seen as an example of his glossolalia, his invented languages. I get a similar sense from your "Unword" piece where you systematically negate words, 'underivedness' was one word in particular which I thought was crucial to understanding what is at stake in this piece from an Artaudian perspective. The statement that "none of this will be derived. It has been derived but I will negate its derivedness."

**MP:** That's right ... and the words are becoming more and more isolated. The system of their production in this installation is to progressively isolate them and to create a mental projection where words sit out there and look back at you like objects.

**NT:** And that whole notion of the 'Unword' is almost a rejection of the totalising capacity of the word. The word that surrounds you and locks you in and imprisons you until that's all you have left. But the moment you refuse it it's actually quite a liberating thing and in this sense schizophrenia is a liberation because, at least when you approach schizophrenia, everything is unlocked, there are no contracts, no more faith. That's why Artaud always returned to God, constantly vomiting and shitting on God, refusing God.

**MP:** Because *God* is the most totalising word. It's always the *word* of God. It's always this edict that falls out of the sky and jams the flows of the body.

**ES:** How do you ungod God?

**NT:** Going back to "The White Hybrid" piece: you walked for 72 hours and approached the condition of exhaustion, 'unknowing' when you were going to collapse and to some extent always being prepared but never being prepared. Watching your face scar itself in this piece seemed to be a massive advancement on those self-imposed scars from the earlier work — I watched it again and again — it was happening beyond your capacity to control it.

**Mike Parr** *Pale Hybrid (Fading)* 1996
Photograph: Paul Green. © Mike Parr.
Reproduced with permission.

**MP:** Yes, this also relates to a piece I'm doing in Japan this winter where I'll be three days out of doors in a glassed-in enclosure attached to a Museum ... I read somewhere that psychotics, for argument's sake, can survive the cold very well. It's not a problem. Hypothermia is a very relative thing and I think Foucault talks about the ability of some of the inmates of a major hospital in France to sit out in the freezing cold. I'm very interested in this idea. And then I read somewhere in a reputable scientific journal that there are cases of people staying underwater for 15 to 17 minutes. They lower their heartbeat and they can go down with a certain quanta of oxygen and utilise it, spread it out to survive 16 or 17 minutes underwater.

Why can't we use these possibilities? It's got something to do with the vanishing point. It's not just death, I think its another relationship to this problem of God ...

**ES:** As the point beyond which our culture cannot see ...

**MP:** God's a sort of corridor. It's a sort of determinism that rules our society and all our society is produced in the image of this corridor. I think that if you can create these suspensions you can arrest the power of this corridor, and this is what I was trying to do down on the pier (at Finger Wharf). I thought if I could walk back and forth into this vanishing point and then out of it again ... I thought I might fall over at certain points as if I was dead. But then I would sleep long enough and then I'd stand up again and I could walk on again and then I'd fall over again like I was dead ... But you're not dead and you can survive this sort of corridor. You can survive being dragged into the vanishing point, you can make it reciprocal, you can assert a kind of autonomy that produces a delay, and I think you can break into time in a very interesting way.

**NT:** This is why "The White Hybrid" took 72 hours ... and the understanding of it involves a delay in time and space ...

**MP:** It's a delay, a gap and you live in this gap, and you live in this gap then that cuts off the arm, you're not imprisoned by the gap, you enter the gap and you live in the gap. You suspend your body, your breathing ... though you're freezing ...

**NT:** The space of time becomes very material ...

**ES:** Is this a kind of supreme performance, where you're not just performing something that isn't yourself but something impossible, acting something out that wasn't possible to begin with?

**MP:** What do you mean? It is possible. I can do this.

**NT:** There's no acting out anymore. The moment it becomes acting out it's all over.

**ES:** No, I don't mean acting as in 'hamming it up,' I mean taking on something else and inhabiting it, something that isn't necessarily you, isn't necessarily your body or your experience but might be inviting a new possibility, the invocation of something to come ...

**MP:** It's very interesting in referring to "The White Hybrid." I said "I am not an actor, I am not a bride, I'm a future being," and I felt that is what was being produced, a future being. It's like you wear everything away, you wear the image away, you wear away the language that turns you into a marionette, the strings get worn away and you enter a space where you float, you're in a space outside a procrustean time, there's no more bed on which you're being cut to fit and I think this is very important in performance ... We can enter the catastrophic blow, you can enter that blow and you can survive it, and you can expand in a way that was unimaginable previously. It certainly wasn't imaginable when I was doing those earlier pieces.

**NT:** It wasn't, but watching that draining on your body as your face became drawn at times, particularly in the late nights when I'd come in and watch it, and it was bloody freezing, but the body seemed to be operating like those psychotics in the cold, it knew what to do in that state of being, that meta-state which I think Artaud is always conscious of (MP and ES agree) in something like the 'body without organs' he's referring to ...

**ES:** It's a new possibility for the body. That's what I was getting at before ... a new possibility which you called a "future being," Mike, which is the same idea ... (MP agrees)

**NT:** It doesn't require the prison-house of the body which functions on its organs, the function of the liver, the function of the heart etc ...

**ES:** Which are all articulated functions, hence the need to dis-articulate the body which is exactly analogous to what Mike has been talking about ... thereby releasing the body from that and releasing language from that interaction where everything has to make sense ...

**NT:** The corporeal body no longer makes sense ... there is no corporeal body left to speak of, and even though the corporeal body is showing the signs of the stasis that overwhelms everything ...

**MP:** When the rigid body passes away so does the rigid language, you've got a new relationship to language and I've always said in answer to the question "Why do you do performance art?" I say "Because it enables me to think," and this is what people don't understand. I go up to a performance like I'm approaching the acute point of a wedge. I do the performance and then afterwards I become voluble. Everything becomes clear. I become incredibly fluid. I have all these ideas. It's like I've broken through the linguistic and I've moved out onto a kind of

flood plain where everything is clear again. So it's a way of breaking through language. This is very important I think, it's a way of breaking through language, through its impositions ...

NT: The demands by which language locks you into *its* condition, into its structure and into its organs ...

MP: So it *is* intimately involved with the body. In this respect Artaud is right of course, there is no separation between language and the body. The two things interchange.

NT: But what was interesting in the performance of "The White Hybrid" was the way that language was no longer constraining the body ...

ES: The body was no longer the bride of language ... the piece was breaking up that marriage.

MP: Yes, and in the language of the performance the character of the bride was there in a provisional way to shift it into the domain of the future being.... the bride gets worn away. It's the worst kind of cosmetic veneer, it gets rubbed out within hours of the piece and then something else emerges — a kind of an amalgam.

## NOTES

\*  Interview held at Artspace, Sydney, on 26 September 1997.

1  *Dead Sun* exhibition at the Art Gallery of New South Wales, 2 October – 9 November 1997, curated by Mike Parr and featuring a performance by him as 'the bride' accompanying a selection of work from the Australian collection.

2  *Body* exhibition at the Art Gallery of NSW 12 September–16 November 1997, curated by Tony Bond. This ground-breaking exhibition included stills, videos of performances and films by Mike Parr as well as pieces from international

collections by artists as diverse as Courbet, Duchamp, and Abramovic.

3   *Body* exhibition.

4   *Body* exhibition catalogue.

5   Klaus Theweleit, *Male Fantasies*, particularly volume 2, *Male Bodies: Psychoanalyzing the White Terror*, transl. Erica Carter and Chris Turner in collaboration with Stephen Conway (Minneapolis: University of Minnesota Press, 1989).

# Sick, Evil and Violent*

## Interview with Sylvère Lotringer, Edward Scheer and Jane Goodall

**ES:** We were chatting yesterday about that tendency in people writing about Artaud to empiricise all that experience and make it the experience of this individual who suffered terribly and who had psychotic episodes ... I mean that experience of madness everyone is so fascinated by. It's so absolutely other that it eclipses the work, it makes the work disappear, it pushes it to one side. I'm intrigued by how he theatricalises all those identities and sort of passes through them in a very playful way which is something your recent writing on Artaud touches on, the theatricality of identity in Artaud ...

**SL:** I think anyone dealing with Artaud feels drawn in to Artaud, and becomes, for better or for worse, an Artaud clone. I don't think anyone I know who has been dealing with Artaud hasn't gone through that phase. I did that too and then I realised that that's not the position to have, I mean not just in relation to Artaud but in general. Because there is only one clone of Artaud and that's Artaud himself, any other person who tries to be Artaud is basically bumped back out. So then I tried to *retoucher* (alter) myself away from that, and one way was to really try and have as many facets as possible — not just with writing, but I went around meeting all these people who knew Artaud, and just by the writing of the responses I got some idea that all of it fitted and none of it fitted, and in some ways Artaud had all these facets. Even people extremely close to him, like Marthe Robert, had to admit that it was impossible to encompass Artaud's mind, that

305

he was like this multi-faceted individual who was always playing himself out, simultaneously in total seriousness and total playfulness, simulating and impersonating and all at the same time. It was a perspectival view of Artaud, and Artaud himself had that view of himself. Another thing I was very struck by was this sentence that André Masson wrote, he wrote just a paragraph on Artaud, or one page, but I was very struck when he said, "never forget one thing about Artaud, .the idea of prestige." You know he was basically a gambler and I think he gambled his life from the very beginning, realised that under the sign of death that there was nothing to lose and nothing that wasn't worth trying, and that his life had no interest in itself but only what he could do with it. Another thing was what-was-his-name, Henri Pichette was a mystic — I met a number of pretty far gone people — Pichette was you know this prophet and he said, "It's amazing how someone as little gifted as Artaud managed to do so much with his life."

**JG:** Depends what gifts you're looking for maybe.

**SL:** But the idea that it all can and cannot fit together, the idea that Artaud basically put himself on the line and decided not to pay attention to the context he was in but was creating a context all by himself, and the fact that he was such a bad actor who could be seen, at the same time, as being such an incredible actor ... but he wasn't playing in the same place ...

**JG:** He was just acting off the stage.

**SL:** Well yeah, but even on the stage he was kind of deliberately trying to play Artaud and that's the other thing that André Masson said, that "Artaud tried to play Artaud" and "that was his best composition," trying to be Artaud. But there was always this discrepancy, the fact that he could never adhere to any one position.

**JG:** The gambler is an interesting way in I think, one of the earliest titles is *Tric-Trac du ciel* (Divine Backgammon) ... do you have thoughts about that particular work?

**SL:** Well it's part of the whole Surrealist period, that particular work ...

**JG:** Gambling was a surrealist motif too ...

**ES:** ... And it's connected with their methods of making artworks, like the *corps exquis* — a game and a process ...

**JG:** Yes, it goes with those aleatory processes ...

**SL:** He was going for broke. I don't know if it's being a gambler because there was nothing he could win, I mean he wasn't really gambling to win anything because he had already lost everything. I always started from the idea that by the time he emerged he was already kind of ... it was over, he had nothing else to lose ...

**JG:** He'd lost. But the other interesting thing about the gambling idea is that it plays between the very serious, even the drastic and the playful, facetious, the putting all values on the line, and it seems to me that some of that is at issue in engaging with Artaud, how you began, the danger of people making an identity for themselves through Artaud, trying on Artaud's persona in some way, or trying on his experience in some way.

**SL:** He was basically testing everyone.

**JG:** But maybe what gets lost is the playfulness? That seems to be what you were getting at with the first thing you said, that there is something very profoundly facetious that's perhaps rather difficult to understand until you've been with the work for a while. It's that

paradox of being *profoundly* facetious, not *slightly* facetious.

**SL:** He was a Marx brother. He had this kind of quality ... One of the most insightful things, I mean from Artaud himself, is when he talks about radical absolute humour, and I always thought it was very illuminating and makes it impossible to unravel what position he had because he was both totally engaged in what he was doing, and at the same time totally detached from it and playing with it and simulating it. That humour for me has always been the most important element. It's the only way ... (laughs) it's the only way out.

**JG:** But doesn't he go further than the Marx brothers and some of the other humourists of his time in that he stakes things no one else stakes? And that's where you get that paradox of moving from the facetious to the drastic, I mean the level of the stakes with Artaud are absolutely drastic.

**SL:** Yeah it's total, it's absolute.

**JG:** They are cosmological stakes.

**SL:** It's imperceptible ... there is no way, no way you can put your finger on it because you put your finger on the wound at the same time. But there is the laughter. Even people who were close to him, like Paule Thévenin ... I remember trying to get her to talk about Artaud's humour and she tried, but it wasn't her thing obviously. Marthe Robert was well aware of the fact that when she was walking with Artaud in the street and Artaud would turn around and say "When I was on the cross ..." and all that, and she would just shrug him off and say "What are you talking about?" And he would just drop it because that was both what he believed, what he tried on people to see if they thought he was mad and just *place* them, and it

was at the same time a certain way of placing himself in relation to people. It was all this simultaneously and she would also say that he would be totally absent, you know he would be talking about something and suddenly he would just come in and do something very facetious. I think there is something for himself that was totally inscrutable, because he was playing like a politician.

JG: This is something that concerns me with the dialogue with the psychiatrists ... that it seems to me of great importance in that dialogue because ...

SL: Which dialogue?

JG: The dialogue with Latrémolière and Ferdière. Because there is that phase where he has to convince them that he's orthodox, that he's devout and he comes up with all these Catholic positions, and then suddenly he goes through a new phase and he reverses it and becomes totally heretical. When you read it back now, you sense that this was someone who knew absolutely what he was doing and the game that he was playing, and the stakes again were drastic. But the psychiatrists weren't picking this up as a game — they thought it was straight pathology, they thought this was someone who had no self-knowledge, no self-detachment, no flexibility of attitudinising and belief and yet there was an absolute flexibility, one so drastic they didn't quite ...

SL: It also depends on the situation, in some ways there is no flexibility whatsoever, but for the most part, yes, there was flexibility and they didn't get it. I mean I was reading the Ferdière book. Artaud says it all, and I remember it because I talked to Ferdière and he said "Well, I mean this guy was becoming a vegetable." Then you read the very first letter of the art therapy, the letter on Ronsard, it's an amazing piece of scholarship. It's totally masterful. How could Ferdière say that he had to

save this guy from becoming a vegetable, because he was so superior? And at the same time when you go further with Ferdière you realise that he was a very smooth talker and used this all his life to defend himself, but he would come up with these ideas: that Artaud was speaking behind Latrémolière's wife, and that he was burping at the table, and that he was dangerous for public safety.

ES: Because he had bad manners (SL laughs). But whatever his skills as a psychiatrist, Ferdière was certainly not much of an art critic, it seems. As with Artaud's writings, he couldn't read the drawings, the drawings were for him also pathological marks on paper rather than constructions or "*voluntairement baclé*" pieces as Artaud said, voluntarily stuffed up pieces.

SL: And for an anarchist he developed this reaction, all of which I have on tape, "Of course you couldn't let these people do what they wanted." He was like an autocratic anarchist, he was reading *Le Canard Enchaîné* and that allowed him to be on the good side, and he was actually I think. I defended him for a number of years in my mind because I thought he'd been unjustly attacked. He basically saved Artaud's life. But Artaud didn't come up against people who were on his level, even Breton. Breton was pathetic.

JG: But again he was gambling, I mean he was really gambling in that relationship with ... the letters to Latrémolière in particular, and that phase when he's trying to convince him that he's devout and the positions he puts are those of the Cathars who were the early French heretics. When I looked, the location of the Rodez is in the Languedoc isn't it? I mean, how could they have been so stupid as not to realise that what was being thrown at them was absolute prototypical French heresy. Artaud must have known.

**SL:** I think it was in 1943 that he came up with all these things about Jews and all that. It was circulating everywhere and he was picking it up ... it's like talking about some person connected to the web, Artaud was connected to the web before it was even given the name, and that's I think one element I liked about him. This element of humour meant that he was basically simulating and scrambling all the codes, and that's why he's impossible to grasp because you expect him here and he's already there. He was an actor at the level of the society, basically. And I guess that's what I liked about him, I never considered him as this pathetic personality, but as someone who was totally connected to society, who was totally there. He was a scrambler, the scrambler of all codes. That's why humour is so important as it gives him this kind of untouchable position, one that he played out constantly, and that's why it's impossible to know exactly what he's about, he's about everything.

**ES:** He talks about Humour Destruction in *Le Théâtre et son Double* and this, he says, will restore the theatre to what is truly serious about it. It's interesting that someone like Heiner Müller picked up on this as well. In your interviews with Müller — published in that *Germania* edition of Semiotext(e) — some of those texts come back to Artaud. But Müller only read one entire half of Artaud, he said that Artaud "needed a wall" (like the Berlin Wall, so important to Müller's geopolitical writing), probably to concretise some of his thinking, and it seems that he missed the humour. I find this extraordinary because Müller himself uses humour so much and in such a similar way.

**SL:** Well, he also had to scramble the code but he wasn't very humorous about it. But he managed to be a communist and have a foot on the other side (laughs), but the situation was schizophrenic, he was not so different to Artaud and now when you say Artaud is schizophrenic it doesn't mean anything, it means that he had these kind of

multiple positions, that it was impossible to push him out of ... Sometimes I feel that he was totally reterritorialised on one position and there is this moment where he is fixed, as our friend Lacan would say, but he's not fixed for ever.

**JG:** But isn't that also why it's such a high risk strategy because he is always going to be mistaken by the very nature of it and yet there was also a kind of agony all the time about being mistaken, people not working on this level of radical danger.

**ES:** That's in those letters to Latrémolière as well. Apart from all this kind of elaborate heretical repositioning, there are also some very desperate letters there. He is saying, "Will you please try and understand what I'm doing ..."

**JG:** But the desperateness is an act too.

**ES:** I wonder about that, I mean when he's saying "Please stop giving me this electroshock therapy because I would have thought you could understand what I'm doing ...," that seems to reflect a genuine sense of crisis in the game plan if you like ...

**SL:** Well it was kind of a limit, he was being paid in his own coins. He always tried to literalise everything and he was kind of being *had* there. Artaud wrote about the theatre of cruelty and the theatre of shock and he was given too much of it. But yes, in discussion with Latrémolière he is like totally Latrémolière, he is more Latrémolière than Latrémolière, he is more mystical than Latrémolière, and he (Dr. L) couldn't take it. And in the same way his position towards sexuality is more Freudian than Freud. I mean Freud projects sexuality everywhere. Artaud went one step further (laughs). It's impossible to have that position but he managed to be in this impossible position.

JG: Even when the stakes are torture or electric shock treatment, I mean people do that sometimes under torture: contempt wins out over the trauma of being tortured. People will go on insulting their torturers. You could even read the relationship with Latrémolière that way: even if you are going to give me more electric shock, I'm going to go on taking the piss out of you, provoking you. The contempt is more important than ...

ES: I think he perceives that what is happening is the denial of his own subjectivity, so he's kind of proliferating subjectivities everywhere as a ruse partly to escape, but it's also partly homoeopathic: accepting what's happening to him and responding in kind almost.

SL: Well it's the same in relation to his own suffering. I went through a period where I doubted everything about his suffering. I doubted that there was any suffering to start with, it's so elusive and yet sustained and documented. You could say anything and you could think that he's like a drug addict ... In his letters to the doctors he comes out with everything, all the cues that you'd expect and he really plays it up. At the same time there is something there that he feeds on and works in, and given this suffering and this pain he turned it into his material. He really was an artist in pain. Like you have the hungry artist, he was the suffering artist. He used it to the hilt ... Suffering is used in so many ways at the same time. Even when he doesn't suffer he can use it. He explodes every parameter, that's really what makes it so mind blowing, that you can't rely even on what is true.

ES: Which takes me back to that idea of the gambler which actually crystallises quite a lot, because if you accept that life is not a gift, life is something that you have to create, for oneself, if you take that as Artaud's originary position, then everything that follows is similarly up for grabs, absolutely everything. Any kind of form has to be, not negated but abreacted, it has to be brought on and

looked at and then destroyed, precipitated ... Something else has to be put in its place. It doesn't stop anywhere, it can't stop anywhere. Everything has to be actioned and re-actioned because nothing can be accepted on face value, or any other value.

**JG:** There is never any quietness, never a lull.

**SL:** There is a route *to* that, and I think the experience of death as a starting point is really an absolute experience that eradicates every possibility of gaining, and that's really what he comes back and plays with and scares people with ... He plays Grand Guignol, scaring people off with what he was scared of himself and that's really the amazing thing that he really ... He is a great example of someone for whom there are no limits. In any reading of Artaud we always tend to put a limit somewhere because we think we've got him, but he himself never got himself.

**JG:** You were suggesting just now that you went through a phase where you doubted everything. You were kind of doubting everything you claim to have ever said or done, is that what you meant? One of the things that interests me is whether or not he actually went to the land of the Tarahumaras.

**SL:** Oh, he did.

**JG:** I thought there was some doubt about that, as to whether it could have been an entirely imaginary construction?

**SL:** No, no he went there ... I mean I doubted it ...

**JG:** But isn't there doubt as to the journey into the interior, or is there now evidence that it actually happened?

**SL:** All I can say is that I went to the Tarahumara to check it, and I didn't believe it ... But as soon as you get there ... the descriptions ... I even have tapes of the answers.

**JG:** You're the proof.

**SL:** I'm no proof.

**JG:** You brought the proof back.

**SL:** I'm no proof but I've talked to people in Mexico too, like Louis Aragon, and he was in Mexico City for sure, but I don't believe this primary school teacher who saw him being hailed by the Tarahumaras and all that. The Tarahumara are not very welcoming people to start with, but what he says about the landscape is extremely accurate, and actually we are going to have a series with some anthropologists at NYU with Mick Taussig etc., talking about the Tarahumara period. There is no doubt in my mind that he was there. Our premise is that Artaud was right *and* that he was wrong. All these premises were false and he ended up being on top of it because he thought he found this population that was totally syncretic and had amalgamated, and that's what they were. They were converted by the Jesuits in the fifteenth century. But part of the original religion was actually oriented in a cross-like way, and so it was like your usual Catholic re-capping of previous cultures happened in a miraculous way with them, and then the Jesuits were chased away in the nineteenth century for a century and a half so that the Tarahumaras regained the original tradition and incorporated Christian tradition. But when Artaud comes on top of it hallucinating like Heliogabalus... he happened to be right there ... all the premises were wrong but what he saw was exact and his description was extremely accurate.

**ES:** 'The abolition of the cross' was one of the rites he witnessed in the peyote taking ceremonies which seems

to fit this retrofit religious situation you're describing ...

**SL:** When I was in there, there were hundreds of Tarahumaras in the church, in all their costume and their bells and all their period hats, everything that he described. It really is precise, he was just there, except that these dances were imported from Venice and adapted by the Jesuits themselves for the Tarahumaras. Artaud was lucky enough to strike exactly that.

**ES:** That community seems perfect for him on a number of levels, their spirituality is the kind of skewed imported antipodal kind of Jesuit Catholicism, perfect for his heretical bent. He can understand the 'abolition of the cross' precisely because there is a certain kind of process of anathematisation that happens when religions get transplanted into different cultures, there is a creolisation of the faith which Artaud would have obviously responded to positively. But the other thing about the Tarahumaras is that they are almost superhuman physically (SL agrees) — the games they play, where they go for four or five day runs and they just run and they drink this mixture of water and flour and just keep running, correspond to an idea of the possibilities of physicality that he was working through at the time in the thirties in the theatre essays. It doesn't come through directly as a reading of their practices but I wonder ... did you experience this when you were there?

**SL:** Yeah, I met the Tarahumara who won at the Olympics. He was 45 years old, he had to lie about his age otherwise he would not have been admitted. But they look very impressive when they have their mirrored hats on, in fact they are very small and very unprepossessing. I mean, this champion looked like nothing, but once he wrapped himself up in his tablecloth and put on the high heels, you know they are really like gods ... of course I took pictures and all that ... but I couldn't believe how exact Artaud's

descriptions were, because it's only just forty years ago and they have kept that ritual for centuries, so when you go there that's exactly what you see. So I know he was there, there is no doubt about it. It's just one of these miracles of Artaud, the way he managed to exactly position himself so that he became entrenched ... he became a Tarahumara himself.

**ES:** An honorary Tarahumara?

**JG:** In his account of it it is a completely reckless process, the description of him getting on horseback, like a bag of bones with no clothes. Somebody else describes this don't they? Him riding off with ...

**SL:** Without clothes ... he described him at the end of *To have Done with the Judgment of God* like nature rides totally romanticised, of course at that point it becomes totally mythical, the Tarahumaras don't ride naked.

**JG:** There is description of him, maybe it's a description by ... what's the name of his contact again, in Mexico?

**SL:** Louis Aragon.

**JG:** Maybe it's Aragon's description of him riding off, not naked, but just completely inadequately dressed or equipped.

**SL:** Yes, he gave him his pants. Well Artaud, for all I know from Louis Aragon, Artaud was living in terrible conditions. He was living in the east village of Mexico, just hitting people for drugs, and having no money. He was basically passing on texts to these people who were translating them on the spot and publishing them. He hardly saw anything. He didn't see any of the ancient Mexican art which was close to Mexico, basically he was in this kind of downward phase. He was down and out. I got very interested, and that's what

I'm trying to talk about in my paper here, I'm very interested in how there's a lack of a change, then there is a mutation. There is a delirious phase, and how it was really deliberately engineered, basically because it was the only way to recover from this kind of impossible situation, to play his own theatre, to become truly delirious, which is really what the theatre is about, and that made me reread *Le Théâtre et son Double* because it's a theatre of madness. But a very special madness, not the madness of alienation, but a madness that's will to power.

**ES:** Madness that's not undifferentiated experience, but actually carefully differentiated. It's excluded experience, but it's very precise as you say.

**SL:** And madness doesn't mean anything. Ferdière had his own definitions, that it was "confabulatory paraphrenia," which means that Artaud, according to him, could just get into this kind of fable ... but then a few minutes later he'd be talking to the usual 'common ground.' So it was not invading his own personality, it was just a way in and out of a story. Now whether these stories were invented for a purpose or whether he actually believed them ...? It's all true. Basically I think that in relation to Artaud's pain and suffering, I guess you have to question everything and you have to accept everything. You can't really sort things out, it's both totally true and totally simulated and that's the only way.

**JG:** Well it's always strategic (SL agrees), it's never ingenuous.

**ES:** But you can't really use an empirical discourse to account for it, you have to use something else, you have to be ficto-critical ... you are forced into that situation of being 'creative' whenever you are even discussing Artaud.

**SL:** Yeah, and I think that given the fact that most people

take Artaud as a victim, I think the best position is not to start from there, but to assume that he was totally in control, and that the control itself was madness. That's what it is, but to see him as a victim, he *was* also a victim because he was everything, but this is the worst possible position. It's the one that blocks out most of what he does.

**JG:** It's almost more than a victim isn't it? ... it's a kind of glamorisation of this sufferer ...

**SL:** Of course, he was a Christian.

**JG:** This kind of high grade sufferer you even get in Deleuze and Guattari. I always think of that description he made of himself, "*Bon Saint Arto, Artaud, le grand Artaud,*" I mean ... a wonderful undercutting of what's been done with this kind of image.

**SL:** That's an aspect that I can really relate to, there is a humour on one side and there is his suffering on the other because in a way he was authorised to suffer, he went beyond it, but he had a whole tradition behind him that valorised it, that made it a position he could occupy and work around ...

**JG:** ... Strategy, I guess ...

**SL:** Strategy ... it was his material, it was a mythical position and he knew it and he cultivated it. At the same time, I was very struck, coming from where I come, that this is a position that was extremely valuable at the time, because the time is not any time. It was a time of incredibly widespread suffering and torture and cruelty, and Artaud, although on his own, in some way managed to be able to have the right to express much more than the people who actually suffered and he had the guts, or the luck, the chutzpah ...

**ES:** ... the *cojones* ...

**SL:** ... to even spend his time in the asylum as a real concentration camp, he suffered from hunger, he suffered from persecution and he himself said it after the war, you remember he exchanged a letter with this guy who was coming back from Germany and in the letter he said, "Look imagine 1933 ... I was telling you all that and I was ...," and he could see the rationality of it, but he also saw the religious underpinning.

**JG:** I am always worried, though, about introducing a line on Artaud that puts him in the position of an anti-rational or an irrational, and it seems to me that maybe he's getting at what's happening more because he is not literal minded, he never is literal minded, so ...

**SL:** ... And he's more than literal.

**JG:** There's always logic at work but it's that theatricalisation, it's the gambling, everything's in the ludic mode.

**SL:** But gambling means that he becomes what he gambles. There is a metamorphosis so that's his way of exploring, he gambles something but then he just moves to neutralise it and from there he reconstitutes everything he investigates, his incredible virus ...

**JG:** But maybe that's for me getting more at why he's someone who could understand, when no one else could, what dynamic was happening in the concentration camps. He could pick up on it because he was never literal minded.

**ES:** And he didn't have a stake in what was happening really, he didn't have a stake in the continuation of any kind of social practice, he didn't have a stake in

continuing his own practice really.

SL: Oh, he had a total stake, I mean he didn't have a stake in communism. Everything he says to Breton on revolution ... His messages are so much on target. I mean half a century later there is nothing else there that he could ...

ES: A *"révolution des châtres"* was how he described the communist plans for revolution ... (a revolution for castrati)

SL: I guess he managed to outdo everyone who actually went there, and that's maybe the paradox and the kind of upsetting element. But he was an artist, and people forget that, they think he was a saint and all that but he was an artist. It was art work to play on the suffering, his own, but it could be spread all over. He was everywhere someone was suffering and there was something shameful about it, but at the same time he was beyond shame, because he was exploring it. So I guess for me there is something very stereotypical in *"témoin de son temps"* (witness to his time). But he wasn't *'témoin,'* he was really engaging with all these codes and engaged so physically that he even managed to get hit by it, hit by the electroshock, hit by hunger, and by following a trajectory that seemed so idiosyncratic or so defined by his hyper-Christianity, and yet he managed to, although he's not anti-Semitic, he revealed anti-Semitism and racism as latent in the society. He just expresses everything and plays with everything that's around, even when he sends the first spell to Lise Deharme and there's the whole diatribe about the cabbala, he can be totally at ease because he is not talking about himself, he is just giving a voice and that's really what it is, he gives a voice to all these voices that cross through his head, he's like ...

ES: An antenna.

**JG:** But he's extraordinarily astute with reason and logic, isn't he, isn't that one reason he can do this? ... he can pick up somebody's logic, the particular kind of parameters that it operates in and play that game, then he can unplug it and plug it in somewhere else and play a completely different game.

**SL:** He re-uses schizophrenic disconnection to the hilt. He had no position to defend, but every position to defend, it's his positionality ... It's a bit like Lacan, I don't like Lacan so much, but when Lacan says the hysteric is a question that has been raised to the medical establishment: Artaud is nothing but the question itself and it's a question that is raised to art, to theatre, and to society. The question itself cannot be defined, because it's the function of the question that is important, and then he managed also to inhabit the question and to make the question his own ...

**JG:** But it's ironic that Lacan missed the game, because it was the game Lacan played himself, the poseur ...

**ES:** "What constitutes me as a subject is my question," he says, and yet he totally denies Artaud any kind of subjectivity.

**SL:** But Lacan occupied a position of power and Artaud never did, and when he does he does it really badly: *"je suis malade!"* (JG laughs). Because there is also a kind of advocation of madness or antic disposition. I mean, put Artaud in a position of giving a speech and he gives this speech and it is like shameful, because he occupied this position too.

**ES:** There is something from Lacan that works with Artaud, the idea about the *epos*, that the patient in that clinical context is somehow someone who is passing through these various kinds of stories (*epos* is a variable

discursive mode) without necessarily historicising themselves or biographising their experience. They are telling stories and performing themselves and Lacan seems to be very aware of that. I mean in some of his theoretical pieces, but in his clinical experiences with Artaud he was a complete disaster.

**SL:** That's Lacan, he was a total disaster for all his patients, like Freud. I knew a number of patients who were going all the way to the south on a vacation just to spend an hour's visit with Lacan. He would just come out and wash his feet for two minutes and send them away. But this is the kind of madness that Artaud was spared except in the last part of his life. But I love the way he dismissed Breton, he really fixed it ...

**ES:** In those last letters from 1947?

**SL:** No, when Breton was back from the States in the cab, Artaud looked at Breton and said, "You know when you saved me, when you were killed trying to save me ..."

**ES:** At Le Havre ...

**SL:** Yes ... Breton didn't know what to say, Breton had no sense of humour, especially no black humour,[1] he was scared stiff of people like Artaud.

**JG:** Artaud was his nemesis I suppose. Breton's always protecting investments, huge egocentric investments in his own personality cult and his art and politics.

**SL:** You mean Breton or Artaud?

**JG:** Breton, and Artaud because he plays everything to such high stakes.

**SL:** You know in the letter he sent to Breton from Ireland,

you know he had been back with Breton, he had resumed contact, and he sent this delirious letter, casting him as this father figure, this God, this all powerful, and also this kind of downtrodden *poète maudit* just like him, he was a portrait of Artaud. It's like when Kafka talks to his father, in a letter to his father, there is something very fishy there and I thought recently about this first spell he sent to Lise Deharme. You know who she was? She was the woman with the blue bob in *Nadja*. She was with Breton for three or four years. She was Breton's ultimate love affair, which never went anywhere, and this letter to Lise Deharme who was Jewish, and he was so abusive of it, he included it in a letter to Breton (laughs). Why? He wanted to draw a wedge between Breton and her, but Breton was already married to someone else, and Breton's first wife was Jewish. Anyway, Artaud's attack on Lise Deharme was also an attack that had to do with her position on Spain, on the Spanish anarchists at the time, which was exactly the position that Breton had, and it touched on the political, which is the reason why he broke up with Breton in the 1920s ... in one spell, in one gesture, he managed somehow to scramble all the codes there and Breton, I guess, was right not to want to see Artaud again (laughs). He did, but he didn't want to.

**ES:** He did after the Paris *Vieux-Colombier* recital.

**SL:** Yeah, but he refused to go and visit him in (the asylum at) St.-Anne. Jacqueline went, but not him. Breton was the antithesis of Artaud. He never gambled.

**ES:** And this came through in that last correspondence with Breton and Artaud in 1947, about the Vieux-Colombier recital. Breton is saying "You are an *homme de théâtre*, whether you like it or not, because you were on stage," and Artaud says, "I don't care what you say about me being on stage. I was on stage, OK ... for the last time, and it was only because I was going to pull bombs out of my pockets and throw them at people, it was only because

I realised that the only language I had, could have, with the public would be that gesture, so you can talk all you like about me being a man of the theatre, but no man of the theatre in the history of theatre or of mankind has ever done what I did that night at the *Vieux-Colombier* ..."
And he throws it right back in Breton's face: this is the stage and my disposition, who I was, who I was playing means that I was outside of the stage.

**SL:** At the same time Artaud was totally out of it and he was a terrible actor. By being a terrible actor he was the best that could be. It's like bringing it back into the same circles, it's impossible to unravel. I guess I'm a bit worried that Artaud has 'come back' in a sense ... I talked to Mike Kelly about it, what is the art world going to do with it? Why Artaud now? Why, I don't know, it's just happening, but to be the good savage is not really what it's all about. It's that he reached the absolute limit of the capitalist system, not the relative limit, the absolute limit, and since he is at the absolute limit he encompasses both the horror, the terror, the hopes, the versatility ... everything you can think of at the same time. It's just totally unclassifiable and that's what makes him so present because he is the crowned anarchist of a society that is totally anarchistic but totally wants to have order all the same, and he is all that.

**JG:** But if he's being rediscovered or re-accessed in some way, maybe that's one of the values ... to be a destabilising influence on a culture that's got a little bit too concerned with protecting its investments and lost the ability to gamble, change the stakes, and it seems to me very much an Australian society, there's an obsession here with good behaviour ... There were very minor riots here recently in relation to the budget which has really been ordering a very radical change in values, social values, it's the presence of the monitarist approach here which will erode all kinds of social frameworks. There was a huge

rally in Canberra and a small group broke into parliament house and became violent, but the reaction to that has been so excessive, everyone has had to distance themselves, make condemnatory pronouncements. There is an extraordinary commitment to good behaviour and politeness and reserve, when in fact something very destructive was going on and it seems that you need an influence from somewhere else, maybe somebody who's just been somewhere else in their head even, to just start loosening that up so that change can happen, because change is not going to happen at that level of good behaviour, and I think it applies in the arts as well, everyone's got caught out on the funding issue, all that artists talk about now is money and you need an artist who has been prepared to be down-and-out in order to do violence on a violent value system. It's a different kind of energy somehow that needs to be accessed.

**SL:** What has changed I think is that it's very difficult to have this modernist heroic position which Artaud was playing off all the time. He was very aware that he was the victim, he was playing the victim, there was a whole range that was open. Now it seems the system is more Artaudian than Artaud ... We live in a totally schizophrenic society. That's why schizophrenia doesn't have the same advantage as it had before. Artaud could be an unpaid schizophrenic, but now the society is being totally schizophrenic and what we are seeing happening now is one of those kind of restrictions ... you know, carving up and getting the fat out, you know one of these periodic things, but I think that Artaud was probably the last to be able to be at the absolute limit and to be scandalised for it ... because I think we are in a system that has no limits anymore although it constantly creates them so you can get the illusion of banging against them but ... that's why if the system were to have a voice it would be Artaud's voice (laughs) ... But the context has changed, you know, violence and suffering all that now have become

anonymous in a sense, you know, we don't need secret
agents for it, and I think Artaud on that level ... you know,
we have the religious right and conservatism but we don't
have this kind of violent crisis in religion that was going on
at the time, and he was pretty much there. He was fighting
like a devil in there but he belonged to that area, that area
which also includes Fascism and Stalinism and that ... and
now we have discarded all this, it's not efficient enough ...
alternative to our society and religion, which has itself
settled into political conservatism, thought is not playing
around it ... and Artaud was God, he was the last God
there was.

ES: Because he picked up all those voices, he was so
unique but so infinitely analogous at the same time.
Derrida calls it "the protest itself, the exemplary protest
against exemplification itself ...," which is Artaud's
'adventure.' It seems to me that there isn't a critical
language to describe that kind of experience or that kind
of positioning without resorting to metaphysical or
religious discourse or something.

SL: I'm not especially religious, but I think that this is an
important element, the backbone of Artaud ... what gave
him this possibility of confronting all that and playing with
that. He was extremely devout, he was extremely
religious. He was hyper-religious, and I think that's a
dimension we can't play down.

JG: And he believed in evil.

ES: Believed in evil, not as a name of our fear of the other
but as something that was actually part of our identity ...?

JG: A cosmological force.

SL: There was nothing that evil in the world or the church
hadn't acknowledged evil inside, so it was loose and I

guess that is a pretty good, accurate description of what Fascism was ... that basically Fascism took a lot from Christianity, which Christianity got away with. But there was a big religious element in Fascism, that's why we still don't know what it was about and Artaud is one of the keys to that, because for him evil was a reality, that's what he wanted, and that's what he tried to do, to introduce.

ES: Evil as an absolute negativity, as an absolute process of demolition, anathematising.

SL: This experience of evil made the church stigmatised, evil was something that was outside, a position assigned to the Jews and that's where the Nazis came and picked up from, even if they turned it against Christianity, for me they are the direct inheritors of Christianity. The Nazis were not as schizophrenic as Artaud. They played with the code, they just amalgamated the communist propaganda, the church organisation within Nazism, they were Artaudian in that respect. In that way Artaud goes in and out of fascism. In Mexico he is raving about races, he is right there ...

ES: In *Messages Révolutionnaires?*

SL: Yeah. It was a paradoxical position ...

JG: But I think you actually need the gnostic logics to get a sense of how evil works in Artaud's thinking. I think they are very difficult to receive, extremely difficult to receive in the late twentieth century, and they've always been difficult to receive. But the gnostics reversed the good/evil dynamic because evil was creation. Evil was actually equated with natural formation and that is extraordinarily difficult for us to receive with our kind of ecological ideologies and so on. But what interests me about the gnostic position is that if evil is equated with structuration and formation, then all institutions are by definition evil, because they are structures and formations, so gnosticism could never have been

compatible with a church as an institution or a state as an institution. That's why it had to become a heresy, it was profoundly dangerous to any organised government and that seems to me to be very much what's happening in Artaud's thinking. I mean, not anything as simple as an influence of gnosticism, but a similar mode of thought that is similarly threatening to all kinds of foundation positions whether they are political, religious, or philosophical.

**SL:** This paradigm is lost, I mean we can listen to Artaud from other angles but this sacred paradigm for us has no time any more and the whole notion of totality has exploded. Even when I teach structuralism, structuralism is just a reversal. Baudrillard, also, is just a reversal of Artaud. But they all somehow try to compensate for lost time, try to redeem time that was disappearing.

**ES:** *Pour en finir avec le jugement de dieu* (To have done with the judgement of god) ... but one never does ... it's continuing.

**SL:** But God was still there. Artaud needed God to be able to finish with him.

**ES:** Right, he needs him as an object to anathematise.

**SL:** Yeah, he was like Nietzsche in that respect.

**JG:** Which is why there's a problem in a culture that does the Nietzschean thing and says that God is dead, though Nietzsche is so much easier because he says God is dead.

**SL:** Because he's dead, but you still have to bring him into the light of day because no one has noticed.

**ES:** You have to shine the torch into the dead eye of God looking for signs of life (JG laughs), whereas Artaud is just putting volts through the body, his corpse, and

reanimating it constantly. He needs it, but I'm no more convinced that it's a living thing than Artaud was I suspect, but that might be where we disagree.

**JG:** It's always at work I think, that's my way of looking at it. This God, whatever it is, is always at work, always very powerfully at work and very strategically at work.

**ES:** But still only a "weak battery, farting away in the clouds" as Artaud wrote ... (JG laughs)

**SL:** He's still there but no one cares about the judgement any more. Artaud did care and I guess he also occupied a position of God, he did everything ...

**ES:** *"Dieu de son vrai nom s'appelle Artaud"* (God when he's using his real name calls himself Artaud). He says this and in a sense that's quite right.

**JG:** But that's also a posture.

**ES:** It's a posture, it's a unique posture, it's an analogic posture.

**JG:** It's a strategy: "Hey what if I play this?"

**ES:** But it's also perfectly true, and it would be true, I'd say, for possibly anyone.

**SL:** That's true for Bataille too, he wanted to be God because God was being sacrificed, it's the best position he could occupy, but not as a God all powerful, but to be God and to lose it. I think that's why he had so much possibility for gambling, it was wide open and it was also a situation of extreme urgency which he really anticipates. And all these people anticipated that it was the last prophetic position that they could see being occupied at the time. I mean now maybe we have another, but not the

same one, I mean obviously something is closed and we
have no access to it and Baudrillard in his book on evil
said, about fashion, 'Well, we could have understood it at
the time, but we didn't and now we have missed it, it's
gone.' My interest in Artaud is that Artaud played it and
it's all there and it's in his writing, in his disposition,
everything, his own testimony, he activates it and allows
us to have access to something which for us is derelict. It's
like a wasteland at this point. Not that it couldn't be, even
what comes back is not the same. He had so many options
and he was one of the few minds who played them all out
and understood exactly how far he could go, and he went
as far as he could go.

**ES:** And what about sickness for Artaud? In contemporary
depth psychology, for example, James Hillman says that the
soul will make you sick until it gets what it wants. So illness
in Artaud is a form of feeding the soul and the soul in
Hillman's form of depth psychology is a very physical
substance, very dark, and I think that Artaud was working
with that principle as well in physically occupying the
position of a sick person. I'm not sure if one of the
definitions of 'mômo' can have that kind of pathological
connotation, but it's one of the many identities that Artaud
adopts: the sick one, as well as the themes in the later work
of *"l'homme est malade parce qu'il est mal construit"*
(man is sick because he has been badly made) in *Pour en
finir avec le jugement de dieu* (To have done with the
judgement of god) ... and the sickness of the society in the
Van Gogh text. It seems that Artaud again takes it on, has to
be sicker than anyone else, and it's a great sickness and it's
a purging sickness, but a sickness that is never cured.

**JG:** Sickness then turns from a passive to an active
dynamic, it becomes an energy thing.

**ES:** But everything has this same sort of cycle in Artaud.
What was passive is now forced to do some work.

**SL:** You can't doubt that he was sick, but you doubt it entirely too because he really willed it. Of course, there was a starting point somewhere between the cause and the consequence, it gets lost whether he had meningitis or syphilis, everything or nothing. The point is that he had assumed this position of the sick person. But then what interests me is the fact that he was actually everything but dispossessed. His dispossession was like a phase that he had to assume on the way to absolute power and absolute power is madness, so he wasn't mad as we actually understand it, it was hyper-consciousness.

**JG:** But it makes the word 'madness' sound useful?

**SL:** Well, you know, Foucault uses it, we all use it, because it's convenient, but it was a position of madness because he had this possibility of occupying this position of pushing things to the extreme, and also he was in a position in his gamble to be out-played with the gamble. I'm interested in that moment: there's a point where he played for broke but he didn't have that many options any more, then he actually became mad, although this madness was not dispossession. He dispossessed himself in order to get to the point where he would regain it all. This was essentially what the gamble was all about. At the same time the madness was not only coming from him, it was coming from the world ...

## NOTES

\*   Interview held at Artspace, Sydney, 13 September 1996, and transcribed with the assistance of Jodie Cunningham.

1   The joke is that Breton edited a collection of black humour recently translated as *Anthology of Black Humour*, transl. Mark Polizzotti (San Francisco: City Lights Books, 1997).

# CONTRIBUTORS

**Rex Butler** is a senior lecturer in the Department of Art History at the University of Queensland. His most recent publication is *Jean Baudrillard: The Defence of the Real* (Sage).

**Alan Cholodenko** is a senior lecturer in Film and Animation Studies in the Department of Art History and Theory at the University of Sydney and editor of *The Illusion of Life: Essays on Animation* (Power Publications).

**Lisabeth During** is the author of numerous articles on European philosophy and aesthetics and lives and works in New York.

**Frances Dyson** is a media artist and theorist specialising in sound and new media. She is widely published and her audio artwork has been broadcast on ABC Radio.

**Patrick Fuery** is reader in the Department of Drama, Theatre and Media Arts at the University of London, Royal Holloway College.

**Jane Goodall** teaches in a transdisciplinary Humanities program at the University of Western Sydney, and is author of *Artaud and the Gnostic Drama* (Oxford University Press).

**Douglas Kahn** is Associate Professor of Media Arts, University of Technology, Sydney and author of *Noise, Water, Meat: A History of Sound in the Arts* (MIT Press).

**Julia Kristeva** is an academic, a novelist and practising psychoanalyst, and Professor of Literature and Humanities at École Doctorale Langues, Litteratures et Civilisations, University of Paris 7 – Denis Diderot.

**Sylvère Lotringer** is Professor of French and Comparative Literature at Columbia University in New York. He is founding editor of Semiotext(e).

**Mike Parr** has been a leading Australian artist for decades. His work has recently been featured in the Liverpool Biennale in the United Kingdom.

**Bill Schaffer** is a lecturer in film studies at the University of Newcastle.

**Edward Scheer** is a lecturer in the School of Theatre, Film and Dance at the University of New South Wales.

**Lesley Stern** is an associate professor in the School of Theatre, Film and Dance at the University of New South Wales and is the author of *The Smoking Book* and editor (with George Kouvaros) of *Falling for You: essays on cinema and performance* (Power Publications).

**Nick Tsoutas** is director of Artspace in Sydney.

**Samuel Weber** is Professor of English and Comparative Literature at University of California, Los Angeles and director of UCLA's Paris Program in Critical Theory. He is the author of many books including *Mass Mediauras: Form, technics, media* (Power Publications and Stanford University Press) and most recently, *The Legend of Freud* and *Institution and Interpretation*, both forthcoming in 2000 at Stanford University Press in expanded versions.

**Allen S. Weiss** is the author of over 20 books including *Phantasmic Radio* (Duke University Press) *Perverse Desire and the Ambiguous Icon* (SUNY Press) and *Unnatural Horizons* (Princeton Architectural Press).